PICTURES *of* LONGING

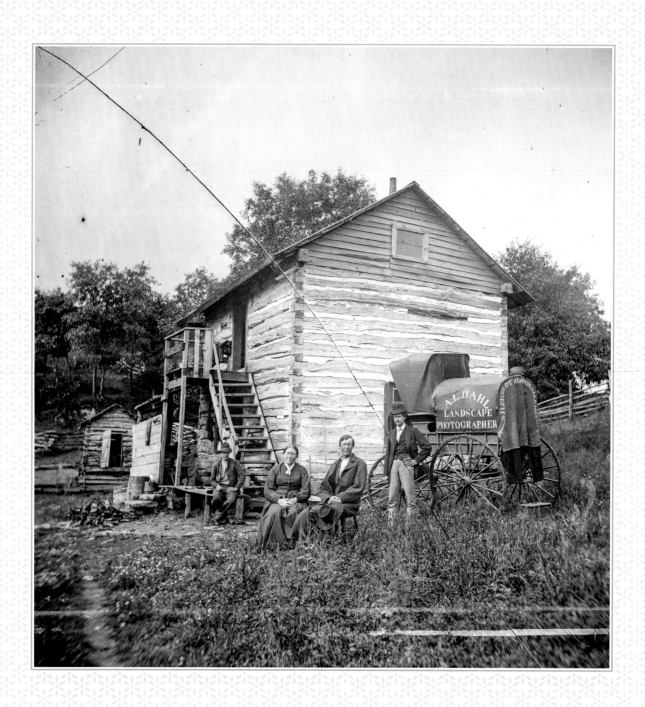

PICTURES *of* LONGING

PHOTOGRAPHY AND THE NORWEGIAN–AMERICAN MIGRATION

SIGRID LIEN

Translated by Barbara Sjoholm

University of Minnesota Press
Minneapolis
London

The University of Minnesota Press gratefully acknowledges the generous assistance provided for the publication of this book by the Research Council of Norway and the University of Bergen.

This translation has been published with the financial support of NORLA.

Originally published in Norway in 2009 by Spartacus Forlag AS / Scandinavian Academic Press as *Lengselens bilder. Fotografiet i norsk utvandringshistorie.*

Frontispiece: Andrew Larsen Dahl, self-portrait, Blue Mounds, Wisconsin, 1871.
Page vi: Andrew Larsen Dahl, farmers in Wisconsin, 1874.

Published by the University of Minnesota Press
111 Third Avenue South, Suite 290
Minneapolis, MN 55401-2520
http://www.upress.umn.edu

Printed in the United States of America on acid-free paper

The University of Minnesota is an equal-opportunity educator and employer.

24 23 22 21 20 19 18 10 9 8 7 6 5 4 3 2 1

Library of Congress Cataloging-in-Publication Data
Lien, Sigrid, author. | Sjoholm, Barbara, translator.
Pictures of longing : photography and the Norwegian-American migration / Sigrid Lien ;
 translated by Barbara Sjoholm.
Lengselens bilder. English translation.
Minneapolis : University of Minnesota Press, [2018] | Originally published: Oslo : SAP, c2009
 under title: Lengselens bilder. | Includes bibliographical references and index.
LCCN 2018008705 (print) | ISBN 978-1-5179-0198-1 (hc) | ISBN 978-1-5179-0199-8 (pb)
LCSH: Vernacular photography—United States—History. | Norwegian Americans—History—
 Sources.
LCC TR23 .L5413 2018 (print) | DDC 770.89/3982073—dc23
LC record available at https://lccn.loc.gov/2018008705

To my father, Torleiv Lien

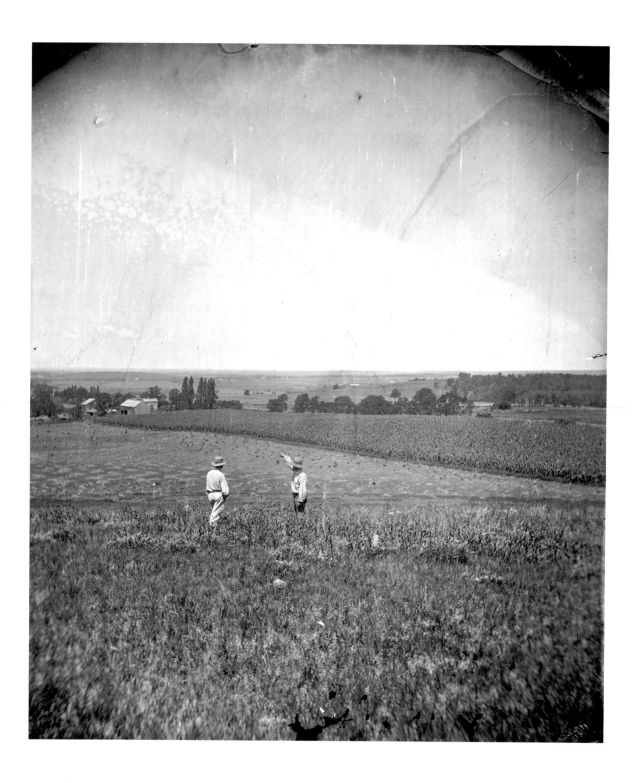

Contents

Preface

I belong to a generation that grew up with pictures of America—both the sentimentally magical images of America as mediated through popular culture and actual photographs and postcards related to the Norwegian emigration. Such photographs are, for me as for many other Norwegians, rooted in family history. I remember how wonderful it was to leaf through my grandmother's photo album. It held pictures of Grandfather's youth in America and shiny Christmas cards from Grandmother's close family in Brooklyn. I remember the thrill of opening parcels from relatives "over there" and the cultural differences that were made visible when the Norwegian-American family members arrived for the Norway Visit—for example, in the 1960s when Grandmother's sister stood in the yard of the farm in the fjords south of Bergen wearing glasses with spectacular American frames, her hair in a blue permanent wave.

Later in life I became a photography scholar at the University of Bergen. By chance I met one of Orm Øverland's graduate students who was working on a dissertation on immigrant correspondence. This gave me the idea of studying the pictures that were often enclosed in these letters, images like those I had seen in Grandmother's album, which are found in so many Norwegian families. I wanted to examine migration history as a visual story. A Fulbright Scholarship made it possible to travel to the United States to collect material, and later the study was incorporated into the larger research project *The Photograph in Culture*, funded by the Norwegian Research Council. This gave the work secure funding and an academically stimulating framework. The newly established Nordic Photo-Historical Research Network became an important place for inspiration and constructive discussions with Nordic colleagues.

Anthropologist Eva Reme was an inspiring coworker in the project's first phases, and together we made many expeditions to archives, private collections, and museums, both in the midwestern United States and in Norway.

I owe a great debt to those supporters in the museum and archive world and would especially like to mention Leonhard Bjarne Jansen and Anna Stella Karlsdottir at the Setesdal Museum; community members in Valle, Setesdal, and in Hå in Jæren; Lisabet Risa at the Regional State Archives in Stavanger; Ingvild Flaskerud, Vivian Aalborg Worley, Geir Palle Haarr, and Jennifer Kovarik at Vesterheim Museum in Decorah, Iowa; John Bye and John Hallberg at the Institute for Regional Studies, North Dakota State University; Dee Grimsby at the Wisconsin Historical Society, Madison; Mark Peihl at the Historical and Cultural Society of Clay County, Moorhead, Minnesota; Georgia Rosendahl of Spring Grove, Minnesota; Shirley Johnson at the Houston County Historical Society, Caledonia, Minnesota; Victoria Hofmo at the Scandinavian East Coast Museum, Brooklyn, New York; and Peter Syrdahl and Glenn Durban and their families. I had the great pleasure of holding conversations with the sisters Linda Heen and Carol Heen, who have made great and inspiring efforts in collecting Norwegian-American photographic material in their community in Minnesota.

The Norwegian-language edition of *Pictures of Longing* was published in 2009 by Scandinavian Academic Press. I thank the University of Minnesota Press and Kristian Tvedten for undertaking the task of publishing the book for an English-speaking audience. The English edition has been made possible through financial support from the University of Bergen, NORLA, and the Norwegian Research Council.

My deepest thanks go to the many Norwegian-American photographers who supplied the raw material for this study: these wonderful images. As visual storytellers, the photographers give us tangible access to this important phase of Norwegian and American history in a way that excites both the eyes and the imagination. Their pictures visualize history as a story of other people's lives, their struggles, and their dreams.

Introduction

"Send Us Your Portraits"

Letters and Pictures in the History of Emigration

Join me! These words are written on the back of a faded photograph in a family album (Figure I.1). The photograph shows a young man in simple work clothing, sitting straight-backed on his horse. He is surrounded by barren scrubland. In the background is a glimpse of the outline of extensive, snow-clad mountains. His descendants can tell us that the picture was taken around 1915 in Montana, where the young man from a small village in western Norway found temporary work on a farm. At home it was difficult to make a living at that time.

My family recalls him as a kindly old grandfather who smoked a pipe in the corner of the kitchen and always offered old-fashioned hard candies. Occasionally he talked about his younger days in America—for example, how on a single day he killed six rattlesnakes or the time he saw a Swede freeze his ears off in the frigid Midwest. But the dream of settling down "over there" vanished when his wife died at home in Norway. His family never joined him in the United States. Instead, Grandfather returned to Norway to care for the two small daughters he was now left alone with. He described it later as his life's saddest journey. After a while, this and other family stories slipped into oblivion, until the day when, long after Grandfather's death, the photograph of him as a young man on a horse suddenly popped up, sent from a distant relative. With that came "the proof" and the reminder: Grandfather had been a cowboy in America. It was true, all of it.

FIGURE I.1. Tor Lien on horseback in Montana, circa 1915.

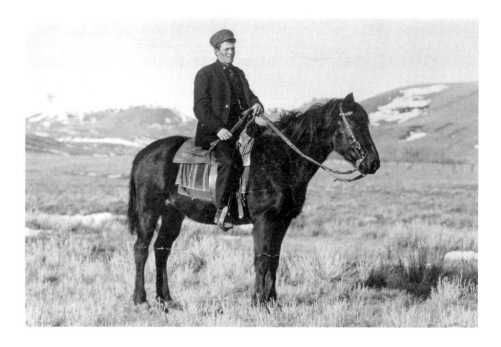

Many similar photographs and stories are found in both Norway and in "Norwegian America." Some of the stories are about those who returned to Norway, as the young man did, after having sought happiness (and perhaps having found it) on the other side of the Atlantic. But the majority of them tell the story of those who stayed and made America their new homeland. This book concerns what in Norway are simply referred to as "America-photographs." These photographs have their background in a long and important era in Norwegian-American history: the great emigration from Norway to America. During the period between 1836 and 1915 no fewer than 750,000 Norwegians immigrated to North America, in what has been called history's largest population migration.[1] Up until 1890 only Ireland had a higher emigration concentration.[2] In this process, thousands of photographs and letters were sent back and forth. The photograph of the young man on the horse in Montana was only one of the many that reached relatives at home in Norway. But despite photography's central role in the migration process and the close relationship between letters and pictures, the America-photographs have not been given great consideration by historians.

Pictures of Longing attempts to meet the need for a fundamental investigation of this particular photographic genre that clearly has meant so much to so many. It

thus puts the role of photography in the history of the Norwegian-American migration into closer focus. The book is based on a comprehensive and years-long search for images in public and private archives and in museums in both Norway and the United States. This search also included collection work in cooperation with Setesdal Museum in Norway. In examining this photographic material, I have drawn on the insights and approaches from two different fields of research: the so-called grassroots history in the tradition of Theodore Blegen (1891–1969), with its emphasis on letters and diaries, and recent studies of photography.

Blegen's focus on correspondence puts a methodological emphasis on "the small pictures" at the expense of "the big picture"—the grand narrative.[3] In the same way, recent approaches to the study of photography, led by John Tagg, emphasize how "photography is made up of histories in the plural, as photograph*ies*, and not as a singular history."[4] Letters and pictures thus steer us toward a history that consists of histories, which are multiple, fragmented, and dispersed in character. The histories that they together bring forth are, in David Bate's words, like "the shards of a shattered mirror on the floor."[5]

Central to my analysis of immigrant photography in its different forms is the idea that such shards also possess the capacity to cut into the existing fabric of grand, widely established historical narratives. This concept of *violation*, drawn from the recent work of John Roberts, is particularly relevant here, as it refers to photography's unstable and destabilizing character. More specifically, violation alludes to photography's way of intrusively pointing to something in the world, an act of disclosure, which in itself is culturally, socially, and politically situated.[6] For Roberts, it was initially with the Russian Revolution and parts of avant-garde art and contemporary art that photography as a violating force came into play. In addition, he localizes examples of counter-hegemonic photography in some of today's everyday amateur practices. The America-photographs I have researched, however, belong to the photographic culture of the late nineteenth and early twentieth centuries. Thus they fall outside the historical context Roberts sets for the violating potential of photography. As he sees it, the photographic practices of the nineteenth century were generally steeped in middle-class (petit bourgeois) culture and thus totally devoid of any critical ability.[7]

It is mainly here, in view of the inherent critical opportunities offered by historical photographic material, that my analysis differs from Roberts's. But, as this book's chapters will show, the America-photographs are rooted in historical processes that deal with something else. The transatlantic photographic exchange between

Norwegian immigrants in the United States and their relatives and friends in Norway can clearly be considered a collective photographic practice involving "the voices of the many." In the same way as letters, America-photographs are part of cultural grassroots practices.

That mobility and politics must be seen in relationship to each other is a recurrent point in historical research on migration. But when such relationships are depicted in this research, written sources are usually the focus. For example, Ingrid Semmingsen describes the emotional and political power of the America-letters and their antiauthoritarian edge, directed at the emigration-hostile forces at the top of Norway's social hierarchy:

> The letters exerted influence not only on the leaders but also on the broader masses of villagers in the farthest corners of the country. The America-letters were read over and over again. Through them the common man received all kinds of new impressions; his intellectual horizons grew wider, his mind had new ideas to work with. Farmers, artisans, and workers learned that there was a country where all trades were open, where there was no deep social chasm between officials and the gentry on the one hand and the simple man on the other. In this way, these classes in the nation received new arguments in the fight for their social and political demands, and at the same time their sense of self-confidence grew, because they could tell themselves and others that even if things were wrong in this country, even if the government refused all reforms, they still had some recourse—they could always buy a ticket to America and say farewell to everything that bothered them here.[8]

It's not hard to imagine that the America-photographs may have had an equally strong intervening force or emotional hold as the letters. But to conceptualize, visualize, and nuance their critical grassroots potential, I have chosen to think of them not necessarily as brutal violations but as historical *interventions*. With this understanding, I have questioned what meanings the Norwegian immigrants and the photographers who took their pictures wanted to communicate through the photographs that were sent home. What kinds of truths about a new life in America did they want to emphasize through such photographs? How are these visual statements to be understood in relation to the cultural, political, and social contexts in which they appear? And how do they present themselves as grassroots interventions in the established narratives of Norwegian-American migration history?

For in the same way as immigrant letters have come to be understood, it is neces-

sary to see immigrant photography as a cultural phenomenon on its own terms and not primarily as a tool for other purposes.[9] To return to the photograph of the young man on the prairie, the viewer can conclude that this and other photographs of the same kind, as Alan Trachtenberg puts it, are not "simple depictions of what happened in the past, but constructions that produce a particular, visual version of history."[10]

Interconnected Histories

The introduction and establishment of photography and the great immigration to America are historically interconnected processes. So-called America Fever had its parallel in a fever for photography that spread through Europe beginning in 1839, from the moment the first known daguerreotype was introduced in Paris.[11] Daguerreotypes were images on metal—an early form of photography that could be produced by making a highly polarized copperplate light sensitive with the help of chemical processes. Not many years after their introduction in Paris, daguerreotypes were also produced in Norway.

The connection between the history of emigration and photography becomes clear in letters sent home from Norwegian immigrants in America. As early as the 1850s, an immigrant minister's wife, Elisabeth Koren, writes in her diary about how lucky her family is to have daguerreotypes and thereby to be surrounded by familiar faces.[12] Daguerreotypes were, however, relatively expensive to produce and therefore most frequently found among the higher social classes. It thus says something about the family's social background when Mrs. Koren describes how her husband, in connection with the move to a new house, leaves with "Travel clothes, etc., over his arms and his hands full of Daguerreotypes."[13] The couple had probably brought the daguerreotypes all the way from Norway. It would have been expensive (and practically impossible) to send such heavy, fragile glass-mounted metal pictures in the mail along with letters.

With the later development of paper-based photographic techniques and the completion of international postal conventions that reduced postal costs throughout the 1860s, it became possible to send photographs along with letters.[14] From this point on, a large transatlantic exchange of photographs began between Norwegian immigrants in America and their relations at home in Norway. A letter from the mid-1860s, written by another well-known immigrant woman, Gro Svendsen, bears witness to the emotional significance of this exchange. Sending a photograph of

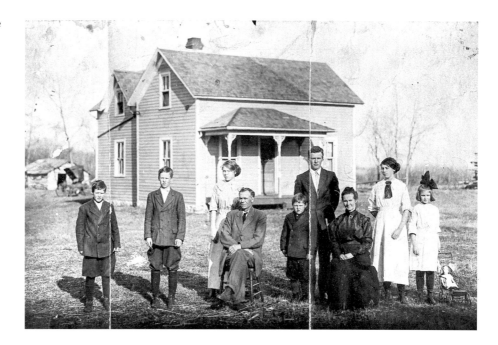

herself and her young son home to her parents in Norway, she remarks on the value of photography: "But let me tell you again that I will have our portrait taken and sent to you as a memory, and to show you my little boy. . . . I think that it will probably please you more than if I sent you a golden dollar."[15]

The comprehensive multivolume work *From America to Norway: Norwegian Emigrant Letters* offers countless examples of how the correspondents beg for photographs.[16] Some examples, such as a family portrait sent home to Valle in Setesdal (Figure I.2), even have crease marks from being folded to fit in the envelope. This portrait is typical of its genre. With serious expressions and more than a little pride in their gazes, the family members pose in their best clothes in front of their new and spacious American home. Other images show how some letter writers even let themselves be photographed while writing, as seen in the photograph that Guttorm Bø sent in the 1920s to his nephew back home in Norway (Figure I.3). Bent over the letter in deep concentration, with an inkwell by his side, Bø poses on the stairs outside a workmen's dormitory.

The interconnection between photography and migration is further reflected in works by Norway's leading photographers of the nineteenth century: Knud Knudsen (1832–1915), Axel Lindahl (1841–1906), and Anders B. Wilse (1865–1906).

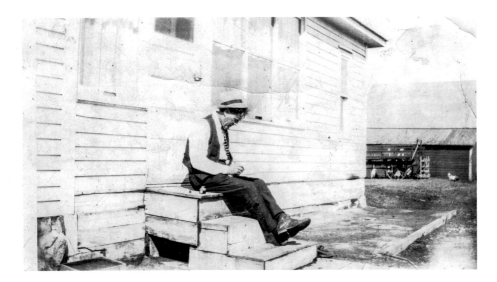

FIGURE I.3. Letter writer Guttorm Bø sent this photograph to his nephew Tarald Berg in Valle, Setesdal, 1925.

FIGURE I.4. Knud Knudsen, *Emigrant Ship on Departure*, Bergen, Norway, circa 1871.

Knudsen advertises in his sales catalog that he can offer pictures of "Emigrant Ship Departing" (Figure I.4). The subject of departure is also present in his competitor Lindahl's well-known photograph from the Seljestad mail station in Hardanger (Figure I.5). Here Lindahl directs his camera toward a group of young girls. They are standing next to a wagon that is harnessed with horses and brimming with travel chests and securely bound baggage. The whole scene emphasizes the charged emotions of the occasion. Is only the little girl near the wagon leaving, or is the entire family saying goodbye forever?

Anders B. Wilse began his photography career as a Norwegian emigrant to America in 1897.[17] Perhaps therefore his photographs, even more than

FIGURE I.5. Axel Lindahl, *Hardanger, Seljestad Station,* Norway, 1897.

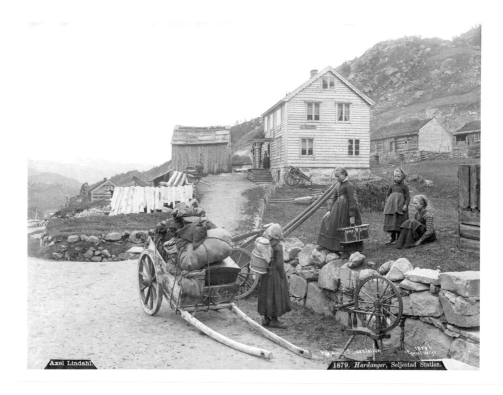

the works by his colleagues, seem to be able to manifest the personal, social, and cultural dimensions of migration—the actual movement of people. This production includes not only photographs from Wilse's time "over there" but also motifs from his own trips to America. He invites the viewer to take part in his journey. He provides glimpses from its beginnings in the fjord inlets of western Norway (Figure I.6) to the steps up the gangplank. Viewers are offered scenes of the social life aboard the ship's deck (Figure I.7), in the dormitories (Figure I.8), in the third-class dining room (Figure I.9), and in the music salon for the more affluent passengers in first class (Figure I.10).

Wilse was far from the only Norwegian emigrant who tried his luck as a photographer in the United States. According to emigration records from different districts in Norway, four hundred individuals listed "photographer" as their occupation on departure to America. Unlike Wilse, most had a solid background in photography even before their departure from home. These Norwegian-American photographers produced great numbers of images that were widely distributed throughout the United States and in Norway.

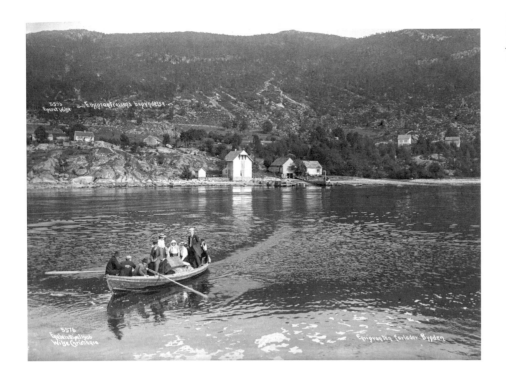

FIGURE I.6. Anders Beer Wilse, *The Beginning of the Emigrant Journey*, Kysnesstrand, Norway, 1906.

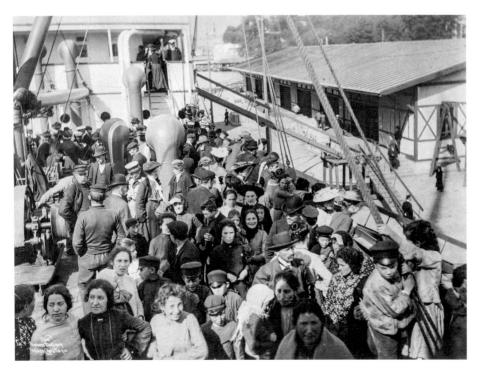

FIGURE I.7. Anders Beer Wilse, emigrants ready to travel on deck of the steamship *Hellig Olav*, 1904.

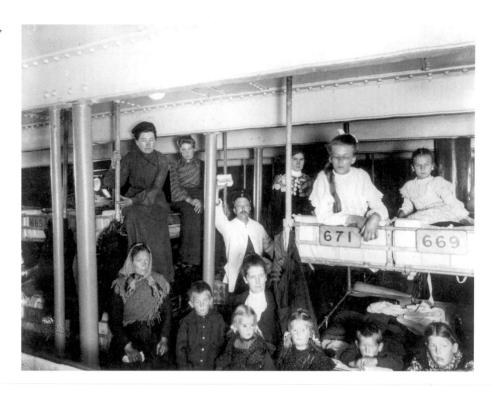

FIGURE I.8. Anders Beer Wilse, cabins on board the steamship *Hellig Olav*, 1904.

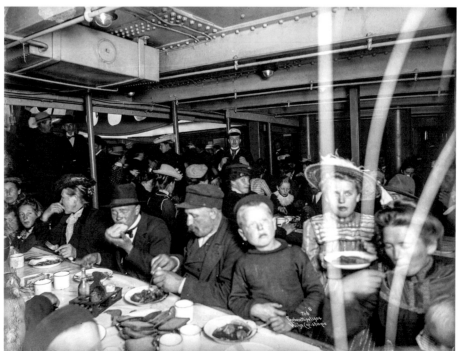

FIGURE I.9. Anders Beer Wilse, third-class dining room on the steamship *Hellig Olav*, 1904.

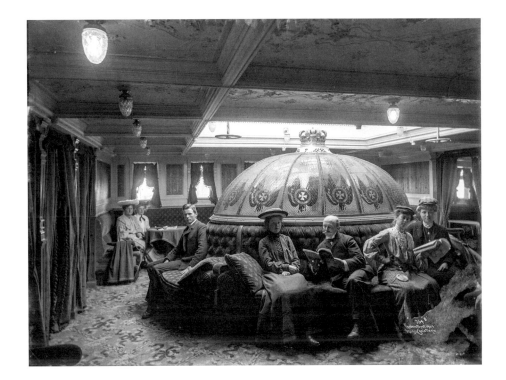

CROSSING BORDERS

Yet the many America-photographers and their work have been largely absent in existing scholarship. Susanne Bonge (1912–2009), one of the pioneers within this field of research in Norway, discusses the large number of Norwegian photographers who emigrated to America in the comprehensive register she compiled and published in 1980.[18] Though Bonge does not reflect on the question of why so many Norwegian photographers chose to emigrate, she does point to the powerful expansion that took place in the profession of photography—both in Norway and in the whole of Europe—after the introduction of the wet-plate method, which predominated from the 1860s. The most important advantage of this method was the ability to reproduce an unlimited number of images from the negative glass plate. This created the basis for photography as we know it today. The quick and extensive spread of this technique led to intense competition between the many who tried to make their living as photographers.[19]

In the foreword to her register, Bonge writes that she chose not to include Norwegian-American photographers in her work because such a survey represents a research project of its own.[20] In line with the national orientation of historical writing on photography, she limits her survey to the emigrant photographers who at the time of their departure stated photography as their profession in Norway. Bonge's registry remains relevant to migration history because it includes a series of concise presentations of each photographer with biographical information—including their background and occupation before they left for America—that might suggest some reasons for emigrating. A few of them are figures whose names already stand out in Norwegian history, like the well-known socialist leader Marcus Thrane. Alongside his political activities, he worked as a photographer both in the United States and in Norway. In the registry he is presented in this way:

> THRANE, MARCUS MØLLER: b. Christiania 10-4-1817–d. Wisconsin USA 4-30-1890, son of state bank director David T. and Helene Sophie Bull. . . . Journalist, teacher and photographer, best known for his political activities. Started as a photographer after imprisonment in 1858, traveled widely in Norway. . . . He probably earned his livelihood as a more or less itinerant photographer until he emigrated to the U.S. by Christmas time in 1863.

The majority of America-photographers had a more modest social background. Like Thrane, many of them appear to have been versatile, talented, and knowledgeable, with a wide range of interests and occupations. This is evident in the brief presentation of Ole Yri from Nordfjord, who worked in Minnesota during the first decades of the 1900s:

> YRI, OLE: b. 1-14-1878 in Olden, m. Marta Andreas Sunde (1909-). Was in Minnesota, U.S.A. 1906-1920 where he was a photographer and church singer, but photographed in Olden both before he left and after he came back. Along with his photographic work (mainly as an amateur) he was a shoemaker, watchmaker, smith, and farmer.[21]

How did it go for these two—and the rest of the Norwegian photographers who set a course for the United States? And what kind of photographs did they leave us? Such questions are not easy to answer. First, it is difficult to trace these photographers from a practical standpoint. Some Anglicized their names. Sigrid became, for instance, Sarah. The surname name Grøsfjeld could smoothly be Americanized to "Grossfield," as the photographer Gabriel G. Grøsfjeld from Egersund did after arriving in his new

country. It may have been for the sake of simplicity but possibly also for its symbolic impact when Amund Nymoen from Målselv became Amand Newman in the United States. Second, the versatility of the early photographers in terms of their skills and occupations is problematic when researching their lives in America. Some of them sought out other types of income-producing work besides photography.

When these photographers moved to a new continent, they also wandered out of the Norwegian national context. In Norway, a national perspective has been prominent in shaping the history of photography. Consequently, photographers who have moved between national borders are easily lost from view. In addition to taking this rather enclosed national focus, traditional research into the history of photography has mainly shown interest in artistic photography. This orientation seems to be dominant in the relatively few publications that see migration and photography in a broader and transnational perspective. Here attention has mainly been directed toward iconic works by canonized photographers (who themselves were immigrants), among them André Kertész, Brassaï, Man Ray, and Jacob Riis.[22] The consequence of this partial approach to migration photography as art is that other important aspects are ignored. Thus, it becomes difficult to establish an understanding of photography's role in migration-historical processes in a broader sense.

Only a few studies approach migration photography with attention to its wider sociocultural and political contexts. One is Carol Williams's research on the British colonization of the Pacific Northwest (2003), in which she argues that photography contributed to constructing cultural and racial differences between settlers and Native Americans.[23] Other studies include Anna Pegler-Gordon's *In Sight of America* (2009), which demonstrates how photography shaped the development of immigration policy in the United States,[24] and Anthony W. Lee's *A Shoemaker's Story* (2008), a complex historical narrative that addresses issues such as the industrialization of New England, the uses of immigrant labor, and the local rise of photography as a profession.[25]

As more recent research has shown, the people of diasporas have always used visual means to represent their notions of loss, belonging, dispersal, and identity.[26] In our own time, characterized by refugee crises and mass migrations, the relation between photography (and visual culture in a broader sense) and migration has emerged as a current and important research subject. At the same time, this scholarly reorientation should also be understood against the backdrop of criticism toward the national paradigm in photography studies in general.

Pictures of Longing has taken shape in a historiographic setting characterized by a shift in methodology: from a nationalistic research tradition to an increasingly

transnational orientation. Historians Donna R. Gabaccia and Leslie Page Moch describe this shift as a development by degrees toward "more comparative studies, adopting global and world perspectives, and experimenting with transnational studies."[27] These tendencies are likewise making themselves known in the fields of aesthetic studies and cultural studies. As Nicholas Mirzoeff remarks, "The idea that culture must be based in one nation is increasingly being challenged. Now it is time to look at the way that culture crosses borders with ease in a constant state of evolution."[28] This book is a contribution to such border-crossing approaches, but with particular focus on "the work" photography is doing in culture. It attempts to establish an understanding of the role of the America-photograph in the many small narratives that make up the history of Norwegian-American migration, and in this way it may be thought of as one piece of a greater, transnational jigsaw puzzle that has barely begun to be assembled.

The Histories of Letters

Although the America-photograph has long been subjected to academic neglect, the immigrant letter, in contrast, became an object of interest within Norwegian-American historical research as early as the late 1920s. In 1928–29, historian Theodore Blegen undertook research trips to Norway to collect letters. Blegen belonged to a generation of younger radical historians of Scandinavian heritage who, inspired by the frontier historian Frederick Jackson Turner, instigated a rebellion against the established written histories and their focus on the masculine, Anglo-American elite. They were also critical of sociological studies where the so-called New Immigration was seen as a problem, for American society or for the immigrants themselves. In opposition to these positions, Blegen and his colleagues George Stephenson and Marcus Lee Hansen sought to study history and immigrant culture from the ground up. Their goal was to establish an inclusive, democratic history, a "grassroots history" that would highlight the immigrants' own experiences.[29] "The pivot of history is not the uncommon, but the usual, and the true makers of history are the people,"[30] wrote Blegen, who emphasized the necessity of studying small, everyday stories as a basis for understanding great historical movements.

As an opponent of statistical studies, which he saw as reducing human interest to "rows of figures or symbols or trends and inter-relationships,"[31] and history written with "emotional remoteness," Blegen characterized the letter writing of immigrants

as "a diary on a grand scale" and a "literature of the unlettered."[32] The letters made for a direct encounter with the experiences and adaptation process of the immigrants—as Blegen put it, they were a human record "of hopes and heartaches, courage and fear, failure and success, and of ferment and transition to new ideas and habits and ways of living."[33] Consequently, in Blegen's view, the America-letters could be of historical interest in multiple ways: first, as "valuable records of the details of the emigrant's experiences"; second, as the basis for understanding "the reaction of the immigrant mind to the new environment of the West"; and, third, as a means of highlighting "the type of influence that was brought to bear upon the mind of the prospective emigrant in Norway."[34] This last aspect shows that Blegen imagined the letters to have the rhetorical potential to move their recipients to change their lives and undertake a trip over the ocean themselves. He thus did not regard the letters exclusively as passive sources but also as texts that actively contributed to making history.

What was radical in Blegen's research is clearly accentuated in his argument for seeing small, regional stories as a platform for a wider transregional and transnational understanding of history. He presented this idea a full century before the concept of transnationality came into circulation. For him, macrohistory was the sum of regional paradigmatic historical stories:

> We start off with a background of local history; we share in the community memory; from the community we first look out upon life and the world. Then we learn the story of the land in which we live and of countries and nations and peoples outside, and we begin to realize that this broader history is the sum of the histories of numberless localities and communities. . . . In that understanding the community is, not an isolated thing, but a living part of the state, country and the world, with myriad bonds of interrelation.[35]

Pictures of Longing is inspired by Blegen's ambitions to look at the story of Norwegian-American history as a history from below. This is no longer a particularly radical perspective; the pluralistic and egalitarian approach that he struggled to establish has long been integrated and accepted in historical research, not least through the continuity this tradition had in the United States, Canada, western Europe, and Australia with the establishment of the "New Social History" of the 1960s.[36] Letters from immigrants are, as David Gerber reminds us, "probably the largest single body of the writings of ordinary people to which historians have access."[37] If the letters inform our reading of the earliest uses of Norwegian to express an American experience, photographs may be seen as their visual counterpart. Though not grounded in

Norwegian language, they represent the immigrants' factual and emotional records and self-presentations while starting a new life on another continent.[38]

Norwegian literary historian Orm Øverland has contributed to establishing a theoretical framework for the understanding of the America-letters. In his important essay "Learning to Read Immigrant Letters: Reflections towards a Textual Theory" (1996), he brings into focus the letters' characteristic features. He points to their patterns of circulation and their combined public and private function; the letters' shared textual and stylistic features; their nonemotional tone of address; the "literary illiteracy" of their writers; the physical conditions under which they were written; and the way the individual letters formed parts of larger bodies of texts (as developing stories or autobiographical records).[39]

This theoretical horizon, and particularly Øverland's perspectives on the circulation and use of the letters, offers a possible starting point for establishing a comparative understanding of the America-photographs and the aesthetic practices in which they were embedded. The letters are a wellspring of empirical information about photography and photographs. Their writers offer important information about how the photographs were valued, aesthetic conventions, contexts of production, and the interplay between the photographers and their customers in Norwegian-American communities.

The letters that Øverland edited and published further bear witness to how the photographs, similar to the letters, were circulated. Many letters contain very particular instructions for how the America-photographs should be distributed in the village back home. In 1871, for example, Paul Torstenson Vigenstand wrote the following to his brother in Oppland: "This time I am sending home 8 portraits of Thor, which he asked me to send, and they should be divided up so that 4 are for you and 1 Ivar Tofte, 1 Thor Tofte, 1 Hans Langdalen and 1 Simen Haugen. I'm also sending 2 of me."[40] Both the letter writer and Thor thus wandered into many homes. Similarly, Arne Jørgensen Brager closed his letter home to Norway in 1873: "The portraits enclosed here can you show them to whoever you want and then can you take them to Tiøl Houghhom/Haavard Sigbornson."[41]

The experience of encountering a traveling photographer is described in a letter from Mary Engum in the small town of Detroit Lakes, Minnesota, on May 30, 1905. Two traveling photographers knocked on her door and asked about taking her picture (and that of her young child), along with the house. She explains that she didn't have time to change into nice clothes:

Early in the morning, before I was done with my work, came two fellows and wanted to take a picture of the house. They wanted me and Joel to stand on the porch. Outside the door, where there is a roof over what is called the porch. There we stood, both of us in our old clothes. Joel was crying with a finger in his mouth. I just had two taken, one for you and one for us.[42]

In a letter from Marie Killi, whose son divided his time between his newly established photography studios in two small towns in Minnesota (Figure I.11), the photographer's daily life is described in similar, nonidealized language. In her letter, she emphasizes that the Norwegian-American photographer's sphere of work is more diverse and that, contrary to what she experienced in Norway, it is not only the wealthy who can afford to have their portrait taken.

Our youngest son runs a photography studio here and makes good money. It's not the same here as in Norway to be a photographer, because here they take pictures of every possible thing and both servants and important people pay dearly for portraits. From 4 up to 12 dollars a dozen. He also has a studio in another town where our seventh son is and he travels sometimes. Our daughter Regine helps him.[43]

FIGURE I.11. Craver Brothers, Hans Kelly's photography studio, Bird Island, Minnesota, circa 1900.

Øverland's efforts to develop, systematize, and publish a theoretical understanding of the America-letter are also important for understanding the America-photograph as a phenomenon. But my study of these images differs from Øverland's examination of the letters in that I do not begin by pointing out the most general characteristics of the America-photograph as a genre. I have chosen rather to move from the particular to the general, by allowing the individual photograph or the individual visual body of work to form the starting point for my discussion of the genre's character. In addition, unlike Øverland, I focus on the striking commonalities between the letter and the photograph, something that contemporary letter scholars have also noted. Liz Stanley, for example, shows how both letters and photography have a special ability to preserve memories and time:

> Letters thereby share some of the temporal complexities of photographs: they not only hold memory but also always represent the moment of their production, and have a similar "flies in amber" quality. This "present tense" aspect of a letter persists—the self that writes is in a sense always writing, even after the death of the writer and addressee; and their addressee is "always listening" too.[44]

Word Pictures

The lack of interest in the relationships and commonalities between letters and photography does not mean that visuality is totally absent in migration history. It is sometimes expressed in other ways, including the use of images as metaphors. For example, to write history is for Blegen like drawing pictures—which can be small or large in format. The challenge is in tying together or integrating the different formats to establish "how these pictures, large and small, . . . fit together."[45] Blegen's pioneering overview of migration history, *Norwegian Migration to America*, published in two volumes (1931 and 1940), can be considered an attempt to meet this challenge.[46]

Here Blegen establishes a *grand narrative*, a picture that in itself takes the form of a journey, a movement from Norway to the United States. The journey begins in the first volume with a description of the country that the Norwegians left behind, such as its demographic and topographic character, the living conditions of its population (especially of farmers and tenants with small holdings), problems of poverty, social and political tensions, inequality in political representation, and

asymmetrical power structures. This narrative holds a particular focus on the charismatic leader Cleng Peerson, growing resistance to the Norwegian state church, the development of the Quaker movement—and finally the departure and crossing of the first emigrant group, which set out in 1825 from the port of Stavanger on the sloop *Restauration.* It continues with the establishment of Norwegian settlements in Illinois and the gradual spread to new territories farther west, including Texas in the south. Furthermore, the narrative includes stories about Oleana, the utopian and unsuccessful colonization of a region in Pennsylvania by the legendary musician Ole Bull, and Norwegian participation in the California Gold Rush of the 1850s. The second volume focuses on the integration of Norwegian immigrants in American society.

Within the framework of this overarching macrostructure, Blegen includes "the small pictures," that is, the historical participants' own voices. The voices unfold as a nuanced and complex tapestry of perspectives and opinions, forces and counterforces. Here there is space not only for the distinct experiences of the immigrants, both positive and negative, as they were mediated in the photographs and letters, but also for voices raised in heated discussions for and against emigration among the Norwegian public.

References to factual, concrete pictures are only marginally present in these scenarios. Blegen briefly mentions the painter Adolph Tidemand's emotionally laden emigration tableaus set in Norwegian peasant culture, but only as sources of inspiration for the extensive Norwegian folk poetry that developed in response to migration.[47] In another chapter Blegen remarks how, during the summer of 1852 in the capital city of Christiania (now Oslo), Norwegians could admire a gigantic painting of the Mississippi River valley.[48]

In his own historiographical discussions regarding the letter as a source category, Blegen consistently makes use of the visual image as a metaphor for characterizing the letter's value, representational power, and ability to rivet the eye. This is particularly clear in his guiding research manifesto, *Grass Roots History* (1947), which successively presents and discusses different kinds of sources for immigration history (song traditions, diaries, literature, mass media, American popular culture, etc.). Here the letters are characterized as "word pictures," in which images of frontier family life are "etched in."[49] Blegen further emphasizes that these word pictures are able to "retain a startling vividness over the years."[50] Particularly gifted letter writers, such as Gro Svendsen, stand out precisely because they possess "a way of drawing sharply etched pictures."[51] Visuality thus plays a central role in historical depictions

of migration, exemplified here by Theodore Blegen's principal work. But, paradoxically, actual pictures—paintings, drawings, graphic art, or photographs—are not present in his publications.

PHOTOGRAPHS AS ILLUSTRATIONS

Illustrations were adopted in the most important work of Blegen's Norwegian colleague Ingrid Semmingsen, who was clearly inspired by his efforts. Semmingsen's *Veien mot Vest: Utvanderingen fra Norge til Amerika, 1825-1865* (The way west: Emigration from Norway to America, 1825-1865) has been described as a "breakthrough for newer Norwegian—and Nordic—scholarship in the saga of emigration history."[52] But in this volume, as in many other historical surveys, the author's use of photographs as illustrations not only demonstrates how the particular evidential potential of photography is reduced but also fails to consider how photographs by themselves are historical interpretations.

A typical example from the book is a photograph of a small farmyard consisting of three little log houses: a main house and two outbuildings in the picture's center and background (Figure I.12). The unpretentious buildings, photographed in natural daylight, are encircled by tall trees. A white horse is centrally placed in the farmyard. It is also possible to catch a glimpse of some chests and what could perhaps be a plow outside the farmhouse in the foreground. The picture is supplied with a brief caption that tells something of the house's history: "This house is built by Gunnul Olsen Vindeg in Christiana, Dane Co., Wisconsin in 1840. Gunnul Olsen Vindeg was the first settler in Christiana and named the place himself after the capital in the old country." The institution in possession of the picture is also given: "Photograph in/from Wisconsin Historical Society, Madison, Wisconsin."[53] But the text gives no information about the picture's provenance, when it was taken, or who took it. Was it taken by a traveling photographer? How long had Gunnul Olsen Vindeg and his family lived on the farm before the photographer came to see them? The use of historical photographs in Semmingsen's book thus appears not to have been subjected to the same subtle critique as the written material that forms the basis of the historical presentation.

In its presumed neutrality or functionality, this photograph is left to speak for itself, free of the demand for further discussion or interpretation. The notable and interesting display of possessions in the farmyard—the horse, the chests, the farm

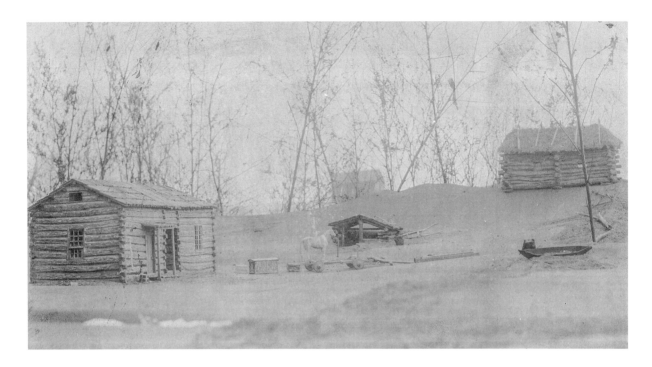

FIGURE I.12. Gunnul Olsen Vindeg's property in Christiana, Dane County, Wisconsin.

tools—which perhaps speaks of the homeowner's need to mark his social status and material progress, is not commented on. The question of why the Norwegian settler chose to present his home precisely in this way to the lens of a photographer is thus not thematized. In addition, the book's limited/imperfect level of reproduction—the simple picture formats and the lack of contrast and detail—contributes to the reduction of their specific quality as photographs. Like the other black-and-white photographs in the book, the image of Olsen Vindeg's farmyard and earthly possessions comes across as homogenized, pale, and lifeless.

Nevertheless, such historical illustrations, as John Roberts has pointed out, possess what is called "embedded 'textuality,' or connection to external social and historical forces."[54] Roberts argues that the textual embeddedness of illustrations can be productively inclusive. Photographic illustrations can, for example, potentially challenge a viewer who already possesses a certain historical competence.[55] Such knowledgeable readers will perhaps allow themselves to be engaged by the tentative arrangement of material prosperity in the photograph of Olsen Vindeg's farmyard and connect it with the chapter's textual themes of "life in the Norwegian settlements."

In this way, the picture's meaning becomes, according to Roberts, "naturalized" through a circular confirmation. The photograph's referent, the reality it supposedly represents, is read as an exemplary representation of the historical narrative presented in the text. Such circular confirmations can result in the photograph's particular historicity being filtered and reduced through a limited and normative set of "invisible" generic categories of meaning.[56] Such categories are strongly controlling, not only in terms of experiencing historical photographs in themselves but also in terms of determining how the photographs are selected or taken from the archives. This use of photographs as illustrations largely contributes to affirming and anchoring the viewer's existing conceptions of the migration history. Nevertheless, it does not take into account that photography is a medium too, with the power both to shape history and to go against its established conceptions.

Pictures of Longing

What then is particular about photography as documentation? What makes the photograph different from other forms of image production? And how may the visual embodiment of the migration experience be studied in ways that transcend overly textualized understandings of culture? *Pictures of Longing* presents a history of migration that understands photography as a grassroots intervention. Because photography regarded in this way is the result of an action, an act of making visible, it engages not only with the choices made by the photographers and the acts of image production but also with the image spectators and the acts of looking and interpreting.[57] Photography is thus written into a social ontology, a dynamic that includes both photographer and viewer.

Four of the book's chapters focus on a selection of photographers, their social realities, their work, and their choices regarding photographic production. These choices concern far more than technique and materiality; they deal also with what should be made visible, what should be honored, and what should be masked. The chapters start from a single image or collection of images. Chapter 1, "The Glass Plates in the Tobacco Barn," presents the photographic production of one of the pioneers of the profession, the touring "landscape photographer" Andrew Larsen Dahl, who worked in Wisconsin in the 1870s.

Chapter 2 addresses the work of some of the photographers who followed Dahl in the next generation, specifically the many small-town photographers who worked

in Minnesota during the first decades of the twentieth century, a period when these towns became the arenas for complex social interactions and for the unfolding of a particular multiethnic culture. Although it has been argued in some studies that diaspora appears to be very much a man's world, chapter 3 seeks to understand the ways gender and sexuality shaped immigrant identity.[58] It considers the life and work of Mina Westbye, a young woman who emigrated from Norway and started a professional life as a photographer in her new home country.

Chapter 4 is a study of the photographic work of Peter Julius Rosendahl from Spring Grove, Minnesota. Most of the Norwegian-American photographers mentioned in this book were professionals, but some, like Rosendahl, were amateurs with an interest in picture production. Rosendahl was already well known in Norwegian-American communities as a cartoonist and the creator of *Han Ola og han Per* (Ola and Per). The chapter examines the relationship between this cartoon series and the author's photographic work and further argues that Rosendahl's photographs may be seen as parallels to his poetry in the context of his political beliefs.

Photographers' social dynamic also includes those who viewed and used their pictures. In the book's later chapters, the America-photographs are viewed in the light of their position today, in albums and archives both public and private. Chapter 5, "Out of Cupboards and Drawers," examines preserved America-photographs in Norway—more precisely, in two Norwegian communities with a relatively high rate of emigration, Valle in Setesdal and areas of Jæren. Chapter 6, "Saved from Oblivion," turns attention to photographs that have been preserved in Norwegian America. The chapter considers how archives are used in Norwegian-American family chronicles to create continuity between the past and the present, to accentuate family values such as closeness and loyalty, and, not least, to make apparent a sense of ethnic belonging.

Inspired by recent discussions of affect and emotion in the study of photography and following in the tradition of the grassroots historians, *Pictures of Longing* tells the stories not of heroes but of ordinary people who experience an entire spectrum of emotions through their lifetime—fear, sorrow, disappointment, boredom, frustration, and longing but perhaps also happiness, joy, humor, and pleasure. These chapters contribute to an ongoing discussion of how the affective capacities of photographs may be methodically approached, especially in relation to written material such as letters. These photographs invite tactile and visual experiences that stir the imagination and turn the past into a place of strong emotions and intense longings.

THE GLASS PLATES IN THE TOBACCO BARN

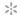

Andrew Dahl's Photographic Production

Fifty years ago a collection of photographic glass plates was pulled from oblivion after having been stored for more than a century in an old tobacco barn in Wisconsin. The plates appeared to represent a large portion of the work produced by Norwegian-American photographer Andreas Larsen Dahl (1844–1923). Dahl, who emigrated from Valdres in 1869, worked as a traveling photographer in Dane County, Wisconsin, and surrounding areas from around 1870 to 1880. Today Dahl's glass plates are housed in the archives of the Wisconsin Historical Society in Madison. The Dahl collection comprises around twelve hundred glass negative plates and forty-three positive plates. It is unusual to find a freelance photographer's oeuvre collected in this manner. That the negatives were not destroyed or widely dispersed can be understood in relation to Dahl's life story.

Andreas Larsen Dahl originally came from modest circumstances in Norway, growing up on the small farm Dalen in Skrautvål in Valdres. He emigrated to the United States after the death of his father, Lars Nilsson Dalen, in 1868 and quickly Anglicized his name to Andrew. His brother Nils had traveled across the ocean seven years earlier and had settled in DeForest, Wisconsin.[1] Dahl probably learned photography soon after his arrival to Wisconsin, and his brother helped him establish a small photography studio in DeForest to make contacts within the Norwegian-American community.[2] In the ship's emigrant register from the port of Christiania from 1869,

his occupation is listed as "worker." In his new homeland, only a year after arriving, he describes himself in English as a "daguerreian artist"; however, no daguerreotypes survive him. Perhaps the word "daguerreotype" was used to describe photographs in a broader sense, long after the daguerreotype's heyday in the United States.

Dahl only worked as a photographer for a limited period. Evidence indicates he did not imagine at the beginning of his career that he would be a photographer for the rest of his life. Alongside his photography work, during the winter months of 1870–73, he studied at the seminary at Augustana College in Rock Island, Illinois, which at that time was a lengthy travel distance from DeForest. Perhaps he wavered for a long while about how best to support himself. Nevertheless, it was in his role as a photographer that one day in 1873 he visited the town of Lodi, Wisconsin, and the home of Gertrude Amundsen. Five years later, in 1878, he married her and in time had a family to support. The year after their marriage, Dahl fell ill with a life-threatening fever, and as the story told later goes, he swore to devote his life to God if he survived. He did, and afterward Dahl completed a full education for ministry at the Norwegian Evangelical Lutheran Seminary in Madison. He was ordained in 1883 and never again used his camera.[3] Despite working piously in the service of the church right up until his death in 1923, it is what he created during his short-lived career as a photographer, paradoxically, that has given him recognition in posterity.

When he gave up his business as a photographer around 1880, Dahl packed up some fifteen hundred glass-plate negatives in large cases and stored them on his brother's property. These glass negatives include a range of subjects, a business approach that becomes clear in the photographer's sales catalog from 1877. On the catalog's cover, Dahl describes himself as a "Landscape Photographer." But in light of what he lists in his photographic offerings, it is evident he was operating within a broader spectrum of motifs than just traditional landscape photography. True enough, he offered a line of town and landscape prospects: general views of small and large towns in Wisconsin, such as Madison. But there he also photographed familiar landmarks such as the capitol, the governor's residence, and the inner lake. Additionally, he included photographs of familiar landmarks of Wisconsin's nearby topography, for example, the rock formation Preacher's Cap in Springdale and the ridge called Blue Mound. But the most historically important motifs in Dahl's photographic assortment were the family group in front of their newly established home and the views of extensive agricultural properties in the Norwegian settlements. How then can Dahl's photographs be activated as a door to the past? How can we get them to speak to us?

Dahl's Family Portraits

The family group in front of their home is a dominant subject in Dahl's photographic production. His treatment of this motif is in no way uniform, as evidenced by the following three examples. The first (Figure 1.1) shows the Ottesen family photographed in front of their home, a large, white-painted, wooden house with two stories. The glass-plate negative from which the picture is copied, like most in the Dahl collection, shows the damaging effects of time. The corners are discolored, and in some places the emulsion has peeled off. However, the motif is clear: the eldest man, calmly and seriously holding sway with his coffee cup at the left of the picture, can be identified as the head of the family, the minister Jakob Aall Ottesen, a central figure in the Lutheran church community of Norwegian America, and his kindly, smiling wife, Catrine Tank Døderlein Ottesen, sits second to the end at the right. Jakob Aall Ottesen, who came from a family of civil servants in Norway, studied theology at the university in Christiania. He was ordained in 1852 and emigrated the same year. In the United States he worked as a minister for thirty years, from around 1860 until 1891, in Koshkonong, west of Madison.[4] Andrew Dahl visited the parsonage there in 1874.

Dahl has placed the numerous well-dressed family members in the picture's foreground, around a table set with a silver coffee service and porcelain cups. He has chosen a low point of view, so that we actually look up toward the subjects of the portrait, who are a good distance from the house. With that he offers the viewer a chance to study in detail the possessions, faces, postures, clothing, and other possible signs of the family members' status and character, as well as their relationships with each other. Furthermore, he opens up a comprehensive view of the parsonage and its surroundings. The well-kept building is depicted from the front, which allows the gaze to absorb both the larger dimensions and the individual details: the small-paned windows with lace curtains and shutters, the plant-wreathed entrance with projecting columns, and (from a Norwegian perspective) the oddly placed chimneys. The lens also takes in the slender farmyard trees, which suggest that the family hasn't lived a long time in this handsome building.

Our attention is also drawn to an even larger degree to the unusual scene on the house's roof. There we can spy the top of a pole flying a Norwegian flag; in its corner is the so-called herring salad, the mark of the Norwegian union with Sweden, which combined elements of both countries' flags. Judging from the photograph, it was a slightly windy day. The trees in the background are somewhat unfocused, but the

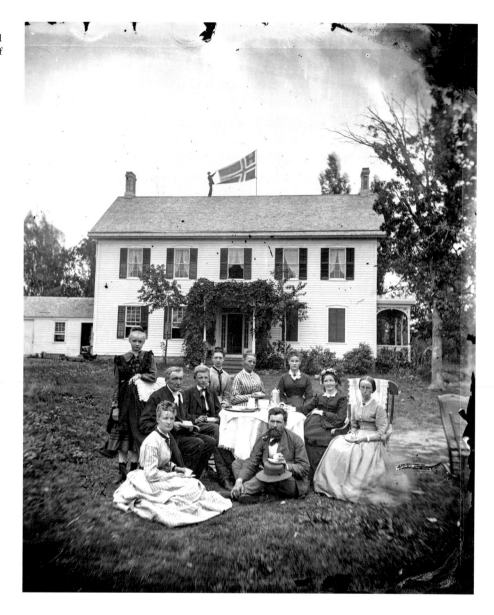

FIGURE 1.1. Andrew Larsen Dahl, the family of Reverend Jakob Aall Ottesen in front of the parsonage, Koshkonong, Wisconsin, 1874.

wind is clearly keeping the tree crowns and the flag in constant motion. The wind is likely the reason that, up on the roof ridge, we see a small figure in clearly defined profile: a man striving to hold the flag still in the wind so it can be fully visible. The scene on the roof demonstrates above all that this family thought it quite important

to show off their nationality, their Norwegianness. The picture also manifests their solid prosperity and close family ties. With a collective gaze securely fastened on the photographer, the members of the Ottesen family let us know that life has been good to them in America.

Dahl photographed many such group portraits of ministers' families, but another example shows he also visited Norwegian-American immigrants from other occupational groups and social classes. In 1876 the family of carpenter and woodcarver Aslak Olsen Lie posed in front of Dahl's camera (Figure 1.2). Like the photographer, Lie came from Valdres, where even before his departure for America he had been known as a skilled woodcarver. He arrived in Wisconsin in 1849 and, together with his brother Ole, built the home that serves as the backdrop in Dahl's photograph: a two-story house that combines American building methods with Norwegian log-notching techniques. Here there is none of the classic architectural symmetry found in the parsonage—no columns or lace curtains, no nicely displayed lawn with farmyard trees. The house is heavy and solid, the logs chopped with an ax and left unpainted; it appears old-fashioned in relation to the large houses of its time with their evenly cut, white clapboards. The house rests on a foundation of coarse, unpolished stone, and the family sits surrounded by freely growing, stiff, tall grass.

A strong contrast is evident between the light cotton dresses of the women in the minister's family and the Lie women's dark, practical garments. The carpenter's family poses with intense seriousness. They sit together, but each of them has assumed individual postures, as if they were in separate rooms. The majority of family members have their eyes turned away from Dahl's lens, apart from the head of the family, Aslak Lie, who stares straight toward the camera. To the right of him sits his wife, Marit Kamben Lie, and to the left is his brother Ole. On the far left we see his daughter, Marit Skogen Thompson, and to the right is her daughter, Martha Skogen Thompson, with two grandchildren. The man who sits in the foreground is unidentified, but perhaps he is Lie's grandson, Ole O. Lie.[5]

Unlike the Ottesens, this family is not gathered around a laden table. Their communal fellowship is emphasized using other telling attributes: the carpenter family's professional tools and samples of what they have produced. In the foreground is a beautifully unformed wooden wagon wheel, which the graying, elderly Aslak holds before him. Around him are other visible objects that speak to the family's woodworking skills: a rake and something that appears to be a washboard, along with their carpenter's tools. Near the feet of his daughter is a screw clamp, and the younger man who is probably his grandson rests a plane in his lap. In addition, the

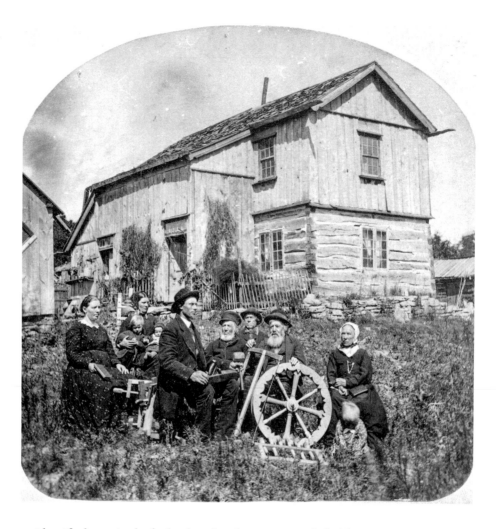

unidentified man in the far back rather demonstratively holds up an ax. The daughter also has a book, apparently a Bible, in her hand, and near the old patriarch romps a little blond great-grandchild. Thus, the basic values are plainly set forth: This is a family that through steady application, pride in their work, family solidarity, and religious humility has managed to find a foothold in their new homeland.

The third example (Figure 1.3) shows another variation on Dahl's treatment of the family group motif. This portrait, from around 1870, is one of the photographer's earliest works and is in many ways closest to what, in the future, would become his more or less standard approach to portraiture. He has placed the family group,

which consists of a young couple and their two small children, in front of their dwelling. They sit together around a little table, which is not set for a meal but used to elaborately display objects that likely have some meaning to this particular family: two bouquets of flowers in thin porcelain vases, a pair of books, and something that appears to be a ball of wool in a small basket.

The house is more modest than that of the minister's family but otherwise of the same type. Again, Dahl has photographed his subjects at a good distance from the house and from a relatively low angle. We look up to the family group and the house in the same way we did in the portraits of the minister's and carpenter's families. This photograph appears somewhat less polished than the other two examples, with traces of small errors in technique. One of the children seems to have turned suddenly to the photographer at the moment of exposure, so her face is unfocused. The father's serious, concentrated face, which is turned not to the child or to the photographer, is also slightly out of focus. In observing the picture, the eye is also disturbed by a light, shining spot in the left-hand corner, probably the effect of unintended reflection.

The portrait distinguishes itself from the other family portraits in Andrew Dahl's production for another reason. Quite obvious in the camera's field of view, behind the young couple and their children and under a large window of the house, is a banner in a gable-topped frame with the Norwegian words "Freedom, Equality, Enlightenment!" in large, black letters. These are the values the young couple wants to attach to their photographic self-presentation, and, in light of this, both their outer appearance and the objects with which they surround themselves are given a new meaning. The banner, the books on the table, and the humble yarn ball tell us about the portrait sitters' respect for not just large and small everyday tasks but also knowledge. The solemn expressions take on a new dimension, similar to the unpretentious way the couple presents themselves. Their tanned faces can be read, from this perspective, as testimony of the hard manual labor under the burning sun; we are thus reminded that physical work was an essential part of everyday life for most of the Norwegian-American immigrants who settled in the farming regions of the Upper Midwest. The couple who sit in front of their home in Dahl's photograph had the surplus energy and the desire to look beyond themselves and their personal circumstances and to reflect on the larger political contexts that greatly affected the lives of new Norwegian-Americans. There is good reason to suspect that this small family belonged to the flock of Marcus Thrane, the immigrant Norwegian socialist leader in Wisconsin.

In his photographs Dahl was concerned with presenting his portrait subjects and the American landscape in which they found themselves in a way that could say something about their identity and position. To achieve this goal, he turned to a broad array of aesthetic working methods. His photographs are thoroughly composed and the subjects convincingly staged through expressive poses and the use of significant attributes, a move akin to the typological characterizations of medieval paintings.

They appear as cultural constructions that in different ways stress the basic values of the subjects. The Norwegian-American farmer who positions himself in front of endless acres and well-kept yards displays, obviously, that for him emigration has been a successful and decisive life choice. The minister's family posed under the flag is signaling loyalty to the country and culture they once came from as well as their secure material well-being. The carpenter's family shows that pride in work and family ties are fundamentally important to life in America, while other subjects allow their political ideals to emerge as superior values in their newly established existence.

Stereographs for Sale

Living in Dane County, Andrew Dahl found himself in the midst of the core Norwegian settlement in southern Wisconsin. After his arrival from Norway, he probably realized quickly the great need for photographers in the Norwegian immigrant colonies. Letters home from America testify to how photographs were not only highly valued but also objects of continuing, often public, contemplation on walls or in albums. In 1867, for instance, Erik Theodor Schjøth gratefully reported how the family portraits from his homeland had a place of honor in the best parlor of his new home in Sturgeon Bay, Wisconsin—one on each side of the portrait of "the Father of America," George Washington.[6]

People wanted photographs despite the expensive cost of having their picture taken. Many of the letters sent to Norway from Wisconsin at the beginning of the 1870s contained detailed explanations of different price and quality levels. Paul Torstenson Vigenstad, who lived in Dane County, reported the following: "In Madison the portraits cost 1 dollar a dozen, 50 cent (or ½ dollar) for 4 or 12 ½ cents for 1. Really fine photographs cost 3 dollar a dozen, 2 dollar for a half dozen and 50 cents each. These that we send cost 1 dollar a dozen."[7] Twelve small photographs cost around a dollar during this time. For comparison, a monthly farming wage could be estimated at between nineteen and twenty-five dollars.[8] Getting a portrait made was thus not an insignificant investment for someone who wanted to include a photograph with a letter home.

Yet it was not only economics that made it difficult to have one's picture taken. Settlement patterns and communications were also factors. In Wisconsin, the first Norwegian settlements were established in the southeast as early as the 1840s: Jefferson Prairie, Rock Prairie, Muskego, and Koshkonong. For a long time these

settlements functioned as model colonies, portals for newly arriving immigrants, who after a time moved farther west to establish new Norwegian settlements, not only in Wisconsin but also in the neighboring states of Minnesota and Iowa. The expanding railroad network from around the 1850s accelerated the process. The railroad not only made it possible for farmers in distant regions to transport their crops to markets in the east but also allowed new arrivals to settle in rural districts, relatively far from towns.[9] But this also meant that the trip to visit a photographer was a long and difficult one, which also was reported in the letters:

> The reason I haven't written you before is that I've thought I would have my portrait taken and send it to you, and I have to ask you to please wait a while. I didn't have the time the whole winter to get to town; now a few days ago I was there for the purpose of being photographed but the photographer had left, and I had to go home with unfinished business. The first thing I will do, when I have the chance to go to another town, is to be photographed and I will send you the portrait right away. It is really too bad that it is taking so long, before I can gratify such a longed-for request.[10]

Judging from their letters, Norwegian immigrants in such rural areas received visits at home from traveling photographers. Clearly, there were many itinerant "cheats" in the profession who didn't do proper work. Their photographs were, as several letters said, "too badly taken."[11] Dahl had obviously realized it would pay off to seek out potential customers where they actually lived in the surrounding districts and to provide them with attractive and skillfully produced photographs they would be pleased with. Additionally, he had a clear advantage by knowing the cultural background of the new Norwegian-Americans. He was one of them himself; he spoke their language.

Although the group portrait in front of the house and the photographs of the Norwegian immigrants' farm properties were the dominant motifs in Dahl's production, some individual portraits taken during his first years as a newly established photographer—possibly in the DeForest studio—also exist. One example is the beautiful portrait of the photographer's sister-in-law, Ingeborg Dahl, from around 1871, soon after her marriage to Andrew's brother Nils (Figure 1.4). In common with many of Dahl's surviving portraits from his early period, the subject is posed *en face* and seated. The background is neutral and relatively dark. Dahl has probably made use of a backdrop cloth. As a result, the viewer's attention is directed solely toward a young woman who sits modestly and expectantly with her hands in her lap. The

light setting accentuates her serious face and gaze, which is fixed on a spot behind the photographer. The woman's rather plain dress, made of coarse woolen fabric, reveals she does not belong to society's higher stratum. Her shoulder-length hair is loose, and the headband with a bow on top and the striped, decorative shawl below the white collar of her blouse bear witness to her national background and a lingering connection to traditional Norwegian regional costumes. What Dahl recorded here for posterity is a newly arrived Norwegian immigrant, one who in body and soul still carries with her the culture and traditions of her homeland.

Even though he had a studio and could offer such individual portraits, Dahl operated mainly as an itinerant photographer, with group portraits as his specialty. He set out on his trips with a horse-pulled darkroom wagon as soon as the snow melted in the spring. For Dahl, as for the majority of other traveling photographers of that time, the technical aspects of his photography were first and foremost framed by the wet-plate process. He took pictures using collodion wet plates and made copies on

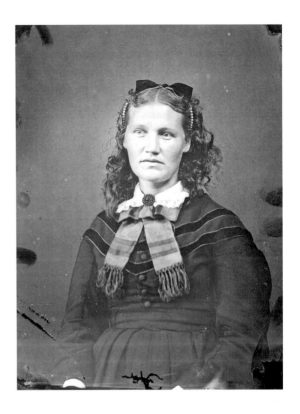

FIGURE 1.4. Andrew Larsen Dahl, portrait of Ingeborg Dahl, circa 1871.

albumen paper. For that reason he had to transport a good deal of heavy equipment: boxes of glass plates, chemicals, and a tripod. Arriving at the shooting site, he had to operate within a very limited timeframe. He needed to work quickly to avoid the wet plates drying in the sun and heat. It is evident from his glass negatives that he composed his pictures with the thought that he later might have to correct the composition by cropping. In many of the negatives—for example, in the image of the hop harvest at Knut Heimdal's farm (Figure 1.5)—the crop lines that he scratched into the glass plate itself are clearly visible. In this photograph we also see how the strong sunlight has cast shadows, such that the photographer himself, involuntarily, to judge from the crop lines, has become part of the picture's subject.

When winter came, Dahl returned to the studio in DeForest, where he made new reproductions on paper from the glass negatives to sell during the coming summer season.[12] He sold his photographs for twenty-five cents apiece. In the first years, his customer base consisted primarily of Norwegian immigrants in Dane County, but eventually his contact list expanded to include other social groups. For example,

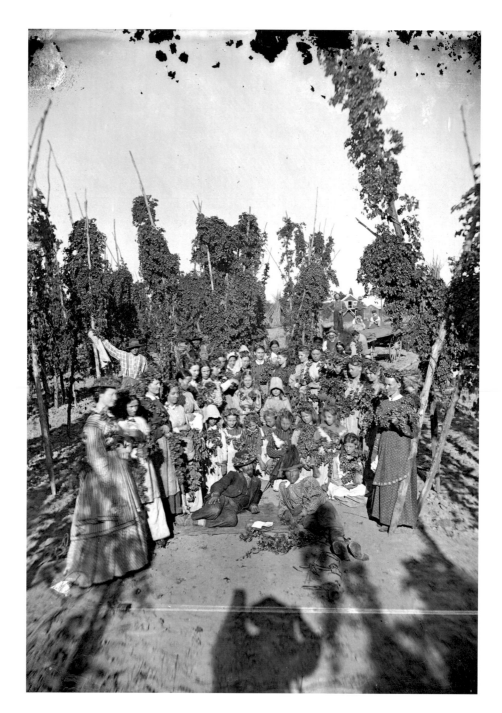

FIGURE 1.5. Andrew Larsen Dahl, autumn hops harvest at Knut Heimdal's farm, Deerfield, Wisconsin, 1879.

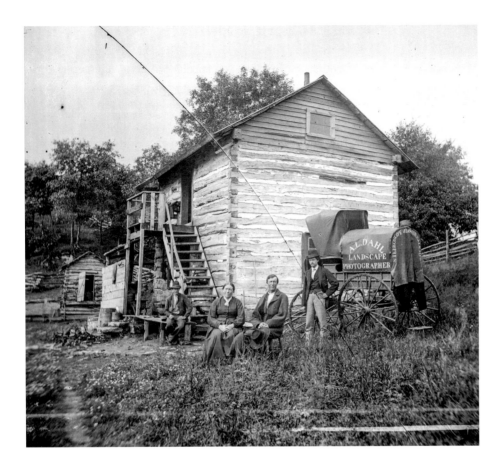

in Madison he came to know the town's most prominent Yankee class, people with power and money: politicians, businessmen, and representatives of the local press. He photographed their churches, businesses, and private homes.[13] But the images he left behind, as well as the sales catalog from 1877 with a paragraph in Norwegian thanking his "countrymen" for the interest they have shown him, testify to the fact that it was the Norwegian-American community that represented the heart of his customer base.

In one of Andrew Dahl's few self-portraits, we can study him in the role of traveling photographer (Figure 1.6). Here he is actually posing next to his darkroom wagon with his clients, an older couple who solemnly pose in front of their rather modest home of hewn logs. The words "A.L. Dahl Landscape Photographer" are painted on the longer side of the wagon, and the back end reads "Stereoscope Views for Sale."

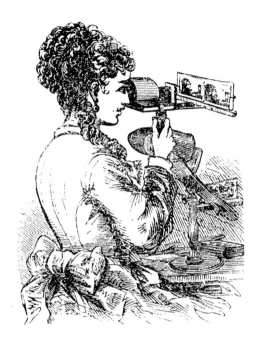

FIGURE 1.7. The stereoscope is a device used to look at stereographic images. A stereograph is two images of the same shot taken in slightly different perspectives. When the photograph is viewed through the stereoscope, an illusion of depth is created.

The pictures Dahl produced were, as advertised, stereoscopes: two pictures of the same subject, taken from slightly different perspectives. Seen through a specially developed viewing apparatus (Figure 1.7), a stereoscope with two glass eyepieces, the two separate pictures become one, so that an illusion of depth is created. To produce such pictures, the photographer used a special type of camera with two objects placed at the same distance from each other as the distance from the pupils. This double camera captured what was in the field of vision of each eye. The technique and its inherent demands on creating convincing illusions also had particular bearings on the pictorial composition. To intensify the sense of depth, it was an advantage to build up the composition with a clearly defined foreground, middle ground, and background. This is exactly what Dahl did in many of his images, for example, in the portrait of the minister's family, the Ottesens (Figure 1.1). Here the family itself makes up the clearly contoured foreground element. The large white house is the middle-ground element, while in the background we glimpse the trees as if they were on a blurry backdrop cloth.

The stereoscope, the instrument for double vision, was developed in the 1830s by the English scientist Sir Charles Wheatstone. However, it did not come into widespread use before the introduction of photography. The wet-plate technique was particularly applicable for the production of stereographs, as this technique made it possible to produce endless copies from the same negative. In the United States the stereographic camera began to be sold in 1850, and by the end of that decade stereography had attained wide popularity.[14] In 1859 the Boston doctor and poet Oliver Wendell Holmes wrote the first of several articles in which, with great enthusiasm, he praised the new method. Holmes was clearly taken by the photographic realism of the stereographs, how the miniscule and sometimes unintended details revealed everything. He wrote about how the stereograph's detail-crammed illusion of depth contributed to a dreamlike stimulation of the imagination.[15] He assumed, moreover, that the stereograph was now so widely available that the majority of his readers would be able to experience stereography on their own.

Around ten years after Holmes's appraisal of stereography, when Dahl was beginning to establish himself as a photographer in Wisconsin, this particular kind of photography was undergoing a new surge of popularity.[16] The Norwegian-American

population that also had discovered the pleasures of three-dimensional photography gladly purchased hand-colored stereographic pictures of well-known national or local landmarks, including city views of the U.S. Capitol or Mount Vernon. Looking at pictures was a beloved social activity that brought family members together. When guests were visiting, the family album and stereoscope quickly made an appearance, providing hours of entertainment.[17] The stereograph's prominent place in the Norwegian-American home is also documented in Dahl's photographs, where the stereoscope often is placed in a central position among arrangements of the portrait subjects' favorite possessions, along with silver, porcelain, and thick family Bibles (Figure 1.8). Thus stereographs also illustrate the significance of the photograph in their new and modern environment as public markers for the social and geographic mobility of the individual.[18]

As a photographer in the field, Dahl had to be able to tackle many challenges simultaneously. On the one hand, he had to manage the time constraints connected with the wet-plate technique and the stereograph; on the other hand was the explicit

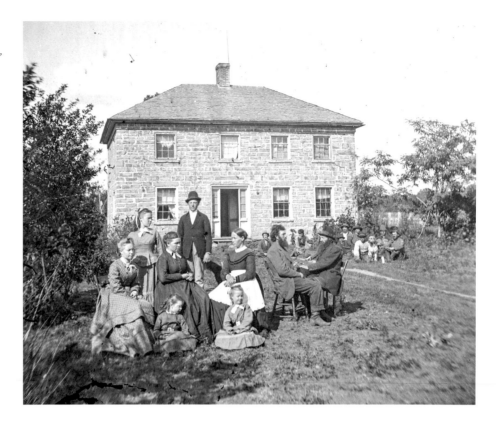

demand for poses that conveyed the essential information about his subjects—their lives, status, and mutual relationships. It is therefore reasonable to imagine that he made painstaking preparations for the poses before he prepared the glass negative. As we have seen, his arrangements of subjects and objects laden with meaning are handled with great care. It takes time and perhaps a special talent for persuasion to convince someone to carry a piano out onto the veranda just for the occasion—or to place a man or two on the roof of a house. In the same way, he had to make sure servants and friends were positioned discreetly in the background, while the central family members towered in the foreground (Figure 1.9). Perhaps it is through these detailed and painstakingly consistent posing strategies that Dahl shows himself to be an extraordinary photographer. Yet how distinctive were the works of this Norwegian-American photographer? Since he was an image producer who moved from one continent to another, it is pertinent to study his photographs in the context of both Norwegian and Norwegian-American pictorial culture.

DAHL'S PHOTOGRAPHY AND NORWEGIAN VISUAL CULTURE

Even though Dahl was not active as a photographer in Norway, he was a grown man when he boarded a ship for America in 1869. It is reasonable to imagine he had a certain familiarity with Norwegian pictorial production in the period before he left the country. For example, it is known that one of the pioneers of Norwegian photography, Marcus Selmer (1818–1900), visited Dahl's native Valdres in 1863 on one of his trips as a landscape photographer.[19] Selmer is considered to have begun the photographic "mapping" of Norway's landscape and inhabitants.

Dahl arrived in America from a country that, in the first part of the 1800s, had started to explore its own character, including its topography. The establishment of photography coincided with the processes of national consolidation that followed the signing of the Norwegian Constitution in 1814. For much of the nineteenth century, the country was in the process of establishing a new national identity. One of the first to contribute to shaping the consciousness of the sublimity of the Norwegian landscape was the painter J. C. Dahl (1788–1857). The emotional visual rhetoric and grandeur of Dahl's landscape paintings had great appeal in a country where the construction of national identity was a major theme. Photographers, therefore, chose to follow in Dahl's footsteps and those of other National Romantic landscape painters.[20]

The most renowned of these landscape photographers was Knud Knudsen, Selmer's earlier assistant. When Selmer stepped down from his work as a traveling photographer during the 1870s and 1880s, Knudsen succeeded him.[21] Knudsen's practice in Norway in the 1870s has much in common with Dahl's in America. In addition to being traveling photographers, both worked with the same technique: wet plate and predominantly stereographs. Knudsen also brought a large-format camera with him on his travels, which he used in parallel with his stereo camera. In his printed catalog, "List of Norwegian Photographic Images," we find a selection of subjects that to a certain extent is reminiscent of the listings in Dahl's catalog from around the same time.

Like Dahl, Knudsen offered stereographs of a number of well-known regional and national landmarks and, in this way, contributed to the extensive photographic surveying of towns and places that was taking place all over the world during this period. But the similarities and differences between Knudsen's and Dahl's productions grow even clearer when we compare one of Dahl's so-called farm sceneries with one of Knudsen's landscape views from Tysnes in Hordaland circa 1870.

FIGURE 1.10. Andrew Larsen Dahl, farmers in the fields, Wisconsin, 1874.

In this scenery, Dahl has photographed a cultivated landscape stretching as far as the eye can see (Figure 1.10). The photograph was taken on a warm summer day in 1874 when he visited a Norwegian immigrant to record his well-kept farm. Apparently, he has asked the proud farmer and his son or brother to position themselves in the foreground of the view of the broad farmlands. Attired in light summer clothes and hats protecting against the sun, both men are firmly planted in the landscape with their backs to the photographer. They are surrounded by farmland on all sides, and their figures appear strangely small in the monumental landscape. One of the men points in the direction of a group of buildings on the left side of the middle ground, probably his own home and outbuildings. The buildings are situated within a horizontal belt of trees that breaks up the farm landscape around the middle of the picture plane. Further farm fields are visible beyond the tree belt under a wide sky. In this way, Dahl has created a traditional composition, consisting of different layers—foreground, middle ground, and background—parallel with the horizon line. The furrows of the field extend diagonally across the picture and contribute not just to creating tension in the composition but also to strengthening the dramatic and overwhelming impression of depth in the picture space. The two foreground figures only appear as a measure of scale in this magnificent landscape, where earth and sky meet. They stand, clearly at rest, with their gaze turned toward the horizon and toward an American landscape that now has become their own.

In his stereograph from 1870s Norway, Knudsen has also photographed farmers in the landscape where they work, here a small family group—two women and two men—in the potato field (Figure 1.11). Similar to Dahl's photograph, two of them stand with their backs turned to the photographer and with their gazes directed at the horizon. This landscape, likewise indicated by a foreground, middle ground, and background, is also monumental, yet quite different from the American landscape in Wisconsin. What is offered is a view not of endless fields but of heath, trees, the fjord, and massive, snow-clad mountains. The photographer has not hidden the fact that the work is toilsome and that the soil is meager between the gray stone out-

croppings. He has posed and photographed not attractively dressed Sunday farmers but simple people in daily drudgery. What is being harvested is not noble wheat but life-sustaining potatoes.

Along with stereoscopes of landscapes, Knudsen offered to photograph private homes, as did Dahl. Such private assignments are not reflected in his sales catalog listings, nor did the photographer number these pictures consecutively, the way he did in the rest of his work. But the Knudsen collection at the university library in Bergen includes many examples of this subject category. From this material it is evident that Knudsen's aesthetic approaches to portraiture do not lie far from Dahl's Norwegian-American group portraits from the 1870s.

This form of "at home" photography (Figure 1.12) is not as heavily burdened with symbolic materiality in Knudsen's work as it is in Dahl's group portraits. The Norwegian photographer does not put personal possessions on display—things that symbolize the family's status and position. Certainly, every one of Knudsen's portrait subjects appears well dressed and well groomed, and their house is similarly well kept. But it is the sense of belonging and the social event that is primarily emphasized in the photograph of the family gathering.

FIGURE 1.12. Knud Knudsen, family portrait, Norway, 1870s.

We can detect particular stylistic features in Knudsen's group portrait that have parallels in Dahl's production. Knudsen has laboriously arranged the family members in separate "niches" in the picture plane. Every one of them, even the family's little lapdog (placed on a table in the foreground), has his or her own "space within a space." Some pose standing, some sitting, and there is no mutual contact. A few of the subjects turn their gaze and bodies toward the photographer; others are in posture and gaze almost demonstratively oriented in other directions. The organized stiffness in the poses, however, does not indicate indifference on the part of the subjects. On the contrary, there is a seriousness in the stiff, absurd "niche arrangement" that is the most striking feature of this photograph.

This pattern of posing was not employed solely by Knudsen. In group portraits by other contemporary photographers, we see how the subjects in intricate fashion

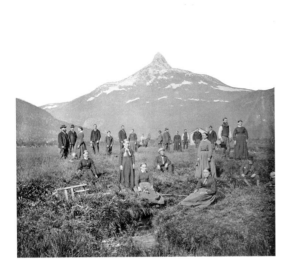

FIGURE 1.13. Ole Tobias Olsen, *Solvaag Peak seen from Junkerdal Farm*, Saltdal, Nordland, Norway, 1870s.

FIGURE 1.14. Family silhouette portrait, circa 1810.

are individually posed with their gazes in mutually different directions. The pattern can be found in the beautiful group portrait from the north of Norway *Solvaag Peak seen from Junkerdal Farm*, which Ole Tobias Olsen (1830–1924) made in the 1870s (Figure 1.13). The compositional similarity to prephotographic silhouette cuttings, which were widespread at the end of the 1700s and the beginning of the 1800s, is striking; this technique demanded that each figure be separated in its own individual space in the composition (Figure 1.14). It is not difficult to envision that the early photographers of the 1800s would search for compositional models in familiar types of imagery.

There is much to indicate that the immigrant photographer Andrew Dahl brought with him not just different genre conventions from the visual culture of Norway, which he developed further in his representation of landscapes, farm properties, and family groups, but also stylistic characteristics with roots in silhouette cuttings. This is evident to some extent in his group portrait of the Lie family (see Figure 1.2), but perhaps to an even greater extent in other photographs, for example, in the portrait of the family of the prominent Norwegian-American businessman Sjur Rekve (see Figure 1.9). The silhouette-like arrangement of the people in the foreground provides the picture with what we today see as a mysterious, surrealistic character, while in Dahl's time it must have appeared as a natural approach to representing the family as a group.

Andrew Dahl, who was active as early as the 1870s as a photographer, represents what we can call the first generation of Norwegian immigrant photographers. But new generations followed, and while Dahl specialized in images from the Norwegian settlements in the United States, many who practiced photography in succeeding generations began to extend their sphere of work. In a change from exclusively producing images in America, many Norwegian-American photographers began to travel home to Norway on a somewhat regular basis to take pictures on assignment from immigrant Norwegians who wanted images of familiar places and familiar faces from the country they had left behind.

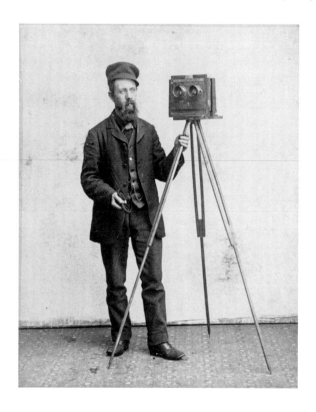

One of the photographers who worked in this manner was Martin Mauritzen, or Morrison, as he called himself in the United States. Morrison was born in Time municipality at Jæren in 1844 and moved to Stavanger in 1857. He emigrated eight years later and established himself as a photographer in the small town of Ames, Iowa, at some point in the 1880s. He started his career in the same way as Dahl, as a traveling photographer in the American countryside with a stereo camera as his working instrument.[22] In a self-portrait he poses alongside his camera, with a good grip on the tripod, which is almost as tall as he is (Figure 1.15). In another image he gives us access to the Morrison family's home in Ames. The family has gathered for a meal in a side room that appears to be a photography studio. There, a window has been cut out of the ceiling to provide overhead light, and in a corner in the background stands a small box where the glass plates are kept (Figure 1.16). But a photograph also exists that shows a spacious tent Morrison set up as a provisional studio in his own yard (Figure 1.17). Here we can see how he arranged his sample goods—pictures in different formats. Some of them are in fact paintings. Morrison was, like many of the other early photographers, multitalented. He also worked as a portrait painter, furniture maker, and gardener. But as is evident from the sign in the foreground

FIGURE 1.15. Martin Morrison, self-portrait with stereographic camera, Ames, Iowa, 1880s.

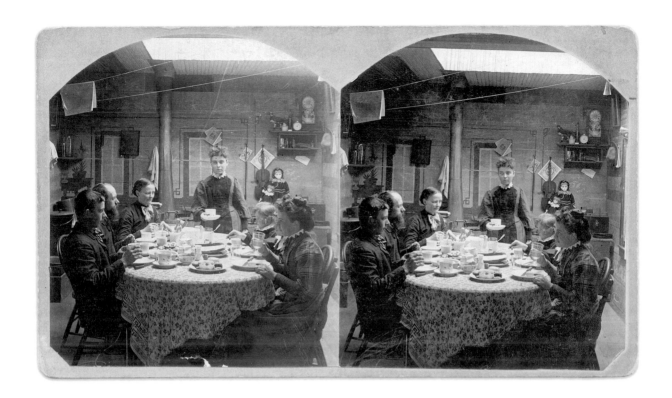

(a regular aspect of his photographs that makes it possible to date his work closely), photography was his main employment. On the sign we can read: "M. Morrison, July 25, 1886, Photographer, Ames."

Like Dahl, Martin Morrison sought out and photographed the homes and families of Norwegian immigrants, as well as American small-town surroundings and the social gatherings of the local Norwegian-American community. He was on hand, for example, for John and Berthe Charleson's golden anniversary in June 1887. He chose to photograph the couple and their large family sitting closely together around a long table in the yard (Figure 1.18). Their gazes and attention are uniformly directed toward the photographer, who has set himself up at the table's short end. Seen through the stereoscope, the picture gives a strong experience of being physically present in this celebratory gathering. The seductive, tunnel-like effect of depth makes each family member stand out in full clarity, as if they were sitting across the room. The empty space in the foreground is almost an invitation to the observer to occupy the free place at the table and take part in the festivities.

FIGURE 1.16. Martin Morrison, the Morrison family in their home, Ames, Iowa, 1880s.

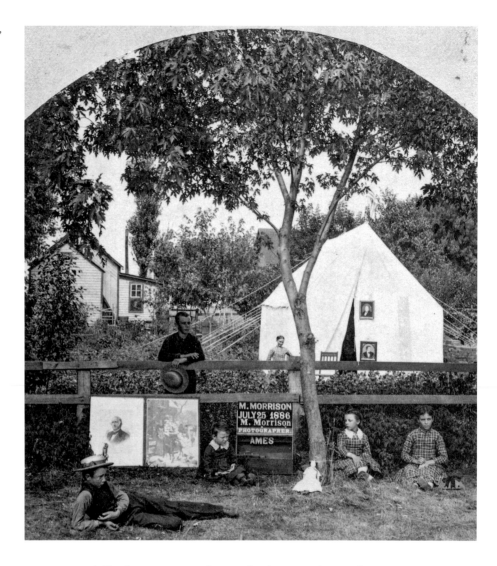

FIGURE 1.17. Martin Morrison, the photographer's house and yard, Ames, Iowa, 1886.

It is not difficult to imagine that such photographs made an impact not just on those present but also perhaps even more on relatives and friends in Norway who eventually received them. Morrison clearly was attentive to these still strong emotional ties to the homeland, for on the printed backside of his mounted photographs is evidence that he gradually broadened his repertoire of subjects to include images from the home country: "A new Lot of Stereographs from Norway at hand— Pictures of Places taken to order in Norway." Thus, he took orders from Norwegian-

FIGURE 1.18. Martin Morrison, golden wedding celebration at the home of John and Berthe Charleson, Ames, Iowa, 1887.

Americans in Iowa for pictures of places they wished to see again. Many of the letters sent home to Norway at this time spoke to how immigrants neither were able to nor wished to forget the places and landscapes of home.

Such feelings were so prevalent in the Norwegian settlements in the United States that Martin Morrison must have seen a chance to make a living from them. In 1889 he returned to Norway to photograph well-known places, including Norwegian mountains, waterfalls (Figure 1.19), and familiar city views in Bergen and Stavanger. During the summer months of that year, he traveled between these two cities to carry out assignments in the countryside—pictures of families at home on their small farms in western Norway. In their best Sunday clothes, these families posed in a row, with their backs toward their house and their faces toward Morrison's camera, as in the photograph of the Nervig family, who lived in Etne in Sunnhordland (Figure 1.20). The serious expressions, the children's freshly ironed clothes, and the awkward postures suggest that the family was aware the picture would be sent to close relatives they likely would never see again. Because we know that the Nervig family had relatives who had recently emigrated to Iowa, it is reasonable to assume that this was a photograph Morrison was assigned to take.

FIGURE 1.19. Martin Morrison, waterfall in Norway, 1889.

FIGURE 1.20. Martin Morrison, the Nervig family photographed
in front of their home, Etne, Sunnhordland, Norway, 1889.

Morrison's version of this particular genre—the family group close together in the foreground and such a good distance from their home that both the faces and the house could be studied with equal thoroughness—has much in common with the manner in which Dahl structured his Norwegian-American group portraits. But Morrison's portraits appear modest compared to the material emphasis on objects and property of Dahl's images. Morrison's group portraits of the small-farm families in the districts of southwestern Norway also distinguish themselves strongly from Knudsen's photographic documentation of family gatherings in the prosperous areas of Bergen. In Knudsen's images, the social events that are recorded appear to be equally important as the material display of home and yard.

Morrison was not alone in making a living from such cross-Atlantic exchanges of photographic memories in the 1880s and 1890s. In 1884, Peder O. Aune (1862–1931), who already had a well-established photography business in Trondheim, sailed by ship to America. There he opened a new photography studio in Portland, Oregon, almost as a branch of his business in the old country. For a long time he advertised both "Trondheim" and "Portland" on his photograph folders before he turned over the American branch in Portland to his brother Struck Aune in order to return to Norway permanently in 1895.[23] It is also known that the photographer Rasmus P. Thu (1864–1946), who was born at Tu in Klepp but lived in the United States for several periods in the 1880s and 1890s, traveled back and forth over the Atlantic with his camera in his bags. As a photographer in America, he likely took pictures in and around the local surroundings of Wisconsin, Chicago, and New York, where he lived. In this way, his American travels can be largely characterized as work related, as Norwegian photography historian Lisabet Risa has pointed out. Back in Norway in the 1890s, he took stereographic pictures in numbered series, with topographic motifs from throughout the country, all the way from Levanger in the north to Arendal in the south. These pictures were likely directed to both the market in Norway and the immigrant communities in the United States.[24]

Another immigrant photographer, who also traveled home to Norway on photographic expeditions, was Kristen (Christen) Pedersen Myklebust (1869–1936) from Uskedal in Kvinnherad. He had established himself in his own studio in Eagle Grove, Iowa, but financed his regular trips throughout the 1890s by taking pictures in Norway and selling them back home in the United States.[25] Following a pattern we recognize from Morrison's similar production, Myklebust recorded small farms, with their inhabitants awkwardly posed in newly mown summer meadows and with hay barns, farmhouses, and tree plantings in the background (Figure 1.21). Such

FIGURE 1.21. Kristen Pedersen Myklebust, photograph from the series "Views from Norway: [The farm] *Litreæt* and the people there," Skjold, Rogaland, Norway, 1890s.

photographs must have awakened the joy of recognition as well as the sentiments of sorrow and longing.

Letters from America testify that such image exchanges continued through the first decades of the twentieth century. In a letter dated December 11, 1905, Mikkel Andersen Lee (Lie) of Mount Horeb in Dane County, Wisconsin, wrote to his brother Anders Andersen Lie in Hedalen: "I have bought Portraits from Ollof Claussen, who traveled around Norway and took landscape pictures." From Lee's letters we understand that the pictures must have been an assignment. On March 10, 1906, he writes again to his brother: "I wrote to ask for Stereoscope-pictures to Olaf A. Claussen who had been in Hedalen and taken such Pictures."[26]

It was not only small, one-man ventures like those of Morrison, Thu, Myklebust, and Claussen that specialized in stereographs from Norway directed at the Norwegian-American settlements in the United States. Judging from the large number of stereographs in this category, which today can be found in museums and archives and also flood Internet auctions, this market was quickly discovered by a range of photographic businesses, including Underwood & Underwood Publishers, Viking View Company (Wisconsin and Minneapolis), John Anderson Publishing Company / Skandinaviens Boghandel (Chicago), Ingersoll View Company (St. Paul, Minnesota), and Thrane Art Company (probably Chicago). Around the turn of the century, the simple photograph of the family in front of their house—the genre that Dahl had been an early exponent of in Norwegian America—continued to be produced on an industrial scale on both sides of the Atlantic.

Cultural Strife in 1870s Wisconsin

Dahl's portraits cannot speak directly about the stories of the people he portrays. But to observe such visual grassroots family histories in the light of the "large history" of this immigrant generation can create a deeper and richer experience, both of the images and of the history of migration. Like all other newcomers to the rural Midwest, Norwegian immigrants were involuntary participants in what has been called an ethnocultural revolution.[27] During this enormous migration from the 1830s onward, this region developed into an arena for ethnic multiplicity. The Midwest became a place where immigrant families re-created their European sense of belonging. The result was that these "foreign minds," the culture and the norms within the different ethnic groups, each in their way came to exert a strong influence on the political, social, and cultural development of the region. Differences in identity were not only advanced as "statements" but also "negotiated" or adapted to the environment.[28]

Americans had divided opinions on this process. For some, the Midwest represented a picture of the land of possibility: a place of potential prosperity and a fluid society in a continuous and healthy adaptation process. Others saw the cultural fragmentation in the region as a potential threat to what at that time was considered a genuine American tradition. The Midwest's immigrant population also faced a cultural conflict. On the one hand, they valued their newly won freedom—especially to worship their faith freely. On the other hand, they felt pressure to adapt their own culture to the emerging American pluralism.[29]

These were the kinds of tensions that characterized culture in Norwegian America when Dahl traveled the roads of Wisconsin with his ambulatory darkroom wagon. He was well acquainted with what became the cornerstones of the Norwegian-Americans' collective ethnic identity: church and language. Through their church membership and the Norwegian language, immigrants chose to maintain their ties to the "old world." But they did this in the name of their newly won freedom, and the choice was based not least in a need for security and continuity at a time of violent upheaval.[30] "It was almost as [if] the immigrant could not feel safe until he had built a church," writes O. E. Rølvaag in one of his novels. The way Rølvaag portrays his characters bears witness to how the Lutheran identity could be more important than any other aspect of their Norwegian heritage.[31] How then did Dahl and his Norwegian-American portrait subjects—the carpenter Lie's family; the minister Ottesen's family; and the young, freethinking couple—situate themselves in this identity-political landscape?

The carpenter and woodcarver Aslak Olsen Lie (1798–1886) is the eldest of Dahl's portrait subjects. What we know about him and his family now is connected to his reputation as a skillful craftsman both in Valdres in Norway, where he was born, and in Wisconsin, where he came as an immigrant in 1849. He grew up in a time when daily life was characterized by the disastrous consequences of the conflicts among the Great Powers that were playing out in Europe. The English blockade of the Norwegian coast during the Napoleonic Wars led, for instance, to starvation and destitution in many regions of the country, including the mountain village where Lie grew up. He came from modest circumstances: his parents were tenant farmers, and his father died when he was only twelve. But against all odds, this fatherless tenant farmer's son worked his way up in life. Not only was Lie capable and hardworking, but he took an additional step up in the social hierarchy when he married a farm owner's daughter.[32]

At the age of fifty he sold all he owned and embarked with his wife and their six children on a ship to America. But prosperity and high social status did not await Aslak Lie and his family in Wisconsin.[33] They settled in Springdale, where, during the winter of 1849–50, they built the house that is seen in Dahl's photograph. The house was not particularly large, but at the time it must have been an imposing home, with two floors and a spacious entryway. Over the course of the 1850s, Lie was very active in the local Norwegian-American community in Springdale, where the church functioned as an important social junction, as it did in other Norwegian-American settlements. He was an assiduous contributor to this congregation, financially as well. However, this changed during the first part of the 1860s, when the family was struck by several misfortunes. Aslak and his wife, Marit, lost one son to sickness, another to the Civil War, and finally the next oldest, Knut, was struck by lightning. That son left behind a wife and small daughter, who could no longer run the farm Knut had built up with the help of his father.

When Dahl photographed the family in 1876, Aslak Lie had thus gone through major disappointments in his new life in America. His own health was failing; he had been through a financial crisis; and he had lost three of his sons. Perhaps the photograph also testifies to Lie's inability by then to follow up on his ambitions. The house the family poses in front of must have, by this time, seemed old-fashioned and rather primitive in relation to the large, white-painted, clapboard homes of the more prosperous farmers in the area. For instance, it does not yet have a chimney; there is only a stovepipe sticking up out of the roof.[34] But Lie still had his craftsmanship to live off of and was fully active as a carpenter. His carpentry that survives demon-

strates his will to adapt and Americanize while carrying on the artisan traditions of northern Europe, with its roots in medieval culture.[35] But in Dahl's portrait of an aging immigrant pioneer, we are struck first and foremost by the stubborn will to survive and by upright pride. The photograph thus seems to speak about a man and a family in the intersection between two different cultures.

In the Ottesen family's portrait, what is primarily emphasized—through the spectacularly placed flag—is their attachment and loyalty to the homeland of Norway. However, this affection wasn't necessarily reciprocal. The Norwegian government was not interested in assuming responsibility for the spiritual and physical needs of the immigrants in America.[36] The few university-educated ministers who left Norway to work in the United States, as Ottesen did in 1852, had demanding tasks before them. Not least, it proved to be difficult to unite the ideal of religious freedom in American society with the need to uphold authority in internal church affairs. This tension between freedom and authority was the germ of many conflicts in Norwegian-American Lutheran congregations.

Ottesen belonged to the leadership of the high-church faction of Norwegian-American Lutheranism, the Norwegian Synod. The leading ministers in the Norwegian Synod were highly dogmatic. They considered their synod a daughter church of the Norwegian state church and sought to conform as many of their practices as possible to Norwegian patterns. Still, after a while the Norwegian Synod moved away from the mother church, and at the same time it was riven by inner conflicts. These conflicts often sprang from the attempt to connect Lutheran Bible teachings with the understandings of life and God that characterized American society around them. A strong point of contention was the role of laypeople in the church. Who actually had the right to decide which direction the church community should take: the minister in his leadership role or the congregation who paid his salary? What appears to be a theological dispute can also be understood as an expression of social tensions and an emerging ethnic consciousness. Strife over religious doctrines that had their origins in the high circles of the Lutheran Church soon became something that "everyone with great seriousness and burning engagement took part in, everywhere in Norwegian-American communities."[37]

The split that had developed within the Norwegian-American Lutheran congregations only grew deeper with the new generation of ministers who arrived from Norway in the 1870s. These younger ministers came into conflict with the older leaders for several reasons. While the elder ministers all came from the senior civil service class and without exception were university educated, the younger ministers

had a more modest social background. Some were farmers' sons, and some of them were ordained after only graduating from the so-called Latin schools in Norway. These men reacted, among other things, to what they perceived as the synod's elitist view of who had permission to preach and to the apparent favoring of the elite's sons in matters of employment.[38]

These conflicts must have been a significant part of Ottesen's life when Dahl visited him and his family in 1874. The minister was not known for being conflict adverse; during his schooling in Christiania he stood out as sharply dogmatic.[39] But it is known that, in his life as an itinerant minister in the Midwest, he had contracted health problems. Long journeys on horseback had worn him down physically, and he suffered from depression, which meant he was not always up to carrying out his duties in the congregation in Koshkonong, Wisconsin.[40] A few years after the group portrait was taken, Ottesen became involved in a new church battle, and after refusing to accept the majority ruling, he was lawfully removed from his congregation.[41] His family had to move from the beautiful white parsonage in the photograph, which had been their home for twenty-three years. They never returned. In the portrait, the tired, middle-aged minister and church leader is accorded dignity and respect, even though in many ways he had shown himself to be out of touch with his own time. The Ottesen family members pose with apparently secure certainty of their social position and their loyalty to each other, to the homeland of Norway, and to a social and cultural system that, when the picture was taken, was in the process of losing its legitimacy.

In contrast to the subjects of the Lie and Ottesen portraits, the young couple with the two small children in the third example of Dahl's portraiture work is not identified. We do not know their names or personal histories. What can primarily help us to establish their identity in the photograph is the banner with the socialist motto in the background. The banner signifies the family's close relation to the socialist leader Marcus Thrane's movement in Norwegian America. It is therefore pertinent to approach this family through the history of Thrane's activities after he emigrated in 1864.

Thrane was Norway's first significant socialist leader. Between 1848 and 1851 he established the first workers' movement in Norway, a movement consisting mainly of tenant farmers and servants. After serving many years in prison for his activities as an agitator, he attempted to support himself as a traveling photographer. When his wife, Josephine Buch, died, he decided to start a new life with his children in America. After his arrival, Thrane worked a few years as a portrait photographer

for a large business in New York, until in 1866 he was invited to Chicago to run the newspaper *Norske Amerikaner*.

The goals he set for his work were, as Terje Leiren notes, not modest, but relatively simple:

> He intended to raise Norwegians to a level where they would not be looked upon with contempt by other nationalities in the United States. He wanted Norwegians to share the influence and respect to which he believed their large numbers entitled them. Furthermore, this effort was to be directed back across the Atlantic to teach Norwegians about "republican liberty" and encourage them to come to America. Such goals were, according to Thrane, only possible to realize through "political unity and general enlightenment."[42]

But Thrane's newspaper met with strong competition, particularly in Wisconsin, which at this time had the highest concentration of Norwegian immigrants. *Fædreland* (Fatherland) dominated there, with its close ties to the Norwegian Synod. It was not long before Thrane entered into open conflict with the leading conservative stratum in the Norwegian-American community. He positioned himself as highly critical of the influence that the Norwegian clergy in America had on immigrant Norwegians. He believed the Norwegian Synod displayed a lack of understanding of the American Constitution and the republican system; he started a "war" against the synod that lasted around twenty years. The Norwegian clergy, for their part, saw it as a virtue to resist Thrane and everything associated with him. Not least, they were hostile to his Norwegian-American movement, which was established in 1866 and had several features in common with his Norwegian workers' societies. In 1869 the Norwegian-American Association developed into the Scandinavian Society of Progress. That same year Thrane traveled around the Midwest, where he gave speeches and worked to establish local branches of the association. In Wisconsin four such branches were established in Neenah, Winchester, Whitewater, and Janesville.[43]

The young family that Dahl visited in 1870 obviously belonged to Thrane's limited but loyal band of followers in Wisconsin. The banner they carefully included in their family portrait probably had been used in meetings of the local association. In a description of one of the association's meetings in Chicago there is a reference to members gathering under a banner with the revolutionary hero and freethinker Thomas Paine's familiar slogan: "The World is my country and to do good is my religion."[44] In all likelihood, the young immigrant couple was also familiar with such ideas. But despite stressing that all the peoples of the world were their concern, the

couple, like Thrane, did not let go of a sense of national self-awareness. Thrane did not see working for international solidarity as irreconcilable with working toward a national identity. In Chicago he established a Norwegian theater, precisely to unite the work for national pride, education, and political consciousness-raising with popular entertainment. The young family filled with serious purpose in Dahl's photograph does not overtly mark any sense of national belonging with the Norwegian flag, as the Ottesen family does in their portrait. But to the right of the banner they have rather inconspicuously placed a sign of nationality: a chair roughly hewed from a log in traditional Norwegian style, probably brought with them from their homeland. In this way they give notice that they are socialists, freethinkers, and new Americans, yet still Norwegians at heart.

Dahl's scene staging of identity politics thus displays a great range. He makes space for Norwegian immigrants of vastly different social and cultural backgrounds in his photographic universe, where everyone, including the carpenter, the minister, and the freethinker, finds a natural place. Nonetheless, as indicated in his sales catalog, portraits of the leaders of the Norwegian Synod and their families dominate his production within the category "family group in front of the home." This can be seen, on the one hand, as a reflection of the central position these ministers' families had in Norwegian-American culture. They were the families that "everyone" talked about and partly admired. On the other hand, the photographs can be read as an expression of the photographer's personal attraction to the church and clergy.[45]

Many of Dahl's photographs of the homes of the synod clergy testify to a deep fascination for the culture, lifestyle, and material well-being that ruled these settings. He lets the camera ritually document the ministers' families' repeated gatherings and dwell on signs of prosperity and education represented by well-stocked bookcases and glittering crystal chandeliers. His later work as a clergyman, however, had little in common with the form of political positioning that characterized the Norwegian Synod. As a hospital chaplain among the most wretched of the Scandinavian immigrant community in the large city of Minneapolis, he allowed himself to be guided by compassionate thoughts.[46] Perhaps it is also possible to see this humble, sensitive respect for humanity as an underlying premise of much of Andrew Dahl's production in the course of his decade as a photographer in Dane County, Wisconsin. He found himself in the midst of a cultural conflict but was still able to depict all families involved in that conflict, regardless of their background, with equal dignity.

Views from Main Street

<div align="center">⁕</div>

Small-Town Photographers in Minnesota

A photograph transports us to a room where sunlight falls gently through white lace curtains (Figure 2.1). In a corner, surrounded by flowered wallpaper and soft floor rugs, sit two well-dressed young men, each in his rocking chair and bent over his photo album. They are very alike in appearance, and the textual information that accompanies the picture confirms that the two young men, with identical suits and neat, water-slicked hair, are brothers. That they let themselves to be photographed in this way was far from accidental. As amateur photographers, the brothers, Gilbert and Bernt Ellestad, who lived in Lanesboro, Minnesota, were unusually interested in photography. Their double portrait may even be a self-portrait.

We wonder what the pictures they study so eagerly look like, and we search for answers where their photographs are now preserved, in the picture archive of the Minnesota Historical Society. These albums form part of a larger collection left by the brother Gilbert. The photographs are striking in several ways, not least because they give such a lively impression of life in small-town Minnesota around 1900. In one of Gilbert Ellestad's photographs, for example, we meet the gray-haired Norwegian-American country doctor Johan Christian Hvoslef. He hurries down the main street with a newspaper under his arm, a paint can in one hand, and an umbrella in the other (Figure 2.2). Deep in his own thoughts, he walks along, unaware of the photographer who has placed the camera in such a way that we look up the length of the

FIGURE 2.1. Gilbert B. Ellestad, brothers Bernt and Gilbert Ellestad look at photo albums, Lanesboro, Minnesota, circa 1901–5.

street with its sidewalks, streetlamps, and unpretentious, two-story business facades in stone and wood. It is like being invisibly present on the spot in a chance moment— on a quite ordinary day in Lanesboro, a quite ordinary small town.

Perhaps it's not completely by chance that we encounter this Norwegian immigrant in such a small town. Small towns like Lanesboro came to play a very special role in the history of Norwegian-American immigration. Even though the Norwegian-Americans have been characterized as the most rural of the large immigrant groups in the United States, they sought out small towns. In such small towns in the agricultural regions of the Midwest they could find the improvement in social and economic status they were looking for, while keeping their ties to farming. The social setting in these towns allowed them to also cultivate their sense of ethnic belonging in stable frameworks.[1]

Photography studios became regular institutions in the small town, and in Minnesota, North Dakota, South Dakota, and Wisconsin, hundreds of Norwegian-Americans were employed as photographers. The majority were professionals, but

some were amateurs, like the Ellestad brothers. Minnesota is a particularly interesting place to study these small-town photographers' practices. Already by the 1860s, a great number of the state's inhabitants were immigrants, and Norwegians were the third largest immigrant group after Germans and Irish. Minnesota's small towns sprang up after the Civil War, the majority as a result of the railroad's expansion in their vicinity. These towns became areas for a complex social interaction and for the development of a characteristic multiethnic culture.[2] We move on, therefore, to Minnesota and to a few selected photographers who, like Ellestad, were active in the first decades of the twentieth century.

FIGURE 2.2. Gilbert B. Ellestad, Dr. J. C. Hvoslef photographed on the main street of Lanesboro, Minnesota, circa 1901–5.

"Our Time and Realities": Gilbert Ellestad's Photographs from Lanesboro

When he took the photograph of Dr. Hvoslef, Gilbert B. Ellestad (1860–1938) had lived in Lanesboro for ten years. He came to the town in 1890 to start his own business after completing his training as a jeweler in Chicago. Lanesboro is situated in Fillmore County in the southeast corner of Minnesota, a region where, from the 1850s, Norwegian settlements were already established. The town's strong degree of Norwegianness is likely the reason Ellestad, the son of a Norwegian immigrant, chose to settle there. In the first year, he worked from a rented storefront, but the business flourished, and in 1897 he was able to move into his own building on the town's main street.

FIGURE 2.3. Gilbert B. Ellestad, Mrs. Eide in Lanesboro's main street, circa 1901–5.

He advertised that he had good and reliable clocks ("time keepers") for sale, as well as an assortment of "chains, charms, lockets, silverware, spectacles." Besides all this, he sold cameras and other photography equipment. Gilbert Ellestad was also known as a skillful and imaginative expert in the technology of the day, obtaining all kinds of modern gear before anyone else in the little town. He adopted electric lights and burglar alarms early on, and he drew attention when he constructed his own telephone with a private connection from the shop to his house.[3] As the street snapshot of the country doctor indicates, Ellestad was likely tempted to experiment with the photography equipment he had for sale. The photograph appears to have been taken outside the door of his business. Perhaps people in Lanesboro were so used to seeing Gilbert Ellestad with a camera in his hands that they didn't react much when he snapped their picture unexpectedly in the street.

The graying country doctor, who is out to buy house paint and who otherwise used his free time to cultivate his interests in ornithology and natural history, is only one of the many characters caught on camera by the young jeweler in the street scenes of Lanesboro. In his comprehensive photographic gallery of people, we meet Mrs. Eide, the seamstress to the Ellestad family, who, buxom and full-bodied in a flapping skirt with her hat blowing in the breeze, sweeps undaunted down the street (Figure 2.3). He has also turned his camera on two young men in dazzling white aprons and caps, Harry and Henry from Langlie's groceries. They have positioned

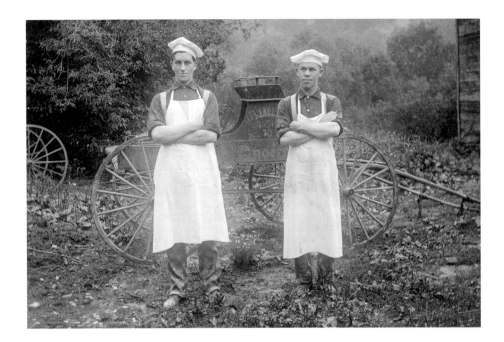

FIGURE 2.4. Gilbert B. Ellestad, Harry (Ike) Greer and Henry (Hank) Langlie in front of the wagon that carries goods to customers of Langlie's groceries, Lanesboro, Minnesota, circa 1901–5.

themselves in front of the wagon used for transporting goods to customers and pose as best they can with arms sternly crossed over their chests and faint smiles (Figure 2.4). In his peregrinations around Lanesboro, Ellestad has also made a short stop in front of the hotel, where the saloon owner has indulged himself in a rest on a bench. The heavy brick wall behind him appears as an expressive backdrop to the subject's solid, rectangular figure. He enjoys a cigar on the warm day and, with his hat pulled down over his forehead, immerses himself in the daily paper without taking notice of the photographer's nearby presence (Figure 2.5).

In front of a small building with large glass windows and a big sign reading *Lanesboro Leader*, Ellestad has stopped to photograph the editorial staff of the local paper. They have arranged themselves symmetrically on the steps, with a small black dog in the middle as a focal point, their gazes directed at the photographer (Figure 2.6). The window surface behind the group reflects a panoramic view of the buildings and streets of Lanesboro, of the realities of small-town society that the newspapermen also tried to reflect in their work. The photographer has also been to the town's small railway station, where he has met Mr. Munch, the traveling salesman representing the Rockford Silverplate Company. He smiles broadly, in a practiced way, at the camera, with a clever glint behind his glasses. With his feet symbolically placed on

FIGURE 2.5. Gilbert B. Ellestad, the local saloon owner photographed in front of the Merchants Hotel, Lanesboro, Minnesota, circa 1901–5.

the railroad ties, he appears to be ready to make a rapid departure to the next destination. Behind him the landscape is obscured by mist (Figure 2.7).

In this series, Ellestad portrays Norwegian-Americans in a typical American small town. It is useful to compare his depictions with the literary presentation of such societies. A good example is the novel *The Rise of Jonas Olsen: A Norwegian Immigrant Saga* (1920), which draws a portrait of a young Norwegian immigrant, Jonas Olsen, who has just arrived in such a small town at the turn of the century.[4] The saga, narrated by the author, Johannes B. Wist (1864–1921), stretches from the protagonist's first years as a newcomer in Minnesota in the 1880s until, after an unsuccessful career in business, he moves west to the Red River Valley. Here, following a lucky land deal, Jonas sets himself up for success. At the novel's end, around 1912, he achieves complete financial and political control over the town that bears his name, Jonasville.

The form Ellestad chooses to depict small-town life for Norwegian-Americans and his approach to the characters and environment show clear similarities to Wist's literary project. Several years before Wist created *The Rise of Jonas Olsen*, he expressed the wish to write a novel about the Norwegian arrivals' lives in America that

would be *realistic* and not *idealistic* in form. The novel would deal with the present, with "our time and realities," and not with conditions in the past.[5] Wist depicts the town Jonas has founded with a series of written "snapshots." In a manner recalling Ellestad's photographic wanderings in Lanesboro, Wist guides the observer through the streets of the town's center without a hint of idealized beautification:

> As usual, Main Street didn't live up to its name. Except for Johnson's smithy, Jens Mastad's *barbersjap,* the shoemaker Konstad, who lived above his shop, and Nils Beinvold's livery stable, there wasn't much to note about Main Street apart from its name. Lincoln Street was a longish street of five to six blocks with four saloons, six so-called department stores, two butchers, Hoff's shoe store, and two drugstores, one of which was run by Lorentz Essendrop Berge, who also turned an extra two bits with illegal sale of whiskey. Further there was Ole Fundeland's jewellery and watchmaker business, two banks (Jonas' and Moland's) and two hotels, one of which, The Scandinavie, was run by a former sloop skipper from northern Norway named Captain Elisæus Hermansen. There you would also find

Iver Jacobsen's machinery agency, Mrs. Hans Tømmerland's millinery shop, and Einar Morvik's tailor shop.[6]

Both Wist's and Ellestad's efforts have been directed toward creating an unpretentious and realistic inventory of a society at a certain moment in time. The small-town inhabitants who come to life through their text and images are in this way also to be regarded as different exponents for a particular culture and worldview. Seen in a photo-historical perspective, Ellestad's photographs might also be compared to the work of the interwar German photographer August Sander. In 1920 Sander decided to create a photographic overview of the people of modern Germany. Tellingly, he called the project *Anlitz der Zeit* (Face of our time).[7]

But Gilbert Ellestad's images also point the way forward to the later American documentary tradition as it unfolds, for example, in Walker Evans's low-key photographic confrontations with people in New York and in the streets of Chicago.[8] Evans's unembellished snapshots recall in some respects Ellestad's fleeting encounters with small-town inhabitants in the Midwest. The Norwegian-American photographer does not avoid, for example, depicting the old Native American "Lake Eagle," who hobbles around with a wooden leg in Lanesboro's streets (Figure 2.8), or the aging Civil War veterans as they prepare for a Memorial Day parade (Figure 2.9).

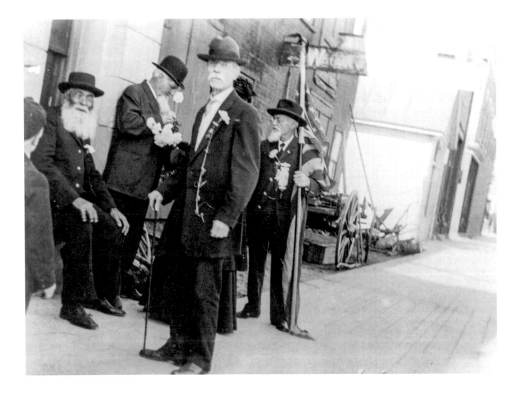

FIGURE 2.9. Gilbert B. Ellestad, Civil War veterans getting ready for Memorial Day, Lanesboro, Minnesota, circa 1900–1905.

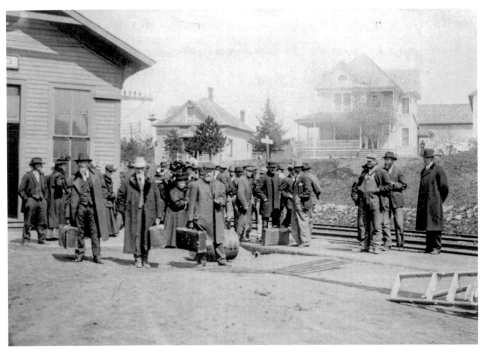

FIGURE 2.10. Gilbert B. Ellestad, Norwegian-Americans at the railway station in Lanesboro, Minnesota, en route to visit Norway, circa 1901–5.

In photographing the veterans, Ellestad gives us an oblique look into the small group of somewhat frail men who are not presented as heroes but who appear to have enough to do just to maintain discipline: getting the flag ready to carry, putting carnations in buttonholes, and in general doing their best just by being there. At the train station he photographs a second, larger group of older men with suitcases in hand, their gazes half fastened on the photographer and half fastened, restlessly, on their pocket watches: shouldn't the train be here soon? What we see are Norwegian immigrants who are setting out to visit the land of their birth, perhaps for the last time in their lives (Figure 2.10). Gilbert Ellestad's photographs are not sentimental; they simply assert that "this is how it is." In this way, we get a glimpse into how life looked through the eyes of a young Norwegian-American in the small town of Lanesboro, Minnesota, one day in 1910.

Postcards from a Small Town: The Travels of Haakon Bjornaas

When Ellestad photographed the old men at the train station in Lanesboro, the Norwegian settlements in southeast Minnesota had become older and somewhat overpopulated. As a consequence, their descendants started moving farther to the northwest. Like the protagonist of Wist's novel, they set their course for the Red River Valley, the wide region on either side of the river that marks the border between North Dakota and Minnesota. This process had already begun in the 1870s, when long trains of covered wagons moved slowly, over months, through the vast landscapes of the West. The Red River Valley was soon populated by first-generation immigrants from Norway who came to make a living from farming.[9] The married couple Ole and Ingeborg Bjørnås belonged to this category. In 1872, they settled down as farmers in the small town of Underwood in Otter Tail County. One of their twelve children, their son Haakon Bjornaas (1885–1949), became a photographer.

Among the many photographs in the Bjornaas collection, which is now kept in the archives of the Northwest Minnesota Historical Center at Minnesota State University Moorhead, is a small, sepia-colored postcard photograph from an early point in his career (Figure 2.11). It is dated 1909, and its caption reads, "Farm scene near Underwood, Minn." A cornstalk with two large, swelling ears of corn fills the picture frame. Sunlight falls from the left, creating an atmospheric softness in the image and dramatic contrasts of light and shadow. But the picture also surprises. Out

on the tip of one ear of corn sits a small man with his hands in his lap, gazing at the photographer. The figure of a second man in miniature on a lower ear looks up at him. A small dog is also included in the scene. What we are viewing is a montage, put together from several photographs.

The combination of the text, with its matter-of-fact wording stating that the scene was from a local farm, and the photograph with vegetables of surrealistic dimensions has an obvious ironic nature. Bjornaas, who probably was pleased with his humorous postcard montages, made a series of them (Figures 2.12 and 2.13). They are all variations of the same theme: contrasts between oversized farm produce (corn, squash, potatoes, tomatoes, etc.) and satisfied farmers in miniature format. The irony is connected to an idea that all immigrants must have been well acquainted with: everything was big and wonderful in America. As an immigrant's son growing up in a large family, the creator of the postcard had likely experienced the conflict between the golden dream of America and its everyday reality.

Such conflict is also comically thematized in Wist's novel about the Norwegian immigrant Jonas Olsen. After a long and laborious trip from Minneapolis, Olsen gets off the train in the Red River Valley along with his wife, Ragna, and discovers that the area they have arrived in does not conform at all to his expectations. But the couple is met by the local guide, the eternal optimist Jim O'Brien, who sees things differently:

FIGURE 2.11. Haakon Bjornaas, "Farm scene near Underwood, Minn.," postcard photograph, circa 1909.

> It was quite a town, he told them, with many businesses, a great location, and everything well kept. As a market it had no competition within the circumference of fifty miles. His description did not correspond to Jonas' impression as they walked down the muddy street, and Ragna, whose galoshes were safely in her suitcase, which they hadn't yet collected, was no more enthused than he, since her feet were wet. As far as they could see, the town consisted of a single street, with a few homes spread out here and there on the prairie without any order. Jim admitted that the population was only six hundred, but it would at least be doubled by next year.[10]

Bjornaas must have been well acquainted with towns of the kind Wist describes here. Between 1908 and 1920, he worked as an itinerant photographer in numerous

FIGURE 2.12 (above, left). Haakon Bjornaas, "Grown at Clitherall, Minn.," postcard photograph, circa 1909.

FIGURE 2.13 (above). Haakon Bjornaas, "Clitherall Products," postcard photograph, circa 1909.

FIGURE 2.14. Haakon Bjornaas, caricature drawing of the traveling photographer and his portrait subject, circa 1906–11.

counties in both Minnesota and North Dakota. In a caricature he drew probably during this period, he depicts his picture taking with a light touch (Figure 2.14). The informal photographer wearing far too short trousers is most likely a self-portrait, while the small woman with the round eyes represents his typical customer, a worn-out, hardworking Norwegian-American female immigrant. The traditional portrait photography, however, represented only a lesser part of his business. His most important income came from his production of postcard photographs.

Bjornaas later said that the aim of his many trips was primarily to collect raw material for his postcards.[11] The reason he began to travel in 1908 was probably because

the American postal system that year, after having discontinued its monopoly on producing postcards, was allowing people to write their own words on the address side of the card. In 1908, millions of postcards were mailed from the United States, and Bjornaas was obviously one of many who saw the possibilities of earning a living from the great enthusiasm for this new kind of communication.

He found the motifs for his postcards in Minnesota's small towns, and there were many of them at the beginning of the twentieth century. Despite the fact that the new inhabitants of the Red River Valley, including a large number of Norwegian immigrants, had found their way there to raise crops, many of them eventually experienced a greater level of urbanization than they had known at home. Even in the heart of the farming districts of the Red River Valley, the populations of the small towns increased during the years from 1885 to 1895, while the number of those who lived on farms steadily diminished.[12] A postcard that could show the towns and places the new settlers felt at home in and were proud of, and that could also be easily sent back to Norway or to relatives in other places in Norwegian America, must therefore have been a highly desirable product. In one of Bjornaas's photographs featuring what appears to be some kind of lunch establishment, we can see how a towering display stand with hundreds of postcards is part of the natural environment, alongside a gramophone and advertising posters on the walls (Figure 2.15).

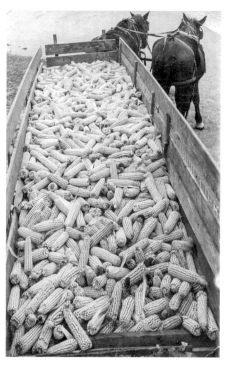

FIGURE 2.16. Haakon Bjornaas, "Market day at Norcross, Minn.," postcard photograph, circa 1909–10.

FIGURE 2.17. Haakon Bjornaas, cartload of corn, postcard photograph, circa 1909–10.

One of the small towns Bjornaas visited during his postcard expeditions was Norcross in Grant County, where on the town's market day he set himself up in the morning sun to photograph the heavy traffic on the main street. In the picture he took, we see a line of new American cars, closely parked along the street. On the wooden sidewalks, curious passersby stare at the photographer (Figure 2.16). Perhaps it was on this same occasion that he climbed up on a horse-drawn wagon to take a picture of crops offered at the market—namely, a wagonload of shucked corn (Figure 2.17). By shooting from a high angle, Bjornaas allowed the large, ripe ears to fill the entire frame. He actually tilts the load toward the viewer for a closer look. This way there would be no doubt of the first-class crops produced in this area, a motif that most certainly would have the potential to win admiring glances.

In the town of Maine, he recorded another agricultural product, the full, round cheese wheels in Wilson & Putnam's cheese factory (Figure 2.18). Here, too, he moved in close to his subject and at the same time kept the camera low, so that, more than anything else, the texture and form of the cheeses, the overwhelming number of them, and the meticulous orderliness of the production floor met the viewer's gaze.

WILSON & PUTNAM CHEESE FACTORY, MAINE, MINN

Tordenskjold Lutheran Church

The postcard could hardly have been a bad advertisement for the local enterprise. In Otter Tail County, Bjornaas photographed one of the many white-painted Norwegian churches in the area, Tordenskjold Lutheran Church, attractively encircled by tall, bare tree branches (Figure 2.19). Membership in the Norwegian Lutheran Church was important in the immigrants' cultural and social adaptation process in American society, not least as an ethnic refuge. For the small-town inhabitants of the Midwest, the church was a place where one was allowed to cultivate and play out one's Norwegianness, something that also made for an obvious postcard subject.[13]

The arena of winter sports was another place to demonstrate Norwegian identity and was reflected accordingly in Bjornaas's work. In Fergus Falls, the Norwegian-American photographer went out to the ski jump to capture one of the many

FIGURE 2.18. Haakon Bjornaas, "Wilson & Putnam cheese factory, Maine, Minn.," postcard photograph, circa 1909–10.

FIGURE 2.19. Haakon Bjornaas, "Tordenskjold Lutheran Church," Otter Tail County, Minnesota, postcard photograph, circa 1909.

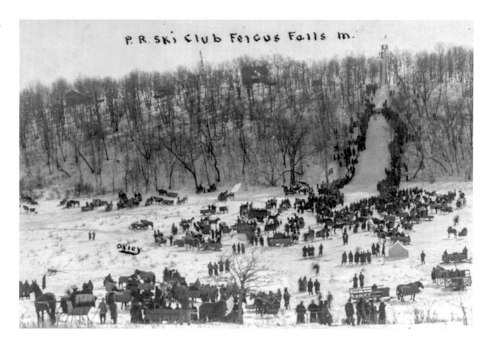

competitions that took place there (Figure 2.20). He set himself up on a ridge nearby with a view of both the hill and the wide plain in the foreground. The lively crowds tell us that this must have been a popular event in the local community, obviously something to write home about. Bjornaas's postcard production also included events that had no specific connection to Norwegian-American culture. He photographed, for example, the aging American showman Buffalo Bill in front of the tents during a tour (Figure 2.21), and he went to a horse race at a state fair in Fargo, North Dakota, in 1910 (Figure 2.22).

In the town of Clitherall, Bjornaas allowed himself to be fascinated by quieter subjects. On a warm summer day, he stopped to photograph a small family (mother, father, and two young children) fishing on the river. They look up humbly at the camera, the father and oldest child holding fishing rods, the mother concentrating on the youngest. In the image we also see how the boat and its inhabitants are reflected in the still water, as are the trees on the riverbank (Figure 2.23). In the town's main street, the photographer found yet another idyllic postcard subject—the play of light and shadow under a beautiful row of lush deciduous trees (Figure 2.24).

Clitherall was obviously a lovely place, and perhaps for that reason Bjornaas established his own photography studio there. One of his pictures offers the chance

FIGURE 2.21. Haakon Bjornaas, "Buffalo Bill," postcard photograph, circa 1909–10.

FIGURE 2.22. Haakon Bjornaas, "Race at Fargo State Fair, 1910," postcard photograph, 1910.

FIGURE 2.23. Haakon Bjornaas, family on a fishing trip, Clitherall, Minnesota, postcard photograph, circa 1910.

FIGURE 2.24. Haakon Bjornaas, "Main Street Walk, Clitherall, Minn.," postcard photograph, circa 1910.

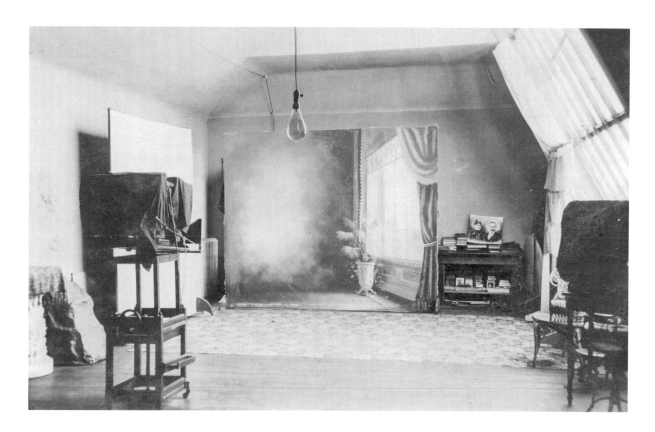

FIGURE 2.25. Haakon Bjornaas, the photographer's studio, Clitherall, Minnesota, postcard photograph, circa 1910.

to look into the rather modestly equipped studio interior; a large slanting window with curtains that can be pulled closed suggests an attic room. A bare lightbulb hangs down from the ceiling, and in a corner is a shelf with books, papers, and photographs. The photographer's large plate camera is centrally placed in the picture's foreground, with the lens directed toward a simple backdrop on the far wall. This painted backdrop creates an illusion of a bourgeois interior with a large window, palms, and draperies. A centrally positioned lightly obscured "misty" space was obviously intended as a soft background for portrait photography (Figure 2.25). The Bjornaas archive contains several examples of images produced in this studio, including a portrait of three young couples neatly arranged in a row in identical affectionate poses (Figure 2.26).

Bjornaas also had other backdrops at his disposal. In a self-portrait we see him sitting on a smiling half-moon in front of a dark, starry sky, where a small, winged Cupid is about to shoot an arrow of love from his bow (Figure 2.27). Wearing a

FIGURE 2.26. Haakon Bjornaas, group portrait taken in Bjornaas's studio, Clitherall, Minnesota, postcard photograph, circa 1910.

FIGURE 2.27. Haakon Bjornaas, self-portrait, Clitherall, Minnesota, postcard photograph, circa 1910.

black suit and tie, he confidently stares into his own camera. This "dandy portrait" stands apart from both his ironic self-portrait as a shabby traveling photographer and other later self-portraits. It also testifies to the large range of social roles that small-town photographers could assume. In 1910 Haakon Bjornaas moved north and bought land in the Rapid River area in Minnesota, not far from the small town of Baudette. In the self-portraits from his new life as a settler, we see him sitting alertly, with his gun in his lap in front of a small tent at the edge of the forest, or raising his ax when cutting timber in a wintery forest landscape (Figures 2.28 and 2.29).

Bjornaas tried to combine the hard work of pioneer life with photography, and around 1911–12 he joined a group of photographers who formed the Riverside Studio. The tent seen in one of the self-portraits functioned as his mobile branch. Bjornaas continued his postcard production, and in some of the postcards he made in Baudette he again ironizes over the contrast between the American dream and the realities of life. As a commentary on the settlers' rather simple

Photo by Battleson & Bjornaas

Free lodging and delightful climate at Baudette, Minn.

BE IT EVER SO HUMBLE THEIR'S NO PLACE LIKE HOME

FIGURE 2.28. Haakon Bjornaas, self-portrait as a settler in the Rapid River area, postcard photograph, circa 1910.

FIGURE 2.29. Haakon Bjornaas, the photographer logging in the Rapid River area, postcard photograph, circa 1910.

FIGURE 2.30. Haakon Bjornaas, "Free lodging and delightful climate at Baudette, Minn.," postcard photograph, circa 1910.

FIGURE 2.31. Haakon Bjornaas, "Be it ever so humble their's no place like home," postcard photograph, circa 1910.

accommodations, he photographs, for example, a man in work clothes lounging casually on a wagon under an open sky. He is surrounded by railroad cars, a barracks building, and dirty oxen lying in the mud. The caption reads: "Free lodging and delightful climate at Baudette, Minn." (Figure 2.30). In another photograph two small frogs have crept under a broken chamber pot someone has thrown into a dirty ditch, and the caption reads: "Be it ever so humble their's no place like home" (Figure 2.31).

Bjornaas's photographs also display a simple sensitivity to the beauty of the American landscape that surrounds him. He directs his lens, for instance, to a little river moving through an opening in the forest and allows us to experience the reflections in the water, the intricate patterns of floating logs, and the misty, fairytale-like atmosphere (Figure 2.32). It is a land and a landscape that have become his own.

FIGURE 2.32. Haakon Bjornaas, river with floating logs, Rapid River area, Minnesota, postcard photograph, circa 1910.

Socialism and Aesthetics: Ole Mattiason Aarseth's Photographs from Sioux Agency Township

The soft, hazy depictions in Bjornaas's landscape photographs are characteristic of pictoralism, a trend within art photography of the early twentieth century. This movement attempted to raise photography to an art form by making it look as much as possible like painting, and, as a rule, like New Romantic, Impressionist painting.[14] Bjornaas was not the only Norwegian-American photographer who produced landscape postcards in a pictorial style.

In Yellow Medicine County in the southwest part of the Red River Valley, Ole Mattiason Aarseth (1881–1965) also worked with postcard photography. He photographed portions of local landscapes, like a river with children playing along its banks, in a way that brought out how the light could model and softly transfigure the figures and the vegetation (Figure 2.33). His subjects have something innocent about them, and the photograph makes life appear to be a Garden of Eden where old and young can enjoy the sunshine together. We can also observe this concept in a photograph of a Norwegian-American family that has settled down in the shade of some trees on a warm summer day (Figure 2.34). The father sits proud and straight-backed without

FIGURE 2.33. Ole Mattiason Aarseth, children playing by the river, Minnesota, circa 1915.

FIGURE 2.34. Ole Mattiason Aarseth, family in the woods, Minnesota, circa 1915.

a jacket, wearing just a shirt, and, with a small bowler hat on his head, seems well pleased with his large family of children. In this moment, in this photograph, life is nothing but sunshine, beauty, happiness, and family togetherness.

These photographs stand in clear contrast to other aspects of Aarseth's work, which in a literal sense put the realities of life into sharper focus. In one of his postcards, which carries the inscription "The Great Town Board of Sioux Agency

FIGURE 2.35. Ole Mattiason Aarseth, "The Great Town Board of Sioux Agency 1914," Sioux Township, Minnesota, 1914.

1914," we see the photographer standing neatly in a row with three other men by the entrance of a prosperous home (Figure 2.35). This is the small town board of Sioux Township, Aarseth's hometown. As is evident from the picture, the photographer was a member of the board. The four men are dressed nearly identically, in simple work clothes and with visored caps on their heads. But their political views must have been quite different. Aarseth brings national politics into the visual representation of local society by identifying in white ink the political affiliations of each of his subjects. The man on the far left is a Republican; the one next to him is a Democrat; the third from the left is a Bull Moose, a member of the Progressive Party created by Theodore Roosevelt during his 1912 campaign for president. On the far right we see Aarseth, clearly marked as a socialist.

We can thus establish that the Norwegian-American photographer Ole Aarseth had other interests besides photography and aesthetics. He was also a socialist and deeply engaged in politics. But we don't know much more than that about him, apart from the sparse biographical information found in immigration records, American censuses, and the photo registry of the Minnesota Historical Society, where his

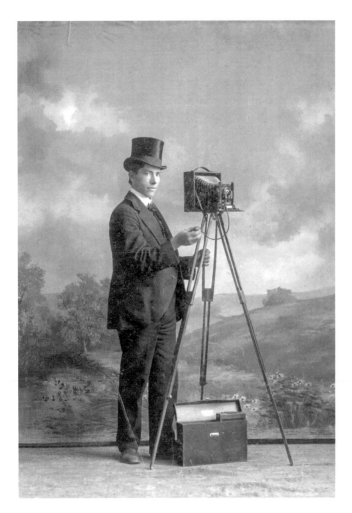

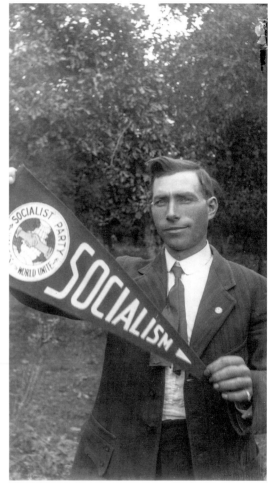

FIGURE 2.36. Knute Mattiason Aarseth, studio portrait of Ole Mattiason Aarseth, Minnesota, circa 1901–2.

FIGURE 2.37. Ole Mattiason Aarseth, self-portrait with socialist banner, Sioux Agency Township, Minnesota, circa 1915.

photographs are preserved. From these sources it is evident that Ole Aarseth came to America from Hjøringfjord in Norway as a seven-year-old in 1888, together with his parents, Mathias and Malena, and three siblings. The family settled on a farm in Yellow Medicine County, near the small town of Sioux Agency Township. At some point during the 1890s Ole's eldest brother, Knute Mattiason Aarseth (1874–1915), established himself as a photographer in the neighboring towns of Echo and Belview. Apparently he trained Ole in the profession, which must have begun early. Around 1901–2, Knute photographed his brother, who was then in his twenties, standing in a suit and top hat behind a tripod-mounted camera in the studio (Figure 2.36).

Included in this professional portrait is a backdrop with a landscape motif and a case of photographic plates at his feet, both allusions to the profession's mobile character. Ole could have worked for his older brother as a traveling photographer.

Knute died at a young age in 1915, and the photographs of Ole Aarseth are all dated to the years before and directly after his brother's death. Yet a great contrast is apparent between Knute's traditional, formal studio portraits and Ole's own, far more informal self-portraits. In one of these portraits, we see him gently smiling while raising a socialist banner demonstratively in the direction of the lens (Figure 2.37). The photographer leaves no possible doubt about his political position. In another, he looks up toward the camera from a pile of branches, where he sits whittling a piece of wood (Figure 2.38). He presents himself in a simple way, as a man with down-to-earth connections to the everyday life of the people. From other photographs it is clear that he was not alone in his political views but belonged to an entire small community of socialists. The socialist banner is included as a background element in many portraits of individuals belonging to Aarseth's close circle of friends and family, as in a photograph of a young man posing under the banner with a guitar in his lap (Figure 2.39).

This community's engagement with socialism was most likely connected to the experience of Norwegian immigrants in American small towns who generally found themselves in working-class jobs. As Odd Lovoll observes in his study of Norwegians in prairie towns, most of them lacked professional education. With the exception of

FIGURE 2.38. Ole Mattiason Aarseth, self-portrait, Sioux Agency Township, Minnesota, circa 1915.

FIGURE 2.39. Ole Mattiason Aarseth, young man with guitar, Sioux Agency Township, Minnesota, circa 1915.

the clergy, the best-paid positions were largely taken by Americans—Yankees.[15] Such social and political tensions are also drawn in Wist's novel about Jonas Olsen. Even if the Norwegian immigrants represented the largest ethnic group in the Red River Valley, the Anglo-American settlers from the northeastern states dominated the political and cultural arena. Upstart Jonas Olsen's strongest opponent in the struggle for power is unsurprisingly a Yankee, Elias Ward.[16] In the novel, Ward's relationship to Norwegians and other European immigrants is described as a blend of breeding, arrogance, and ruthlessness:

> Ward had decided that Norwegians were an ungrateful lot. But they were remarkably forward, considering that they were, according to Ward's New England view of the world, a backward race. But although Ward thought he had good reason to resent the Norwegians, he was usually polite and obliging with them. He was a cultured man who fully understood the importance of appearances as he had a remarkable ability to control himself regardless of personal feelings. Even when he "found himself forced" to foreclose a farm, he would come with the most sincere assurances of his warmest sympathy with the victims. Floen used to tell the story of how Ward once, after having taken the farm from an Irish widow, cried with her and gave one of her children a dime for candy to lessen the pain. But outside his business affair with common people, Ward had no relations with them. Socially speaking, he and his family were high above all others in Normansville, except for Newell and Brackens, the judge, who were in his pay and who were Yankees like himself.[17]

Despite the obvious class differences in the Midwest, there is little to indicate that working-class mentality or ideas about solidarity were particularly widespread in American small towns, in clear contrast to the culture that existed among Norwegian workers in Chicago.[18] Aarseth and his political community thus represented an exception. Judging from the banner, they belonged to the American Socialist Party, which was created in 1901. After a while, this party developed different "ethnic departments," including a Scandinavian one that had its origin in Chicago. But branches also sprang up in Minnesota and the Red River Valley.[19]

Political views are not something easily expressed in photographs. Photographs are primarily descriptive. By themselves they cannot inform us about the world. For that we need anchoring, in the form of supplementary information—as we notice, for example, in Aarseth's political postcards with informative wording. Once we are aware of Aarseth's political sympathies, the images then have an anchoring subtext.

The viewer sees his photographs with fresh eyes, noticing his humble representations of working life in the quiet presentation of a group of hunters with the day's catch in heavy loads on their backs and the portrayal of robust small-town women who, with sleeves rolled up, butcher pigs on the porch, surrounded by children (Figure 2.40).

FIGURE 2.40. Ole Mattiason Aarseth, women butchering pigs near the small town of Echo, Minnesota, circa 1915.

A respectful portrait of a young immigrant woman with her hands in her lap and her gaze turned in thought away from the photographer makes us think about how the struggle for women's rights in the United States had its origins in the societies of the political left (Figure 2.41). In a photograph of Norwegian farmers harvesting wheat, we again notice the obvious aesthetic qualities of Aarseth's photographic compositions (Figure 2.42). He situates himself close to the subject, which he captures with a slight bird's-eye perspective. This gives the image a strong sense of flatness and at the same time presses the depicted realities toward the observer, in a way that reveals the true beauty in the simple and ordinary.

FIGURE 2.41. Ole Mattiason Aarseth, young woman, Yellow Medicine County, Minnesota, circa 1915.

FIGURE 2.42. Ole Mattiason Aarseth, Andrew Knutson and Jens Lere during the wheat harvest, Echo, Minnesota, Yellow Medicine County, circa 1915.

SYLVESTER WANGE: HAWLEY'S PHOTOGRAPHER–BARBER

In Wist's novel we meet life as it unfolds in the small town of Jonasville. The author presents a series of individual characters, both Norwegian-American small-town inhabitants and immigrants with other ethnic backgrounds, and he describes the interplay between them in the social life of the town. We get to know not only the entrepreneur Jonas, his clever life partner, Ragna, and their strong, rebellious daughter, Signe Marie, but also the outspoken and popular doctor, the socially reserved Lutheran minister, the highly Americanized shoemaker from Christiania, the calculating dry goods dealer, the saloon owner from Fargo, the hardworking cleaner Jørgine, and the opportunistic journalist at the local paper.

Wist does not include any local landscape photographers in his gallery of characters, but if he had done so, a figure like Sylvester Wange (1866–1956) would have been well suited. Wange was, like Bjornaas and Aarseth, a small-town photographer in the Red River Valley. He lived in Hawley, Minnesota, east of Fargo and Moorhead. In this town he ran a photography studio for sixty years. Many of those who wandered in and out of his studio over the years could have also peopled the small-town milieu Wist describes in his novel.

Sylvester Wange, or Sylfest Vange (his name in Norway), came originally from Gudbrandsdalen. There, from the age of fifteen, he had unusual occupational training: he became both a barber and a photographer. In 1889 he bought a ticket to America. Upon arrival, he traveled to the small town of Ada, Minnesota, where he began to work as a photographer. A few years later, he moved thirty miles south to Hawley, where he took over a studio and its equipment from another Norwegian-American photographer, O. K. Lee. He married Kristi Eide, and the couple had five children. After Kristi died in 1909, Wange wed Olga Nelson, a marriage that resulted in five more children.

FIGURE 2.43. Sylvester Wange, self-portrait with fish, Hawley, Minnesota, 1890s.

In a self-portrait we meet Sylvester Wange in his studio in Hawley (Figure 2.43). He poses elegantly, dressed in a suit, with a hat and a slight smile, in front of a backdrop with a landscape motif. From his hand, oddly enough, hangs a fish on a string, perhaps to suggest that he is on a fishing trip in rural surroundings. The portrait appears to us today as a strange, mildly surrealistic, and comic bit of scene staging. Stories told about Wange strengthen viewers' first impression that the subject of this portrait must have been a colorful personality. He was a socially active and leading figure in the small-town community. In Hawley he stood out as one of the prime movers of the local Lutheran congregation. He was for many years a representative to the town council and the school board and was a two-term mayor. Wange's income-producing work was not limited to photography. In the basement under his studio

he ran a barbershop in grand style, with around twenty apprentices. The barbershop was not just a place where a man could get a shave and haircut; Wange also offered hot baths and facial massages. When his satisfied customers left the barber chair with newly cut hair and neatly trimmed beards, Wange was ready to photograph them in his studio one floor up.[20]

Like his colleagues at the time, Wange employed the technology that revolutionized the photography profession in the 1880s: the dry-plate process. He made use of factory-made light-sensitive glass plates, which he obtained in Minneapolis. After loading the plates in the darkroom, he placed them in the camera and removed the protective folio before the plates were exposed to the light. Afterward he returned to the darkroom with the plate to develop the negative image. The next step was to make paper copies by placing light-sensitive paper in a frame and laying the negative over the paper. Then he exposed the frame to sunlight until a positive image appeared on the paper. This was fixed in the darkroom, then mounted in a cardboard folder with Wange's signature, and later presented to the photographer's expectant clients.

During his long career Wange produced thousands of rather conventional portraits in his atelier. But the photographs that are conserved in the archives of the Clay County Historical Society reveal that he also had a feel for fanciful and non-traditional scenes of a humorous or dramatic character. When the two Norwegian-American Overson brothers visited Wange's studio, freshly barbered and finely dressed, they posed in profile with closed fists raised at each other in front of the photographer's highly decorated backdrop of painted columns, garlands, and ornamental arches. The idea was apparently to soften up the otherwise formal pose with a little "air boxing," done in a good, brotherly spirit (Figure 2.44). Such informal modes of posing are found in many of the portraits of friends that were taken in Wange's studio. In one, a group of young men have gathered around a small table with an enormous white pitcher as the midpoint (Figure 2.45). With glasses raised toward the photographer, they propose a toast. Behind them we see Wange's familiar backdrop, which covers only part of the picture surface in the background. The photograph, which was probably going to be cropped later, thus also offers a view of the studio, an attic room in which the light falls in from a skylight window from the left.

Between the production of portraits, Wange also found time for more artistically ambitious projects. He shot a series of images of a beautiful young woman by the name of Emma Erickson (Figure 2.46). These were mounted together as a montage, in the form of an allegorical tableau. In the allegorical representation titled "Faith, Hope, Love," we see Miss Erickson in dramatic floor-length costumes and with long,

flowing hair. Her different poses were obviously intended as representations of the three abstract concepts. If photography was going to be art, then the photographer had to detach himself from the desire to represent the facts of nature—at least that was the thought in art photography circles in the 1880s, a concept that landscape photographer Wange had also grasped.

FIGURE 2.45. Sylvester Wange, "Five Men Drinking," Hawley, Minnesota, circa 1890–1910.

FIGURE 2.46. Sylvester Wange, "Faith, Hope, Love," allegorical presentation, Hawley, Minnesota, circa 1900.

Primarily, however, Wange had to keep to the assignments he received nearby, as when the traveling ventriloquists Anton Olsen and Carl Braaten called on him at the studio to have publicity shots taken for their performance (Figure 2.47) or when the proprietors of local businesses wanted photographic documentation of their activities. Wange would set up his camera in dry good stores, shoe stores, automobile garages, or the local telephone exchange, while the owners, staff, and customers agreeably posed in front of the well-stocked shelves and sparkling glass counters (Figures 2.48–2.50). The otherwise quite enterprising Wange didn't find it necessary to learn to drive a car. When he went to areas around Hawley to undertake local assignments like portraits and landscapes or the documentation of special events, he traveled by horse and wagon. One fine autumn day circa 1910–15 he visited the abundant apple orchard of "Grandpa" Nels J. Thussel. Here Wange photographed the proud apple farmer surrounded by trees and flourishing vegetation. Along with a young man, probably his grandson, old Nels stands reverently as he admires the year's wonderful crop (Figure 2.51). The photograph mirrors the rhythms of life near Hawley.

FIGURE 2.47. Sylvester Wange, studio portrait of ventriloquists Anton Olsen and Carl Braaten, Hawley, Minnesota, circa 1910–20.

Through his photography assignments, Wange came in close contact with the major events of people's lives. One of his photographs witnesses the simple civil marriage of a young couple (Figure 2.52). The photographer has placed himself at close range, behind the judge who, with an open book, is performing the ceremony. He is standing face-to-face with the well-dressed wedding couple, he with a top hat and she with a new hat and a bouquet. Bride and groom appear far more preoccupied by the photographer's presence than by the wedding vows being read to them. Their gaze is directed at the photographer, indicating his role as a kind of unofficial master of ceremonies. The photograph will become a lasting reminder of the event.

FIGURE 2.48. Sylvester Wange, Archer's Shoe Shop, Hawley, Minnesota, 1917.

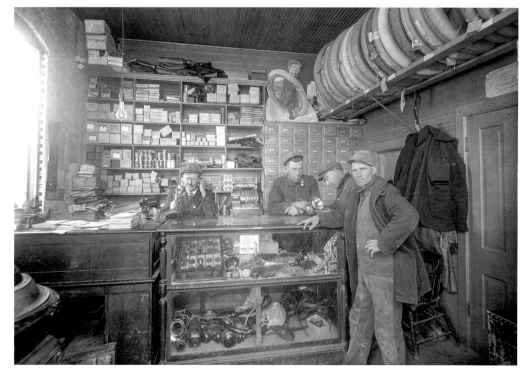

FIGURE 2.49. Sylvester Wange, Evan's and Melland's Garage, Hawley, Minnesota, 1917.

FIGURE 2.50. Sylvester Wange, telephone office, Hawley, Minnesota, circa 1912.

FIGURE 2.51. Sylvester Wange, Nels Thussel's apple orchard, near Hawley, Minnesota, circa 1910–15.

FIGURE 2.52. Sylvester Wange, wedding ceremony, Hawley, Minnesota, circa 1915–30.

Just as the village photographer in the homeland had done, the small-town photographer Wange produced pictures that could function as objects of contemplation both in joy and sorrow. One picture testifies to his respectful presence on the church steps to photograph a pair of young parents and their farewell to their dead infant (Figure 2.53). Mother and father sit on the steps with a small casket between them; it is open and tilted toward the camera. The child, beautifully swaddled, lies as if in deep sleep, but the flowers and the parents' faces tell us that this is a lasting rest. The mother looks at the photographer as if to reassure herself that he in fact has taken the important final picture of the child they were not able to keep.

In this funeral photography Wange emphasizes the ritualistic nature of saying farewell. He shows, for example, a sorrowing family around an uptilted coffin placed among trees and green vegetation (Figure 2.54). The coffin may have been positioned exactly there to mark the place where the departed lived with his dear ones; it is also where the leave-taking happens. In another photograph Wange captures the

FIGURE 2.53. Sylvester Wange, parents with infant's casket, Hawley, Minnesota, circa 1915–20.

FIGURE 2.54. Sylvester Wange, funeral, Hawley, Minnesota, circa 1890.

moment when the sun breaks through the cloud cover and casts light over a group of mourners (Figure 2.55). They stand tightly encircling a casket in a prairie landscape under thin trees crowned with leaves. Their closeness to nature and to this particular place, as well as to each other as inhabitants of this place, is prominent in the visual documentation of this Norwegian immigrant's last journey.

The four photographers presented in this chapter all can be seen in relation to a particular historical situation and time period: Norwegian-American small-town life at the beginning of the twentieth century. As we have seen, they present this time and place in entirely different ways and from quite different starting points—as a small-town flaneur, an itinerant postcard photographer, a political idealist, and a local master of ceremonies. Gilbert Ellestad, Haakon Bjornaas, Ole Mattiason Aarseth, and Sylvester Wange operate within a wide spectrum of genres and stylistic expressions. If we had included more examples from the large registry of Norwegian-American photographers who were active in this arena during this period, we would probably have been able to note even more variations. The images of small-town

FIGURE 2.55. Sylvester Wange, burial, Hawley, Minnesota, 1900–1910s.

photographers are not just witnesses that tell us how things once were; like historical novels they are cultural constructions that also leave a mark on the reality they portray. Novels and photographs can mutually illuminate each other, but the comparison also highlights the differences between the two mediums, between photography's silent moment and the novel's continuous narrative. These pictures demand that we, as present-day viewers, reflect on how they affect us and on how, more than one hundred years after they were created, they still have the power to move us.

LAST SEEN ALONE ON THE PRAIRIE

<div align="center">✳</div>

Emigration and the Unseen Female Photographers

The young woman in the photograph sits all alone on the prairie (Figure 3.1). The photographer is at a low vantage point in relation to the subject. The sky is big and the horizon line low. We look up at a slight angle to where she sits in front of the modest building: a tiny shack of planked wood covered with tar paper—and with a flat, seemingly endless landscape of grassland in the background. Even though the house is small and humble, the young woman is still, like so many immigrants, interested in presenting herself and her world with dignity. Through the little window facing the photographer, we glimpse neatly ironed curtains. Dressed in a white lace blouse and wearing a bonnet, she poses like a young woman from the urban middle class—straight-backed and deeply absorbed in what appears to be a book or magazine. Her posture and grooming stand in strong contrast to the dismal shanty where she apparently lives. Even though a shovel is leaning against the wall, her relationship to the landscape seems to be quite different from that of a farmer's practical, utilitarian perspective. The portrait of her is also clearly differentiated from the aesthetics of more traditional immigrant photography, which documents and dwells on the great size of the fields and newly achieved prosperity.

The young woman is Mina Westbye (1879–1969), who emigrated from Trysil, Norway, in 1902. The photograph may be a self-portrait, since we know she worked as a photographer, among other jobs, during her years in the Midwest. Westbye was

FIGURE 3.1. Unknown photographer (possibly Mina Westbye, self-portrait), Mina Westbye alone on the prairie, Trysil, North Dakota, circa 1903–8.

just one of many young women who left Norway around the turn of the century in hopes of a better future. Before 1890 it was largely men who emigrated from western Europe. The need for female workers was therefore strong, with great demand for European women in particular.[1]

Interestingly, among the many young women who emigrated from Norway, a relatively large number of them were photographers. Not only was the early photographic culture characterized by movement and migration over borders and between social classes; it was also anti-exclusive and included female as well as male photographers. Emigrant records from the different counties in Norway assert that a third of the approximately four hundred people who stated "photographer" as their occupation on their departure to America were women. This is a surprisingly high

number, considering that during this period Norwegian women from the middle class had barely begun to look for work outside the home. There likely was also a difference between women as a whole and those who were brave and enterprising enough to set off for America on their own. It seems obvious to suppose that the camera in the United States, as it did for many women back home in Scandinavia at the time, worked as something of "a woman's emancipatory apron."[2] Yet, there are reasons to question what we actually know about these young women who emigrated with cameras in their luggage.

THE DREAM OF A BETTER LIFE

Most of the women photographers listed in the emigrant records were young and unmarried when they left Norway. Their desire for a brighter future was stated as the reason for emigration. A few wrote that they were traveling "to get married." But phrases such as "better future," "better conditions," and "earn more" are the ones most often used. Realizing that it might not be easy to survive as a photographer, a few stated that they were open to finding new occupations. They would look for "house positions" or simply, as some also wrote, take "anything available" in their new lives.

We know that these young women left Norway and that many of them worked as photographers in America. We also know that some of them returned to their homeland after some years. One was the industrious Louisa Aanensen, who had several studios in Karmøy in Rogaland before she immigrated to the United States in the 1920s.[3] Why she returned is unknown. Most likely her dreams in America did not come true.

Another who returned home was Magdalene Norman (1877–1979), who left Norway with her female partner, Klaudia Kristoffersen, on June 16, 1906. Between 1906 and 1909 they lived together and had studios in New York and Boston. But when Norman contracted tuberculosis in the United States, she had to travel home again, even though she preferred to stay in the country.[4] Back in Norway she probably continued her work as a photographer. And even if her photographs from her time in America have by all accounts gone missing, her interesting travel descriptions from her ocean crossing were saved. These diary entries testify to the female photographer's identification with middle-class values and lifestyle. Wandering through the streets of Liverpool on her way to the ship, for example, she remarks with disgust how "horribly ugly" and "hideously" dressed "the women from the working class" are.

Aboard the ship she also expresses disappointment over her fellow passengers in second class, who do not live up to her ideals of breeding.

> We are sharing a four-person cabin together with the aforementioned Mrs. Hansen. Luckily there are only three of us here. The cabin is nice, with comfortable berths, but it's narrow. It is pleasant and comfortable in 2nd class. And we are waited on in every way. But I will never forget our disappointment after realizing who the passengers in 2nd class are. I would not have expected this at all. All kinds of trash and riff-raff travel 2nd class. We are around 160 or 170 in 2nd. Of this, about 10 are presentable. Besides that, there are Mormons of various nationalities—Swedes, Danes, Germans, Austrians, and English people—not one Norwegian. In this class there are only 3 of us Norwegians. So our illusions of "fine" travel companions blew up quickly.[5]

In a portrait of her and Klaudia Kristoffersen, the two young women pose together on the fire escape outside their apartment in New York (Figure 3.2). They both smile at the camera—and we wonder what it was that made them leave their homeland. Was it for economic reasons, a lust for adventure, or quite simply that the big city could give them the possibility of a freer life?

It is difficult to establish how life in America turned out for the great majority of women photographers who did not return home again. Some obviously found it necessary to give up photography and take up other occupations. Others married, such as Benedicte Cathinca Hageman from Risør. After an independent life as a photographer in Bergen, she immigrated to the United States as early as the 1860s, where she married and spent the rest of her life as a doctor's wife in New York.[6] Others Anglicized their names or became "invisible" as assistants or coworkers in other photographers' studios. Christina Brandlien (who later became Christina Brandly in America), for instance, had her own photography studio in Hanska, Minnesota, under the name Brandlien Studio. When she married the photographer Andrew P. Lien, she continued her work in the same manner as before, while he made a living as a carpenter. Yet the photographs she produced carried her husband's signature.[7] In the same way, the Norwegian-American Harold Rudd (Rud) left the task of running his studio to his wife, Magdelin, while he worked at what he enjoyed, being a traveling musician. The pictures taken in these years still carried Harold's business logo.[8]

In this way it is possible to track down a few of those who are recorded in the emigrant registries. Of the many young women who left Norway, there were also those who were not photographers on their departure but who became one in their

new homeland. In a letter dated August 26, 1898, from a Norwegian immigrant woman living in Park River, North Dakota (where she writes that her family had just had their home photographed), it is evident that the itinerant photographer had help from not only his wife but also a female assistant in training:

> We have now had a picture of our house taken and I plan to send it to you as soon as we get it ready. Today Knudt [her husband] went to town but I did not get the letter finished because I had so much to do today. The house was taken nicely, but we are all sitting there grinning in the sun. . . . The old woman is the mother of the one sitting on the ground, and there is the wife of the photographer and the girl who stands on the other side who is learning to be a photographer.[9]

Most of the women photographers appear to have been strongly involved in family businesses—as sisters, daughters, or wives. One example is Edna Rosaas, who took over her husband O. T. Rosaas's studio in Duluth, Minnesota, in the 1930s. Another is Anna Oleson, who not only took charge of Oleson Galleries in Minneapolis after the death of her husband, John H. Oleson, but also married his successor, the Swedish-American Andrew Heighstedt. In a double portrait, the Olesons study one of their photographs (Figure 3.3). A portrait of Ole E. Flaten and his wife, Clara, taken with a self-timer in front of a mirror shows the couple standing close together behind the camera (Figure 3.4). This portrait hints that Clara was also quite involved in the family business. Petrina J. Erickson only grew visible as a coworker in Erickson's Studio in Fargo when her husband, Soren, left her in 1914. She ran the firm on her own for a few years, until the couple's divorce in 1916.

FIGURE 3.2. Magdalene Norman and Klaudia Kristoffersen, self-portrait in New York, circa 1906–9.

FIGURE 3.3 (above). Jacoby's Art Gallery, John and Anna G. Oleson, circa 1875. The married couple ran a photography studio in Minneapolis, Minnesota.

FIGURE 3.4 (above, right). Ole E. and Clara Flaten, self-portrait, Moorhead, Minnesota, 1880s. The portrait suggests that Clara must have been highly involved in the business of her husband Ole's photography studio.

This list of female photographers who learned to take pictures as coworkers in family businesses could no doubt be expanded with many more names. We could include Geneva Vikre, who ran the Vikre Studio in Ortonville, Minnesota, from 1910 until 1940 with her husband, Harold; Christena Berg, who inherited the Berg Studio from her father in Grand Forks, North Dakota; and Pearl Voss, who, along with her sisters, operated the firm Voss Sisters in Glenwood, Minnesota, in the years 1920–30.[10] Emigration records also give evidence that some of the photographers emigrated with sisters or women friends who worked in the same profession.

But to a large extent information is lacking about what happened with these young women in the United States or their photographic work or whether they even continued in the profession. This also applies to the woman in the photograph from the prairie, Mina Westbye. Let us return to this photograph to let Mina's story (or, rather, the reconstruction of Mina's story) serve as an introduction to the discussion of the invisible women in immigration's visual history.

This story begins with the discovery of the photograph of her on the prairie, a photograph that is preserved at the Norwegian Emigrant Museum in Hamar, Norway. During the research for this book, a second photograph of Mina arrived by

mail from one of her relatives in Norway (Figure 3.5). The sender wrote that Mina had been a photographer in the United States. In this picture we see her in a gently smiling pose, blond and straight-backed in a photography studio along with a female colleague or assistant, who sits at the retouching desk. Daylight streams in from the large glass windows to the left, and in the background are typical objects found in a studio at the time: a chair, a light reflector, room dividers, the corner of a worn backdrop hanging from the ceiling, and a selection of other rolled-up backdrops.

The photograph offers us a glimpse into a vanished time and the chance to create our own stories around the image and the cultural-historical context it springs from. But this is a process of making choices, for the world in itself is not a bearer of meaning. Events of the past, like those happening in the present, contain an abundance of single episodes and meanings. What we do as historians is to reconstruct a kind of order and connection within this chaos through language. But this is also a process that demands that we reflect on our own position in history—and on our distance from that which once was.

FIGURE 3.5. Unknown photographer (possibly Mina Westbye), Mina Westbye (standing) with a colleague or assistant in the studio, circa 1906.

Mina's Photographs: Fragments of a Visual Biography

The photographic material left by Mina Westbye is quite limited in scope, but it has been expanded after a visit to her descendants in the United States. Among other images, the family possesses portraits of Mina when she appears to be in her twenties. One is a head-and-shoulders pose in which the light falls on her face so that our gaze is involuntarily caught by her lively, smiling expression and her alert, sparkling eyes (Figure 3.6). The other portrait, in which she turns carelessly toward the photographer with a cheerful smile, also strengthens the immediate impression that Mina must have been an interesting young woman with integrity (Figure 3.7).

FIGURE 3.6. Unknown photographer (possibly Mina Westbye, self-portrait), Mina Westbye, circa 1906.

FIGURE 3.7. Unknown photographer (possibly Mina Westbye, self-portrait), Mina Westbye, circa 1906.

The starting point, then, for the reconstruction of Mina's life as an immigrant photographer lies in a handful of photographs supplied by her family. It is not even known which of them were taken by Mina. The photographs seem to be part of a family chronicle. As a whole, they form the personal photographic fragments of a visual biography. In combination with the limited information from the family and from other sources, such as the emigration records, we are able to sketch an outline of Mina Westbye's life.[11]

Some of the family photographs are from Mina's childhood in Norway. In one of them she appears with her siblings in front of their home in Trysil (Figure 3.8). They are smiling at the photographer, each with a cat or dog on their lap. Their names have been written on the photograph in black ink. At the far left sits Mina; she looks

to be around thirteen or fourteen. Next to her is her brother Johan, already a young man, wearing a suit and hat. To his left is their sister Helga; then comes the youngest brother, Aksel. Far to the right we see their sister Jenny. The siblings sit together on the stairs in front of a well-kept house with white-painted columns and tidy plantings. Their clothing and surroundings tell us they belong to the middle class. This impression is strengthened by other photographs, including a group portrait of the three Westbye sisters taken in the photographer's studio.

The children's father, Peder Westbye, was a military officer of lower rank. He deserted his family in 1888 to immigrate to the United States. Twelve years later, around 1900, Mina followed, apparently to live with him. She was twenty-one at the time. Seeing her father again must have been a disappointment to her, for according to her descendants he had alcohol problems and had remarried. Most likely Mina understood the necessity of shaping her own future after arriving in America. One way of doing that was to speculate in real estate, which is why we find her in the photographs alone on the prairie. According to official sources, Mina homesteaded in North Dakota in 1903. She called her property Trysil after the village where she grew up in Norway. She purchased this plot with the intention of making a profit when she sold it. But she also had to agree to live on the property for three years to be able

FIGURE 3.9. Unknown
photographer (possibly
Mina Westbye), Mina
Westbye's claim shanty
in Trysil, North Dakota,
circa 1903–8.

to sell it and to use the capital to make a new start in life. A photograph of the little pioneer shack evinces how modest Mina's home on the prairie was—and how lonely it is in the wide-open landscape (Figure 3.9).

But Mina was not completely alone. As some of the photographs testify, her two cousins, Marie and Olive Jensen, had also taken claims in the same area of North Dakota (Figure 3.10). Their "claim shanties," however, were several miles from Mina's, and the next closest neighbors lived five miles away. In the small collection of pictures left by Mina, we also find photographs from more urban surroundings (Figure 3.11). In one of them we see her with a female friend by a front gate in what appears to be an American small town. Both are dressed elegantly as city ladies. The image seems to support the information indicating that Mina left her claim in the winter months to take work. During the first years she worked in Minneapolis and in later years found work in the little town of Hanska, initially as a seamstress and then as a photographer.[12] With these earnings she probably made enough money to support herself the rest of the year on the prairie.

In Minneapolis and Hanska, Mina lived with the clergyman Amandus Norman and his wife. Norman, who originally came from Stange in Hedemark, was a

FIGURE 3.10. Unknown photographer (possibly Mina Westbye), Mina Westbye with one of her cousins, Marie or Olive Jensen, Trysil, North Dakota, circa 1903–8.

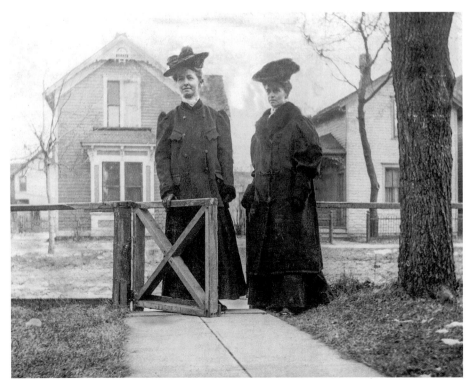

FIGURE 3.11. Mina Westbye with a friend in the city, circa 1903–8.

FIGURE 3.12. Mina Westbye, Mina with her sisters in their childhood home in Trysil, Norway, circa 1908.

pastor in the liberal Unitarian Church, first in Minneapolis and then in Hanska.[13] He was one of Kristoffer Jansen's colleagues in the United States and carried forward Jansen's liberal ideas, which in their time had caused the Bergen-born theologian to break with the Lutheran Church. Jansen had visions of America as a liberal alternative to the church-dominated, classist society in Norway—but his experiences in Norwegian America changed his mind. He came to consider the saloons as well as the Lutheran Synod as the real enemies of the people, with the potential to destroy, one, the body's life and, the other, its soul.[14] In his pastoral work Norman sought to further Jansen's ideas about perfecting human beings through knowledge and education. Perhaps it was just these kinds of ideals that appeared attractive to Mina Westbye, with her enthusiasm for learning.

Among the photographs she left behind are also pictures that were taken after her return to Norway in 1908, after eight years in America, when she worked as a photographer in her home village of Trysil. In one of those photographs, we see her with her two sisters in what is likely the fine parlor of their childhood home (Figure 3.12). The interior is warm and comfortable, with elaborately carved wooden furniture and a woven tapestry on the wall, in line with the National Romantic style of the day. There are flowers on the table and a grandfather clock in the corner dated 1906. A lace curtain filters the sunlight from the window. In the middle of the room Mina stands firmly with her hands behind her back (most likely to hide the self-timer), and her gaze is calmly directed toward the camera. Her presence is clearly important and appreciated; one of her sisters looks up at her with care and respect.

These photographs from Mina's years in Trysil, Norway, indirectly also bear witness to perhaps the most important event in her life and her decision to return

to America. They are representations of the life she decided to break away from when, in 1911, she made this return trip to marry another Norwegian-American immigrant, Dr. Alfred Gundersen (1877–1958), a talented academic she probably met in the home of the Normans. Among the photographs from Mina's new life as an academic's wife in America is one image that shows her with her two daughters at the family's summerhouse in the Catskill Mountains of New York (Figure 3.13). In the last known photograph of her, we encounter Mina as a gray-haired older woman, next to her husband, Alfred (Figure 3.14).

On the one hand, this collection of family photographs may be read as a family chronicle providing brief glimpses into the life of a Norwegian immigrant woman. On the other hand, it is easy to become fascinated by the individual images. The picture of Mina on the prairie displays, for example, a striking contrast between a high level of culture and rough living conditions. The young woman does not present herself as a hardworking settler in the midst of cultivating the land. Mina's attitude toward her environment seems rather more aesthetic: she picks flowers and puts them on the table for decoration (Figures 3.15 and 3.16). Thus she seems like a passing guest, a middle-class woman who in a headstrong as well as aesthetically sensitive manner adapts herself to a foreign environment while waiting for life to take another turn.

FIGURE 3.13. The Gundersen family at their summer house in the Catskill Mountains in New York, 1950s.

FIGURE 3.14. Mina and Alfred Gundersen, 1950–1960s.

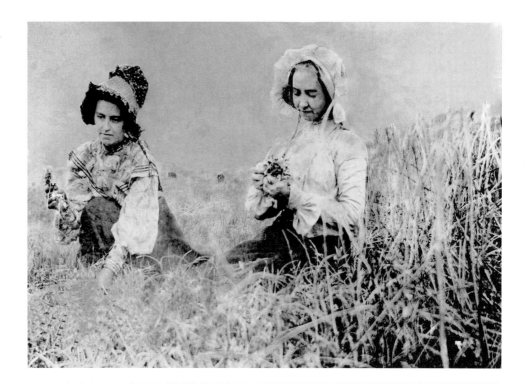

FIGURE 3.15. Unknown photographer (possibly Mina Westbye), Mina Westbye and Marie or Olive Jensen, North Dakota, circa 1903–8.

FIGURE 3.16. Unknown photographer (possibly Mina Westbye), Mina and one of the Jensen sisters in front of the claim shanty, Trysil, North Dakota, circa 1903–8.

Mina's Letters

Although the photographs from Mina's life appear to be objective and reliable proof of what her world looked like, they cannot explain that world on their own. Information from her family and from other scattered sources have helped to make the visual narrative of Mina's life coherent. Yet the history offered is so fragmented that further anchoring seems necessary for the visual material to lead meaningfully into the past.

Fortunately, Mina Westbye's descendants possess a comprehensive and interesting collection of correspondence that can be used to provide this sort of informative anchoring. This material consists of letters that Mina wrote to her future husband, Alfred, when she was young and alone on the prairie. The correspondence stretches over a seven-year period, from 1904 to 1911, and the letters are written partly in Norwegian and partly in English. According to the family, Mina's daughter Sylvia once stopped her mother in the process of burning some old letters. Most of the letters saved from destruction were those that Mina wrote to Alfred. Thus, with few exceptions, it is mainly Mina's voice that is expressed through this material.

There is good reason to celebrate that the letters were saved from the flames. First, they shed light on the questions of why women like Mina chose to become photographers and why some later left the profession; second, the well-written letters provide an interesting cultural-historical context for the visual material. They add depth to the pictures and allow us to see their author and the subject of the portraits at close range. For instance, Mina writes in great detail about everyday life on the prairie but doesn't hide her lack of interest in farming. Yet she also doesn't complain about her life. She describes, for example, her little shanty and her circumstances with a mixture of sober realism and humor in a letter to Alfred dated April 28, 1905:

> Finally I am out here! Here it's so fresh and nice! You really become a different person. What a closed-up life I had. This is such a peaceful spot, but it can be lonely sometimes, like today. It's blowing, snowing, and raining so much it's practically impossible to go outdoors. All the same I like the rain, people say it's so dry here. That is also true, whatever the reason is. . . . Have you ever seen these common "claim shanties"? Mine is 10 by 12 feet—simple . . . walls, covered with tar paper outside, barely keeping the wind and rain out—but it's also all that's needed. Cozy—indoors anyway. You should see it. I'm so far away from people and good manners—*that* is what is so great. In the evenings, oh, then it is beautiful—clear and starry! When it is not windy—which by the way is quite infrequent—it's so quiet you almost feel afraid.

It is obvious that Mina did not always feel safe. She writes that she owns a gun but is not completely certain how to use it. Judging from her letters, she spends most of her time on the prairie walking. Mina writes in one letter that she walks about ten miles every day. She says it is a half mile to fetch milk and water, sixteen miles to the nearest store and post office, and thirty-five miles to the railroad. She reads a lot (though she complains about the difficulties of getting new literature), embroiders, undertakes botanical studies, presses plants in her herbarium, and studies the moon and stars through a borrowed telescope. And she writes letters incessantly. But to understand the context and background of the correspondence, it is necessary to present more closely the recipient of the letters, Mina's future husband.

Alfred Gundersen came from a wealthy merchant family in Kragerø, on the southern coast of Norway. After losing both his parents at an early age, he came to the United States when he was fifteen to study and start a new life. He first took a degree in physics and then worked as a teacher at the University of Minnesota as he continued his academic education by studying botany. Afterward he studied anthropology at Harvard University before returning to Europe for doctoral studies at the Sorbonne. As an academic whose research field encompassed botany, geology, and anthropology, Gundersen was especially interested in evolutionary theory and the interdependence of the plant and animal worlds.[15]

The correspondence between Alfred and Mina is touching. In Alfred's first letter it is evident that he has decided to be honest and to tell her everything about himself and his life before meeting her. He emerges as a rather gloomy character who, with bitter irony, compares himself to the main character in Arne Garborg's *Weary Men* (*Trætte Mænd*), a figure he does not particularly like. He writes of problems in finding deeper meaning in his studies; of his early exalted thoughts about himself; of his own intellectual capacities; and, finally, about how, desperately tired of life, he went gold-digging in the Klondike, only to develop a severe fever that almost killed him.

But in his letters, the young academic also emerges as a man of ambition. In one dated several months after his first letter to Mina, he professes his intentions to return to Norway to "liberalize the country." He wants to abolish, or completely change, the Lutheran Church, replacing it with what he calls the religion of science—something radically different from the freethinking ways of the "Kristiania Bohemians," which he calls their "silly negation." He also intends to introduce the study of evolution as a subject in the public schools. Mina is clearly part of his vision: "But I need someone to help me," he writes in English. "And who better than you?"[16]

Together the letters form a love story with many complications and changes in temperature and mood. But Mina had her reservations: "I believe in you—and want to make life easier for you," she writes.[17] But she also says she does not like the tone of his letters, "so weary and hopeless." "It hurts me," she maintains. "You read too much—and take too little interest in life itself and in people. . . . I believe that pessimism is another form of egoism."[18]

She also emphasizes that she found him privileged, because he was able to spend all his time acquiring knowledge while she, as she formulates it, knows all too little: "I have no time to read. In the evening I am so tired." That does not mean she was unwilling to learn—on the contrary: "There are so many things that I want to read about and study—nature, plants, animals, astronomy, and many other things." Mina also stressed her economic independence: "You talk so much about finances. I for one have always been used to surviving on little—so in that respect I am not very demanding."[19]

Mina's letters thus confirm and reinforce her visual self-representations as a strong woman leading a double life as a settler in isolated and primitive surroundings on the American prairie and as a lively and extroverted city dweller. Her letters from the city sound happier and more optimistic than those written on the prairie. They are also much shorter, not only because she works long hours but also because in the city she has an active social life. She has almost unlimited access to books, and she writes enthusiastically about reading Russian contemporary novelists and attending literary nights hosted by Pastor Norman. While writing from the prairie, on the other hand, she struggles hard to keep up a facade of happiness and vigor. Some letters simply overflow with homesickness, loneliness, and social resignation:

> Often days may pass without us seeing anyone here. We, my cousin and I, came here Thursday and today is Saturday—and not a person have we seen—yet. But never mind. The people living here are so narrow-minded anyway—at any rate, the Norwegians. Even out here the Synod and the United Church prey on the minds of the immigrants.[20]

But then the letters can suddenly shift to a lighter tone: "Oh, but now it is so beautiful outside. The sun is shining and the wind has abated. Tomorrow it will be splendid, you'll see, to go out searching for flowers—I've noticed some gray-blue bellflowers already, the flowers came first and then the leaves, also some snow-white, miniscule star flowers, they grow in large clusters, they are so pretty."[21] Here Mina is obviously flirting with the botanist in Alfred.

Sometimes the correspondence subsided, for instance, when it appeared, indirectly, that Alfred had been involved with another woman in one of the cities where he was teaching. "You and I are too far apart from each other," she observes, "and I do not mean the distance between Boston and Minneapolis. . . . Friendship and love? I long for both, but cannot find either."[22] She also begins to write about her plans to go back to Norway and about her longing for the forests around Trysil. But she is still bound by the homestead contract, which required her to stay on her property in North Dakota for three years before she could sell it.

The correspondence resumes, even though the letters are a little more formal in tone. Mina no longer addresses Alfred as *Dear Friend* but as *Mr. Gundersen.* He sets off to Paris to study at the Sorbonne and wants very much for Mina to come with him. But she answers that it's not possible because of her contract. She asks him in a somewhat poisonous tone if it's really true that he is going to be studying "for even more years to come? I cannot imagine that you can find any personal happiness in that." She also advises him to take an interest in "natural, vital people, not only geniuses and scholars."[23]

Mina then informs him that for her part she wants to be "immensely practical." She wants to be a photographer: "I have gotten it into my head that I want to learn a trade. And for that reason I will begin to learn photography." Yet at the same time she asks him rather carefully whether he is "sad" that he ever met her. "You were very dear to me—that was true—but there were so many things in between that made it impossible. . . . But shouldn't we keep corresponding? Even if I don't write more, you can feel certain that I always wish you every happiness and success."[24] In a later letter, she tells him she is doing well as a photographer in the little town of Hanska, where she took over Andrew P. Lien's studio, run by his wife, Christina Brandlien (Brandly).[25] The photograph of Mina and her assistant is possibly from this studio. Alfred still wanted her to live with him in Paris, but Mina refused him yet another time, making reference to her own financial independence. Writing in English, she explained: "Yes if I had a good deal of money, and knew a trade to perfection so I could be sure of getting a position—and besides had enough money on hand to leave any day I wanted it—if I could depend altogether on myself—I would go to France."[26]

After selling her homestead property, she chose instead to return to Norway in 1908. She wrote that her sisters needed her at home and that, after being homeless for many years, she felt a need to have a secure home. On her way back, she stopped in Christiania to perfect her abilities in the art of photography. She worked with the royal court photographer, who was known as "the best in town." She stated with

impatience that she wanted to learn more: "I love everything beautiful—images as well as other things—so I am confident that I will be enjoying my work—it is also interesting to work with all sorts of chemicals. The worst of it is that it takes time to be good at this—I should have started much earlier."[27]

Back again in Trysil, she establishes herself as a photographer in her childhood home, which she buys with her two sisters. She is obviously certain this is going to be her future, and she asks Alfred to burn the letters and the photographs she has sent him. Everything is pointing toward a spinsterish existence in her childhood home with her sisters. But gradually she realizes that her years of independence in the United States have changed her. The time "over there" has altered the sense of her core values, something that doesn't make life at home any easier. She and Alfred again renew their correspondence, and their letters begin to exhibit a new emotional intensity. Mina tells him she leads a quiet life as a photographer in Trysil, even though she confesses she is not happy with the quality of her work. Her writings demonstrate the conflict she was experiencing between the demand to be efficient and make money and her ambitions for artistic quality:

> I do not doubt that I could make a lot more money out of the business than I do—but it is not my way to work like that. There is so little of what I do that I am really pleased with—the rest has to be done in order to make money. But all in all I am quite content. If it gets too trivial, I throw it all away for a while and go for a walk in the sunshine![28]

Mina thus describes the joy she finds in the sunshine and in nature. Nevertheless, her letters do not conceal the fact that she feels lonely and estranged, even from her nearest family:

> My sisters and I enjoy each other's company, yet we are so different. I cannot, for example, decide whether or not to go to church. I do not think I have anything to do there. They seem to find that very wrong, as they go every Sunday. Basically, I have no friends here; I walk around alone, and when I am with someone, I rather prefer my own company, at least at times. I have become tired of almost everyone.[29]

So when Alfred proposed yet again in 1911, seven years after they first started corresponding, Mina finally said "yes" and bought a ticket for the first boat across the Atlantic Ocean. She left all her cameras and photographic equipment in Norway, ending her five-year career as a photographer. She never took any photos again, not

even of her own children. Alfred accepted a position as a conservator in the Brooklyn Botanical Garden and helped build up the garden. The couple settled north of New York City. But the place they felt most bonded to was the summerhouse they bought in the Catskills, because it reminded them so strongly of Norway. It was also here where Alfred and Mina were laid to rest.

LIFE CHOICES AND GENDER IDEOLOGY

Seen in relation to each other, Mina's letters and pictures function as a reminder of how important the biographical and cultural-historical dimension can be for understanding a photographer's place in history. Examining this material makes apparent how choices made over the course of one's life are based on culturally required norms and values.

This point is even clearer when we read the story of Mina against the background of ethnologist Tone Hellesund's work on the history of Norwegian spinsters, that is, unmarried bourgeois women. She discusses the cultural construction of gender in Norway and how new possibilities opened up for women from the bourgeoisie and middle class at the end of the nineteenth century. Having lived a sheltered existence as daughters living at home, as aunts, governesses, and social companions, these women were given the freedom to enter a variety of occupations. They could become teachers, telegraph operators, nurses, and photographers.

These new women were preoccupied with economic independence, women's rights, and moral conduct. Hellesund describes how a spinster culture developed in Norway that was oriented toward femininity as a positive contrast to masculinity. This culture was characterized by different kinds of female communities and intimate friendships. At the same time, the spinster was created as a social stereotype. In the cultural narratives about this kind of woman, descriptions of femininity and of lack of femininity had a central place.

Gradually, however, this spinster society came to lose its legitimacy. A shift grew in the perception of women's role in society—a kind of "de-spinsterization" of society. Academic women, including Hulda Garborg and Sigrid Undset, began advocating for a new ideal woman who came to replace the more independent spinster. What they stressed as important in the human experience was the erotic and sensual, the mysteries of motherhood, and love between man and woman. In the decades after the turn of the century, the focus was again directed toward women as mothers and

wives. Thus it was no longer the struggle for women, especially unmarried women, to enter public life that was central.[30]

Mina Westbye appears as a kind of intermediate character in this gendered, ideological landscape. In the first part of her life, when she is active as a photographer, she fights both for professional and for personal economic independence. But over time she pulls back from an independent career to become a housewife and mother—putting photography aside for good. Mina was not alone in choosing photography as a means to achieve personal and economic freedom. Nor was she alone in leaving the occupation. She is only one of the many names in the emigrant records. But her story and those of other female photographers contribute to making visible the many who have long been invisible in history and in the history of photography. In doing so, they construct alternative and necessary interventions in the established historiographies of migration.

Place and the Rhythm of Life

✳

Peter J. Rosendahl's Photographs from Spring Grove

We are looking at an old photograph in black and white (Figure 4.1) and are immediately taken back in time to a summer's day on a veranda more than a hundred years ago. An elderly man with gray hair and a goatee is sitting on a high-backed chair with a blond, round-cheeked little girl on his knees. His chair and the door behind him are shiny with fresh paint, and on the stool beside him are a ceramic jar and an empty tin. The setting is simple but at the same time neat and orderly. The same goes for the old man's clothing. He is wearing a coarse workingman's shirt. His wide trousers are held up by broad suspenders. He has taken off his shoes, and the darning of his thick wool socks is visible. His appearance makes a strong contrast to the girl's light, laced-trimmed summer dress. These differences between the two subjects—the tall, skinny old man and the round little child—attract our attention and touch us when we look at this image. The man's gaze is calm and thoughtfully directed toward the girl. He is holding his left arm safely around her, while his right hand carefully touches her chubby little foot. She beams, secure and content, at the photographer—who has chosen a low position to keep eye contact with the charming toddler. He has also gone for a tight, vertical format that nicely frames the closeness between his subjects.

The photograph was taken around 1913 on a farm on the outskirts of the small town of Spring Grove, the oldest Norwegian settlement in Minnesota. The man behind the camera was Peter Julius Rosendahl (1878–1942), whose name is well

FIGURE 4.1. Peter Julius Rosendahl, Grandpa Melbraaten with his granddaughter Gladys, Spring Grove, Minnesota, circa 1913–14.

known in the history of the Norwegian settlements in the United States. He was the son of a Norwegian immigrant couple, Paul and Gunnhild Rosendahl, who settled in Spring Grove as early as the 1850s. His father came from Hadeland, Norway. Paul Rosendahl worked as a register of deeds for Houston County and was also a representative in Minnesota's legislature, but he unfortunately died when his sons were still young. Unlike his brother Carl Otto, who left home to study and later became a professor of botany and forestry at the University of Minnesota in Minneapolis, Peter remained in Spring Grove, where he worked as a farmer his entire life. In 1905 Peter married Othelia Melbraaten, another Norwegian-American, and between 1906 and 1919 they had four children.

Peter did not achieve his renown as a photographer, however, but as a cartoonist. He was the creator of *Han Ola og han Per*, a comic strip he drew for the Norwegian-American paper *Decorah-posten* between 1918 and 1942 (Figure 4.2). During the 1920s the paper had as many as forty-five thousand subscribers.[1] The comic strip was continuously reprinted until the paper stopped publication in 1972. The series became familiar and beloved among the Norwegian-American community, and some claim that its two main characters, Ola and Per, were almost like family members.[2] The comic strip represents a unique example of the humor in this particular ethnic group in addition to serving as an authentic linguistic document from the daily life in a bilingual community, and for these reasons the series has been the subject of several academic studies.[3] These studies make it clear that Peter Rosendahl was a man of many talents. Not only was he a farmer and a cartoonist, but he also was an inventor who painted portraits and wrote poems and song lyrics. That he was a photographer is less known.

For a long time, Rosendahl's photographic production has been difficult to access. His negatives—hundreds of glass plates—are safely preserved in the picture archives at Vesterheim Museum in Decorah, Iowa. But in 2007 the images were scanned, and now for the first time it is possible to form a complete picture of Rosendahl's photo-

graphic work. In addition, the individuals in the photographs have, as far as possible, been identified by Rosendahl's daughter-in-law, Georgia Rosendahl. From her we know that the little girl and the old man in the photograph are Peter Rosendahl's daughter, Gladys, born in 1913, and his father-in-law, Engebret Hanson Melbraaten. The old man is sitting with his grandchild on his lap. He was about eighty when the picture was taken and died only two years later. Encountering Rosendahl's comprehensive picture archive today raises some questions: Why did this Norwegian-American farmer and comic-strip maker also take photographs? And how should we understand his photographic images?

FIGURE 4.2. Comic strip from the series *Han Ola og han Per,* which Peter Julius Rosendahl drew for *Decorah-posten* from 1918 until 1942.

A Photographic Comic Strip?

If we look more closely at the photograph of Grandpa Melbraaten, we will immediately establish that both in clothing and in appearance, with the thick gray hair and the characteristic goatee, he reminds us more than a little of the comic-strip character Ola (Figure 4.3). Today it is possible to see different physical and thematic connections among Rosendahl's biography, his photographs, and the comic strip he was most known for. To investigate this correlation, we must become more familiar with the comic strip and its characters, its particular humor, its creator, and the cultural context in which it was created.

Throughout the comic-strip series, the two neighbors Ola and Per are constantly struggling to adapt to the American lifestyle, and the comic element lies in this struggle. They find themselves mentally caught between two worlds, the old and the new, at the same time. The language they use emphasizes this conflict. Different

FIGURE 4.3. Peter Julius Rosendahl, comic-strip figure Ola from the series *Han Ola og han Per.*

subjects are individually characterized by a double set of parameters: first through their dialects, which reflect their Norwegian backgrounds, and second by their use of English, employed on a scale from so-called newcomer English to complete "yenkie."[4]

As types, the characters are neither particularly industrious nor bright, but they are continually and naively enthusiastic about their new country's modernity and new technology—the car ("karsen"), the radio ("the weierless"), and all kinds of strange machines, such as a pig-feeding machine, an eternity machine, an egg-cleaning machine, a dishwasher, and a wood-cutting machine. Per is obviously the most enthusiastic; he is the long-legged figure with a full beard who is always wearing a bowler hat and a dress suit with tails. He is always in the process of trying out new inventions or thinking up his own inventions to make life on the farm easier. As a rule, this ends in chaos.

Ola, his somewhat more clever neighbor, has a more relaxed attitude toward life. He is down-to-earth, bareheaded, wears farmer's overalls, and constantly breaks out in laughter when faced with Per's error-ridden and idiosyncratic approach to technology. The cartoon includes four other characters: Per's wife, Polla, the city girl from Fargo who hasn't quite found her footing in rural life; their little daughter, Dada; Per's brother, Lars, the helplessly overeducated academic; and the mother-in-law, the brutally tough and hardworking pioneer woman. And, of course, there are all the farm animals, which always prove to be far wiser than their two-legged fellow creatures.

Over the course of twenty-four years, Rosendahl drew more than seven hundred strips of *Han Ola og han Per*, and during this time the comic strip developed from slapstick, via family entertainment, to thrilling adventure stories. This development corresponds with the general history of American comics in the 1920s and 1930s.[5] Nevertheless, *Han Ola og han Per* is above all a Norwegian-American series, rooted in the everyday life of an immigrant society, a reality that its creator was highly familiar with. Like his character Per, Peter Rosendahl was very interested in technical matters. He qualified as an engineer in mechanics and electronics through correspondence courses in 1911.[6] Creative by nature, he had many ideas for new inventions. Among other things, he constructed his own tractor. Between 1919 and 1920, shortly after introducing *Han Ola og han Per* to the readers of *Decorah-posten*, he also took a correspondence course in comic-strip drawing. Drawing comics and performing technical experiments were, however, something he only did alongside farming. When the farmwork demanded his full attention during the summer and

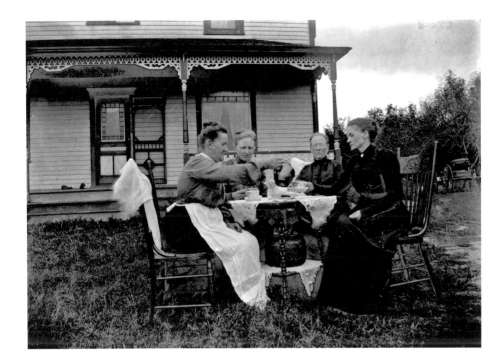

FIGURE 4.4. Peter Julius Rosendahl, coffee visit in Spring Grove, Minnesota, circa 1913–14.

fall harvest months, he simply sent his characters Ola and Per away on vacation—and then allowed them to return in late autumn and winter.

The same applied to photography. In a certain sense, Rosendahl acted as a village photographer in Spring Grove. The collection of photographs he left behind includes a relatively large number of portraits not only of his family and neighbors but also of the town's inhabitants (Figure 4.4). Photography was never a full-time activity for him as it was for the professional photographers in Spring Grove, among them Frank Joerg and Christian Engell. Rosendahl did not take pictures in order to sell them but gladly gave them away to family members, friends, and acquaintances—or made sure that his wife, Othelia, put them nicely in the family album. Images in his photographic production reveal that he worked with photography in a very different way from the professional photographers. He was also more liberated technically than the studio photographers, who used large and heavy plate cameras.

Rosendahl worked with an Adlake plate camera, a model that came into production in the 1890s. This camera, which closely resembled the later handheld Brownie (apart from having glass plates instead of modern celluloid film), was simple and flexible to handle. It was also lightweight, which made it possible to take more

snapshot-like pictures. One self-portrait of Rosendahl shows him in action as a photographer, bent on his knees with his head under the black camera cloth (Figure 4.5). As was typical, he is photographing out in the open air. That Rosendahl also left celluloid negatives in his collection indicates that he later must have also purchased one of the smaller portable cameras, perhaps a Brownie.

But what is the relationship between the comic strips and his photography? The first Ola and Per comic strip was drawn in 1918. Judging by the ages of the children in the images, the Rosendahl photographs in the collection at Vesterheim Museum in Decorah, Iowa, were most likely produced around 1913–14, about four to five years earlier than the comic strip. It therefore seems plausible that these images may have functioned either indirectly as sources of inspiration or more directly as studies for the creation of the characters and themes of the cartoons.

Rosendahl emphasized that the comic-strip characters should not be regarded as anything but products of his own imagination.[7] That they were not intended as portraits or caricatures of certain individuals from real life was expressed in a little poem he wrote about Ola and Per:

> There are two older fellows,
> Whom I hold very dear;
> The name of one is Ola,
> And the other one is Per.
> But whether they are real,
> I certainly can't say,
> I see them just as fantasy,
> A dream by night or day.[8]

In another verse of this poem Rosendahl says something about the intended function of these characters. Through humor, he hopes they will make life easier to bear: "For most of us can see that when everything goes wrong / A little fun and foolishness / Make it easier to get along." The life experiences referred to here are largely taken from the comic-strip creator's own reality as a farmer in Spring Grove. The raw material for the character Per and his toils does appear to be based on Peter Rosendahl's personal life and work. Per's and Peter's common interest in technology has already been mentioned, and, in a self-ironic gesture, Rosendahl even allows his comic-strip alter ego to expand his practical competence through different correspondence courses. According to Georgia Rosendahl, Peter was known as a "mechanical farmer" in Spring Grove—a farmer who wanted to mechanize farmwork instead

of, for example, milking cows, something he simply loathed. It is not difficult to discover other parallel traits in Peter's and Per's lives. Just like Per's brother, Lars, in the comic strip, Peter Rosendahl's own brother Otto was an academic with a PhD and had studied for many years in both America and Europe. Peter Rosendahl, like Per, wore several hats in the local community. He served as a member of the school board, and one of his duties was to appoint new female teachers to the local school. In the comic strip, this duty leads to a comical fit of jealousy acted out by Per's wife, Polla. Peter Rosendahl's own wife, Othelia, had a sister who was married and lived in Fargo. So when individual characters go off for a visit to Fargo, we know this is a trip the Rosendahl family undertook on a regular basis. We also know that he was busy using his camera during these trips.

Despite Rosendahl's insistence that the characters in the comic strip are pure fantasy, it is not difficult to discover physical likenesses between some of the characters and the subjects in Rosendahl's photographs. The character Ola has borrowed features from Peter Rosendahl's father-in-law, Engebret Melbraaten. The Spring Grove pioneer was a highly respected man in the Norwegian-American community. Like Ola, he was known to be a wise, down-to-earth person, someone who would always assist others. In early annals of Spring Grove history, a story is still told about how during a particularly hard winter he had the idea of attaching snowshoes to the horses' hooves in order to transport firewood, food, and other necessities to those who needed them.[9]

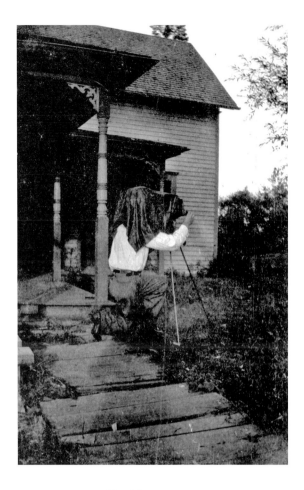

FIGURE 4.5. Peter Julius Rosendahl, self-portrait with camera, Spring Grove, Minnesota, circa 1913–14.

Beyond their capacity as study material for the comic strips, the photographs reflect themes in common with Rosendahl's drawings for *Han Ola og han Per*. They testify to the same kind of fascination with modernity expressed in the comic strip, but without the satiric undertone. Rosendahl has, for example, proudly immortalized the tractor he constructed (Figure 4.6); his family in the new Model T (Figure 4.7); the process of building a modern cistern (Figure 4.8); and a local event out of the ordinary, a plane landing in Spring Grove, surrounded by curious onlookers (Figure 4.9).

FIGURE 4.6. Peter Julius Rosendahl, the photographer's self-built tractor, Spring Grove, Minnesota, circa 1913–14.

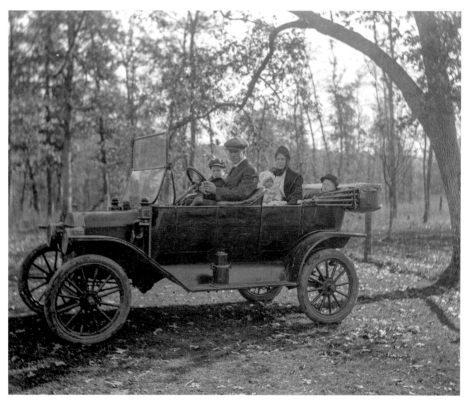

FIGURE 4.7. Peter Julius Rosendahl, the Rosendahl family out driving the new Model T, Spring Grove, Minnesota, circa 1913–14.

FIGURE 4.8. Peter Julius Rosendahl, bricklaying the cistern, Spring Grove, Minnesota, circa 1913–14.

FIGURE 4.9. Peter Julius Rosendahl, airplane landing in Spring Grove, Minnesota, circa 1913–14.

Like the comic strip, the photographs seem to reflect a fundamental respect for and a strong interest in nature and animal life. In one photograph a white foal stares alertly at us from an opening in the woods (Figure 4.10); in another we can contemplate the sight of a woodland bird that, with rustling wings, is about to fly up from the farmyard (Figure 4.11). Also like the comic strip, the photographs reveal their creator's taste for humorous scenes captured in the instant of their occurrence, for example, in the photograph where a man calmly smoking a pipe pushes his laughing wife around the farmyard in a homemade wheelbarrow (Figure 4.12), or where a little girl happily wanders off wearing her father's hat (Figure 4.13), or where a toothless baby smiles happily at the photographer under a hat brim almost as wide as the tub in which she sits (Figure 4.14).

There are also themes in the comic strips that are absent in the photographs, such as the ironic approach to the bicultural and bilingual situation of the characters.

This absence is obviously due to media-specific differences between the cartoon and the photographs. Linguistic irony is not easily expressed in photography, yet the characters' ties to Norwegian language and culture are clearly a satiric main theme in *Han Ola og han Per*, where Rosendahl also makes fun of the modern urge to search for ancestral roots. In one of the comic strips, Per and Ole pull out books to find out where their relatives in Norway came from, and Per points out his grandfather—a big gorilla.[10] The comic strips delivered a political sting during the period in which they were published: in his Norwegian-American series, Rosendahl gave his characters permission to have double national and linguistic identities at a time when a systematic campaign was directed against so-called foreign languages in the United States.[11] A shadow of seriousness is found behind the humor, and a correspondingly serious undertone can also be detected in the photographs; these qualities have political implications. The photographs, however, appear to be primarily private. As a visual diary, they tell the story of a Norwegian-American farmer's life in a little place in the American Midwest at the beginning of the twentieth century.

FIGURE 4.10. Peter Julius Rosendahl, white horse in the forest, Spring Grove, Minnesota, circa 1913–14.

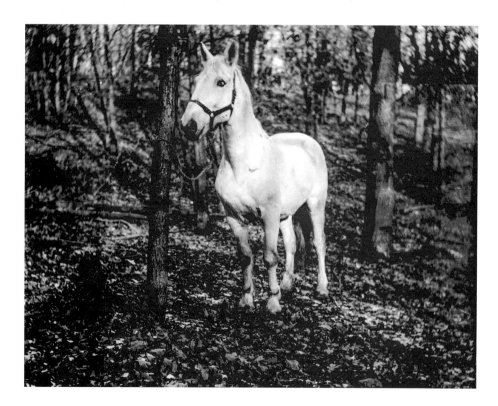

FIGURE 4.11. Peter Julius Rosendahl, woodland bird in the yard at the Rosendahls' farm, Spring Grove, Minnesota, circa 1913–14.

FIGURE 4.12. Peter Julius Rosendahl, married couple in Spring Grove, Minnesota, circa 1913–14.

FIGURE 4.13. Peter Julius Rosendahl, child with large hat, Spring Grove, Minnesota, circa 1913–14.

FIGURE 4.14. Peter Julius Rosendahl, toddler in basin, Spring Grove, Minnesota, circa 1913–14.

A Diary in Snapshots

The photographs could be considered a visual counterpart to Peter Rosendahl's written diaries, which he kept on a more or less regular basis from about 1907 until the early 1930s. His entries from the month of March 1910 are a typical example of the character of these short texts:[12]

> March 1st, 1910—Tuesday—Down to see the old folks.
>
> March 2nd, 1910—Wednesday—Down to see the old folks.
>
> March 3rd, 1910—Thursday—Hauled hay.
>
> March 4th, 1910—Friday—Did not do much of anything in particular.
>
> March 5th, 1910—Saturday—Heard the first robin. Up to see Dr. J. [Dr. Jensen] about Harold Gynther [Rosendahl].
>
> March 6th, 1910—Sunday—At home all day.
>
> March 7th, 1910—Monday—Just loafing around most of the time.
>
> March 8th, 1910—Tuesday—Sawed wood at N. H. N. [Narve H. Narveson].
>
> March 9th, 1910—Wednesday—Sawed wood at O. P. R. [Oliver P. Rosendahl] after dinner.
>
> March 10, 1910—Thursday—Sawed wood at O. P. R. [Oliver P. Rosendahl] before noon. Sawed here at home afternoon.
>
> March 11, 1910—Friday—Finished wood sawing at noon. Started to split wood.
>
> March 12, 1910—Saturday—To town with the whole family.
>
> March 13th, 1910—Sunday—Stayed home with boys. Mrs. down to her pa's, then home and down to ma's, then home again.

In the form of keywords, Rosendahl reports on his daily activities: he hauls hay, chops and saws wood, buys new cows, repairs the henhouse, plows, and takes his son to the local doctor. The diary also testifies to the close social network he was a part of in Spring Grove: work communities, frequent gatherings of family and friends, trips to the city, and his attendance at his mother-in-law's funeral. But the brief notes also show his sensitivity to the "small" and immediate events in nature. He writes, for example, about hearing a robin and seeing the first spring flowers and the first groundhog of the year. Nor is it difficult to sense the humorous undertone in the writing when he refers to the henhouse and the cowshed as the respective headquarters of these animals and his lack of self-importance when on some days he reports that he has done nothing at all: "Just loafing around most of the time."

In this way, Peter Rosendahl's everyday reports are in striking contrast with the thrilling events that were described fifty years earlier in the diaries of his father, first-generation immigrant Paul Rosendahl. In addition to fighting in the American Civil War, Paul Rosendahl served under Henry Sibley in the campaign against the Sioux Indians following the Dakota conflict in mid-1862. During this campaign he wrote in his diary:

> July 24—Battle of Big Hill . . . the most eventfull day of our campaign. Came into Camp at 2 p.m. the Indian Camp 3 miles Distant. Indians on every Hill . . . a parley proposed. Indian killed Doc Wiser at 4 p.m. and Bale Camince imidiately cleared then from the hills and chased them about 10 miles . . . killed about 29, lost 5.

> July 26—Battle of Buffalo Lake . . . traveled about 12 miles . . . and had another scrimage with the Indians . . . they lost 10 or 12 killed and we got one wounded it being a runing Cavalry fight . . . the Indians led on good Poneys.

> August 29—Travelled through tamerock Swamps and over Pine openings . . . passed many Beautiful Norway Pines.[13]

The text, whose orthography bears witness to the writer's unfamiliarity with written English, also illustrates how Paul Rosendahl, like his son Peter, was sensitive to the natural environment. Along the way, for instance, he notices the beautiful pine trees that resemble those he knows back in Norway. But riding through enemy territories, pursuing Indians, and witnessing the resulting lost lives are events of a very different and more dramatic character than the quiet, daily work described by Peter Rosendahl in his diaries. In contrast to his father, he describes a life that is not lonely, roving, and strongly influenced by the conflicts in the larger society but instead rooted in one place, peaceful, and anchored in a close social network.

His photographs also reflect this life. As visual recordings of everyday life, they are quite unlike the formal posed sittings of professional studio photographers. Despite the lack of flexibility of the large-format camera he worked with, Rosendahl has managed to infuse his images with life and dynamism. He gives them a snapshot-like feeling that clarifies and expands the brief entries in his diary. With our own eyes we are able to examine what it actually looked like when the comic-strip farmer filled up the pigs' trough on the farm, closely surrounded by piglets and a black dog wagging its tail in the foreground (Figure 4.15); when his wife, Othelia, fed the chickens or raked leaves in front of the house (Figures 4.16 and 4.17); when the potato field was

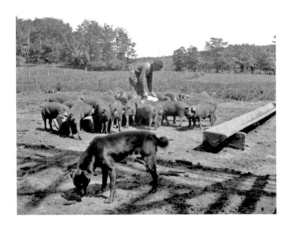

FIGURE 4.15. Peter Julius Rosendahl, feeding small pigs, Spring Grove, Minnesota, circa 1913–14.

FIGURE 4.16. Peter Julius Rosendahl, Othelia Rosendahl feeding the family's chickens, Spring Grove, Minnesota, circa 1913–14.

FIGURE 4.17. Peter Julius Rosendahl, Othelia Rosendahl raking leaves, Spring Grove, Minnesota, circa 1913–14.

FIGURE 4.18. Peter Julius Rosendahl, plowing the field, Spring Grove, Minnesota, circa 1913–14.

FIGURE 4.19. Peter Julius
Rosendahl, cutting wood,
Spring Grove, Minnesota,
circa 1913–14.

FIGURE 4.20. Peter Julius
Rosendahl, winter in
Spring Grove, Minnesota,
circa 1913–14.

plowed (Figure 4.18); when there was work to do sawing timber in the woods (Figure 4.19); or when the farmer had to get through the woods with horse and wagon on a snowy winter's day (Figure 4.20).

"Stayed home with the boys," Rosendahl noted on one page of his diary. Judging by this and other entries, his children were very much present in his daily life. They perhaps play an even bigger role in his photographs. They build "snow ladies" with their father (Figure 4.21) and are present during the plowing, when the foundation for a new house is dug (Figure 4.22), or when the family goes for a walk in the woods (Figure 4.23). They play with the family's animals (Figure 4.24) or try their hand with a hammer and nails (Figure 4.25). The photographs show an unpretentious respect for the child's world. Rosendahl takes children seriously, meeting them where they are and photographing them at eye level (Figure 4.26). He poses with them, as in the portrait of him on a bench in the garden together with his daughter, Gladys—a portrait where both father and daughter, solemnly but also smiling a little, have taken off their summer hats in honor of the photographer (Figure 4.27).

It is tempting to characterize these pictures as family photographs or, rather, as family snapshots, a genre that traditionally is considered predictable and conservative in style. Yet the images of the Rosendahl family appear free of well-rehearsed "photography gestures." Seemingly at ease with the camera and the presence of the photographer, the Rosendahl children let themselves be photographed wherever they happened to be, in the midst of play or work. If, in passing, they glanced briefly at the camera, it is simply to register that "well, here he is again" or to respond to the attention with an ostensibly spontaneous, familiar, big grin.

FIGURE 4.21 (top, left). Peter Julius Rosendahl, "Snow lady," Spring Grove, Minnesota, circa 1913–14.

FIGURE 4.22 (top, right). Peter Julius Rosendahl, excavating a plot, Spring Grove, Minnesota, circa 1913–14.

FIGURE 4.23 (middle, right). Peter Julius Rosendahl, trip to the forest, Spring Grove, Minnesota, circa 1913–14.

FIGURE 4.24 (bottom, left). Peter Julius Rosendahl, small child with dog, Spring Grove, Minnesota, circa 1913–14.

FIGURE 4.25 (bottom, right). Peter Julius Rosendahl, boy with hammer and nails, Spring Grove, Minnesota, circa 1913–14.

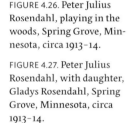

FIGURE 4.26. Peter Julius Rosendahl, playing in the woods, Spring Grove, Minnesota, circa 1913–14.

FIGURE 4.27. Peter Julius Rosendahl, with daughter, Gladys Rosendahl, Spring Grove, Minnesota, circa 1913–14.

Perhaps for that reason it is more fruitful to understand the family snapshot as a kind of photographic everyday language.[14] One of the most compelling characteristics about photography is this ability to show the same thing in an unlimited number of ways. This can also apply to family photographs. We see not only the same individual photographed from different angles and in different circumstances but also the same individual photographed through a long period of time. Like language, the photograph is inscribed in complex interpersonal relationships. Even if family photography operates within a strongly regulated set of social and aesthetic frames, there is still a large potential of expressing individuality within these frames,[15] something that Rosendahl's images clearly show us.

The images also present us with portraits of the places where Peter Rosendahl and his family lived their lives. He apparently never gets tired of photographing his house and farmyard (Figures 4.28 and 4.29). He similarly photographs wide views of the surrounding landscape with fields and groves, sometimes saturated with romantic atmosphere (Figure 4.30). He allows his lens to dwell on a quiet river, capturing the reflections of the riverbank trees, or he zooms affectionately into more intimate fragments of nature, such as branches of mountain ash in full bloom (Figure 4.31) or the tree trunks and hills where the crocuses bloom—the favorite place for family picnics. He shows us the places or the surroundings where the family unit is inscribed into a larger setting: the ski slope in winter, the church, the children's school (Figure 4.32), and the streets of the small town of Spring Grove. We are reminded that these

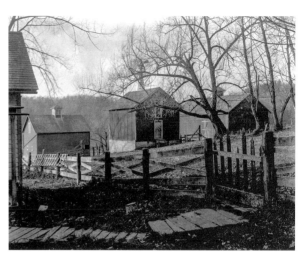

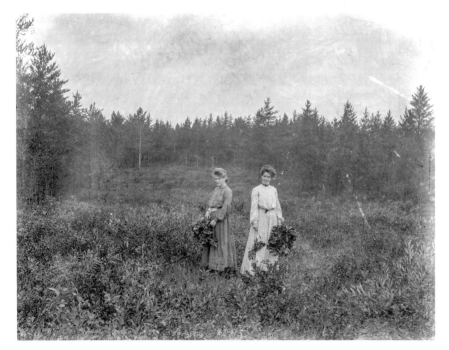

FIGURE 4.28 (above, left). Peter Julius Rosendahl, the Rosendahl family house, Spring Grove, Minnesota, circa 1913–14.

FIGURE 4.29 (above). Peter Julius Rosendahl, the yard at the Rosendahl farm, Spring Grove, Minnesota, circa 1913–14.

FIGURE 4.30. Peter Julius Rosendahl, young women in a forest landscape, Spring Grove, Minnesota, circa 1913–14.

photographs, like all others, bear traces of the photographer as subject. They testify to Peter Rosendahl's existence. Through these images he tells us that he has been here—here in this place he has lived his life.

FIGURE 4.31. Peter Julius Rosendahl, mountain ash in bloom, Spring Grove, Minnesota, circa 1913–14.

FIGURE 4.32. Peter Julius Rosendahl, Melbraaten School, Spring Grove, Minnesota, circa 1913–14.

Place in Words and Images

But what, actually, is a place? Peter Rosendahl answers this question in his literary work, including the poem "Around Spring Grove," published in the *Spring Grove Herald* in March 1926. For him, place creates the possibility of experiencing the world as an ordered universe, a totality. Only through familiarity with a small space are we able to experience the large world, the all-encompassing cosmos. In this way he locates himself inside an understanding of place that also accommodates the idea of place as a protected or enclosed space.[16]

In Rosendahl's poem the enclosure of the place is already indicated in the title, which refers to the ridges surrounding Spring Grove: "ridges which were old even when the world was young." Between these ridges, the place appears as a "Garden of Nature"—"a mystic Fairyland." Fairy-tale perfection appears to reflect a creative force, a larger cosmic order. The landscape is thus understood as an enclosed space, a space within a perfectly ordered world:

Ah, what Genii first conceived it!
And what Master wrought and planned
All this fair and rugged landscape—

Like a mystic Fairyland?
They are beautiful, these ridges,
And the valleys in between,
Just as fair in winter's whiteness
As in summer's radiant green.

For Rosendahl, the landscape is the interior where the simple elements stand in meaningful inner relationship to each other and to the large space. Both places created by nature and by humans contribute to furnishing the landscape.[17] In the poem "A Cabin in the Woods" (1925), he writes suggestively of the small cabin he is going to build in a quiet woods of hazel trees as a retreat from the world and in intimate proximity to "Nature and Nature's God":

I'm going to build the cabin of pounded earth and stone
I'm going to build it simple and build it all alone
And the door shall face the sunset—and I'll let it stand ajar,
So I can see what's going on where the forest creatures are:
And, at dusk, I'll hear the crickets and watch the bat's erratic
 flight,
While the owl shall call off the hours through the stillness of the
 night,
And the winds of night shall lull me as I sit and dream'ly nod.
For I'll be close to Nature and close to Nature's God.

Even though the poems are written after the photographs were taken, it is tempting to draw certain parallels between Rosendahl's poetic use of imagery and the subjects in his photographs. The photographs seem to reflect the same attitudes toward place and nature that are expressed in the poems. He has not only written about but also photographed the simple cabin he is in the process of building. He has photographed it from a distance, as we would first see it when walking through the woods. In the foreground we see sharply detailed leaves and twigs, and in the middle ground is the cabin itself in a small pool of light. Photographs are able in this way to convey both the totality and the details of the landscape. The cabin is snugly enveloped by thick bushes and tall trees, but at the same time it is accessible to the warming rays of the sun, its doors and windows wide open to nature all around (Figure 4.33).

"To create a place is to create a place in a landscape, to find a place is to find a place in a landscape," writes the Norwegian philosopher Anniken Greve. She stresses how

the path to place goes through a landscape—a path one must walk.[18] In Rosendahl's poems and photographs, the path through the woods is a central motif. In "The Forest Trail," a poem from 1927 that was set to music and later published as song lyrics, he describes the path through the woods as the path forward to a place that can give inner peace:

> Down below the dusty highway
> Where the thorny brambles grow,
> There's a quaint and shaded byway
> Where I often love to go.
> There I hie myself when duty
> Leaves me free from such a quest,
> There, 'mid wildwood's charm and beauty
> Is where weary souls find rest.

In many of his photographs Rosendahl takes a close look at the path through the woods. He directs attention toward the sun's flickering play among the thick fern undergrowth that surrounds the path in summer (Figure 4.34). He also shows how it appears in midwinter, with visible tracks from skiers and wagon wheels in

the snow surrounded by thick, snowy trees (Figure 4.35). Like the romantic landscape painters, Rosendahl as a photographer is very attentive to how the interplay between light, clouds, and weather contributes to shaping the character and atmosphere of a place. Poetically, his images document how such changes in weather and season affect Spring Grove. But he also takes a keen interest in the rhythm of human life. Just as respectfully as he captures the child's experience, Rosenthal turns his lens on people in the last stages of life, in old age. He photographs an elderly couple in front of a barn that shows the effects of times past, just as the faces and bodies of his human subjects do (Figure 4.36). Their hair is white, their clothes worn. She supports herself with a cane. He has placed himself slightly protectively one step ahead of her. They are standing there together, stooped and unsteady. They meet the photographer's gaze calmly, seemingly ready for the perspective of eternity that the camera offers—and for yet another day of their life together.

FIGURE 4.34. Peter Julius Rosendahl, the forest path in summer, Spring Grove, Minnesota, circa 1913–14.

FIGURE 4.35. Peter Julius Rosendahl, the forest path in winter, Spring Grove, Minnesota, circa 1913–14.

FIGURE 4.36. Peter Julius Rosendahl, elderly couple, Spring Grove, Minnesota, circa 1913–14.

"The Foreign-Born Farmer" in the Land of Freedom: Rosendahl's Photographs as Political Statements

The photograph of the elderly couple is beautiful, but Rosendahl does not hide the fact that this couple, who are likely first-generation immigrants from Norway, has had an arduous life as farmers in the Midwest. In the poem "Happy Farmer" (1936), he writes ironically about just this image of the farmer's worry-free life:

> The farmer has a happy day,
> So free from care and worry,
> Serenely all his days go by,
> He never needs to hurry,
> Now can you tell me, if you please,
> How some can welter in such ease?
>
> All day behind the plow he plods
> And gladly goes the limit
> To turn and pulverize the clods
> Just for the fun there's in it.
> No matter what the fates may say
> His cheerful soul knows no dismay.

When the poem was written, Rosendahl for many years had been involved in the political struggle to improve the conditions for farmworkers. Around 1917 he contributed satirical drawings to a newspaper called *The Organized Farmer*, and in 1918 he took on the task, without any luck, of selling shares and subscriptions for a new magazine to be published in Norwegian, *Fremtiden* (The future), in Houston County. In the letter of invitation to become a shareholder, *Fremtiden*'s secretary, Sigvart Rødvik, states that the magazine "in relation to politics" will subsidize different organizations that aim to "support the demands of the farmers." One of the organizations that *Fremtiden* supported was the Nonpartisan League, which worked to promote more government control of agricultural-related industries. The initiative to form this organization came from the midwestern farmers who felt exploited by the strong capital interests in control of the railroad, the mills, the banks, and other entities. Peter Rosendahl obviously supported the American farmers' struggle for better living conditions. Among the papers he left behind is a poem by the Canadian poet Edmund Vance Cook; this poem spread throughout the political circles that Rosendahl was

a part of. It ridicules the American dread of
communism and the fear of being associated
with left-wing liberal movements:

> You believe in votes for women? Yah!
> the Bolshevik do.
> And shorter hours? And land reforms?
> They're Bolshevistic, too.
> "The Recall" and other things like that
> are dangerous to seek;
> Don't tell me you believe 'em, or I'll call
> you Bolshevik
> Bols-she-vik! veek, veek!
> A Reformer is a freak!
> But here's a name to stop him, for it's
> like a lightning streak.

FIGURE 4.37. Peter Julius
Rosendahl, immigrant
political commentary,
published in *Fremtiden*,
March 18, 1920.

But along with holding to a platform that was "liberal, democratic, and progressive"
("Of the people, by the people, and for the people"), the short-lived *Fremtiden* was first
and foremost a Norwegian-American publication. Rosendahl was clearly eager to see
the Norwegian-American community preserving its cultural and linguistic identity.
In a drawing published in *Fremtiden* in March 1920 (Figure 4.37), he comments on
the need for such publications directed toward specific ethnic groups in their own
language. The drawing shows new American immigrants from every corner of the
world arriving in their new homeland, a country offering freedom for all and demo-
cratic rule. The bridge leading to American ideals and social life, however, is about to
be destroyed by a fanatic who immediately wants to force the English language on the
newcomers. He does this by breaking up and destroying the only thing that in reality
helps them over the cultural divide: publications that offer necessary information in
the immigrants' own language.

Seen in a broader perspective, Rosendahl's drawing also documents his engage-
ment in the cultural conflict that Jon Gjerde describes as "the rural Midwest's ethno-
cultural evolution process," already mentioned in connection with the review of
Andrew Dahl's photographs from Wisconsin in the 1870s.[19] Dahl's photographs
give insight into how Norwegian immigrants behaved during this process, which
to a great degree was a question of adapting to other ways of thinking and to other
cultural patterns. The pressure of having to adapt to American culture was obviously

still present forty or fifty years later in Minnesota's small towns. One way of making the process of adaptation less strenuous was to search for reunification with people of a similar cultural past—friends and family of the same national background. Rosendahl's native Spring Grove, the first Norwegian settlement in Minnesota, is a typical example of such a colony based on common background, common religious beliefs, and common cultural patterns transported from the old country. As in other Norwegian-American societies, the inhabitants of Spring Grove during Rosendahl's time also fostered an understanding of themselves as having an identity different from the American one.[20] Even though Peter Rosendahl was born in the United States, he could both speak and write Norwegian fluently. He grew up with Norwegian food, such as lutefisk and lefse; he taught his children how to ski; and he worked diligently to allow schoolchildren in Spring Grove to maintain their connection to Norwegian culture, including the language.

At the time his photographs from Spring Grove were taken, Rosendahl's new country was turning into a nation at war. According to Gjerde, these historical conditions led to increasing Americanization in the Midwest. The need to mobilize the country's army and to procure war materiel increased the influence of the government, even on a local level. These centralizing tendencies were ideologically coupled with the Americanization movements. In addition to calling into doubt the patriotism of new Americans, these movements did everything in their power to eliminate "un-American" elements in society, such as groups with undesirable political positions. Further efforts worked to undermine the social influence of immigrants, ethnic institutions, and the use of non-English languages. "There is no need for maintaining a Germany, or a Norway, or any other country in America," the *Minneapolis Tribune* wrote in 1918, as a part of the argument to legally forbid teaching in any language other than English in public schools. Such prohibitions were soon put into effect in many other American states.[21]

Peter Rosendahl's comic strip can be seen as a critical rejoinder to this kind of politics. What his series shows, in humorous fashion, is how a small ethnic group could be both Norwegian and American at the same time—without sending out any subversive political message or in any way representing a threat to the larger society. He shows how this group's members, each in their own way, struggle to master an American identity; the underlying message seems to be that the greater society should leave them in peace to do so (Figure 4.38).

Although the photographs are devoid of such polemical sting, it is tempting to read them in light of the cultural and political context in which the photographer

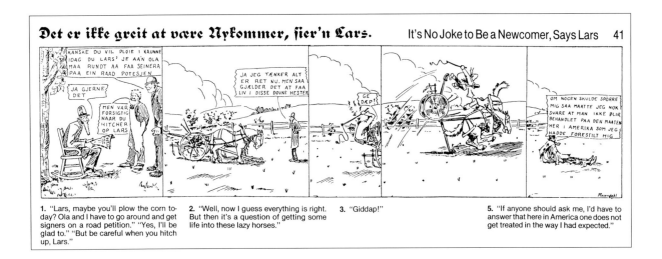

FIGURE 4.38. Peter Julius Rosendahl, "It's No Joke to Be a Newcomer, Says Lars," comic strip from the series *Han Ola og han Per*.

Peter Rosendahl found himself. In these images (which are simultaneously visual diary notes, family snapshots, and a personal art project), he takes us to Spring Grove and shows us the place and the rhythm of nature and life in the close community of family and friends to which he belongs. But through his focus on the experience of continuity in nature and human life, which we encounter in the photograph of Grandpa Melbraaten with his grandaughter on his lap, the photographer also seems to allude to the existential questions posed in many of his poems. Along with its political aspects, this small photograph collection from the Midwest does nothing less than ask the great question of life: "What's the meaning of it all?"

> What intelligence created
> This strange realm we wander
> in?
> When were living things first
> mated?
> How and where did life begin?
> What almighty power is driving
> Ever onward, great and small?
> For what purpose are we
> striving,
> What's the meaning of it all?
>
> —Peter Rosendahl, "The Puzzle of the Ages"

Out of Cupboards and Drawers

America-Photography in Norwegian Rural Communities

She peers, stoop-shouldered and anxious, at the camera lens, the young immigrant girl who, sometime before her departure from Norway at the end of the nineteenth or early twentieth century, found herself in a photography studio in Valle in Setesdal (Figure 5.1). The portrait of her is a head-and-shoulders pose. She is wearing the traditional dress of the Setesdal region, with a high yoke in embroidered wool, a belt, a silver breast pin, and a scarf twined tightly and artfully around her head. After being photographed, she took off the costume, which she surely had worn since she was a small child, and put on modern clothes. This was the usual thing to do in Setesdal before the great journey to America. Once she arrived in Grand Forks, North Dakota, the young girl went to the studio of photographer A. P. Holand to order copies of the picture she had taken before her departure and brought with her on the ocean crossing. He rephotographed the portrait and then fixed it into a cardboard folder printed with the name of his own studio, a common practice among Norwegian-American photographers of the time.

Perhaps the young girl had promised someone at home a portrait to remember her by, someone who was close to her. The oval-shaped, black-and-white photograph was, either in Norway or in America, decorated with a beautiful frame of heavy paper and adorned with die-cut pansies and forget-me-nots in many colors. Someone had carefully made a few holes in the paper and threaded string through

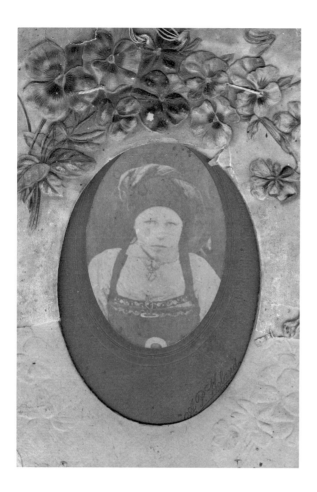

FIGURE 5.1. A. P. Holand, portrait of a young woman from Setesdal, Norway, rephotographed in Grand Forks, North Dakota.

them and then hung the picture on the wall. In this way the young woman's face could still be present, despite the distance and separation. Her portrait and its framing are a reminder that photographs are not only for viewing but also something that can be held and touched. This physical and tactile experience of the photograph as a three-dimensional object is, as Elizabeth Edwards has formulated, what also makes it suitable to be lovingly touched, hung on the wall, put under the pillow, or cried over.[1]

Today the young girl's photograph is faded. The same is true of the fine frame with the pansies; the fragments of string are yellowed and dirty. The portrait no longer hangs on the wall in the house of those who knew her. Along with other photographs and some photo albums, it was saved from the house in Setesdal when it stood derelict, around a hundred years after the girl sent her portrait home. There is no longer anyone who remembers her name or the story of her life in America. "In a photograph a person's history is buried as if under a layer of snow," wrote Siegfried Kracauer in his article on photography from 1927.[2] This short article continues to be of interest, not least because in it Kracauer discusses the relationship between photography and memory.

Kracauer compares two photographs: a contemporary movie star portrait he found in an illustrated magazine and an older photograph, a sixty-year-old portrait of his own grandmother as a young woman. He discovers that the experience of the present-day photograph of the young movie star necessarily converges with the certainty that she is a living being of flesh and blood. In this way the image is different from the older photograph. The young woman here no longer exists. Likewise, there are no longer any memories to attach to the picture of the young emigrant woman from Setesdal. For such reasons, according to Kracauer, the viewer's attention slips past this unknown face and is instead drawn to the details, "the outer decoration," and particularly to the old-fashioned look of the costume itself.

Thus, Kracauer argues that photography will come up short in comparison to memory, which is subjective and arbitrary. Memories are grounded in a simplistic, overarching principle: We remember what "means something to us." Photography, on the other hand, freezes what is depicted at a fixed point in time and in this way also dislodges it or alienates it from its own time. The only method of bringing it to life again is through memory. Without the help of memories, the photograph becomes, like the image of Kracauer's grandmother, something unsettling, something ghostly.

But is it true that all memories are involuntarily lost? Aren't there still reminiscences, oral and written stories, that can give images renewed life and thus open them up to new experiences of history? Such ideas are expressed in Kracauer's later scholarship.[3] Here he abandons his earlier negative evaluation of photography compared to memory and, instead, proposes a theory that photography, by interaction with memory, can give a more complete understanding of a previous time—of history.

When Kracauer writes about the picture of his grandmother, it is to speak of personal, subjective memories and recollections. The picture functions differently for relatives (Kracauer's parents), who have personal recollections of her, than for later generations, who do not have them and for that reason only see the clothing, the ghost. It is true of course that "memories," conveyed orally or in writing, can give the images life for observers who are not involved. But then we speak of other types of memories, namely, of representations of "externalized" personal memories, which after a while become formalized and polished into anecdotes when they are told often enough. Such "intersubjective" representations of memories, which are read, heard, and interpreted by someone who does not have a direct, personal relationship to the subject of the photograph, can likely never "bring it to life again." Yet, they can still contribute to a form of anchoring the picture's information and in that way lead to new experiences of history.

It is precisely the encounter between this type of "communicated" or textually represented memories and photographs that is at the center of this chapter and the next one. I visited two Norwegian rural communities—the inland community of Valle in Setesdal and some coastal communities in Jæren, near Stavanger—to research what kinds of visual traces can be discovered from the immigration to America and what kinds of oral and written memory material can be tied to the America-photographs. The material presented is both the sort found in museums and archives and the sort found in private homes in cupboards and drawers.

"After a while it was almost like we knew them": Photography and Recollection in Setesdal

One of those who have seen the value of taking care of the visual and oral memories of the emigrants from Setesdal is Ingebjørg Vegestog Homme (born 1930). For nearly forty years she has systematically collected photographs, among them many from America and from her local community, Valle. She has worked to identify the individuals in the pictures and to reconstruct their life stories where possible. Vegestog Homme was the one who saved the photograph of the young Setesdal girl from the collapsing old house. The man who once owned the house had many relatives in America. In that way, he was hardly alone in Setesdal—emigration from this area was unusually high.

There are several reasons for this. In the local Valle history volume *Kultursoge* (Culture history), we can read, for example, that the population of the community grew quickly in the first decades of the nineteenth century.[4] Up until 1840 the community managed to make space for those born there, but there were limits to how many small parcels the large farms could be divided into and to how little a person could make as a smallholder (*husmann*). Nor was it easy to find work in other places. It is not unreasonable to imagine that those from Setesdal who were used to making a living from farming felt a certain resistance to fitting into an urbanized industrial work environment. The thought then of maintaining the traditional connection to their work by emigrating to the midwestern farming districts likely grew more appealing. Emigration was also an escape when crop failures and crises struck the agricultural communities of Setesdal.

The first emigrants from Setesdal left as early as 1843 on the sailing sloop *Aeolus*. Many followed them. Between 1843 and 1865 as many as 423 emigrants traveled from Valle to America. Statistically, Setesdal stands out on a national scale with so many inhabitants emigrating relatively early in the nineteenth century. They can thus be considered what American historians call "pioneers." The authors of *Kultursoge* mention traveling "America-agents" as important actors in this process. Printed circulars with emigration information were distributed widely in the rural communities, and Søndenfjeldske Private Bank steadily announced that American dollars could be "bought and sold." The somewhat more prosperous times of the 1870s probably affected emigration rates, which decreased in this period, but still a full 558 people left between 1881 and 1895. Emigration levels declined again toward the turn of the

century, and it was only in the years between 1901 and 1905 that the number of emigrants averaged more than twenty people a year.

In America, the emigrants from Setesdal settled first in Wisconsin before later migrating westward to Minnesota and then to North Dakota. People from Setesdal had a good understanding of soil, and along the banks of the Red River they found fertile land several meters deep. In Grand Forks County they established their own settlement, which they called Walle, where they warmly welcomed other emigrants from their home community in Norway. One of them was Eivind Sigurdsson Berg, who arrived in Grand Forks in 1912. No one met him at the station on the day of his arrival, so he and his fellow travelers were left walking the streets, asking if anyone knew Norwegian. The answer came quickly, not just in Norwegian but in the Valle dialect![5] From North Dakota the Red River flows northward to Canada, where during the last wave of emigration after 1900 many from Setesdal chose to live, in the forests around Alberta.

This is the brief, historical framework for the Setesdal emigration. But photographs and other oral and written memory material contribute to making this history come alive. The faces, bodies, and characters step forward, so that the history becomes a collection of stories of individual people's lives in the great transformations associated with emigration.

Farewell Pictures

In the collections of Setesdal Museum we find two small group portraits in "visiting card" format, which are perhaps the earliest photographic portraits of Norwegian-American emigrants before departure that have been discovered (Figures 5.2 and 5.3). The portraits show us the married couple Gyro Knutsdotter Kvasaker (born 1833) and Olav Gjermundsson Homme (born 1829), with four sons, the oldest around ten years old and the youngest around two years old. The family emigrated from Setesdal in 1867, but just before sailing from Stavanger they paid a visit to the photographer Dorothea Arentz, who had a studio in Hetlandsgaten in the port town. There they were photographed in their traditional clothing, perhaps for the first and last time, before they boarded the America-boat. The pose is simple and straightforward. The female photographer has chosen to photograph her subjects frontally and at full height. In the group photograph the family members are standing side by side. In the

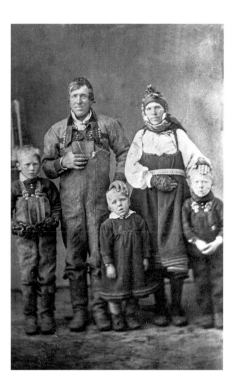
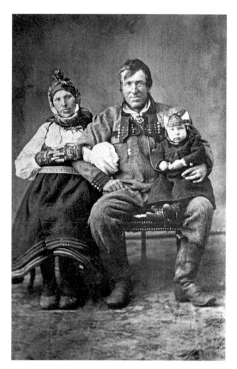

other, the family group only consists of mother and father and the smallest child. Gyro sits next to her husband, her arm through his, her fingers linked together in front of her. The child, who perhaps was too restless to be included in the first take, is here placed securely on his father's knee.

The background is neutral. We see only a hint of the studio's slanted wall in the one photograph and some props far to the left; the foreground is slightly unfocused. For that reason, the figures and not least their clothing, with all its decorative details, fill the picture frame and catch the eye. We let ourselves, as Kracauer describes it, be fascinated by the old-fashioned style of the costumes and shoes, in this case rough leather boots and simple wooden clogs (strangely out of place on the photographer's carpet); the mother's intricately wound head scarf; the extravagantly embroidered wool gloves; the shiny buttons; the silver buckles on the suspenders of the high trousers; and the heavy woolen fabrics. But most striking about the photograph are the expressions of the faces and their uncertain gestures. The portrait reminds us that this couple was in fact born before the invention of photography had arrived in Norway—and that they were likely unfamiliar with this new picture technology. They have not

yet learned to pose in line with the conventions and with the formal distance that we normally find in such early portrait photographs. The father is alert and in a festive mood; he smiles at the camera with a twinkle in his eye. The mother is reserved, serious, her body posture stiff. And the small boys cannot manage to hide their anxiety in the new surroundings. Possibly they suspect that the visit to the photographer is only the introduction to the great changes that will soon enter the family's life.

Were the expectations of a better life in America met? If we consult the local history source, we immediately get an impression of how arduous the long journey must have been for this family. After seven weeks at sea, their ship anchored in Quebec. The family had to travel farther by train to Buffalo, New York, where they took passage on a boat over Lake Erie. From there by ox wagon they went to Dubuque, Iowa, and then continued farther by boat up the Mississippi River to Lamville, Minnesota. There they were met by Olav's brother (also named Olav) and by other people from Valle. This same short account also gives some insight into the difficult conditions that met this family after they settled down. They remained in Fillmore County barely one year before they headed farther north with five other households. Finally, the family established itself permanently near the Yellow Medicine River, where initially they lived in a dugout dwelling. Here Gyro gave birth to twins. These children are not counted in the American census of 1880, however. Perhaps the Hommes lost these twins. Later the family grew with the addition of two girls and a boy. The large family also faced a series of difficult tests at the hands of nature: a forest fire, destructive grasshopper swarms, and harsh winter storms.[6]

The archives of Setesdal Museum call attention also to the positive mark the family made on the local community. Here we find, for example, a visiting card inset with a portrait photograph and the words: "I respectfully solicit your support." This is a small piece of election publicity from 1908, the year that Gyro and Olav's eldest son, Gjermund O. Homme, stood for election for sheriff in Yellow Medicine County (Figure 5.4). Sent home to Setesdal, the pictures and stories of the Homme family and other emigrants from Setesdal created intimacy despite the distance and the passage of time. In addition, they could demonstrate that spending a few years of childhood in a dugout did not necessarily hinder one's success in life. The pictures were constantly brought out for new and ongoing

FIGURE 5.4. Portrait of Gjermund O. Homme, election advertising for Gjermund's run for sheriff in Yellow Medicine County, Minnesota, 1908.

PRIMARY ELECTION, SEPT. 15, 1908

G. O. HOMME

REPUBLICAN CANDIDATE FOR
SHERIFF
OF YELLOW MEDICINE COUNTY

I RESPECTFULLY SOLICIT YOUR SUPPORT

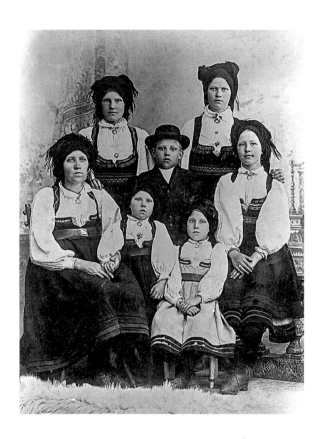

FIGURE 5.5. Sigrid Ånundsdatter Berg and her six children, Valle in Setesdal, 1904. All died during the crossing to the United States when the *S.S. Norge* was wrecked in 1904.

contemplation and reminiscences among relatives and local community members, as expressed by Ingebjørg Vegestog Homme: "After a while it was almost like we knew them."

Close to forty years after Gyro, Olav, and their four sons were photographed, another Setesdal family wearing traditional clothing visited the photographer's studio just before boarding their ship to America (Figure 5.5). Their family photograph shows Sigrid Ånundsdatter Berg and her six children, a son and five girls, the eldest an adolescent. Sigrid's husband and the children's father, Torleiv L. Berg, had emigrated some years before, followed by the two oldest children from his first marriage. Now the whole family would be reunited in America. The faces of the oldest girls express excited expectation, but their mother's face indicates another mood. She seems calm, distant, and perhaps even strangely hesitant. The reunion never took place. The ship that Sigrid and the six youngest children sailed on, the *S.S. Norge,* sank off the uninhabited granite island of Rockall in the North Atlantic on June 4, 1904. The family was among the 582 passengers who died in the disaster. People in Setesdal still talk about the dream Sigrid had the night before she left home—when she saw seven coffins floating on the sea.

The portrait of Sigrid and her children before departure remains as a wistful reminder of something Roland Barthes has called attention to as the characteristic element of photography.[7] Each photograph will in the last instance function as magic and intimate proof of something absent—it points toward death and toward the fact that we all will die. But it must be added that photographs also speak of the lived life—and of what moments and situations in people's lives are found worthy of preserving. The photographer can thus be seen as a kind of master of ceremonies. Many people marked the occasion of departing home and making an ocean passage to a new life precisely by allowing themselves to be photographed in their Setesdal clothing just before departure, like the Homme and Berg families.

But not everyone was pleased with his or her farewell photographs. Tarald G. Bø had his picture taken just before his departure by a photographer in Kristiansand.

FIGURE 5.6. Ånund O. Nomeland photographed in Setesdal before his departure to the United States, 1909.

FIGURE 5.7. Ånund O. Nomeland in American uniform, 1914–18.

The day before he boarded the America-boat in 1892, he sent his portrait home to his stepfather, Gunder T. Strømme, with the following laconic comment: "Well, here's my portrait. You can have two copies if you want them, unless you want to burn them. I am not happy about sending them, as he [the photographer] made me gape."[8]

In the new world, modern American fashions awaited. One who emphasized this transition photographically was Ånund O. Nomeland. In a photograph taken before his departure in 1909 we see him sitting, filled with serious purpose, wearing traditional dress with a chalk-white shirt collar, silver at the opening by the throat, and shiny buttons on his breast (Figure 5.6). Behind him is a richly ornamented large shape, perhaps the tall back of a magnificent chair. The young man, who sits as if on a throne, has literally assumed the place of honor in departing from the rural community and culture he has grown up in. In great contrast is a later photograph of him, taken with a comrade when he was a soldier during World War I (Figure 5.7). As far as Ånund was concerned, the Americanization process went quickly. He wears an American uniform, his hair is cut close in military style, and he writes burning love letters in English to an unknown girl and signs them "Andy." On the outside he is no longer Ånund from Valle.

Kjenner de meg her!

In letters and visual material found in Setesdal, many emigrants in America comment on the big changes in wearing something besides the heavy wool clothing worn in Norway. "Do you recognize me here?" a young man writes under a photograph in which he poses in a new suit, his hat aslant, in front of an American car (Figure 5.8).[9]

Few photographs can be found showing how the departure from Setesdal took place, but the Helle family was paying attention when Svein H. Helle was about to leave for America in 1914. They made sure that Svein's great-uncle, Knut J. Helle, was summoned as photographer when they said their farewells on a cold winter day (Figure 5.9). The picture is taken outdoors. The ground is snowy, and in the background we glimpse heavily forested steep slopes. The horse and sled with driver await. Svein and his father shake hands in goodbye, and the other family members stand devoutly and quietly in a row next to the side of the house. The driver is ready to go. The horse moves impatiently. Soon the moment is over and the journey begun.

FIGURE 5.8. "Do you recognize me here?" Photograph of a Setesdal man with a new blue suit in front of an American car.

The beginning of the journey could also be marked in other ways than photographically. In the vicinity of Valle, a sort of informal emigrant ledger circulated, a book where, one after another, people wrote down their names and travel plans (Figure 5.10): "Tomorrow I intend to travel to America," wrote Halvor Olsson Nomeland, brother to Ånund Nomeland, in 1903. "Will be out at sea April 3 on the steamship *Hektor*," wrote another. And on February 28, 1905, Halvor's younger brother, Eirik Olsson Nomeland, took pen and ink and made the following addition: "I plan to go to America this coming week and on March 10 I will be at sea."

Eirik Nomeland did set off by sea and spent many years in America. But like other emigrants from Setesdal, he could not forget his home village and returned to settle down in Valle in 1932. By then the smallholder's son had saved up enough money to buy his own farm. In Valle's local history book, Eirik is mentioned as an example of

one of the few from Setesdal who commuted between Norway and America. He traveled back and forth three full times and during these visits managed to find himself a wife in his home village and have two children. The photographs that were taken of him in America and successively mailed home to his wife, Valborg, and their children, who stayed in Setesdal, remain in the family's possession.

Relatively sparse comments accompany the photographs to sketch in the story of Nomeland's years in America. We can study him from the time he poses, newly arrived, with slicked hair and a new blue suit (Figure 5.11). We see him in the work gangs he was a part of as a young man in Washington State and notice that he has drawn an X on one of the photographs, next to his foot, probably to be certain that those at home would recognize him (Figures 5.12 and 5.13). We see him in front of the simple hotel that was his home in Everett, Washington, where he worked at a sawmill, and read the writing on the back of the photograph (Figure 5.14): "On the other side you see me on the veranda. I have lived here at the Hotel Nordal 13½ years altogether. My room is on the second floor, where the window is open. I eat down in the dining room first floor. You probably won't recognize me." We see him as he poses, well dressed with a hat and a flower in his buttonhole, with both a relaxed

and a determined look on his face, after an obvious advancement in his working life (Figure 5.15). On his chest he wears a bright sheriff's star, and in his hand is an equally shining bright pistol. His descendants say he was a "watchman" in America. In the last picture we see him newly married with his young, beautiful, blond bride in her Setesdal dress (Figure 5.16).

We perceive that an exciting story lies in these images, but their history remains sketchy, due to scarce contextual information. The same applies to many of the other preserved photographs from Setesdal. They give the impression of "containing more" but are reduced or simplified in one way or another to illustrations. We see only the outer details, quite simply because the historical framing does not allow for reconstruction.

FIGURE 5.10. "Tomorrow I intend to travel to America." An informal emigrant ledger from Setesdal, in which friends and family have written their names before departing to America, 1900s.

FIGURE 5.11. Eirik O. Nomeland after his arrival in the United States, 1905.

FIGURE 5.12. Eirik O. Nomeland (first row, right) with coworkers in Washington State, circa 1905–10.

FIGURE 5.13. Eirik O. Nomeland (far left) during a pause in work, circa 1905–10.

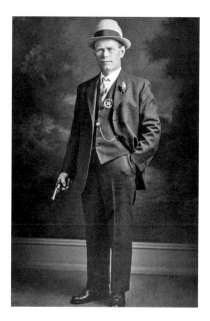

FIGURE 5.14. Eirik O. Nomeland in front of the hotel where he lived in Everett, Washington. The photograph was sent home to Setesdal in 1929.

FIGURE 5.15. Eirik O. Nomeland with sheriff's star on his chest, circa 1920.

FIGURE 5.16. Eirik and Valborg Nomeland, circa 1918.

"How it looked when I left"

When twelve-year-old Torbjørg Taraldsen Uppstad traveled to America with her family in 1928, she sent a friend back home in Setesdal a postcard with a photograph by Anders Beer Wilse of an America-boat departing from Oslo (Figure 5.17). This is an example of the many industrially produced pictures that were sent home starting in the 1890s. Such images could be as stereotypical in character and composition as the traditional studio photographs. Torbjørg's picture postcard exemplifies the typical representation of the departure: the quay in the foreground is crowded with people, and the ship looms large and striking in the midst of smaller boats escorting it in the harbor. Torbjørg not only has made a cross on the outside of the ship where her cabin is located but also with large, childlike script has written a greeting on the photograph: "How it looked when I left from Oslo. Greetings, Torbjørg." After arriving safely in the port of New York, she sent another friend in Setesdal a gilded, hand-colored postcard photograph of the Statue of Liberty (Figure 5.18). The handwriting on the front emphasizes that she had actually seen this monument with her own eyes: "Here you see the Statue of Liberty in Nyork. Here there is much to see! I saw this every evening during the 13 days I was on Ellis Island."

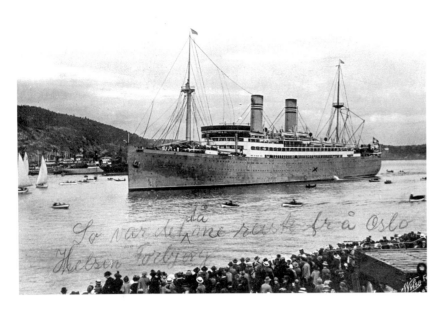

The crossing of and encounter with the great ocean undoubtedly made an impression on people from the inland community of Setesdal. Gyro E. Haugland, who traveled to America at the end of the 1920s, wanted a photograph of this powerful view. She sent home a remarkable, knife-sharp image taken from the ship deck one gray day as a ray of sun streamed in from the right (Figure 5.19). The light is reflected in the wet, dark deck planks and in the white-painted sides of the ship that reach diagonally across the surface of the photograph. In the upper right corner we see a lifeboat. But our gaze is pulled involuntarily from the ship's railing up toward the foaming wave crests, which are as high as the deck's horizontal line. Visible over them is only gray sky. The photograph offers us the experience of being there ourselves, unsteadily on deck, in the rocking waves, with saltwater and sea air in our faces. We might wonder how the photographer managed to reproduce the subject so sharply when the sea was so violent. "Here is a picture from the trip so you can see what an ugly sea we had," Gyro comments on the back of the photograph. But she also reports on quite opposite experiences. "Have had a fine trip here onboard. Very good food and many nice people. No bad weather at sea," she wrote on the back of a postcard sent home to her sister in Valle (Figure 5.20). The postcard shows a grand dining hall in tourist class in the fashionable art deco style, with discreet lighting, stiff white tablecloths, and flowers on the tables. And, of course, she marks her own place in the dining hall, at left: "I'm sitting where the cross is."

FIGURE 5.17. Anders Beer Wilse, postcard photograph of the America-boat departing. When twelve-year-old Torbjørg Uppstad traveled to the United States in 1928, she sent this postcard home to a friend in Setesdal.

FIGURE 5.18. Irving Underhill, hand-tinted photographic postcard of the Statue of Liberty. Sent to Norway from an immigrant from Setesdal. Inscription: "Here you see the Statue of Liberty in Nyork."

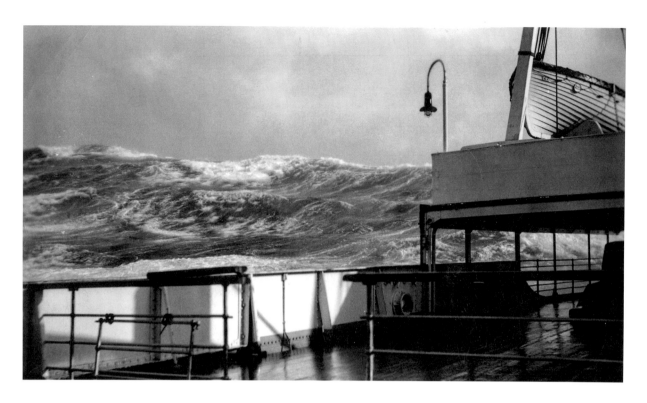

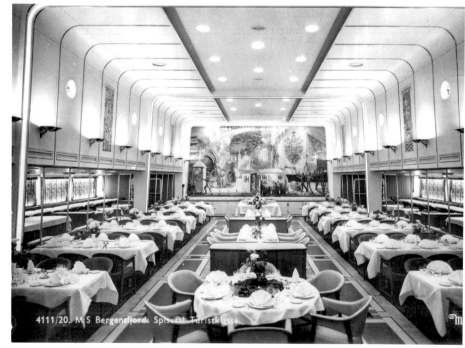

FIGURE 5.19. Photograph taken on the deck of a ship to the United States, 1920s.

FIGURE 5.20. Postcard photograph, *M/S Bergensfjord*, dining room, tourist class. Gyro E. Haugland from Setesdal sent the postcard home to her sister in Setesdal, 1920s.

Bragging Pictures

Gyro had learned to be a cook in Kristiansand and worked periodically in America for well-off families in New York. The remaining photographs she sent home give insight into a reality quite different from the one that met the majority of people who emigrated from Setesdal. In one of these photographs we see her sitting with a lapdog in a cane chair with an extravagantly large curved back, in front of the door to a fine home, likely the residence of her employers (Figure 5.21). She poses happily, wearing an elegant, flowing silk dress and with short, waved hair in the style of the 1920s. In another picture she smiles enthusiastically at the photographer from the front seat of a luxury car (Figure 5.22). Her relatives in Norway learned that she was working for the Rockefeller family, who owned the car, which Gyro was allowed to test-drive. The message was clear: life could also be like this in America.

These "bragging pictures" were sent home in great numbers. Another example is the photograph that Knut Pålsson Rysstad, who emigrated along with four of his brothers in 1910, sent to his remaining sister in Setesdal (Figure 5.23). Big brother allows himself to be depicted at the wheel of a nice American car in front of the brothers'

FIGURE 5.21. Gyro E. Haugland from Setesdal, who worked as a cook for the Rockefeller family in the United States, 1920s.

FIGURE 5.22. Gyro E. Haugland posing in the Rockefeller family's car, 1920s.

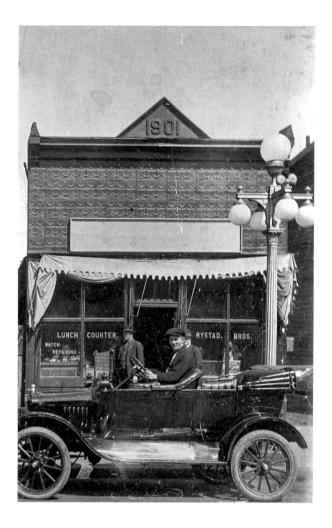

business in Grand Forks, North Dakota. "Rystad Bros.," "Lunch Counter," and "Watch Repairing" stand in large letters in the front windows of the small but well-kept building behind him.

The majority of bragging pictures that reached home were from the many Setesdal emigrants who became farmers in America. There are countless variants of "the family in front of the farm" photographs that usually were sent home from Norwegian-American settler families. One is the image that the photographers Marthinson and Borgen, who came from Reynolds, North Dakota, produced when they visited the farm of Olav K. Kvasaker in the 1890s (Figure 5.24). Judging from the photograph, farmer Kvasaker has done very well for himself. Holding the reins of two white horses, he stands erect on a wagon. Behind him towers an imposing American house with chimneys, columns, and a veranda. His dog sits obediently in front of the wagon. Not far from him is a small lad who plainly represents the next generation of Kvasakers. He is standing there as serious as his father, with his hat well pulled down over his forehead and his hands resolutely behind his back. The photograph is not accompanied by any commentary: it appears to speak for itself.

Gunnar Å. Berg, who settled in Canada, found it necessary to supplement the information in the photograph he sent home with text. In this image we see him in the process of plowing the earth of his new property (Figure 5.25). He holds a span of four powerful workhorses by the reins. In the surrounding landscape, the flat grasslands stretch as far as the eye can see and the sky is overpoweringly big. He is photographed from a low angle, making it seem like he is actually rising up out of the landscape. On the back of the photograph the Norwegian-Canadian farmer supplies viewers with important additional information: "In Canada I don't use a spade to break up the earth as I did at home in Norway, but use four strong horses with the plow."

FIGURE 5.23. Knut Pålsson Rysstad, who emigrated with his brothers in 1910, sent this photograph home to his sister in Setesdal. He poses in front of the family's newly established business, Rystad Brothers Lunch Counter, circa 1910–15.

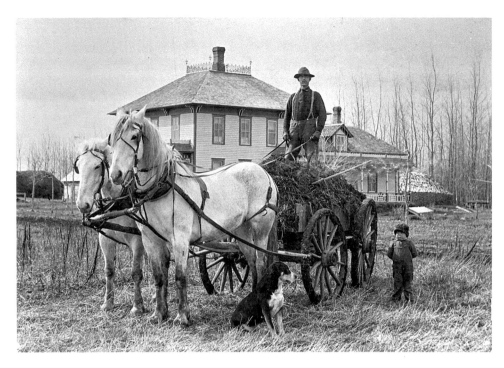

FIGURE 5.24 (left). Marthinson & Borgen, farm of Olav K. Kvasaker, North Dakota, 1910s.

FIGURE 5.25 (below). Gunnar Å. Berg plows the earth on his new property in Canada, 1920–30s. On the back of the photograph he writes: "In Canada I don't use a spade to break up the earth as I did at home in Norway, but use four strong horses with the plow."

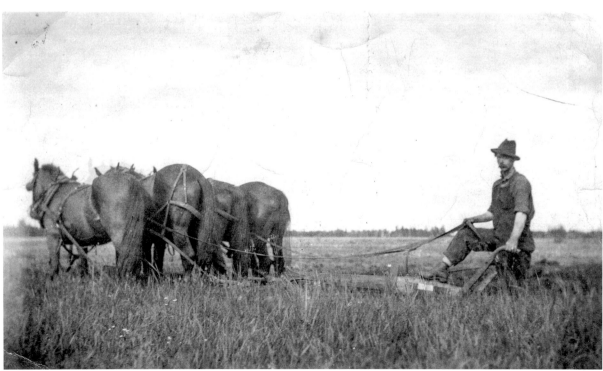

FIGURE 5.26. Knut Å. Rysstad, bear hunting in Alberta, Canada.

Another man from Setesdal who moved to Canada had something else to brag about. Knut Å. Rysstad settled in Hythe, Alberta, and allowed himself to be photographed smiling while logging in one of Canada's deep woods. In his portrait, he is holding a gun in one hand and proudly resting the other on the bear he has just shot (Figure 5.26). In a letter from the logging camp, another immigrant from Setesdal had this to tell: "One thing will perhaps please you to hear: I am doing well in America and here in the forest there is unusually good food. One can get full as a pig when so healthy. I weigh 164 pounds . . . 87 kilos, and at home I weighed 72.5 kilos."

Many of the photographs that were sent home made visible the newly arrived immigrants' encounter with the modernization processes that were taking place in the society around them. The shops where one could purchase lightweight American cotton fabric were naturally a sight worth recording in a photograph (Figure 5.27). And even if the telephone had already come to Valle in 1899, the two friends Gunhild D. Lunden and Ingebjørg Homme chose ten years later to pose at the photographer's studio by a small pedestal table with a telephone apparatus between them. Each with a receiver at the ear, they demonstrate their knowledge of how to use the new and fantastic technology (Figure 5.28).

Streets with electric lighting in the evening must also have been a great experience for new immigrants. "The streets are lit with electric lights, and they shine so bright, it's like being in pale sunshine," wrote Ånund O. Rysstad in a letter dated July 12, 1888.[10] Ten years later Gunnbjørg Rysstad was impressed by the artificial evening light, and in December 1910 she sent home a tinted postcard, an evening scene of the streets of Grand Forks (Figure 5.29). On the card's back she wrote: "Dear Mama: This is Third Street here in Grand Forks. It's nice here. This is in the evening." A large, glowing advertising sign in the middle of the picture with the words "Gas Electric Light & Power" captures the eye. So do the electric streetlights, which seem to compete with the moonlight. The electric lighting casts shadows on those strolling down the streets in such a way that viewers of the image can see it is actually possible to walk the streets of America even after nightfall.

FIGURE 5.27. Setesdal women admiring American cotton fabrics, 1890s.

FIGURE 5.28. Gunhild D. Lunden (left) and Ingebjørg Homme pose with a telephone in the United States, circa 1900–1910.

Third Street, at Night, Grand Forks, N. Dak.

FIGURE 5.29. Tinted color postcard from Grand Forks, North Dakota. Gunnbjørg Rysstad sent the card home to her mother in Setesdal in 1910. On the back she wrote: "Dear Mama: This is Third Street here in Grand Forks. It's nice here. This is in the evening."

"That's how it is in America"

Meeting the new and modern world could also cause conflict. The contrast was great between the culture and traditions from Setesdal that the emigrants had left behind and the culture that met them in the new country. Once in the 1920s, a woman who had emigrated from the Harstad farm in Setesdal expressed her feeling that young people, and in particular her granddaughter Gladys, now had far too much freedom in America. She mailed home a pretty, Hollywood-inspired studio portrait of a young woman with a fashionable bob, plucked eyebrows, and discreetly painted lips, with the caption: "This is Glædis. She was always so obedient and kind. Now that's all gone. That's how it is in America" (Figure 5.30).

Some people from Setesdal also did not think that American music was anything to boast about. They still felt most familiar with the old country's traditional fiddle playing (Figure 5.31). Gunnar Austegård, who lived in New York, had the following to say in a letter he mailed home in 1928, in the midst of the great jazz era:

> I almost never play any more. I have not had the courage to do so, as I have been so low spirited after all the setbacks and misfortunes I have experienced ever since I came here. The American music is ugly as hell, and people here do not understand any of what is truly beautiful. They have of course listened for so long to noise that they are spoilt.[11]

The encounter with the highly rationalized and profit-oriented American work life was also more of a strain than many had imagined beforehand: "The working man isn't worth much here," wrote Gunder T. Strømme in a letter dated October 1894. "For my part I think it is just as good in Norway as it is in America, because our wages are low. We get $1.25 or 5 kroner a day and it is not a lot for everything you need to get along." He concluded bitterly, "No, I don't want to be here any longer. . . . It's no use toiling away here and not having any pleasure like we do in Norway." Other letters speak in a similar way of miserable conditions: "Well, I've been many places since I came to America. First I was in the woods in Minnesota and worked to build a railway. I was there a month, then I went to a steam-driven sawmill, but the work was so hard I cleared out, I didn't want to sell my health for money." This was written by a young man from Northwood, North Dakota, to his sister at home in Norway. He added, "No, it's no heaven here, the way people imagine back home. . . . People are consumed by homesickness and the result is that they take to the bottle to forget the happy times back in the valleys and mountains."

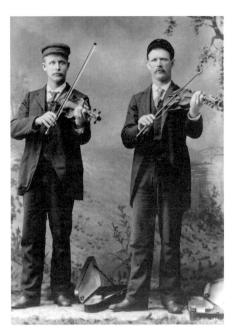

FIGURE 5.30. Photograph of a young woman, granddaughter of a woman who emigrated from Setesdal, 1920s. On the photograph's backside we find this inscription: "This is Glædis. She was always so obedient and kind. Now that's all gone. That's how it is in America."

FIGURE 5.31. Fiddlers Hallvard S. Rysstad and Knut A. Helle photographed in the United States.

The reality described in the letters—exploitation at work, alcohol abuse, and homesickness—is not directly apparent in the photographs. On the contrary, a striking number of photographs show people from Setesdal enjoying a glass in lively camaraderie, frequently with the glass raised in the direction of the photographer. But these seem to have been meant "for show." Rather than presenting realistic visual accounts of the darker sides of immigrant life, they seem to have been produced merely for the purpose of creating reminiscences of dissolute times in good company. An example of such informal "comrade photographs" is an image of three young men who clearly find themselves in a bar or a communal hall (Figure 5.32). They are nicely dressed in suits and slanted hats. Two of them are ceremoniously toasting each other, while the third is smiling and relaxed, sitting with a book open before him. The whole scene appears rather tidy and innocent. The hall where they sit is neither disquieting nor threatening, nor are there any "indecent women" in sight.

Another example of this genre can be found in a highly informal and, technically, quite slovenly produced group portrait from around the turn of the century (Figure 5.33). It represents five lively young men from Setesdal, all wearing costumes. The basis for the costumes is obviously one of the period's popular themes: "The Wild West." Here we see cowboys with pistols in hand, a winter-clad settler with a spade

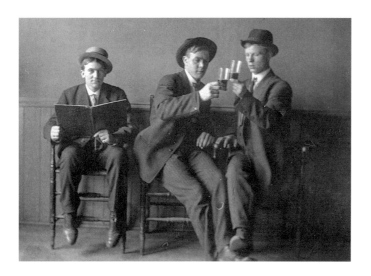

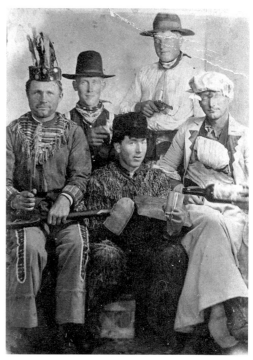

FIGURE 5.32. Three men from Setesdal drink in festive company in the United States.

FIGURE 5.33. "The Wild West" staged by immigrants from Setesdal.

in his lap, a "pioneer woman" with an apron and bonnet, and a feather-decorated blond "Indian" in highly fanciful dress. But the cheerful alertness on the faces of those posing tells us that what we are witnessing is not exactly unlimited debauchery or human misery.

The presence of the "Indian" in the picture is thought provoking. It represents one of the few references to the existence of the American indigenous people in the pictures that were sent home to Setesdal. The Native American is present here, but merely to be laughed at, as a parody or cliché. In this way the indigenous population could still be perceived as comfortably conquered and rendered harmless, entirely in keeping with the traditional narrative of the strong and resourceful immigrants who created new homes in a new land.[12]

Such indirect references to the Native American population can also be detected in other photographs and in the memory material attached to them. When the wedding portrait of the young and pretty Betsy Kjørvestad is displayed in Setesdal (Figure 5.34), the story is told that Betsy, a second-generation immigrant living in the settlement of Walle, North Dakota, "was so afraid of the Indians that she took

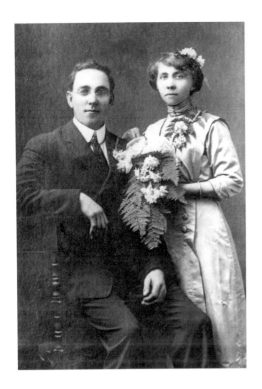

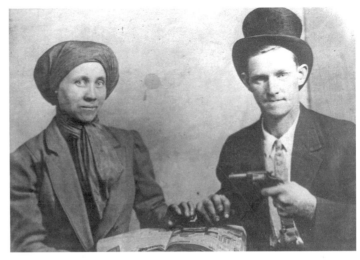

FIGURE 5.34. Wedding portrait of Betsy Kjørvestad, second-generation immigrant living in Walle, North Dakota, circa 1910. In Setesdal it was said that Betsy was so afraid of Native Americans that she carried a gun with her even when fetching water.

FIGURE 5.35. Betsy Kjørvestad photographed with a man holding a pistol, 1910s.

the gun with her, even when fetching water."[13] There may have been good reason for Betsy, born in 1887, to be frightened. She was just a small girl when the battle of Wounded Knee took place in South Dakota; she must have grown up with the older generation's stories of the bloody events, as well as with the experience of their fear. This fear was also expressed in the America-letters sent home from this area, letters that speak of the Indians' brutal murders of white people and of how settlers were allocated rifles by the government to defend themselves.[14] Such atrocities were something that the letter writers had not experienced themselves, but the image of Indians as "worse than wild animals" came to be a fixed part of the immigrant culture in which Betsy Kjørvestad lived. Her security depended on the continued defeat of the local indigenous people. In a later photograph of Betsy as an adult, we see her smiling cautiously at the photographer, in oddly relaxed proximity to a man in a top hat who is pointing a pistol at her (Figure 5.35). Perhaps this photograph was also meant as a kind of parody. Seen in relation to Betsy's own history, it appears nonetheless as a slightly absurd and uncomfortable confrontation with aspects of emigration history that are not always examined in the open.

FIGURE 5.36. Olav G. Haugen from Setesdal and his son Norman visit "Indians' camp," 1930s. The back of the photograph reads: "I took Norman to an Indian camp. An Indian girl proposed to me right away. And I had to eat buffalo meat with them."

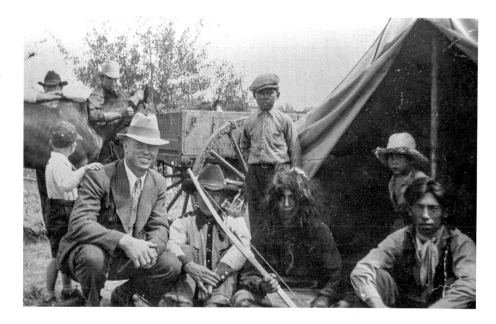

The prerequisite for the modern America where Norwegian immigrants could eventually feel at home was the ability to define indigenous peoples through a mythical past. That is how it appears in a photograph that Olav G. Haugen sent home during the 1930s (Figure 5.36). The tanned and healthy young Norwegian-American represented here is plainly a tourist on an Indian reservation, together with his son Norman. He smiles broadly and self-confidently at the photographer while squatting by the opening to a tent. He is comfortably dressed, with a tie and a light summer hat, posing next to representatives of a tribe, a few young men and boys in western-style clothes; he shows a polite, museum-like, and slightly patronizing interest. The young men's gaze is far more reserved. One of them holds a bow and arrow toward the camera, as a sort of dutiful reminder of something that once was. Olav's little son hangs back in some anxiety, with his hand nervously resting on his father's shoulder. When he sent the photograph to Setesdal, Olav wrote on the backside: "I took Norman to an Indian camp. An Indian girl proposed to me right away. And I had to eat buffalo meat with them."

The photographs thus speak, again indirectly, of the costs associated with the Americanization process—in this case, the costs for the people who were there before the Norwegians and other Europeans settled on the wide prairies. But some images also demonstrate the painful events that befell those who came over the ocean from

Setesdal (Figure 5.37). A photograph of an older woman in black, with her hand resting heavily on a simple grave cross in a military cemetery, makes visible her grief over a lost son. The information that accompanies it tells us that this is Sigrid Tveiten, who lost her son when he served as an American soldier in France during World War I.

Again, as Siegfried Kracauer writes, "In a photograph a person's history is buried as if under a layer of snow." But in cupboards and drawers there are bits of text that allow certain contours to emerge. It does not take much before the thaw sets in: an inscription on the photograph or a few lines in the accompanying letter. Behind the "outer decoration," the person begins to come to life again.

An anecdote with the title "Egg and Bacon" is inextricably tied to a portrait of three smartly dressed young men, photographed in half-profile and shoulder to shoulder in an American studio (Figure 5.38). Their relatives in Setesdal explain:

FIGURE 5.37. Sigrid Tveiten at the grave of her son, who lost his life in service as an American soldier during World War I.

FIGURE 5.38. The Helle brothers from Setesdal, who immigrated to the United States in the second half of the 1920s.

Three brothers from the Mo farm in Helle in Setesdal traveled to America in the last half of the 1920s. Svein H. Helle (1901–1968) left first, and when he came to New York he quickly realized he needed to learn something of the language as fast as possible if he was going to get some food in his belly. So he went into restaurants and listened to what people said when they ordered. Among all sorts of tongue twisters he found the words *egg æn beiken*, and that's what he came to eat over the next month. After that he was so tired of eating this that he traveled further west and eventually arrived in the big city of Detroit. He found work at a factory there and the year afterward he was joined by his brothers, first Jon H. Helle (1903–1974), and later, Knut H. Helle (1911–1961). The picture shows Svein, Jon, and Knut, and was taken just after they all gathered "over there." The three brothers worked in the auto factories the rest of their working lives and are buried in Oakland Hills Memorial Gardens—next to each other—like they are in their portrait.[15]

"THE ONES WHO LEFT": PHOTOGRAPHS AND MEMORIES FROM THE RURAL COMMUNITIES OF JÆREN

The rural communities of Jæren, near Stavanger, have the same sort of rich source material as Setesdal. Some of this material can be found today in the State Archives in Stavanger. This in itself indicates that the connections to "the ones who left" are no longer as close as they once were. The reason for emigration from Jæren was, similar to Setesdal, a lack of work. There was a limit to what degree the small farms could be divided up, and the smallholder system was on its way out. In the second half of the 1800s, infant mortality decreased in Norway, and the number of children in an average family grew larger. But for those living in Jæren, it was easier and more natural to work at sea or to seek work in the coastal fisheries than to set out on the long journey over the ocean. There was no mass emigration from Jæren, even though the number of those who went to the United States and Canada is quite high.[16] There were, for example, many from Time, Gjesdal, and Hå in Jæren; from Bjerkreim and Helleland in Dalane; and from Sirdal in Vest-Agder who went to Montana to work as sheepherders. A large number of people from Jæren also ended up in Minnesota and the Dakotas. Furthermore, a concentration of people from Varhaug district settled in southern Alberta in Canada.[17] Many also returned to their home community after a few years "over there."

If we leaf through old family albums in the State Archives, it is apparent that emigration is present as a silent footprint. An album of visiting cards belonging to the Øvregaard family, for example, is filled with pages and pages of family members photographed in different studios in Stavanger. Judging from the clothing, the oldest sepia-colored photographs are from the 1870s and the most recent ones are from the years around the turn of the century. We can study the father, grandfather, mother, children, and grandchildren throughout different stages of life. But among these images, portraits of relatives who immigrated to Chicago pop up with regularity (Figure 5.39). No one is left who recognizes these travelers to America and their histories. Time has passed, and the direct memories that were attached to the faces have largely vanished. The images have gone from being active agents that release memories and conversational objects in family and friendship circles to becoming passive archival material. They are now available only to those who visit the archive.

But as in Setesdal, there is also in Jæren a wish to reconstruct fragments to create wholeness and connection in the memories. This is manifested in publications like Lisabet Risa's *Pictures from Hå: People and Environment, 1860–1950*.[18] In this volume, photographs of "the ones who left" are strongly present and richly annotated. Risa draws attention to the many farewell photographs that were taken before the departure. People from Jæren, like those from Setesdal, obviously turned the departure into an event that included a ceremonial photography session before they boarded the America-boat. Generally, this session took place in a photography studio in Stavanger and often included those who were merely there to see off the emigrants. In the State Archives, we also discover photographs of some of the many who became sheepherders in Montana, pictures that were clearly sent home. There are also examples of photographs sent in the other direction. One of them is a picture from the funeral procession of an elderly woman from Skretting in Varhaug. Three of her four children settled in the United States and Canada. After she died in 1936, the remaining child in Norway made sure that pictures with the casket from the farmyard and from the entrance to the cemetery were sent to the siblings, who lived on the other side of the Atlantic.[19]

The Scent of Aunt Thea's Album

The wish to hold fast to history is also expressed in private family archives. In such contexts families work, often in collaboration with Norwegian-American relatives,

FIGURE 5.39. Page from the Øvregaard family album featuring photographs taken in Norway and Chicago, 1870s–1900.

to take care of albums, single photographs, and oral or written recollections attached to the family's particular emigration experiences. An example of this is the album left by Thea Tollefsen, or Aunt Thea, as she was called by her family members. Her family was from Nærbø, but Thea was born in Stavanger in 1887. She married and worked for the firm Rogaland Woolens for thirty years. She remained in Norway her whole life, but her brother of around the same age, who had trained as a master tailor, emigrated in 1923. He settled in Madison with his wife, Anna Skaja, from Kristiansand.

Twelve years later, in 1935, Thea went to Wisconsin to visit Tollef—a reunion that clearly was considered worth preserving for posterity. In a hand-colored photograph we can see the middle-aged Thea posing between her brother and sister-in-law in the United States (Figure 5.40). Small and tidy, she is wearing a new flowered summer dress, with a fashionable hat and gloves in her hand. In the background, to the left, we glimpse the shape of a travel trunk. The photograph was later placed in an album that Thea received from a niece in the United States after a second American trip at the end of the 1950s. In this album Thea pasted in not only the fine hand-colored photograph from her first visit but also the photographs that the family in America sent her during the 1950s and 1960s: small amateur color snapshots of her brother Tollef and his wife's great pride: their house and garden. The photograph of a well-kept little white house with blue window shutters has, for example, a clarifying description in ballpoint pen: "Stamford—our home." On the same album page is a portion of the flowering garden with the words "Back yard—Morning Glory" (Figure 5.41).

This is followed by pages that show the couple's modern American kitchen in shining Formica and steel, with flowered wallpaper and separate sections for cooking and dining. Another page shows a photograph of Thea as an older woman; the subtext tells us that this was taken during her "first week in the U.S. in 1961" (Figure 5.42). Thea obviously valued her trips to America, and much of her joy probably lay in returning home to friends and family to show her pictures and talk about the trip.

FIGURE 5.40. Hand-tinted portrait of Thea Tollefsen from Stavanger, who is visiting her brother Tollef and his wife, Anna Skaja, in Madison, Wisconsin, 1935.

FIGURE 5.41. Page from Thea
Tollefsen's album, 1960s.

FIGURE 5.42. Page from Thea
Tollefsen's album, 1960s.

That was when she brought out the album. Today, Thea's great-niece in Stavanger owns the album. She still remembers when it was new, how fantastic it was to leaf through and sense its fragrance—Aunt Thea's album smelled like American chewing gum. Through the album, the memories of Thea and Tollef are kept alive; at the same time it makes visible the dreams of the 1960s and a good life in modern America. When the fragments of memory and the photographs are placed together, the stories about life and longings come more clearly into view: not only of the families' travelers to America but also of those they left behind.

Valetta Ree's America-Photographs

In the collection of photographs left by Valetta Ree, one in particular stands out. It is now faded and almost worn to pieces after being passed from hand to hand through several generations (Figure 5.43). In the foreground on the right we see a family group standing in a row along a little track in the flat landscape of Jæren. The track extends diagonally from right to left past an old stone wall and a potato field, up toward a farmyard with a low house, which is protected from wind and weather by thick walls. By the yard, in the background, we catch sight of a small cluster of people, a family with young children formally dressed for the photographer. Yet the group in the foreground draws most of the attention. There we see Valetta Ree (born 1849) and her family. Foremost in the picture is her husband, Arnt Jensson Ree (born 1847), bearded and legs planted far apart, his hands resting on his hips. Next to him stands the family's youngest, Lisa Taletta, who was born in 1890 and here appears to be around ten years old. The picture was likely taken around 1900. Valetta stands to the girl's right, wearing a simple, black woolen dress typical of the period and with her hair tightly pulled into a knot at her neck. She is holding her arm securely around the shoulder of the small, light-haired girl. To Valetta's right is her smiling eldest daughter, Johanna, who must have been twenty-five when the photographer came to call. Then, arranged in steplike fashion by age, from twenty-something to early teens, are Valetta and Arnt's five sons: Jens, Nils, Lars, Arnt, and Wilhelm. They stand in a row in identical simple wool suits and wool caps. All the family members are present, even the family's sheepdog. The accordion at the feet of their son Jens is there to mark the festive occasion.

We are likely observing a departure photograph. The passenger lists of the ships to America tell us that Valetta had to say farewell to all her sons between 1900 and

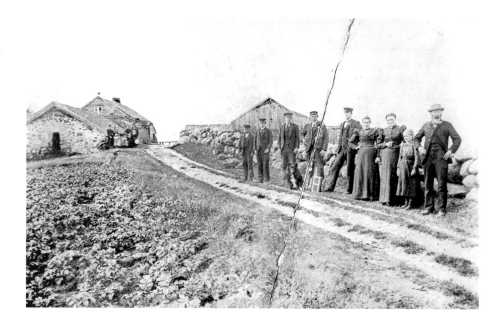

FIGURE 5.43. Henrik Wiig (Sandnes, Norway), the Ree family from Time on Jæren, circa 1900. Five of the sons in this family emigrated to the United States between 1900 and 1905. Only the eldest, the heir, returned home.

1905. The boys knew well enough that this was the last chance to be photographed for posterity with their parents in the place they had grown up. The passenger lists also reveal that they went to Hanley Falls, the same area in Minnesota where many of those from Setesdal turned up. The photograph also provides evidence of a typical feature of emigration from Jæren—that it was primarily the young people who left. From Valetta's large flock of children, only the two daughters did not travel over the ocean. Only the eldest son, the heir to their small farm, returned.

The sense of loss over those who left must have been great. It is therefore not surprising that among the photographs left by Valetta, several family reunions are documented. A studio photograph taken in the United States shows, for example, that Valetta's husband, Arnt, managed to reunite with his sons before he died in 1908 (Figure 5.44). He visited them around 1906, not many years after they had left home. In the photographs we see him with graying beard and hands devoutly in his lap. He is placed in the foreground, surrounded by his young, well-dressed sons—all smiling with wet-combed, center-parted hair. To the right of Arnt sits an old acquaintance from home. It must have been nice to meet familiar faces so far away.

A few years later, in 1914, it was Valetta's turn to visit. According to tradition she also had herself photographed in the neighboring municipality of Nærbø before departure. In her head-and-shoulders portrait, we see she has become an older woman.

FIGURE 5.44. Studio portrait of Arnt Ree (front row, center) visiting his sons in Hanley Falls, Minnesota, 1906.

Her hair is still dark and her features sharp and clean, but around her narrow, serious mouth and eyes, fine wrinkles now appear. By this time Valetta had become a widow and traveled alone. But at her sons' house in Minnesota, care was later taken to mount her departure portrait together with a picture of her husband, which had been cropped from the portrait of him and his sons, so that their descendants could once more enjoy seeing the couple together (Figure 5.45).

Valetta's visit to America lasted longer than she had first expected, for the outbreak of World War I made the return trip impossible. She remained safely in Minnesota during the war years. The photographs she left behind bear witness to her active engagement in the social life of the little colony of people from Jæren in Hanley Falls. In one image, we see her sitting with one of her daughters-in-law and the woman's mother, one of Valetta's many old acquaintances from Time (Figure 5.46). Perhaps the dramatic world events were discussed in such circumstances or perhaps issues lying closer to home, such as who had become the new pastor at home in the Lye pastorate. The letters Valetta later received at home again in Norway suggest that it was just such questions that preoccupied those who had emigrated from Jæren.

The sons also sent home photographs, both of themselves and of their children. From Wilhelm, Valetta received a portrait of two smiling girls close in age, his daughters Violet and Bernice (Figure 5.47). The girls had learned to speak a bit of Norwegian from their father and mother and later in life went to Norway to visit their parents' birthplaces. Nils, who had worked as a painter in Stavanger before he left but became a farmer in Hanley Falls, also sent home pictures of his family. In a snapshot with the inscription "to Grandma" on the back, Valetta could admire his six sons, nicely dressed in front of the family's car and arranged in a row, just like the old departure photograph of their father "Nels" and his brothers from the farm at the Ree home (Figure 5.48). Nils kept up contact with his family in Norway, even after Valetta's death. In one of the last photographs in the Ree family collection, a small amateur snapshot, we see him as an older man visiting Norway. He stands closely surrounded by a smiling group of relatives on the harbor wharf in Stavanger after disembarking from the America-boat (Figure 5.49). They all squint at the photographer. The sun shines on the stones of the wharf, and the shadow of a car falls across the foreground: half a century has passed since Nils was photographed with his parents and siblings before his first great journey to America. Valetta's photographs thus represent a series of farewells and reunions. The collection makes up a typical, rather undramatic history, which many Norwegian families with relatives in America will recognize.

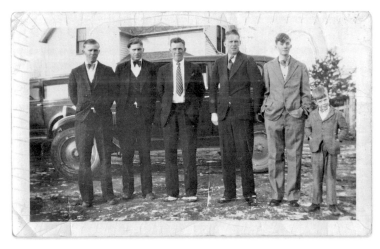

FIGURE 5.46. Valetta Ree (left) with Gustava Pedersen (center) and Gustava's mother, Grethe Maria Lende. Like Valetta, Gustava and Grethe came from Time; they emigrated in 1881 and lived in the Hanley Falls area. Gustava was the mother-in-law of Arnt Ree, Valetta's son.

FIGURE 5.47. Valetta Ree's Norwegian-American grandchildren, sisters Bernice and Violet, 1920s. Valetta received the portrait in Norway from her son Wilhelm in the United States.

FIGURE 5.48. Nils Ree's sons photographed in the United States, circa 1930. From left are Erwin, Newell, Waldo, Arthur, Kermit, and Homer. On the back is written "to Grandmother."

FIGURE 5.49. Ellis Hirman and Nils (Nels) Ree visit relatives in Norway in 1950, together with his daughter Gladys and son-in-law Ellis Hirtman. The picture was taken in Stavanger harbor, just after Nils had stepped off the ship.

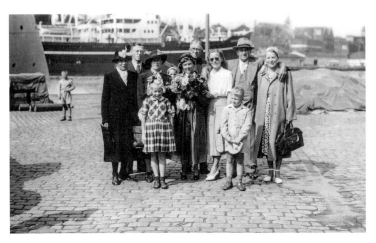

The Story of Regine Gundersen

The eventful and dramatic story attached to the photographs of Regine Gundersen represents an exception to this pattern. It belongs to a family in Jæren. One of her relatives, a seventeen-year-old boy, gathered and preserved her memories when in the 1970s he wrote a school project report about his relatives who emigrated to America. Through his text and the photographs that have been kept in the Norwegian family, Regine (born 1865) appears before us. Much of the information that was the basis for the report came from the boy's grandfather, Palle Gunnerius Haarr, who was Regine's nephew. In a studio portrait taken around 1900 in the photographer Hoffstad's studio in Chicago, we see them together: Regine and Palle from Hå, both young and well dressed, in a typical studio pose in front of an extravagant backdrop with columns and draperies (Figure 5.50). The age difference between aunt and nephew was not very great. The two have obviously known each other well. They lived at that time not far from each other in Kensal, North Dakota, where they each ran a farm. This closeness likely made it possible for Palle to pass on Regine's particular story to the family at home in Norway later in his life, for in 1909 Palle traveled home again to marry and take over a share of the family farm.

The very earliest photograph of Regine (a yellowed visiting card with holes in it, suggesting it once served as wall decoration) shows her as a small girl. We see her standing large eyed and serious beside her mother, Rakel Rasmusdotter, and her oldest sister, Malena (Figure 5.51). Regine was the youngest of ten children, and the Haarr family's existence was far from sorrowless. Several of the siblings died young. One of Regine's brothers drowned as a young boy while working in the herring fishery, and one sister drowned along with nine other young people on the way home from Egersund in 1870. But Regine, who must have been strong-willed, sailed alone to America to make a better future for herself. According to the family, she arrived in 1889. A letter she wrote home from a place outside Chicago one winter day in 1905 suggests she is working as a servant girl. She describes what she received as Christmas presents from her "Missus" and indicates that she wants to send money home to her mother, whom she continues to be concerned about: "Dear Mother I know you are old and need help, I have many times wished that I could help you. I could at least have made up your bed. You are many times in my thoughts." Regine's mother must have highly valued the letter. It was ceremoniously placed in the spine of a beautiful Bible that Regine sent home from Chicago, which is now a treasure in the Haarr family.

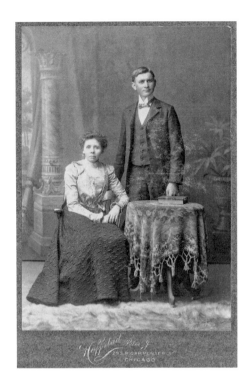

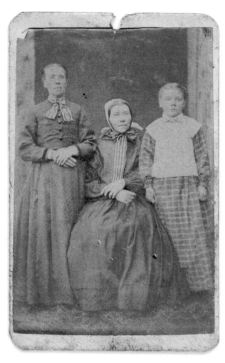

In a photograph taken in Anton Rohde's studio in Chicago, we meet Regine at close range (Figure 5.52). She poses in partial profile with her gaze pensively directed to a place left of the camera. Her face, with slightly heavy, pronounced features, is strong, and we sense that this is a person with will and integrity. Apparently, Regine managed somehow to save up significant means during her first years in the United States, and she did not remain a servant girl in Illinois. In 1906 she had managed to buy a farm in North Dakota. She was at that point in her forties. A few years later she married a somewhat older man from back home in Hå, Jonas Pedersen Efjestad. The photographs she left include what could be their wedding picture (Figure 5.53). It is a studio photograph taken in Jersey City, New Jersey. Perhaps the wedding was performed in this city, for Jonas had a stepdaughter, Inga, who lived there. Regine stands straight next to her husband, and the photographer has ensured that the mature couple's shiny wedding rings are discreetly visible. They pose stiff and solemn in their best clothes. That the relationship between them was remarkable, to put it mildly, is not visible in the photograph. This has later been accounted for by Regine's descendants.

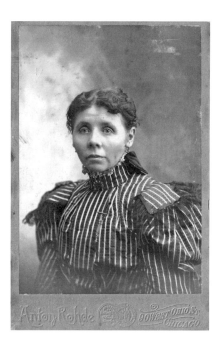

Around a decade earlier, in Norway, the bridegroom had been married to Regine's older sister by thirty years, Anna Pedersdotter Haarr. Jonas left Anna in 1879 when their son was born. He borrowed some money, mortgaged the farm, and disappeared to America. Anna, abandoned with an infant and the little girls from her first marriage, died shortly after from tuberculosis. In the family history, Jonas is described as a powerful, red-headed man with freckles, "a person who was greedy for money and a bully." But according to his Norwegian-American grandson, Regine was nevertheless the stronger half of the relationship. It was she who had "the business brain." Jonas made bad investments and lost money, while Regine made sure to keep their funds away from her husband. She was ambitious, and in 1909 the couple moved from the farm in Kensal, North Dakota, to Spokane, Washington. There Regine bought a hotel, and not long afterward she mailed home a photograph of the building, which (despite being located in Washington) bore the name Dakota Hotel.

Under the photograph of the spacious three-story building, with a typical American false front facing the street and a large sign with the hotel's name along the roof ridge, Regine wrote proudly, "Here is our Hotel." She described it thoroughly to their relatives. The ground floor consisted of the lobby, dining room, kitchen, and living quarters. The second floor had twelve rooms "for rent to men," while the third floor

had an additional three rooms to let out as well as storage space. Meals were served to the lodgers. Regine's hotel was centrally located in the town of Hillyard, which later merged with Spokane. In Hillyard there was a major freight terminal with passengers and a lot of activity, which certainly helped the hotel business. Regine's hotel expanded rapidly; in a later photograph we see the building freshly painted white with an addition on the right. At the front entrance stands the hotel owner along with her husband, Jonas. Regine wears a simple work dress with a white apron and headscarf (Figure 5.54).

The photograph is an exception to the rule, for in most of her portraits she is exceptionally well dressed. Her consistent elegance and generosity made a big impression on younger family members, and memories of both ostrich feathers and lavish gifts have been passed on through family history. Someone on the American side of the family said: "I am telling this from a little girl's point of view. She was pretty with curly hair, always expensively dressed. Ostrich plumes decorated her hats. She was generous and kind. She gave me dolls and new dresses for me right from the store." An enterprising businesswoman, Regine obviously took great pleasure in her new acquisitions and enjoyed going to the photographer to immortalize them. In a photograph taken in a studio on the main street in Hillyard, she posed in

FIGURE 5.55. Royce Studio, portrait of Regine Gundersen in a Persian lamb coat, Hillyard, Washington, circa 1910–12.

FIGURE 5.56. Hakon Johannessen, portrait of Regine Gundersen, Stavanger, Norway, circa 1913–14.

a magnificent full-length fur of an elegant cut and with an equally eye-catching fur hat on her head (Figure 5.55).

Regine's business prospered brilliantly. But her marriage and personal life were not as successful, and the family at home probably was aware of this. Regine traveled several times home to Hå to visit relatives—but always alone. In the last photograph of her, we see her as a white-haired and attractive older woman, dressed in a simple black dress (Figure 5.56). It can be dated to Regine's last journey home around 1913–14, when she also took the time to visit the photographer Hakon Johannessen in Stavanger. A few years later, in 1917, she wrote to say that she had had enough of her husband. Now she wanted to come home to Norway for good. But first, she asked if she could stay with relatives in Idaho. According to family history, the suitcases arrived but Regine did not. It was reported that she had died suddenly of typhoid, but the family gave little credence to that explanation. In the version told by the seventeen-year-old historian, which balances the need for historical objectivity with a strongly personal interest, her death is explained differently:

What was said here in Norway was that she was on her way home. She died in a hotel room in Chicago, and it was claimed that Jonas killed her. My grandfather, Palle Gunnerius Haarr, said he was a scoundrel. When his wife wanted to leave him and go back to Norway with all the money, he wanted to try to stop her. Then when she died he got all her money. He sold the hotel to his son Peder Johan in 1919 and since then no one knows much about him.

The life of Regine Gundersen thus takes on the shape of a novel, with a dramatic, unsolved ending. It is the interaction between photography and recollections conveyed over several generations that draws us into the story. It seems again pertinent to refer to Siegfried Kracauer's thoughts about the relationship between photography and history. He reminds us that the historian has some of the characteristics of the photographer but that historical reality at the same time resembles camera reality. For Kracauer, photography was neither art nor pure documentation: it was both. In the same way, he maintained that the writing of history is neither art nor philosophy nor science, but all simultaneously. Thus, photography was for him a means of reclaiming history's visibility and provided a chance to look at history from many different perspectives. In their interaction with the fragments of recollection, the photographs left by Regine and other immigrants offer the opportunity to see the story not only through their own contemporary eyes but also through the eyes of later generations. The photographs demonstrate what, according to Kracauer, is quite specific to the photographic medium: its potential to pierce through the viewer's introspective experience of memory and history.

SAVED FROM OBLIVION

Photography in the Chronicles of Norwegian-American Families

On a shelf in the archives of Vesterheim, the Norwegian-American museum in Decorah, Iowa, is an old photo album. It is an ordinary album like the ones commercially produced and widely distributed in the last decade of the 1800s, with pockets for inserting cabinet-card photographs. The yellowed cover sheet says that the album belonged to Iver Rockvog. On one of the album's first pages we find what must be a photograph of its owner: a head-and-shoulders portrait of a good-looking young man in his twenties, where someone has written "Iver" along the edge (Figure 6.1).

A search of emigration records and Norwegian population censuses tells us that the album's owner came to the United States from Rakvåg in Møre and Romsdal as a sixteen-year-old in 1885. In the album portrait he seems a few years older. Leafing through the album, we can get a sense of how life turned out for him as a new immigrant. It appears, for example, that Iver in one way or another managed to get an education. Next to a studio photograph, in which he poses with another young man in front of a wintery backdrop, someone has written: "schoolmate Minneapolis, 1892 about" (Figure 6.2).

The album doesn't show only pictures of Iver's schoolmates, friends, and relatives: it also displays his heroes. Among these are photographs of the Norwegian skater Harald Hagen, who was internationally known for his feats on ice. Perhaps Iver was among the many eager spectators when Hagen toured America in the

193

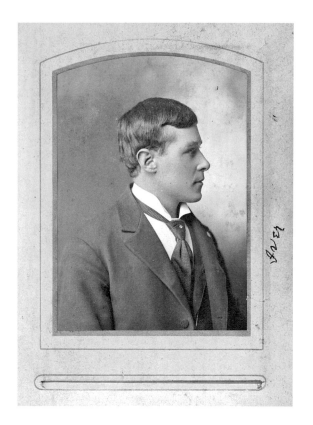

FIGURE 6.1. Portrait of Iver Rockvog, 1890s, from the first page of his photo album.

FIGURE 6.2. Iver Rockvog with a schoolmate from his years in Minneapolis, Minnesota, 1892. From Rockvog's photo album.

mid-1890s. It is not inconceivable that on such an occasion Iver managed to secure a photograph of his idol, a souvenir that he later put into his album. In the album we see the sports hero close up, heavily laden with medals and with a fine moustache twisted at both ends (Figure 6.3). In another studio portrait Hagen is photographed in body tights and wearing his skates in front of a wintery backdrop. With a scarf wrapped extravagantly around his waist, he bends forward in a springy pose—obviously ready for a spin on the ice (Figure 6.4). The album also contains portraits of familiar Norwegian cultural personalities, such as Alexander Kielland and Ole Bull (Figures 6.5 and 6.6). But Iver also had mounted heroes that belonged in the Norwegian-American milieu, including the legendary Knute Nelson, an emigrant from Voss who became a Republican senator (Figure 6.7).

If we look him up in American censuses, we find that Iver Rockvog bought land in Liberty Township, Beltrami County, Minnesota, and died there in 1962. He is listed as divorced in the census of 1930. He lived the rest of his life in solitude, which is per-

haps why his album ended up in the museum's archive. Still, the album is a witness to the young man he once was, the time period he lived in, the people he was close to, what he was interested in, whom he admired, and not least his dual cultural identity. Someone arranged for the preservation of the keepsake of this first-generation immigrant. Many similar albums have had a harsher fate, whether thrown into the trash or auctioned on websites.

Private photo albums have long been a marginalized genre within photo-historiography. The album's photographs have clearly been regarded as less important than photographs exhibited on gallery walls or found in photography books and magazines. Creating an album is an activity associated with the popular and the amateurish and, as such, something that photography scholars apparently have found difficult to take seriously.[1] But we should not forget that albums were the most widely spread format for storage, display, and circulation of photographs in the 1800s and the early 1900s. The lavish albums contained nothing less than the

FIGURE 6.3. Norwegian skating star Harald Hagen, who toured the United States in the mid-1890s. From Iver Rockvog's photo album.

FIGURE 6.4. Skate racer Harald Hagen in a familiar position. From Iver Rockvog's photo album.

FIGURE 6.5. Portrait of the Norwegian author Alexander Kielland, 1890s. From Iver Rockvog's photo album.

FIGURE 6.6. Portrait of the Norwegian violinist and composer Ole Bull, who was also famous in the United States in the late nineteenth century. From Iver Rockvog's photo album.

pictures people valued most. This emotional aspect attached to photographic pictures is still underproblematized in scholarship.[2] It is only natural to ask questions about personal pictures, as highly treasured as they were. How did album photographs create expectations, desires, and pleasures? How were they used to cope with more difficult issues such as grief and loss? And how have they been used in our own time, as an attempt to reclaim history?

Archives and museums in the Midwest contain many examples of Norwegian-American family chronicles created later by descendants of those who once left Norway. These Norwegian-Americans of the second, third, and fourth generations make extensive use of old photographs, loose or fastened to original album pages, in researching their ancestors' history and the family's background in another, distant culture. Their use of photography is clearly connected with a need to redefine or re-establish identity. Such historiographic endeavors thus become journeys in time, and the Norwegian-American historian accordingly plays the part of a foreign traveler.

FIGURE 6.7. Portrait of Knute Nelson, a Norwegian-American from Voss who became a Republican senator. From Iver Rockvog's photo album.

In form and content these immigrant chronicles are of highly variable character. Some appear as purely written content with loose photographs among the pages; other chronicles resemble ordinary family albums, but with more text. There are chronicles that are heavy with materiality—images, texts, and other keepsakes—

closer to the genre of scrapbooks, while new software technology has made it possible to create easily accessible electronic versions. The family chronicles are thus stored in many kinds of archives, both private and public, material and digital. The forms of the archives contribute to shaping the stories that are being created and the way they are communicated.[3] This chapter will examine the contents of such archives through a series of examples. In doing so, it discusses the different ways in which the material is organized and the no less important question of how to make sense of it.

"May God bless every member": The Eken Family Chronicle

In the archives of the old and venerable Wisconsin Historical Society in Madison, we find a worn typewritten manuscript of about ten pages that carries the title "The Ekens."[4] It tells the story of the Eken family, who emigrated from Sogn in 1875, and is signed by the family's historian, Ingeborg Grinde Worringer (born 1909). A photograph of the family is pasted on the manuscript's cover: they are attractively arranged in a photography studio around 1890, with the caption below giving the family members' names and placement in the image. The text, which was written in 1971, is introduced by a description of how the patriarch, carpenter Iver Iverson from Kvalheim in Sogn, decided in 1875 to immigrate to America with his wife and six children. After that comes a description of the miserable conditions during the crossing, seasoned with an anecdote characterizing the father of the family as "proud" and having an unruly temper. The historian also stressed that it was "Father" who, after arriving in America, decided that the family's last name should be changed from Iverson to Eken. Next is the tale of how, after living with other families for several years, they were able to establish their own farm in Wisconsin. The family is said to have grown; in America the Eken couple had four more children, including a pair of twins. There are stories, too, about the grief that struck the family when the youngest son died of diphtheria at the age of eleven and when Mr. and Mrs. Eken died, respectively, in 1901 and 1917.

Attention then shifts to the next generation and the lives of the many Eken children and their descendants in subsequent generations. Here we learn that the eldest son, Thorvald (who became Tom in America), married a woman who also came from Norway. Along with his younger brother Ola, who remained unmarried (though Worringer assures us that he was "mighty popular with the maidens"), he

built up a large farm near Madison. We also learn that the sisters Ingeborg (who in America was called Emma) and Sarah both died early and that their brother Sjur became a grocer, while the younger sister Annie gave birth to as many as ten children.

The story of the twins, Iver and John, is both tragic and moving. According to the manuscript, the brothers were identical in appearance and close throughout their lives. But while Iver married and started a family, John remained a bachelor. In 1907 the brothers and Iver's wife moved west to South Dakota, where they bought land in Lyman County. Not long afterward they were involved in a tragic accident. Both brothers were struck by lightning on the way across the prairie during a violent storm—only Iver survived. He moved back to Wisconsin without his brother.

The account of the Eken siblings also includes the youngest, Olena. She is portrayed as a brave woman who, before her marriage, acquired a separate piece of land in South Dakota, just like her brothers. The author describes how, among other things, Olena fearlessly rode alone across the prairie to collect needed supplies from the nearest town. Unlike her brother Iver, she lived in South Dakota throughout her life. Eventually it becomes clear that the storyteller, Ingeborg Grinde Worringer, is Olena's daughter. Thus, the story is brought forward to the present, the circle is completed—and the chronicle can be concluded: "Now the first chapter of the Eken family closes. Time passes and the family grows and continues to prosper. May God bless every member."

Worringer also handed over photographs related to the Eken family's history to the archive. They are stored in different boxes from her chronicle, separated from the story they are rooted in. They show cross-references to Worringer's chronicle, but they are placed in large, general files either with labels such as "studio portraits of couples and groups of men" and "studio portraits of women" or in surprising and slightly absurd categories like "studio portraits of a man with and without facial hair." The clearly structured and easily accessible text of the family chronicle appears therefore in sharp contrast to the kind of organization that characterizes the Eken family's photographs in the archive, where the question of whether or not the portrait subject has a moustache may determine where a photograph ends up. It is tempting to see this as an expression of the relatively low status of images as historical source material and as another example of the tendency to use photographs exclusively for private sentimental value. The consequence of this lack of thematization of the relationship between text and image is that it is completely left to viewers to establish these relationships on their own.

FIGURE 6.8. Andrew Larsen Dahl, visiting card portrait of Mrs. Eken with the twins, Iver and John, Wisconsin, 1870s.

With Worringer's text as a starting point, we can begin to search for these connections, for bridges between the two different introductions to the Eken family's earlier life. The family portrait on the first page of the chronicle helps us recognize faces and determine identities in the other photos. For example, we find a worn visiting card photograph that carries the signature of Andreas Larsen Dahl, a Wisconsin photographer (Figure 6.8).[5] It is a traditional head-and-shoulders frontal portrait of a woman dressed in black who stares, erect and serious, at the photographer. But the extraordinary thing about the picture is that she sits with two infants, dressed in christening clothes, in her lap. This must be the family's matriarch, Mrs. Eken, with her twins, Iver and John, photographed in the 1870s. A later photograph of a herd of grazing cows (Figure 6.9) takes us to the dairy farm run by the eldest Eken brothers, Tom and Ola. Included is also a photograph of their small horse-drawn milk delivery wagon with a sign reading "Eken Bros. Home Dairy" (Figure 6.10). The wagon is parked in the street by a white-painted house surrounded by leafy trees. In front of the wagon stands a little boy and a man carrying milk cans. We imagine this is Tom, out with his son delivering milk to regular customers. The dairy wagon appears in several photographs. The brothers must have been proud of both the farm and the business.

We also find a photograph that shows the five brothers gathered as adults (Figure 6.11). We recognize the stalwart big brother with the splendid moustache in the middle of the picture—and the twins, exactly alike, who stand behind the three others. The picture must have been taken before the twins traveled west to South Dakota as settlers. Another photograph that shows the family together, with the exception of the twins, was likely taken after the tragic event where John lost his life. In the photograph the mother and father sit with their grown children, the three oldest sons and the three daughters. It is not difficult to imagine that they must have been thinking of the one they had lost as they gathered together. The eldest brother, Tom, has placed his hand consolingly on his father's shoulder (Figure 6.12). Their faces express gravity and reflection.

FIGURE 6.9. Grazing cows at Tom and Ola Eken's dairy in Wisconsin.

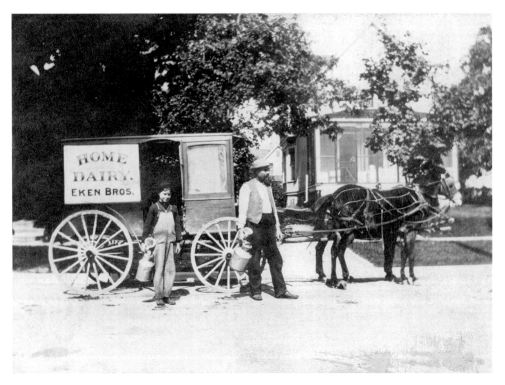

FIGURE 6.10. The Eken brothers' mobile milk store, "Eken Bros. Home Dairy," Wisconsin.

FIGURE 6.11. The five Eken brothers.

The archive boxes include the siblings' wedding photographs, pictures of their homes (including Olena's new house on the South Dakota prairie), and photographs of their children. In one photograph we see a graceful, light-haired girl wearing a white, newly ironed dress with silver buttons, who smiles shyly at the photographer with a finger in her mouth (Figure 6.13). The writing on the back identifies her as the author of the family chronicle, Ingeborg Grinde Worringer, at a young age. We are back again where we started.

With the written narrative chronology in mind, we have involuntarily arranged the photographs according to the same chronology. The structure of the archives has, unintentionally, made us link text and image. Such connections help give flesh and blood to the dry lists of people and facts. The Eken family members gain faces, bodies, and expressions. We are able to study family resemblances, to observe age changes, postures, and moods—something that in itself may be quite entertaining. At the same time, this process reminds us that photographs do not refer only to their original context. Through the discovery of these images we become aware of how photography borrows meaning from several connections: from Worringer's mediation, from the ordering of the archives, and finally from our own context as

contemporary viewers.[6] We also experience the movement that has occurred while engaging with this archive: from the mere desire to reconstruct the past to involuntarily paying more attention to our own role as co-creators of history.

FIGURE 6.12. Portrait of the Eken family without the twins, Iver and John.

FIGURE 6.13. Studio portrait of Ingeborg Grinde Worringer.

Memories of Grandma's Place: The Melstad Family's Chronicle

Around thirty years after Ingeborg Grinde Worringer wrote her family's chronicle, the Norwegian-American Melstad family took a similar initiative to gather and write down their family history. The result, a book titled *Memories of Grandma's Place, Homesteading & Our Families*, was created for the family's members, both Norwegian and Norwegian-American, in 2002. In contrast to Worringer, the Melstad family historians chose to create a chronicle consisting of both text and pictures. The photographic material includes pictures the Norwegian-American branch received from their relatives in Norway; photographs taken by professional American photographers; and some amateur photographs taken by family members during a particular period in the family's history. The photographs, which have been given identifying captions, are spread rather unevenly throughout the presentation.

The book is introduced with a letter from one of the Melstad clan members, Helen Olsen Lundwall, to the rest of the family. In this letter Lundwall, who has edited the history, describes how the family chronicle came to be—as the result of collective writings of personal reminiscences. Family members were asked to write down their memories from Grandma's house, preferably the happy ones, or to pass on family stories that were told in their parents' generation.

This family chronicle has thus become a collection of a relatively large number of shorter texts of different kinds. Some are stories that hold together, while others appear as small sketches or fragments of memory of different family members and different situations. The Melstad chronicle also includes poems, genealogical summaries, a list of "important milestones in Norwegian history," and a collection of the family's recipes. In this way, many voices speak together, which provides a greater textual unity or scope for storytelling. Lundwall also writes about how, in the beginning of the project, she had hoped that the chronicle would be livened up with perhaps a scandal or two or some frightening encounters with Indians. But her efforts on the chronicle strengthened the impression of the family as "hard working, conservative and law abiding citizens." The Melstads also seem to have been a family that took care of each other when necessary.

This chronicle, too, begins with the narrative of the emigration of the grandparents and depicts how Synneva and Johannes Melstad (who became John in America) sailed over the ocean in the 1870s. They had left their home in a small place north of Bergen to settle in America. John actually came first. He arrived in Chicago in 1873, just after the Great Fire. As a carpenter, he found it easy to obtain work in the city. Two years later Synneva arrived and found work as a maid with a well-off family. In 1877 the young couple married, and in 1880 they traveled west to search for land in the Dakota Territory.

This backward look at family history includes sections about Synneva's and John's respective families in Norway. There is a photograph of Synneva's family, taken several years before her departure to America (Figure 6.14). The photograph shows a tightly arranged family group, their whole figures posed frontally. They are all dressed in coarse, traditional wool clothing and fasten their gazes on the photographer. The women in the front are sitting devoutly, hands folded in their laps, while the men and a young girl stand silently and soberly behind them.

The nature of the chronicle's text is not, however, exclusively focused on the past. The present-day connections to the family in Norway are also incorporated by references to the correspondence that has taken place with Norwegian relatives. In

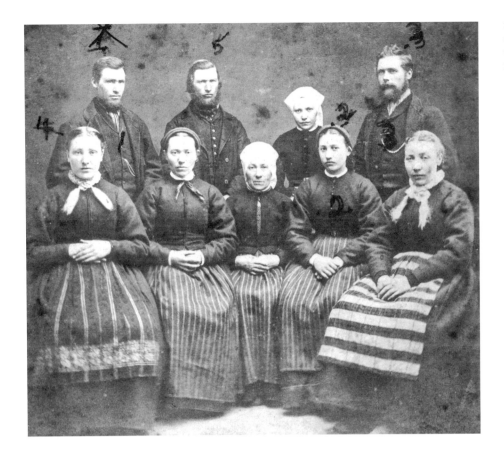

contrast to the Eken family's chronicle, the photographs are here activated in the narrative. When Grandmother Synneva's family photograph is presented, each family member in the image is correspondingly mentioned in the text, along with information about how life turned out for this branch of the family in Norway. One of Synneva's grandchildren, for instance, writes:

> Mother told me a little about her mother's life in Norway. Grandmother Synneva and her sisters had to do heavy labor such as cutting hay on the farm while the men folk hired out to do carpenter work. There were fun times, too, especially at Christmas when they celebrated for two weeks. Grandma said they would scrub the floors until they were white and spread pine boughs about the house. Then they would bake many goodies for the holidays. Happy hours were spent skating and sliding as well.[7]

The photograph enlivens the text, and the text enlivens the photograph. One's imagination wanders and plays with the thought of how it might have looked when the family members in their tight grouping, wearing traditional dress, blossomed in daily life and festive gatherings.

Synneva and John settled in South Dakota near the little town of Hetland. Here they built a log cabin, and in the family chronicle we also read that the couple, in the course of sixteen years, had ten children—five girls: Ingeborg (or Belle), Marie, Anna, Bertha, and Josephine; and five boys: Martin, Lewis, Maner, Edward, and Carl. Their father, John, worked for long periods as a carpenter in other places, walking all the way to the neighboring state of Minnesota to find work, while his wife, Synneva, managed the farm. In the chronicle several photographs are reproduced of the family's home, "Grandma's Place."

In a photograph from around 1900 we see John and Synneva standing in front of their white-painted, two-story house, surrounded by their many children (Figure 6.15). The motif is the archetypal immigrant photograph: the family in their best clothes in front of their house. But once again the photograph is related to a memory text that causes us to dwell more closely on it and imagine a house full of life and activity. In this text the second oldest daughter, Marie, writes about her childhood home—how it stood out in size beyond the norm, how it was furnished, and the great and small joys of growing up in the Melstad house on the prairie:

> My mother often spoke of their house on the homestead which was built by my father as one of the nicest around. Most of the early settlers started out with sod shacks but our house was of lumber. There was a large living room, bedroom and an upstairs with space for two or three children. Also there was a lean-to for storing fuel and a grainery and sod barn nearby. We had very little furniture at first. Some of it was built by my father. A large walnut chest of drawers is still owned by a member of our family. The vegetables and milk were kept in a stone-walled cellar. For heat we sometimes used twisted hay but a more pleasant memory is of a big hard coal heater with clear windows of icing glass. How comforting it was to get up in morning to its warmth and to sit around it in the evening enjoying the beauty of the live coals shining through the glass doors. We had no storm windows when I was little girl so the frost grew thick on the cold panes in the winter making pretty pictures. What fun it was to scrape away the frost to see outdoors.[8]

Since the initiative for the family chronicle came from the third generation of the Melstad clan, Grandma and Grandpa appear as faint memories in the reminiscences.

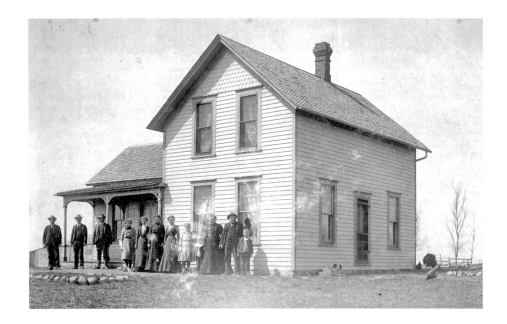

Some of the grandchildren remember Grandma as sick and lying in bed. They also remember problems communicating with her, since she, even after a long life in America, mainly spoke Norwegian. In the chronicle, someone remarks ironically that she seemed to have fewer problems talking to her chickens than with her own grandchildren. Therefore, it is the second generation of Melstads, John and Synneva's children, who appear in the foreground of the story. Two of the five sisters—Marie and Belle—also contributed texts. These, along with poems and short portrait sketches written by nephews and nieces, draw attention to the individual siblings, with all their particularities, like a little portrait gallery. Notably, the textual portraits are placed together with photographic portraits.

One such photograph is a studio portrait of the five Melstad sisters, lined up in front of a backdrop with a floral motif (Figure 6.16). The oldest, dressed in black, is in the middle, flanked on both sides by two younger sisters in elegant white-lace blouses. There are clear family likenesses, but the differences between the young women in age and in appearance are still the most striking. It is difficult to avoid noticing one sister's eye-catching beauty, how thin and fragile the youngest seems, or the contrast between the strong, mature face of the oldest and her younger sisters' more unfinished, girlish faces. This sense of differences is amplified through the written portraits.

Marie, second from the left, is referred to as the beauty of the family, the one who, according to her nieces, always liked to pose for the photographer. She was also the one who was academically gifted; she went to college to become a teacher. Bertie, second from the right, wearing glasses, was musical, like several of the Melstad siblings. She played the guitar, and the younger generation also observes that she always wore beautiful clothes. They also said that Bertie became a teacher like her older sister Marie. She later moved to Washington and created a great scandal when she married one of her students—someone ten years younger.

Belle, who stands on the far left, was, according to the descendants, the adventurer among the five sisters. In the chronicle, she writes about the enchantment and sense of freedom in being able to sit on a horse and ride over the prairie. Belle was outspoken and strong, but the grandchildren also write about her mental health problems later in life, speculating about whether they were due to the life she lived, which did not challenge her enough. Anna, the oldest, is portrayed as someone who spent much of her childhood helping her mother by taking care of the many younger siblings—and who ended up working hard her entire life. Josie, the youngest, suffered from tuberculosis at a young age. As a result, she never married and was the one who undertook responsibility for their mother, Synneva, in her old age. Josie is characterized as a quiet, loving person who was happiest when the Melstad house was full of guests.

The various outward appearances of the sisters in the photograph are thus strengthened in the written accounts of how they each in their own way took on different roles in regard to each other and how they acted out their differences through play. This role consciousness was eventually passed on to their children. One of the daughters in the next generation tells us, for instance, how the Melstad sisters amused themselves by taking on the roles of the sisters in Louisa May Alcott's semi-autobiographical novel *Little Women* (1868):

> Mom read Louisa May Alcott's book, "Little Women" to us when we were in the first or second grade. At that time she told how the four girls (Belle, Marie, Bertie, Josie) pretended they were Jo, Beth, Meg, and Amy and acted out scenes from the story for a pastime. My guess is that Belle was Jo, the tomboy; my mother Marie probably Beth, Josie would have been Meg, the homebody; and Bertie, Amy, the artistic one.[9]

There were also brothers among the siblings, and in the portrait taken on the parents' twenty-fifth wedding anniversary in 1902 they are all present (Figure 6.17). The photograph was taken in the parlor of the family home, a room distinguished by its secure economic comfort with modern, large-patterned wallpaper and lace-curtained windows. In the background hangs a large, framed portrait photograph, and to the right is an organ featuring mirrors and enormous carvings. On a small table, prominently placed in the foreground, the family "treasures," photo albums and books, are neatly stacked. Yet the Melstad parents and their large brood take up most of the space in the room. Most of the family members are gazing attentively toward the photographer. All but one of the sons sit in the foreground, while the girls, with the exception of the youngest one, are placed in the background. The age difference is great: the eldest of the Melstad siblings were in their mid-twenties when the photographer visited the family; the youngest, only five.

In the chronicle, the portrait has captions identifying family members, again inviting the viewer to draw connections between the written and photographic portraits. The text emphasizes that the Melstad family's many sons, like their father, were highly skilled craftsmen. Several of them were carpenters, and some specialized in the construction of musical instruments, such as violins and mandolins. Otherwise, the Melstad sons are portrayed in the same way as the family's daughters, each with characteristic features. Martin, the oldest, who in the portrait is sitting heavily, with broad shoulders, next to his father, was, according to the descendants, a hard-working loner who rarely smiled. The second oldest, Lewis, who sits to the right of

FIGURE 6.17. Family photograph taken in Hetland, South Dakota, on the occasion of John and Synneva Melstad's silver anniversary, 1902. From the back left: Maner, Anna, Marie, Bertie, Belle. From the front left: Josephine, Synneva, John, Martin, Lewis, Ed, Carl.

the big brother in the picture, made an economic success of his carpentry business, which he later expanded. The story about him is accompanied by a photograph in which he proudly displays his new car to his family.

The chronicle also tells about the family's black sheep, the younger brother Edward. In the family portrait from 1902, he is still a little, wide-eyed boy who stares vigilantly out of the frame. We wonder how this little boy turned into "someone it was difficult to like," as several people have written. We are discreetly informed in one text that he was involved in bootlegging during Prohibition in the 1920s, something he was never punished for. Elsewhere we are told that he "developed a drinking problem that took all his money," causing his siblings years of pain. In a third text Uncle Ed, is portrayed, in a bitter tone, as someone who expected that all the others should fix his life when he met obstacles.

The one who emerges as the hero in the tale, as the favorite uncle, is Maner. He is the nice-looking young man we see in the back row to the left in the photograph. In the text he is credited not only with good looks but also for his kindness. He stayed on at the farm to take care of his elderly mother and sickly sister Josie. He was said to be successful at everything he undertook: he grew crops, milked cows, planted trees, modernized the farm, introduced new hybrid plants, built violins, and bought

the family's first radio. His favorite hobby was photography. With the exception of the professional portraits, most of the photographs in the chronicle were taken by Maner, and they speak as his voice in the family history.

Maner's activities as a photographer appear to have been related to an important phase in the life of the Melstad siblings. Around 1900, Hetland, the town where the family lived, evolved to become a vital small local community. New roads and the railroad had made the town easily accessible. Electricity, telephones, and even running water were available to those who could afford them. As noted in the family chronicle, there was no reason to leave. But in 1910 everything changed. The area was hit by severe drought, the crops failed, and work was difficult to find. It did not make it any easier that the families were large and the children were now adults. There was only enough work for one or two children per farm. In this situation, many were tempted by the promise of free land in the northwestern corner of South Dakota, several of the Melstad siblings included. Three of the brothers (Lewis, Martin, and Maner) and three sisters (Belle, Marie, and Bertie) decided to travel west to each make his or her own land claim.

It is the history of these events that Maner wishes to document in his photographs. Through the camera he allows us to follow the siblings and other settlers in the process of building their simple sod houses or settler shacks on the prairie. In one of the photographs, we see the three Melstad sisters smiling on the roof of Belle's newly built prairie shack (Figure 6.18). In another he takes us into the shack, where Bertie and Marie are visiting (Figure 6.19). We are immediately struck by how well outfitted the interior appears in the otherwise very simple surroundings. On the richly decorated iron stove (which takes up a good deal of space in the small room) is a generously sized coffee pot. Wall space is neatly utilized for the decorative arrangement of pots and pans. Under the window stands a small table with a patterned oilcloth. The sisters are settled around the room: Bertie has found the guitar, Belle is playing hostess at the stove, and Marie poses attractively under the window. In another photograph Maner has snapped his sisters as they, along with neighboring women and children, smile and enjoy fruits of Marie's gardening: ripe watermelons (Figure 6.20). Maner's photographs seem to speak about the siblings' enthusiasm for the earth's bounty and the joyful expectations of their new and independent life.

The memories presented in the written chronicle offer a quite different picture of this history: accounts of loneliness, bad-tasting food, and a drought that only made the situation worse. The prevalent seriousness is implied by descriptions of neighbors struck by typhus, of the fear of contaminated wells, and of other difficulties.

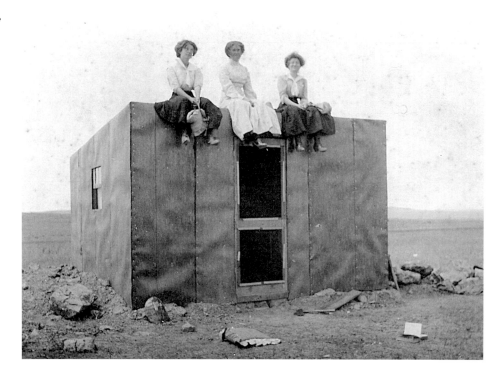

FIGURE 6.18. Maner Melstad, the Melstad sisters on the roof of Belle's newly constructed prairie home, South Dakota, circa 1910.

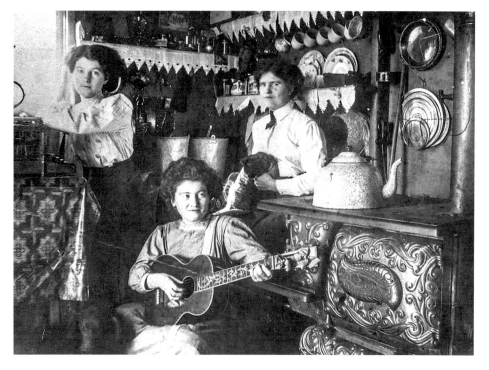

FIGURE 6.19. Maner Melstad, interior of Belle's homesteader's cabin on the prairie in South Dakota, circa 1910.

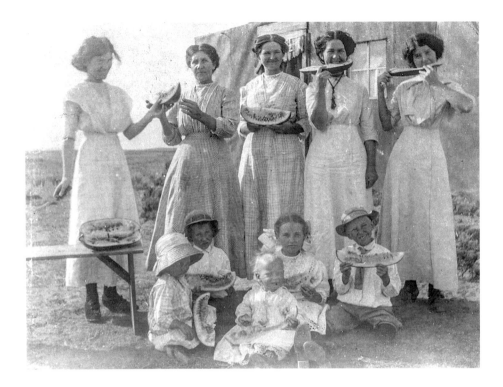

FIGURE 6.20. Maner Melstad, the Melstad sisters and neighbors enjoy fresh watermelon from Marie's garden, South Dakota, circa 1910.

The homesteading adventure had no happy ending. The siblings returned to the family home after only six months on the prairie. Some married and established their own homes. The Melstad farm continued to be the family's gathering spot for years, the place where the traditional family dinner was served and where the feeling of continuity and tradition was maintained.

Yet in 2002, when the chronicle was written, the solid log house built by John and Synneva had stood empty for many years. By that time the crowded little town of Hetland, with the good school and the busy shops, had more or less been abandoned. The family chronicle came as a result of a deeply felt change in the present and from a corresponding need to establish an identity and a personal history as part of the greater history of Norwegian emigration to America and assimilation into American society. The photographs and the written reminiscences are both important as remedies in this experience of loss: soon everything is lost; soon everything is far too late.

The pieced-together, collage-like form of the Melstad chronicle breaks with traditional historiography's objective tone. Instead of one continuous account with one dominant voice and a narrated subject, we encounter many, at times rather

incoherent, accounts, many voices, and many subjects. Some of this is expressed in the fragmented memoir essays that the sisters wrote of their childhood. Belle, who wrote her story when she was eighty-seven, actually describes her text as time travel, which is necessarily disjointed: "I am just writing as I think of it. Sometimes I get the cart before the horse."[10] Her text moves forward and back in time. In one section she writes about how, as a young girl on a beautiful spring day, she escaped through the window of the farmhouse to avoid having to accompany her family to a Sunday church service. Then quickly she moves to a story of a prairie fire, next to her sister's wedding, followed by the memory of how her parents lost three hundred dollars during the Depression. The photographs that are woven into the book are likewise scattered widely, appearing as fragmented as memory itself. But they are just as expressive of the same desire we find in the text: to create a truthful picture of what was.

"Oh, how I have longed": The Albums of the Kallestad Women

A middle-aged woman on a staircase in the sunshine: it is the subject of an old amateur photograph in black and white (Figure 6.21). The woman, leaning against the stair post, gazes pensively with her head resting on her flat, upraised hand. Her hairstyle and outfit (a striped dress protected by a floral patterned apron) bring us back to the 1940s. The stairs she stands on are tidy and painted white; they lead to the door of a house. The woman in the photograph is Josefa Kallestad, who was a seaman's wife and homemaker in Chicago. On the back of the photograph that she sent to her sister in her native town of Lillesand, we find the following sentimental message in beautiful handwriting: "I long for Norway my fatherland, where the birch and the buckthorn stand bright and beautiful, Norway with its valleys and hillsides and granite mountains, oh how I love you—Your longing sister."

The photograph of the longing Josefa resides in the archives of NAHA, the Norwegian-American Historical Association, in Northfield, Minnesota. Two boxes marked "Kallestads" contain what the archive categorizes as "family memorabilia": a series of albums, letters, official documents, and, not least, a large number of photographs. The material came to the Chicago branch of NAHA at the end of the 1980s. It was then forwarded to the organization's central archives in Northfield with a noteworthy cover letter. The NAHA representative writes that he has gone

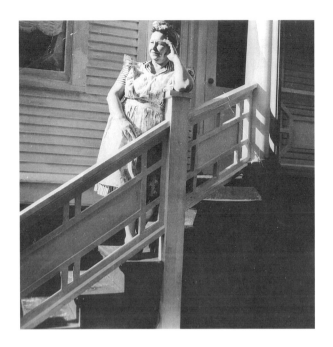

FIGURE 6.21. Josefa Kallestad on the stairs in front of the family's home in Chicago, 1940s.

through the material and mentions four of the photographs as especially interesting. He suggests they could fit into Odd Lovoll's book about Norwegians in Chicago. But if we page through Lovoll's *A Century of Urban Life* (1988), we see that the photographs from the Kallestad family's life were not used as illustrations.[11] Lovoll's study does, however, have a final chapter, "The Modern Metropolis," that gives an interesting picture of Chicago at the time when Josefa and her family arrived in 1923.

Lovoll describes how modern Chicago took shape during the 1920s. Because of large-scale immigration there was an upturn in housing construction. Around 1930 the population had risen to nearly 3.4 million. The city expanded in all directions. Higher wages and new consumer goods increased prosperity, car sales increased, and the availability of modern electrical appliances grew. Around 1930, the city's Norwegian population of nearly twenty-two thousand was so great that Chicago could be regarded as "the third largest Norwegian city" after Oslo and Bergen.[12] Lovoll is interested as well in how the Norwegian population in Chicago throughout the 1920s actively demonstrated their ethnicity—apparently with a dual purpose: first, to make Norwegian-Americans who were born in the United States aware and proud of their Norwegian background and, second, to make Norwegian society visible to Americans of other nationalities.

In his book he identifies a whole range of individuals with Norwegian backgrounds—men, without exception, who made a positive impact in Chicago within the areas of banking, technology, and academia. He also writes specifically about "the Logan Square community," where a vital neighborhood of buildings called "Little Norway" could be found. Here Lovoll describes the Norwegian church in this area, the Norwegian clubs, the many associations, and the political and cultural life that unfolded within these boundaries. We note, however, that this is a story that almost invariably emphasizes male actors: Norwegian-American ministers, politicians, lawyers, club and union leaders, artists, and sports heroes.[13]

Where are the women in this story? Where do we find the story of Josefa and the many other Norwegian-American women who worked inside and outside the home in interwar-era Chicago? Although they did not stand out as individuals in the public sphere, their lives and everyday struggles undeniably represent an important aspect of the history of Norwegian immigration and assimilation in American society. Where then is the story of how it was to live as everyday Norwegian-Americans in Chicago in the 1920s and 1930s, the story of all those toilsome things that make up a normal family life?

The photographs and personal memorabilia that we find in the Kallestad archive boxes in Northfield help us approach these aspects of the story. Such an approach requires that we examine this material with an eye for how it, as a whole, opens up the possibility of letting accounts of individual lives emerge. This is something radically different from evaluating material merely in the light of how single photographs can be extracted from the totality of the archive to serve as illustrations to other texts. This approach entails being sensitive to the totality of the material (images, texts, documents) by noticing how some narratives stand out as more striking or more detailed than others. The photographs are thus interesting not only because of their documentary value or their realism. The photographs in the archive, including the albums, are equally important as expressions of the wishes, hopes, and longings of their creators.

Usually albums were made by women. Both the Eken and Melstad family history projects were initiated and carried out by female members of those families, and it is the same with the Kallestad material. Esther, Josefa's daughter, collected and passed on the physical memories of the family's existence that are now found in the NAHA boxes. So first and foremost the voices of the Kallestad mother and daughter, Josefa and Esther, are expressed in this material.

On the top layer of one of the archive boxes are four file folders. Esther has painstakingly collected material, one folder for each family member: Johannes (John)

Kallestad, Josefa Kallestad, their son, Leif, and their daughter, Esther. When we open the folders, we find documents, letters, and photographs that together provide a rough outline of the most important events in the respective family members' lives. But there is no preexisting framing history that can help us further. The albums certainly have captions, and some photographs have explanatory inscriptions, but basically we are left to seek connections between the different components of the material.

In John's folder we find official documents indicating that he was born in Kristiansand in 1893 and was by profession a first mate with a certificate to work on both sailing ships and steamers. In a photograph in beautiful shades of browns, the young mate Kallestad poses in a tightly fitting uniform on the deck of a ship (Figure 6.22). His posture is straight, and his gaze is fixed commandingly on the photographer. The folder includes his application from 1921 to the U.S. Coast Guard for a license as a "master of steamships." In other words, John Kallestad established himself in the American workplace before he bought tickets in 1923 for Josefa and the two children to join him.

Among the letters and photographs of Josefa's folder we find her baptismal and confirmation certificates, which state she was the same age as her husband. The folder's contents include the passport she acquired when she and the children left Norway in 1923. In the small passport photograph we see her as a somewhat tired mother of young children, along with Leif Edmund, who was then six years old, and his sister, Esther Johanne, two years younger (Figure 6.23). The letters in the folder are mostly those she wrote to Leif, who as an adult lived in California. The letters give the impression that she was a mother who was not exactly restrained in her declarations of love and warm presence. "To my Dearly Beloved Dear kind Norwegian Son Leifeman!" she writes to him—from the time he joined the military as a young man until when he retired with a pension in his sixties.

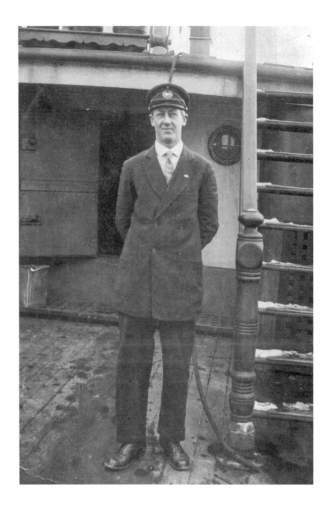

FIGURE 6.22. Johannes (John) Kallestad in first mate's uniform on the ship deck, 1920s.

FIGURE 6.23. Josefa Kallestad's passport photograph with her children, Leif and Esther, circa 1923.

In Leif's folder we find letters with the same emotional intensity. As a young man, on vacation in Canada, he writes home to his mother, and he does so in Norwegian, apparently to please her. He describes his experiences of nature—trees, mountains, and valleys—that "remind me of Norway" but makes it clear that he misses the family. "GOD, HOW I LONG," he writes in capital letters on the first page, but then quickly remembers to remind his mother to "keep all the sports newspapers" that he can "not live without" and to "tell all the girls that I'm coming home soon." Among Leif's papers is his military record, which says he served in the U.S. Army during the war years 1942–43. A photograph in the folder shows him home on leave on the street outside the family's home in Chicago (Figure 6.24). In full uniform he shakes hands with his mother, Josefa, who seems aware she is posing. In a new coat, stylish hat, and polished shoes, with a handbag hanging neatly from her hand, she smiles proudly and tenderly at him, knowing that this will be a nice photograph to show off to friends and acquaintances.

In another photograph, a small snapshot in black and white, we see Leif together with a fellow soldier in a military camp (Figure 6.25). This is no drill scene or tough

military exercise we are witnessing, but the exact opposite: Leif, on his knees and with arms outstretched, performs an apparently rapt declaration of love, perhaps in the form of a song, directed at his friend, who grins at him from a cot where he lounges in the sunshine. Like the other Kallestads, Leif was interested in music and singing. They were all members of their Norwegian congregation's choir in Chicago. In Leif's folder we find songs he wrote and a photocopy of the cover of a disc with a song of his that was released on Columbine Records. This event, which took place quite late in his life in the early 1980s, is given as much importance as the papers documenting the bachelor's degree he received in his youth from California State College.

In contrast to her brother's folder, Esther's folder contains nothing particularly eventful. She has obviously been more reluctant to include information about her own life. But the little that exists makes it all the more clear what she will be remembered for. In a Hollywood-style

FIGURE 6.24. Leif Kallestad, wearing an American military uniform, shakes his mother's hand, Chicago, circa 1940–43.

FIGURE 6.25. Leif Kallestad (right) serving as a soldier during World War II, circa 1940–43.

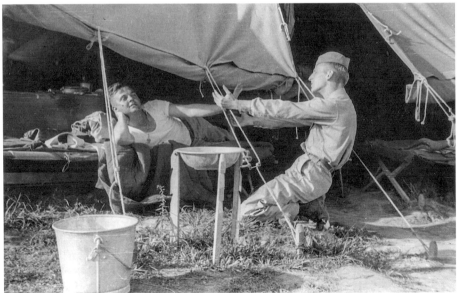

studio portrait, we can admire her as the beauty she was as a young woman (Figure 6.26). She smiles at us in a close-up like a movie star. The professional lighting and soft focus cause her blond hair to flare like a halo around her narrow face, with its plucked brows of the era and heavily applied lipstick. The photograph dates from

the 1930s, when Esther Kallestad participated in the local Miss Norway contest in Chicago. From the writing on the back, we understand that the picture was once sent home to relatives in Norway as a Christmas present. Esther added a few lines in English, giving a strange, brief summary of her life using keywords. "Short Career," she remarks, perhaps ironically: "E. Kallestad Gulbrandsen. After High School went to Vera-Jane Mode Studio (in Lyon-Healey building), then worked at the Fair Store as elevator operator and modeled some at the Harding Rest. on 3rd floor and fabric dept. Short Career. Got married." In Esther's folder is a press clipping from the beauty pageant and a newspaper notice of the time her husband, artist Per Gulbrandsen, had a painting accepted for an exhibition organized by the venerable Chicago Art Institute.

Further down in the archive boxes we find the Kallestad family albums. Some are Josefa's old albums, while others are those Esther made later—perhaps as a result of the decision to place the family's memorabilia in a public archive. When we study these albums to locate their most prominent features, narrative structure, and mind-set (the album maker's longings, desires, ideals, and fantasies), two aspects strike us: it becomes clear, first, how family albums greatly accentuate values such as closeness and solidarity and, second, how the family, and particularly first-generation immigrant Josefa, emphasizes their ethnic affiliation and connection to Norway.

"My wonderful warm loving family—The Kallestad's," writes Esther under one of the many family portraits in the album. The first was taken the year after Josefa and the children arrived in Chicago (Figure 6.27). Here we meet a different Josefa, not the tired mother of toddlers from the passport picture. She now appears smiling and relaxed at a photographer's studio in an elegant new coat with art deco patterns in the shiny fabric. Behind her stand her husband, John, and a glowing, happy Leif. She has placed her arm securely around the blond little Esther. The photograph is in one

of the albums Esther made many years afterward, when she had become an elderly woman, an album collecting the intimate stories of family life. But it is still Josefa who emerges as the protagonist of the Kallestad family album. She obviously loved to be photographed. Disregarding the years that pass and the body that ages, Josefa poses tirelessly throughout her entire life.

On some album pages, Esther has glued in photographs reflecting her mother's life from her childhood and adolescence in Kristiansand to her adult life in Chicago (Figure 6.28). The visual narrative also includes a page on which Esther has placed a picture of herself, alone by her father John Kallestad's grave, along with a photograph of her father in his ship's officer uniform and a photograph of her mother, Josefa, dressed in mournful black (Figure 6.29). Through juxtapositions of photographs and other types of memory material (such as locks of Josefa's hair, condolence and congratulations cards, love letters, newspaper clippings, copies of lyrics, and postcards), the album pages appear to be fragmented collages. This use of so-called mixed media emphasizes photography's realistic character while providing power to the imagination through touching and through combining and strengthening sense experiences.[14]

FIGURE 6.27. Studio portrait of the Kallestad family, Chicago, 1924.

Esther's album is not arranged strictly chronologically. She allows herself to jump forward in time, and on the same album page she is happy to glue in, for example, a professional photograph from the 1940s of herself as a young mother with her son, Perry, in her arms; a sepia group portrait from 1890 of her father's family in Norway; a youthful portrait of herself and her husband, Per; and a snapshot of the family's shiny new American car (Figure 6.30). In this way the continuity is established between what is and what has been, between her own life and the family's past existence and connection to Norway.

Josefa's albums point even more strongly back to Norway. The intensity of her devotion to the homeland is particularly evident in one of the photo albums, made up almost entirely of glossy postcard images with scenes from Norway. But the musically inclined Josefa also likes to glue in the verses of a solemn national hymn, such as "Among All the Lands," next to photographs of a white-washed house from

FIGURE 6.28. Page from Esther Kallestad's album, including photographs from her mother Josefa's life.

FIGURE 6.29. Newspaper notices along with condolence cards and photographs commemorating John Kallestad's death. From Esther Kallestad's album.

southern Norway, islets, and reefs, or she adds the verses of "When the Lights Are Lit at Home" next to a picture postcard showing the lit Christmas streets of Bergen. It is primarily the home districts around Kristiansand and Lillesand that appear in her album, although her love of her home country also flexibly stretches slightly north toward Bergen and east to the sights of Oslo as the last album pages approach.

The emotional ties to Norway manifest themselves with even greater force in the photographs that were taken on the occasion of Josefa's trips home in 1947 and 1966. These journeys appear to be highlights of her adult life. In a hand-tinted photograph we see her in a floral-print cotton dress, sunglasses in hand, as she affectionately leans against a birch tree at her brother Olaf's farm in Lillesand (Figure 6.31). It must have been nice to come home to Norway and look a little American in her clothing and equally nice to come home to Chicago and proudly show off all the things she had bought in Norway. In Chicago, Josefa was more Norwegian than American.

FIGURE 6.30. Photographs from Esther Kallestad's life mounted together with photographs from the Kallestad family's relatives in Norway. From Esther Kallestad's album.

In another photograph, we see her sitting on the guest bed in her sister Ragna's house in Kristiansand—completely absorbed by her newly acquired Norwegian trophies (Figure 6.32). The light that falls from the right softly frames her figure, and we can allow our gaze to wander from the pot she is carefully holding to the nicely arranged ornamental textiles, beautifully framed photographs, and generously filled glass jars of canned fruit in the background.

In a photograph with the caption "Open House," Josefa is probably back in Chicago. With assistance from a friend and an apron around her waist, she prepares for visitors in her bright, modern kitchen (Figure 6.33). The table in the foreground is covered with coffee cups and bountiful plates of cake. With hectic red cheeks and a smile, the hostess shows off a new set of kitchen knives, perhaps one of the many treasures from Norway that would rouse admiration in America. In the album a small newspaper clipping in Norwegian is affixed, saying that the event did not go unnoticed in Mrs. Kallestad's local society:

Last Sunday it was open house at Mr. and Mrs. John Kallestad's home, 2438 N. Bernard St. It was on the occasion of Mrs. Kallestad's return from Norway.

FIGURE 6.31. Hand-tinted album photograph from Josefa Kallestad's first trip home to Lillesand, Norway, in 1947.

FIGURE 6.32. Album photograph of Josefa Kallestad admiring the things she has purchased during her visit to Norway.

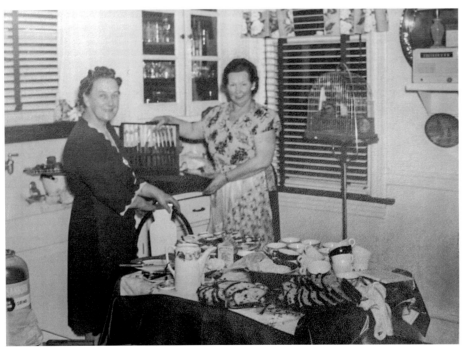

FIGURE 6.33. Josefa Kallestad holds an open house in Chicago after her homecoming from her trip to Norway in 1947.

Around 50 of their friends were gathered in their cozy home. Mrs. Kallestad had brought many lovely things from Norway that it was quite like a museum, and we must not forget the delicate buttered slices of bread, cake and coffee.

Josefa's last trip to Norway in 1966 is also well documented in the album. In a small, faded color snapshot with the caption "Surprise!" we catch her at the moment she arrives at the surprise party that friends and family have organized before her departure to Norway (Figure 6.34). Pleased and carefully astonished, she stands in the doorway wearing her elegant new travel coat trimmed in white fur and with a pillbox hat on her head. In the foreground we see how her arrival is met with enthusiastic clapping. In the album we can also study the picture postcard image of the ship she sailed on and photographs in which she poses with well-bred fellow passengers or next to the ship's Christmas tree decorated with Norwegian flags (Figure 6.35). Home in Norway, her sister Magda and her son Nan wait for her on the dock, and Josefa in her stylish coat, American flag in hand, is photographed receiving a warm embrace (Figure 6.36).

Josefa marked her Norwegianness throughout her entire life. One of the highlights of her old age was when King Olav visited Chicago. Enthusiastically she offered to make a speech for the occasion. It was not possible, but the pastor of the Norwegian Memorial Church in Chicago later sent the speech to the palace in Oslo, and Josefa received a polite thank-you letter with a personal greeting from the king. The letter has obviously been given a place of honor in the album, next to one of the last photographs taken of Josefa. We see that she has become a small, thin woman, rather slumped in her chair. But we cannot fail to notice that she still likes to look smart: her hair is arranged in curls, and her smile is wide and life affirming (Figure 6.37).

The letters she writes during this time are not as bright and cheery as those she wrote in her younger days. Her identification with her ethnicity tips over into prejudice when she advises her son, Leif, "not to mingle with any females [from] foreign nations [who] are not worthy of a nice Norwegian man."[15] Toward the end of her life, she is concerned that everything has changed for the worse. She complains that the family's old neighborhood in Chicago is no longer a place where you can walk safely on the street, that she has not seen her grandson in years, and over the loss of her beloved husband, John. She longs for the time when the family was together and happy. In this state of mind, this recognition of loneliness and change, photographs are more important than ever. She keeps them around her and writes that she "speaks to all of them." For her, they are the soothing bond between a difficult present and a

SURPRISE!

FIGURE 6.34. "Surprise!" album photograph, color snapshot taken on the occasion of Josefa Kallestad's departure for Norway in 1966.

FIGURE 6.35. Josefa Kallestad poses on board the ship in 1966 with fellow passengers and next to a Christmas tree with Norwegian flags.

FIGURE 6.36. Josefa Kallestad photographed on her arrival in Kristiansand, Norway, in 1966.

FIGURE 6.37. Josefa Kallestad in Chicago, 1975.

past happiness: "Yes, we were a happy family in every way, oh, I have wished myself back in that time. Oh, how I have longed."[16] For us who now encounter the archive box labeled "Kallestads," the photographs and albums left by Josefa and Esther represent an entry point into understanding their lives, thoughts, and dreams as well as those of a Norwegian-American family in the interwar years and in postwar Chicago. Through sensually tactile and visual experiences, our imaginations are stirred and the past is made into something that deals with lived life.

"Maintaining a sense of history": Peter Syrdahl's Digital Family Album from Norwegian Brooklyn

"You are invited to view Peter's photos." This is the text we encounter as we open the link to a website where Peter Syrdahl (born 1946), a Norwegian-American living in Brooklyn, New York, presents his family photographs. We select one of the newer files, named "17th of May Parade, Brooklyn," and start the slide show, which takes us back to 2007 and the celebration of Norwegian Constitution Day in Peter's community. Quickly passing images invite the viewer to float in the pictorial stream and slip into the role of the photographer's companion on the big day. In the first

FIGURE 6.38. Peter Syrdahl, self-portrait in front of his home in Brooklyn, New York, May 17, 2007.

photograph in the sequence, we meet him in front of the house where he and his family live (Figure 6.38). The entrance is decorated for the occasion with both Norwegian and American flags and pots with red flowers. The white light that falls from the left tells us it is still early morning. Peter sits smiling and expectant on the steps in a Norwegian knit sweater, with a camera bag over his shoulder. He is ready for this year's 17th of May parade, one of the highlights of the social life in Norwegian Brooklyn, and will use a camera to document it all, as he has done throughout the years since his daughters were small. Peter is a third-generation immigrant. His grandfather came to New York to make a living in the years before World War I but later returned to Norway and his birthplace of Grimstad with his family. As an adult, his daughter, Peter's mother, returned to New York, where she met a young Norwegian, an engineer in the Norwegian merchant fleet. They married and raised their son, Peter, in Brooklyn.

Peter Syrdahl has been interested in photography for as long as he can remember. He photographed often when, after completing college, he served as a soldier in the Vietnam War, and he continued to take pictures as the father of young children living in Brooklyn in the 1970s and 1980s. At home in the pleasant house of red brick, he has gathered many family photographs that largely relate to holiday events in the city's Scandinavian community. As a young man Peter joined the local lodge of the

Norwegian-American organization Sons of Norway and has been very active in nonprofit organizations in Brooklyn. In his professional life he long played a central role in the administration of New York City mayor Rudy Giuliani. The experience of being Norwegian-American is deeply rooted in his identity, but, given the Finnish family background of Peter's wife, it has been just as natural for the family to maintain their connection to the Finnish ethnic community as to the Norwegian one. Since the Norwegian-American population in Brooklyn is now somewhat reduced, their social circle is quite pan-Scandinavian and inclusive. Peter just as happily shoots photographs of a royal visit from Sweden, openings of new IKEA branches in the New York area, midsummer festivals in Central Park, and the Swedish Christmas Lucia procession as he does Finnish celebrations and local beauty pageants in the Norwegian-American community.

But his photographs do not tell us anything of this when we see them in slide shows online: this information can be obtained only through a personal encounter with the photographer. Peter's own words help to anchor the photographs in a cultural context that gives them life and color. For example, when we begin to engage him in conversation, we understand that the 17th of May celebrations are closest to his heart as a photographic subject. He then pulls out albums with pictures from Brooklyn's 17th of May parades, photographed over a number of years. One of the photographs shows his two daughters, Lisa and Kristen, who with 1980s hairstyles and slightly reserved expressions let themselves be photographed in their *bunad*, the traditional Norwegian dress, in front of the legendary Thoralf Olsen's Bakery. In another picture, they pose in festive clothes, holding a Norwegian flag, with their father and their Norwegian grandmother (Figures 6.39 and 6.40).

Many years later, in 2007, Peter is again ready with his camera to record this year's parade. He explains how as a photographer he has always tried to create images that are honest and that can show how "things really are," and he mentions the famous American documentary photographer Lewis Hine as a role model. Hine also used New York's ethnic communities as a motif; in the history of photography he is honored for having managed to depict their unfortunate and abusive living conditions while also presenting his subjects with human dignity. Socially speaking, it is a long way from the slums Hine portrayed in the early 1900s to the Norwegian-American communities in Brooklyn more than one hundred years later. But Peter Syrdahl is, like his role model, fervently keen to show respect to those he photographs. Or, as he says, "I will not make anyone embarrassed." Aesthetically, his spontaneous amateur color snapshots are far from Hine's carefully composed black-and-white

FIGURE 6.39. Peter Syrdahl, the photographer's daughters in front of Thoralf Olsen's Bakery during the 17th of May celebrations in Brooklyn, New York, 1990s.

FIGURE 6.40. Peter Syrdahl, the photographer's mother and daughters photographed during the 17th of May celebrations in Brooklyn, New York, 1990s.

photographs. But the pictures are still steeped in his ability to be present in the moment and in his strong personal commitment to the celebration of Norwegian heritage.

Peter stands on the sidewalk curb, photographing those who pass by him in the parade. His camera captures police on horseback who lead the parade, as one of them greets someone in the crowd with an outstretched arm (Figure 6.41). He snaps a picture of Victoria Hofmo, the driving force behind Brooklyn's Scandinavian East Coast Museum. She waves gently to him as she passes, blond and attractive, wearing a *bunad* and sunglasses with the Norwegian flag painted on the lenses (Figure 6.42). The motorcycle club roars past with Norwegian flags on their giant American bikes; we zoom in to be greeted by a smiling biker girl with a fluttering blond mane and bulging muscles (Figure 6.43). In a similar way Peter snaps a passing group of students and alumni from St. Olaf College, the Norwegian-American liberal arts school in Northfield, Minnesota (Figure 6.44). They are blond and Nordic in appearance, but with their yellow school banners, megaphones, and black T-shirts they resemble more than anything else an enthusiastic crowd at an American sports arena.

This framing of Norwegian ethnicity connected to the American lifestyle and to American symbols emerges as a recurrent theme in Peter Syrdahl's 17th of May photographs. In another photograph from the parade, we can study that year's Miss Norway of Greater New York (Figure 6.45). She is posing in a *bunad* for the photographer, along with one of her handmaidens, in the back seat of an open sports car. Peter has carefully made sure to get the car and Miss Norway situated in front of a travel agency that, with its name "Kon Tiki Travel Inc.," creates an association with the heroic Norwegian expedition. But the car is also surrounded by a close formation of cadets from the American Merchant Marine fleet in gleaming white uniforms. Had it not been for the blond beauty's Norwegian costume, we might have been completely lost in the illusion of a scene from the romantic American film classic *An Officer and a Gentleman.*

A photograph of a street vendor, a hunched-over woman rushing by holding Norwegian flags and plastic chains in Norwegian colors, indicates how the celebration of Norwegianness takes place in an environment of cultural diversity (Figure 6.46). Peter does not avoid directing his camera toward the parade performances by bagpipe players in Scottish kilts with Viking helmets on their heads (Figure 6.47), the Danish chairman of the local 17th of May Committee (Figure 6.48), and the young Norwegian-American Glenn, who, dressed as a Viking, wanders past with his Chinese wife and a baby stroller duly decorated with Norwegian flags (Figure 6.49).

FIGURE 6.41. Peter Syrdahl, police on horseback at the head of the 17th of May parade in Brooklyn, New York, 2007.

FIGURE 6.42. Peter Syrdahl, Victoria Hofmo, director of the Scandinavian East Coast Museum in Brooklyn during the 17th of May parade, New York, 2007.

FIGURE 6.43. Peter Syrdahl, motorcycle club passes by during the 17th of May parade, Brooklyn, New York, 2007.

FIGURE 6.44. Peter Syrdahl, students and alumni from St. Olaf College during the 17th of May parade, Brooklyn, New York, 2007.

FIGURE 6.45. Peter Syrdahl, Miss Norway–New York, during the 17th of May parade in Brooklyn, New York, 2007.

FIGURE 6.46. Peter Syrdahl, street vendor with Norwegian flags, 17th of May celebrations, Brooklyn, New York, 2007.

FIGURE 6.47. Peter Syrdahl, bagpipe players with Norwegian Viking helmets during the 17th of May parade, Brooklyn, New York, 2007.

FIGURE 6.48. Peter Syrdahl, the Danish chairman of the 17th of May Committee, Brooklyn, New York, 2007.

FIGURE 6.49. Peter Syrdahl, "Viking Glenn" with his children and Chinese wife during the 17th of May parade, Brooklyn, New York, 2007.

In the final photograph, we are back to where we started, outside the photographer's home. It is late in the day, but at home waiting on the steps in front of the Norwegian flag is one of his daughters and her boyfriend (Figure 6.50). Peter is again back with his family, and by placing this particular photograph as the last in his slide show, he emphasizes his photographic expeditions as a project deeply connected to family and the need to see family life as part of a larger relationship, a bigger story. He is a member of the local Bay Ridge Historical Society in Brooklyn and vitally engaged in the history of Norwegian Brooklyn, a history that largely deals with latter-day immigration and the dissolution of Norwegian-American society that began in the 1960s.

This is a process that several Norwegian cultural historians in the recent past have described in detail. In *Lapskaus Boulevard: Et gjensyn med det norske Brooklyn* (Lapskaus Boulevard: A reunion with Norwegian Brooklyn), Siv Ringdal firmly holds that today the Norwegian colony in Bay Ridge is history. She portrays its shift from a thriving environment with the largest urban concentration of Norwegians outside Norway to a community in regression, with shop and restaurant closures as well as

FIGURE 6.50. Peter Syrdahl, the photographer's daughter with her boyfriend outside the Syrdahl family home during the 17th of May celebrations, Brooklyn, New York, 2007.

depopulation due to residents' desire for a greener suburban life or a new start in Norway. Today it is not Norwegians but people from different cultural backgrounds who live where the Norwegian colony once flourished. The Norwegian businesses, bars, and cafés have been replaced by Chinese fish markets and vegetable shops or businesses with Spanish-sounding names.[17] Vivian Aalborg Worley, who grew up in Brooklyn in the 1960s in a family with strong roots in the social life centered around the Norwegian Seamen's Church, describes her own experience of all these changes:

> We attended all the social functions; the annual "jule-trefest," Everybody's Birthday Party and bazaar, concerts and other festivities. We were there when His Majesty King Olav V and other members of the royal family visited their "landsmenn" abroad. We frequented the reading room at "sjømannskirken" so that my parents could catch up on news from home, and until I was old enough to be allowed upstairs to watch the young sailors shoot pool, I would listen to my parents' quiet conversation with elderly men who expressed their regrets for never having returned to "gamlelandet." Some of them had lost contact with family in Norway; others had kept in touch but never been back. From the 1950's until the 70's the social and ethnic fabric of Brooklyn was undergoing enormous change which had repercussions well into the Norwegian American community. At church we found our Norwegian friends leaving Brooklyn one family after another. Some moved to the suburbs of New York, others to New Jersey or Connecticut and some moved back to Norway. So then, in 1970 it was official: our family was moving to Norway. In immigration terms this is known as remigration. We called it moving home, despite the fact that both my parents were naturalized US citizens and had never intended to leave America. But times were changing—and so was my identity.[18]

Worley returns as an adult in search of traces of the Brooklyn she once knew and must conclude that most of the physical traces are gone—except for little things, such as a small, forgotten sign that reads "Lute Fisk" in the window of an abandoned shop in the Bay Ridge area. But she shakes off her melancholy and decides to think

about the past in a new way—not as something that is definitively past but as something that remains in continuity with the present.[19] Bay Ridge is still the place where Norwegian-Americans come to celebrate their roots, a place where it is allowed to think back in time and where memories are welcomed. The 17th of May celebrations are one of the opportunities to do just that. Brooklyn is thus still a haven for displaying ethnic belonging. But Norwegian-Americans play out their ethnicity these days within a new cultural diversity, which is emphasized by the director of the local Scandinavian East Coast Museum, Victoria Hofmo: "We co-exist with new groups of immigrants including Palestinians, Russians, Polish, Mexican and older groups of hybrid Americans whose roots hail from Germany, Italy, Ireland, and others."[20]

This accentuation of the Norwegian in a multiethnic context also confronts us in Peter's photographs, not least in what he regards as his favorite picture in the series. Here we are suddenly face-to-face with one of the participants in the 17th of May celebration: a broadly smiling, bulky man (Figure 6.51). Skin color and appearance indicate that his

FIGURE 6.51. Peter Syrdahl, "Kiss me, I'm Norwegian," participant in the 17th of May parade, Brooklyn, New York, 2007.

background may be African-American or perhaps Caribbean, but he has painted the Norwegian flag on his cheeks and in his short, frizzy hair, and he enthusiastically displays a large button on his chest that reads "Kiss me, I'm Norwegian." In his digital album, Peter Syrdahl documents such changes in the Norwegian Bay Ridge community. He is well aware that in his role as the community's visual storyteller, he is continuing a project that several generations of Norwegian-American photographers have been involved in before him.

Efforts to identify these early photographers are just getting started, but the archives of the Scandinavian East Coast Museum, online searches of images, and research in the Brooklyn Public Library enable us to at least name some of them. We know, for example, that Will (Wilhelm) Cappelen was active in Brooklyn around the beginning of the 1900s; that Rudy (Rudolph) Larsen asserted himself as the owner of Falkenberg Photo Studios from the 1920s until the 1950s; and that Knut Vang, who came from Norway in 1924, excelled as the Norwegian-American community's premier portrait photographer in that same period.[21]

In contrast to these photographers, Peter Syrdahl is an amateur in the word's true sense. It is primarily the love of taking pictures and the fondness for his subjects that motivate him, not concern for financial gain. He wants the photographs to testify to how the Norwegian community that he and his family are part of has existed and still exists. For Syrdahl, as for many others, the photograph is still considered a reliable witness of truth. The picture's ability to produce a footprint is still crucial, regardless of whether the light directed into the camera lens is captured chemically on a roll of film or is registered on a sensitive screen and stored digitally as numbers.

As the Bay Ridge community's photographic master of ceremonies, Syrdahl donated earlier copies of his pictures as gifts to friends and acquaintances. The transition to digital photography has meanwhile made photographs more accessible. The magically alluring, sensually tactile qualities that we may enjoy when encountering older photographs in traditional archives are obviously lost in this process. But in return, anyone, including researchers on the other side of the Atlantic (assuming they have the photographer's permission), can click into Syrdahl's album and take part in the photographer's eyewitness accounts of a Norwegian-American community that is constantly changing.

* * *

The particular family stories presented here may not be equally interesting for everyone, but they are still part of American and Norwegian-American history. Through their close-ups of people's past lives, these chronicles tell the little stories within the big story. The chronicles that unfold in everything from prefabricated, commercial albums and fairly comprehensive publications with varying degrees of relationship between text and image to elaborate collages and digital slide shows reflect the different phases of emigration history. With the exception of daguerreotypes, this history is represented through images produced in all the photography techniques developed over time: from wet-plate photography, tintypes, dry-plate photography, early amateur photography using rolls of film, and color snapshots from the 1960s and 1970s to our present-day digital photographs. The interpretative work of this extensive historical material unfolds through various types of historical examinations of the sources, interspersed with anthropological observations, interviews with living persons, detective work to identify unknown portrait subjects, and other resources. I have encountered problems with filling in lacunae in the chronicles, where the source material does not seem to extend to the work of anchoring the meaning of the image. It can be difficult to determine the specific purpose behind a photograph

and how to use it to express what cannot be expressed in words. But in experiencing such lacunae, I have reflected on my own role as a creator of new histories related to the images.

In this final chapter, I have directed attention to how we also may learn something new about the present in our encounter with archival material. The most important insight from this chapter and the preceding ones is that photographs can help us to understand other people—people of the past and their desire to create a better life. The photograph makes us understand this effort better and forces us to think through the objects, not just over them. We can conclude that photographs can help us integrate objects from the outer, physical world into our own world of experience—and thus save them from oblivion.

Conclusion

"God, How I Have Longed"

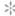

America-Photographs as Interventions

To the extent that photographs have been put to use in emigration history research, they have largely served as illustrations. In this way photography mainly functions to confirm the historical depictions it is presumed to exemplify. But this also means that photography's specific historicity is reduced. As an alternative to this predominantly reductive use of photography, I argued in the Introduction for photography's special potential to cut into the fabric of established historical narratives. Photographs work as interventions because they have the capacity to complement, correct, challenge, or disrupt such narratives. To pay attention to these qualities is, as I see it, a way of approaching photography in its own right, sensitive to its specific historicity.

In the chapters of this book, I approached the America-photographs by focusing on their distinctive capacities as historic interventions. I presented readings of works of particular photographers or collections to demonstrate photography's specific potential to engage with history. Through these readings, I contextualized the individual photographs in words, but there is still a difference between my contextualization and the textual anchoring that surrounds photographs used as illustrations. In my readings of the America-photographs, contextualizing serves not to confirm other stories but to illuminate the photographs' own stories and to demonstrate how they are embedded in historical processes.

This examination of the photograph's inherent value as an entrance to history is inspired by John Roberts's observations about the photograph as a form of singular truth events with critical power and the capacity to function affectively and emphatically.[1] I have argued that the America-photographs may have an equally strong interventional impact and emotional hold as the letters have had. Although the letter writers were cautious in encouraging their friends and relatives to follow them across the Atlantic, they nonetheless showed what could not be directly expressed in words by enclosing images of the bountiful fields and the material prosperity in America (Figure C.1). If letters emphasize fertile lands and their economic potential, the photographers' version of the same subject can assume an almost poetic character.

Andreas Larsen Dahl's photographic work, discussed in chapter 1, also exemplifies this idea. He produces images of farmlands that, unlike those at home in Norway, stretch as far as the eye can see. The foreground figure in Dahl's images, the Norwegian immigrant, becomes a scale for the vastness of this landscape. At the same time, his presence in such surroundings works as a political indicator of the opportunities that a new life in America might offer. Roberts sees the photographer's ability to arrive unannounced as a prerequisite for what he describes as a photograph's capacity to act as a so-called truth event. Dahl, however, was not exactly a photographer who arrived unannounced. He spent time and effort developing his carefully composed images. Yet the realities that he captured with his camera included precisely what those in power may have preferred not to be exposed. His photograph of Marcus Thrane's supporters in Wisconsin, portrayed in front of a banner stating their socialist convictions, would, for example, represent a part of the realities that the dominant Norwegian-American clergy probably would have liked to keep hidden. Dahl's photographs had the potential "to get in the way of the world."[2]

That may also be claimed about another genre in which Dahl excelled as a photographer, the family group in front of the home. His photographs within this genre emerge as material tableaux loaded with meaningful objects. The photographs show off the immigrants' new buildings (adorned with architectural details unknown in the old country), their books, flowers, furniture, lace curtains, and elegant clothing. Some families even managed to have their piano carried out to the porch for the photography session. Such elaborate poses may potentially be perceived as merely an expression of the petit bourgeois mind-set, which Roberts sees as typical of nineteenth-century photographic practices. But for him this understanding is incompatible with photography's ability to disrupt the prevailing ideologies and power hierarchies.[3] It reduces the potential meaning of these images. By sending home the

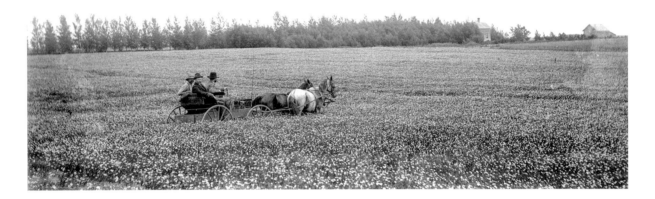

FIGURE C.1. Ole E. Flaten, landscape near Moorhead, Minnesota, circa 1900.

photographic tableaux of prosperity, Norwegian immigrants could demonstrate how life had done well by them in America, despite warnings from authorities hostile to emigration in their country of origin.

Migration historians, among them Orm Øverland, David Mauk, and more recently Daron W. Olson, have long discussed the evolution of Norwegian-American identity and self-image. Olson points to how Norwegian-American image makers aimed at three target audiences: Americans, Norwegians, and Norwegian-Americans.[4] Dahl's photographic work was directed at an audience composed of precisely these categories. Based on my readings of Dahl's photographs, however, it appears paradoxical that the historical research on identity and image making does not take into account the actual visual self-representations that were created in Norwegian-American immigrant communities not only by Dahl but also by other photographers. Dahl's group portraits take the form of complex and conspicuously staged identity-political performances. They reflect both the photographer's attentive and creative presence on the scene and the attitudes and political views of the subjects of his portraits.

The pastor's family posing under the Norwegian flag signals loyalty to the country and the culture they came from. The appearance of material wealth in the background additionally indicates the pastor's prominent and trusted position in the Norwegian-American community. The portrait of the family of carpenters speaks of professional pride and family togetherness, while the married couple who were adherents of Marcus Thrane chose to be photographed under a banner reading "Freedom, Equality, Enlightenment!" They engaged their family portrait to signal the values on which they chose to base their new life on a new continent.

Andreas Larsen Dahl came from a poor tenant-farming family in Norway, and many of the photographers in the generation that followed also came from modest social classes. Their photography businesses were different, in part because they worked as settled, small-town photographers as opposed to Dahl's itinerant practice. The pictures they took appear, to a far greater degree than his, as reflections on being a part of a community: they convey a collective identity. In his photographic strolls with a camera through the streets of Lanesboro, Minnesota, Gilbert Ellestad created a record of a small community at a particular time in history. His unsentimental snapshots of the place and its residents are descriptive and historical but also affective and empathic in nature. These are images that are "unannounced" and exemplify photography's ability to cut into a social reality at a distinct period of time, and thus they both go against and complement the established migration historical narratives.

The interventionist power of America-photography may also be located in Haakon Bjornaas's surreal postcard montages, which with ironic playfulness comment on the clash between gilded dreams of America and everyday realities. The immigrants in American small towns were largely relegated to working-class occupations, and some photographs present themselves as explicit commentary on the social tensions in these towns. Ole Aarseth's portraits with socialist banners featured prominently in the background, as well as his documentation of labor and daily life, speak not only to the photographer's political standpoint; they also bear witness to the choice the photographer has made to use the camera to channel critical engagement on behalf of a collective "we."

The ability of small-town photographers to complement or to cut into the fabric of emigration historiography is also linked to their function as local masters of ceremony. They have captured aspects of Norwegian-American life that often became lost in historical studies. Sylvester Wange's photography, which depicts the daily activity of local businesses and small-town cultural and entertainment life, models

this particular capacity. Wange routinely turned up with his camera at major events such as weddings, baptisms, and funerals. His photographs serve as objects of contemplation for both sorrow and joy. Thus he had, as did many other Norwegian-American small-town photographers, a central identity-building role in the local social community he was a part of in his new homeland.

Pictures of Longing also demonstrates how photographic interventions are not necessarily concerned only with what is depicted in a single photograph. The interventions speak to underlying political and social concerns as well (those that cannot necessarily be seen visibly). For example, the photographic work could have the potential for personal and political liberation when it came to gender. The photograph of homesteader Mina Westbye sitting and reading in front of her modest home on the prairie in steadfast solitude is historiographically challenging on many levels. It evokes reflections about the role of women in migration history and the historical intersection of gender, ethnicity, time, and place, a theme that only a few years ago became a topic of discussion and the subject of systematic studies in Norwegian-American historical research.[5] Read in the context of written material, such as personal letters, this photograph contributes to an understanding of how and why the professional photographic culture related to migration included women behind the camera.

Amateur photographer Peter Julius Rosendahl had no intention of turning his photographic production into a livelihood. His photographs can almost be seen as aspects of a greater artistic lifework, which also included comics and poetry. Perhaps it is precisely this project's poetic, existential character, its closeness to his home in Spring Grove, Minnesota, and to the rhythms and the changes of this place, that gives it the potential to disrupt historical migration narratives. But his photographic production also has political undertones and overtones: for Rosendahl, photographs can, like his comic strips and political poems, be considered a respectful awareness of and a declaration of support for midwestern farmers and their struggle for better economic conditions in an era of communist fear as well as pressure from the forces of capitalism and from linguistic and cultural Americanization policies.

In the book's last chapters I discussed America-photography apart from its present context in the archives, accentuating how these photographs were, and still are, able to not only function as descriptive history but also provide an emotional hold on their viewers. The images materialize Norwegian and American local communities' own stories about migration: emotional goodbyes, dramatic ocean crossings, encounters with and assimilation to an alien American lifestyle and culture. They

highlight the new arrivals' fascination with modernity in the form of pictures of new and modern clothes, streets lit with electricity, and telephones, among other images. Along with life stories and anecdotes—the fragmented memories still to be found in such communities—the photographs are able to intervene in the viewer's experience of migration history simply by breathing life, materiality, and emotion into it. But the archives also have another form of intervening potential, an ability to bring forth migration history's difficult and painful aspects. Some of the photographs in the Setesdal archives, for example, testify indirectly to the historical process that led to the displacement of indigenous populations. Only recently have Norwegian-American historians begun to mention the Norwegian participation in this process as settler colonialism.[6] At the Norwegian Migration Museum in Hamar, this narrative is still absent.[7]

In relation to the question of photography's potential for intervention, I will conclude by briefly commenting on this book's title. When I published the Norwegian edition in 2009, I was criticized by some members of the elder generation of Norwegian migration scholars for my choice of title. They liked the book, but they did not like that I called it *Pictures of Longing.* After pondering this response, I now believe I understand why they reacted as they did. In correspondence with the methodological nationalism that has dominated history writing in general, narratives of emigration history often have a celebratory tone. Such traditional heroic accounts about brave Norwegian settlers (mostly) on the prairie are indeed emotional (Figure C.2). But the qualities and emotions in the forefront of these stories are "the hard ones," often pride, courage, and strength.

Longing, however, the sentiment central to the contents of private and public archives, and particularly to its visual material, is usually placed on a different and softer scale in the wide range of emotions. As argued by Sarah Ahmed, the use of the metaphors of "softness" and "hardness" shows us how emotions become attributes of collectives, which are constructed as "being" through "feeling." She points to how such attributes are gendered, as the soft body is a feminized body, which may be penetrated or invaded by others.[8] My critics were men who did not approve of my emphasis on how the sentiment of longing frequently comes up in the visual and written material of migration archives. As one of them stated: "I do not see any longing in the images in this book—only courage and stamina."

But longing is linked to the experience of being between something, between countries, cultures, past and present. Like many other immigrants, Josefa Kallestad (whose portraits are discussed in chapter 6) surely longed for her family in Norway

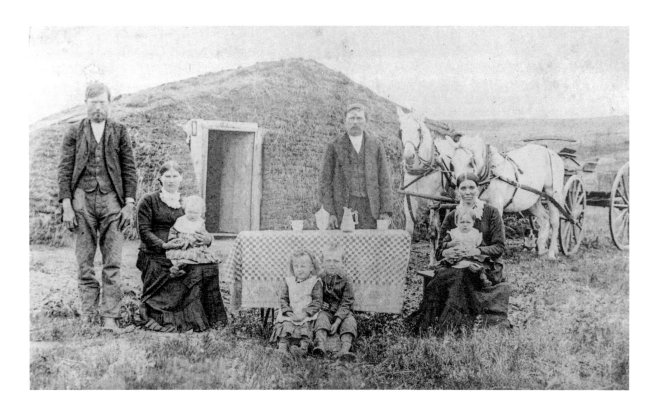

FIGURE C.2. Martinus B. Olson with his family, Griggs County, North Dakota, circa 1886.

and the place where she had grown up. But she also longed for a better future in her new home country. Longing can thus be directed toward the future as well as the past. Photographs have the intervening potential to regain the emotional visibility of history. They allow the viewer to be in touch with history as one of sentiments, including the so-called soft ones, like longing.

The America-photographs clarify what lies between the lines and emphasize the unspoken in the letters. In the photographs are the imprints of the past and the relations with people and places that are no longer reachable. In their details, the memories that visualize and conceptualize the links between present and past are manifested. In the photograph, for example, the wrinkles or smile associated with specific faces can be recognized; the cherry tree by the barn wall begins to waft fragrance again. The longing for and dreams of the future are made visible in the metal luster of the new plow or in the photographic manifestations of endless cornfields. Longing not only for the past but also for the future becomes present and tangible in the America-photographs.

Norwegian-American Photographers, 1860–1960

The following photographers lived and worked in the geographic areas of Norway and America discussed throughout this book. Though this list could undoubtedly be far more comprehensive, this directory points to the high number of Norwegian-American photographers who were active during a pivotal moment in European emigration history. In addition to found photographs, source information comes from the collections of the Minnesota Historical Society, Penn State University Libraries, the Scandinavian East Coast Museum, Setesdal Museum, the Institute for Regional Studies at North Dakota State University, the archives of the Norwegian-American Historical Association, the University of Washington Libraries, Vesterheim Norwegian-American Museum, the Wisconsin Historical Society, and Susanne Bonge's *Eldre norske fotografer: Fotografer og amatørfotografer i Norge frem til 1920* (Bergen: Universitetsbiblioteket, 1980). Further sources of interest can be found in the bibliography.

Aaberg, J. P.
1880s-1890s, Cooperstown, Wisconsin

Aanensen (Aanesen), Louise (Lovisa)
1900s-1930s, Kopervik and Skudenes, Norway

Born in Kopervik, Norway, 1879. Worked in United States 1920s.

Aanes, B. J.
1910s, Shakopee, Minnesota

Aarseth, Knute Mattiason
1890s-1900s, Minnesota (Echo, Belview)

Born in Hjøringfjord, Norway, 1874. Emigrated 1887. Died 1915.

Aarseth, Ole Mattiason
1910s-1920s, Minnesota (Echo, Belview)

Born in Hjøringford, Norway, 1881. Died 1965. Lists "none" as occupation in 1930 U.S. census.

Aarsten, Arnt Jacobson
1910s-1920s, Minnesota (Hallock, Karlstad)

Born in Aarsten, Norway, 1878. Died in Halma, Minnesota, 1936. Worked in partnership with Gust H. Johnson until 1912. Operated a portable tent studio.

Amundson, Alf
circa 1900, Fargo, North Dakota

Anderson, Andrew H.
1893-1902, 1936, Minnesota (Hallock, Crosby, Fergus Falls, Fosston), North Dakota (Grand Forks)

Born in Norway, 1867. Died in Hallock, Minnesota, 1960. Photographer and farmer. Apprenticed in Fergus Falls, Fosston, and Grand Forks before beginning a photography business, Anderson & Hartvig, in Hallock in the 1890s. Sold his interest in the business to partner William Hartvig to focus on farming. Returned to photography when he bought studio of G. G. Shaker in Hallock in 1936.

Anderson, C. W.
1900s-1920s, North Dakota (Grand Forks), Minnesota (Brainerd, Minneapolis)

Anderson, D.
circa 1900, Cooperstown, North Dakota

Anderson, James O.
1890s–1910s, Amery, Wisconsin
Born in Norway, 1866. Lists "none" as occupation in 1920 U.S. census.

Anderson, Ole
1880–1900, Montevideo, Minnesota

Arntsen, John
1900s, Montevideo, Minnesota

Aune, Alexander O.
1880s, Albany, Wisconsin

A *carte de visite* by Aune in the collections of the Wisconsin Historical Society is marked "Alexander O. Aune, Traveling artist."

Baardson, B. L.
1900s, Bismarck, North Dakota

Belgum, Mons M.
1890s–1910s, Cooperstown, North Dakota

Born in Norway, 1856. Died 1913.

Benson, George
1910–1920s, North Dakota (Sharon, Finley)

Born in Sogn, Norway, 1879. Emigrated 1900.

Benson, Ole (Benson Studio)
1910s–1920s, North Dakota (Litchville, Kathryn)

Born in Bremnes, Norway, 1881. Emigrated March 1909. Trained as a photographer in Norway.

Berg, Christena (Berg Studio)
1890s–1920s, Grand Forks, North Dakota

Born in Wisconsin, 1855. In charge of the studio in Grand Forks after the death of her husband, Jacob Berg. Listed in the 1900 census as "photographer."

Berg, Jacob (Berg Studio)
Minnesota (Minneapolis), North Dakota (Grand Forks)

Born in Norway. Died in Grand Forks, North Dakota, 1898. Worked with Swedish photographer John H. Oleson in Minneapolis, 1881–82. Successor: Christena Berg.

Berg, ?? (Bratlee & Berg)
1880s, Devils Lake, North Dakota

Berget, Martin J.
1890s–1920s, Minnesota (Warren, Argyle)

Born in Nordsinni, Norway, 1863. Died in Warren, Minnesota, 1927. Sold the Warren studio to Axel E. Johnson in the 1920s. His son, Norman Berget, operated the photography business beginning in 1929.

Berget, Norman
1920s, Warren, Minnesota

Father, Martin J. Berget, was a pioneer photographer in Warren. Operated a business beginning in 1929.

Bersagel, T. L.
1880s–1910s, Minnesota (Dexter, Lanesboro)

Born in Stavanger, Norway, 1871. Learned photography in the Hanson Studio in Lanesboro. Purchased Hansen Studio in 1887 from A. Hansen. Sold the business to Mathias O. Bue in 1915.

Bjornaas, Haakon
1900s–1910s, Minnesota (Clitherall, Underwood, Baudette)

Born in Otter Tail County, Minnesota, 1884. Died in Underwood, Minnesota, 1949. Operated a studio in Clitherall. Worked as an itinerant photographer throughout northern Minnesota. Many of his photographs were made into postcards.

Boen, P.
1880s–1890s, Portland, North Dakota

Borgen, ?? (Marthinson & Borgen)
circa 1890, Reynolds, North Dakota

Borlaug, O. E.
1887–94, Iowa (Calmar, Decorah)
Born 1856. Died 1894.

Boyer, Henry (Boyer Brothers & Rose)
1880s–1910s, Wisconsin (Superior), Minnesota (Duluth)

Born in Norway.

Boyer, Robert H. (Boyer Brothers & Rose)
1880s–1910s, Wisconsin (Superior), Minnesota (Duluth)

Born in Norway.

Brandli (Brandly), Christianna
circa 1900, Hanska, Minnesota

Born in Lake Hanska Township, Minnesota, 1878. Married to photographer Andrew W. Lien. For periods of time, she would run the studio for him.

Brandmo, R. E.
1880s–circa 1900, Benson, Minnesota

Operated in partnership with A. J. Hoiland.

Bratlee, ?? (Bratlee & Berg)
1880s, Devils Lake, North Dakota

Bue, Mathias (Matt) O. (Bue Studio)
1910s–1940s, Iowa (Decorah), Minnesota (Granite Falls, Cottonwood, Lanesboro, Houston)

Born in Gudbrandsdalen, Norway, 1889. Predecessors: A. N. Hoppelund and T. L. Bersagel. In 1910, bought the gallery of A. N. Hoppelund in Cottonwood. In 1911–12, took over the Bersagel studio in Lanesboro. Combined business into gift shop and photography studio. In 1945, sold the Lanesboro photography studio to Robert Fifield and George Barry and kept the gift shop.

Bye, Hartvig H.
1880s–1900s, Minnesota (Breckenridge), North Dakota (Valley City)

Born in Halden, Norway, 1863. Emigrated circa 1882. Died 1934.

Cappelen, Wilhelm (Will)
Brooklyn, New York

Born in Brooklyn. Listed in the New York City directory in 1915, 1916, and 1925.

Carlson, ?? (Carlson & Wold)
1880s–1890s, Willmar, Minnesota

Dahl, Andreas (Andrew) Larsen
1870s, Dane County, Wisconsin

Born in Valdres, Norway, 1844. Died 1923. Worked as an itinerant photographer.

Dahl, ?? (Dahl Bros.)
circa 1900, Mayville, North Dakota

Dalager, L. E.
1920s, Austin, Minnesota

Dalseg, Olaf (Dalseg Studio)
1940s–1950s, Fergus Falls, Minnesota

Dorge, Elias G. E.
1891–1915, Minnesota (Minneapolis), North Dakota (Fargo)

Born in Stavanger, Norway, 1863. Emigrated 1881. Died 1915.

Eggan Bros.
1880s–1890s, Seattle, Washington

Eggan, Halvor P.
1880s, Minneapolis, Minnesota

Eggan, Ole P.
1880s–1900s, Minneapolis, Minnesota

Eggan, Sever (Seaver) P. (Eggan Studios)
1890s–1920s, Minneapolis, Minnesota

Eggan, Stephen
Minneapolis, Minnesota

Egnes, John
1870s, Story County, Iowa

Eide, Ole Haldorsen (Holden & Eide)
Dell Rapids, South Dakota

Born in Ullensvang, Norway.

Eide, Peter L.
1910–1920s, Minnesota (Hawley), North Dakota (Bottineau)

Born in Østerdalen, Norway, 1869. Emigrated 1888. Died 1961.

Elkjer, Erick (Elkjer Studio)
1900s–1920s, Minnesota (Fosston, Willmar)

Opened a branch studio in New London, Minnesota.

Elkjer, H. (Elkjer Studio)
1900s, Willmar, Minnesota

Elkjer, William P. (Elkjer Studio)
1918-28, Willmar, Minnesota

Ellestad, Gerhard A.
1910s, Minnesota

Born in Fillmore County, Minnesota. Amateur photographer.

Ellestad, Gilbert B.
1890s-1910s, Lanesboro, Minnesota

Born in Fillmore County, Minnesota, 1860. Amateur photographer. Sold cameras and photography accessories as a sideline in his store.

Ellingson, ?? (Ellingson & Laurens)
1880s, Fargo, North Dakota

Most likely Ellingson worked as a photographer only for a short time, presumably between 1887 and 1889. Little is known about his partner, A. Laurens.

Enebo, L. S.
circa 1900, Minneapolis, Minnesota

Engell, Christian (Engell & Son)
1880-1914, Spring Grove, Minnesota

Born in 1841. Engell also ran a funeral agency in a building called "The Morgue."

Erickson, Petrina J. (born Sunstad)
1914-16, Fargo, North Dakota

Born in Leirfjord, Norway, 1872. Ran Erickson Studios after her husband, Soren O. Erickson, left for Montana in 1914. The couple divorced in 1916.

Erickson, S. O. (Erickson Studios, Erickson's Photo Studio, Erickson and Company)
1903-14, North Dakota (Fargo), Minnesota (Barnesville)

Born in Norway, 1875. Emigrated 1875. Trained as a photographer in Eureka, Kansas, 1897.

Evenhaugh, Hans
1890s-1900s, Minnesota (Minneapolis, Fosston)

Evenson, Ole
1902, Perley, Minnesota

Felland (Feland), Ole G.
1880s-1920s, Northfield, Minnesota

Born in Koshkongong, Wisconsin, 1853. Died 1938. College professor and amateur photographer. His collection of 1,500 glass-plate negatives from the late 1800s is in the St. Olaf College archives.

Fjelstad, P. A.
1894-95, Belgrade, Minnesota

Flaten, Gilbert E.
1880s-1890s, Minnesota (Moorhead, with brother, Ole E.), North Dakota (Fargo)

Born in Valdres, Norway, 1856. Died 1896. Took over Haynes Studio in Fargo in 1890; sold the studio to Carl J. Reis and Theodor Larsen in 1893.

Flaten, Ole E. (Flaten Photograph Studio, Flaten & Skrivseth)
1870s-1920s, Minnesota (Minneapolis, Moorhead, Northfield)

Born in Valdres, Norway, 1854. Died 1933. Worked with John Grayton, Northfield photographer. In partnership with Jacob L. Skrivseth. Worked with John Oleson, Minneapolis, who sent him to Moorhead to establish a studio. After his retirement in 1930, he sold studio to Gerhardt E. Oyloe.

Flaten, Ove W.
circa 1900, Moorhead, Minnesota

Flaten, R. W.
1910s, Duluth, Minnesota

Flo, Isaac (Flo Studio)
1880s-1890s, Minnesota (Blue Earth, Ceylon, Sherburn, Fairmont)

Born in Stryn, Nordfjord, Norway, 1866? Died 1922. In partnership with brother, Iver Flo, at Blue Earth; assisted by wife, Tillie Flo. Studio was continued by his daughter, Tillie Flo. Established branch studios in Ceylon, Sherburn, and Madelia.

Flo, Tillie (Flo Studio)
Minnesota (Blue Earth, Ceylon, Sherburn, Fairmont)

Died 1947. Assisted husband, Isaac Flo; then assisted daughter, Tillie Flo.

Flo, Tillie (Flo Studio)
1920–1950s, Fairmont, Minnesota

Born in Sioux Falls, South Dakota, 1894. Died in Fairmont, Minnesota, 1981. Daughter of Isaac and Tillie Flo. Operated Flo Studio until 1956 after Isaac's death in 1922.

Floe, E. E. (Flo Studio)
circa 1900, Minnesota (Ceylon, Sherburn, Madelia, Blue Earth, Fairmount)

Floe, Easton
1904–14, Blue Earth, Minnesota

Forseide, John J. (Wigness & Forseide)
1890s, Buckley, Washington

Born in Norway, 1858. Emigrated 1882. It is probable that John Forseide's partner, Mr. Wigness, is John Viknes, or John Wagness. Forseide moved to Washington in 1890, where he ran a studio specializing in stereo photography.

Foss, Charley
1870s, Luverne, Minnesota

Possibly the same Charles Foss who operated in Trondheim, Norway, in the 1860s.

Foss, H. E.
1910s, Bagley, Minnesota

Foss, Nels P. (Gesme & Foss)
1880s, Morris, Minnesota

Fossum, Levi
circa 1900, Minnesota (Winona, Mabel)

Owned a store in Decorah, Iowa, in 1895. Worked in a bank in Flaxton, North Dakota, circa 1903.

Fossum, Louise
1903–20, Minnesota, North Dakota

Born in Iowa, 1871. Died 1961. Levi Fossum's sister. Came from Minneapolis to Flaxton, North Dakota, in 1902 and homesteaded in Vale Township. Returned to Minneapolis in 1920.

Fossum, P. R.
1920s, Northfield, Minnesota

Frey, Hildur
1910s, Minneapolis, Minnesota

Also known as Hildur Frey Allen Peterson.

Furre, S.
1886, Grand Forks, North Dakota

Gjelhaug, J. A. (Gjelhaug Brothers)
1910s–1920s, Minnesota (Spooner, Baudette)

Also known as J. A. Gielhaug.

Glerum, I.
1880s, Cooperstown, North Dakota

Glesta, Jack
1920s, Fargo, North Dakota

Born in Valley City, North Dakota, 1891.

Gunderson, John
1890s, Minneapolis, Minnesota

Haapland, H. O.
Hanley Falls, Minnesota

Hagemann, Benedicte Cathinca
1863–69, Bergen, Norway

Born in Risør, Norway, 1840. Died 1922. Married in New York to Dr. William Noah Guernsey (died 1901).

Halmrast, Andrew E. (Halmrast Brothers)
1880s–1910s, Minnesota (Stillwater, Minneapolis)

Predecessor: Theodore A. Sather. In partnership with his brother, Gustav Halmrast, in Stillwater until 1900. Bought Theodore A. Sather's in Minneapolis. His son, Eilif, took over the business after his death in 1931.

Halmrast, Eilif (Halmrast Studio)
1930s–1940s, Minneapolis, Minnesota

Son of Andrew E. Halmrast. Took over family business in 1931. After his death in 1945, his wife, Ragnhild Halmrast, ran the studio.

Halmrast, Gustav (Halmrast Brothers)
1880s–1920s, Minnesota (Stillwater, Minneapolis)

In partnership with his brother, Andrew Halmrast, in Stillwater until 1900, when Gustav was listed as sole proprietor.

Halmrast, Ragnhild (Halmrast Studio)
1940s–1950s, Minneapolis, Minnesota

Took over Halmrast Studio after her husband, Eilif Halmrast, died in 1945.

Halseth, E.
1894–95, Kensington, Minnesota

Halvorsen, John, R.
1878–84, St. Ansgar, Mitchell County, Iowa

Hamre, Nels Peter
1910s, Aneta, North Dakota

Born in Selje, Norway, 1877. Emigrated 1880. Died 1940. Lost his leg in an accident in his teens. Apprenticed in Benson. Bought the studio in Aneta in 1910. Many of his photographs were printed in *The Norwegian Farmers in the United States* (Fargo: Hans Jervell, 1915).

Hansen, A. (A. Hansen & Son)
1880s–1890s, Tacoma, Washington

Hansen, Hans T. (Hanson)
1891–1930, North Dakota (Hope, Fargo)

Born in Albert Lea, Minnesota, 1865. Died 1941. Operated as Logan & Hanson, 1893; as Hanson & Stene, 1897; as Hanson & Reis, 1899–1900; as Hansen & Rudd, 1909. A traveling photographer with a portable studio early in his career.

Haugs, J. A.
Galesville, Wisconsin

Hildahl, George S. (Fairbanks & Hildahl)
1878, 1884, 1886, 1892–95, Minnesota (St. Paul, Minneapolis, Austin)

Born in Norway, 1855. Operated with R. I. Smith in 1878. In partnership with Henry D. Fairbanks. Employed by photographers Pepper & Son, St. Paul. Succeeded to the business of R. I. Smith in Austin.

Hoffstad, Peter J.
1900s–1910s, Chicago, Illinois

Born in Norway, 1865. Listed as "photographer" in the 1910 U.S. census. In the census of 1920 his widow and son have taken over the studio.

Hoiland, A. J.
1870s–1880s, Benson, Minnesota

Worked in partnership with R. E. Brandmo.

Holand, Albert P.
Probably 1880s–1920s, Grand Forks, North Dakota

Born in Hena, Helgeland, Norway, 1865. Emigrated 1884. Listed as "photographer and landlord" in his application for an American passport in 1920.

Holden, Hans (Holden & Eide)
1880s–1890s, Minnesota (Ada), South Dakota (Dell Rapids, as Holden & Eide)

Born in Norway, 1861.

Hole, Peter B.
1890s–1930s, McIntosh, Minnesota

Born in Tretten, Gudbrandsdalen, Norway, 1878. Died 1963. Learned photography from O. K. Lee in McIntosh.

Holm, Julius (Holm & Snesrud)
1890s, Minneapolis, Minnesota

Holm, Olof A.
1890s–1910s, Roseau, Minnesota

Holmboe, Even M.
San Diego, California

Born in Tromsø, Norway, 1842. Worked as "photographer and legal assistant."

Hopland, A. M.
1900s–1910s, Minnesota (Dawson, Clarkfield)

Also known as A. M. Hopplin.

Hopland, Wilhelm
Cottonwood, Minnesota

Indrelee, Andrew H.
1890s–1900s, Fosston, Minnesota

Born in Bergen, Norway, 1862. Died 1909.

Jansen, John A.
1910s, Minnesota

Possibly the photographer Johan Martin Jansen who emigrated from Bergen in 1894.

Jansrud, Baklund
1910s, Willmar, Minnesota

Jansrud, J. C. (Jansrud Photo Studio)
1880s–1900s, North Dakota (Fargo), Idaho (Twin Falls)

Born in Norway, 1887. Died 1936. Listed as "teacher" in the U.S. census of 1900. Possibly the J. C. Jansrud who taught design and engraving at the seminary in Willmar, Minnesota, 1884–1905. In partnership with Elias Dorge in Fargo.

Joerg, F. E.
1890s–1900s, Spring Grove, Minnesota

Jorgenson, Niels C.
Cando, North Dakota

Born in Kragerø, Norway, 1858. Emigrated 1896 (1926).

Kelly, Hans Paulsen (Killy Studio / Killy Brothers Studio)
1890s–1930s, Wyoming (Lander, Loger), Missouri (Kansas City), Minnesota (Bird Island, Renville)

Also known as H. P. Kelly and Hans Paul Killy. Born in Sacred Heart, Minnesota, 1880. Died 1935. Worked for F. J. Lee in Bird Island. Purchased Gummert's studio in Renville in 1901. Sold Minneapolis studio at 6–8 East Lake Street to Fred Nordin. Moved into the Bell-Larson Photoshop in 1929.

Killy, Monroe P. (Killy Studio)
1930s–1950s, Minnesota

Born in 1910. Worked in father's studio (Hans Paulson Kelly) in the 1930s.

Killy, Sever (Killy Brothers Studio)
1900s, Crookston, Minnesota

Kjelsberg, Oscar
1910s, Glenwood, Minnesota

Born in Ramsey, Minnesota, 1875.

Klemetsrud, Ole H.
1890s–1920s, Minnesota (Ada, Twin Valley, Ulen, Fertile)

Born in Valdres, Norway, 1865. Established branch studios in Ulen and Fertile.

Kleven, O. T.
1910s–1920s, Grand Forks, North Dakota

Knutson, J. O.
1880s, Northwood, Iowa

Larsen, Rudolph
1920s–1950s, Bay Ridge, Brooklyn, New York

Larson, Christian
1898–99, Blue Earth City, Minnesota

Possibly the Christian Ernst Larsen who, according to Bonge, emigrated from Bergen in 1895.

Larson, Martin E.
1890s–1910s, Minnesota (Wanamingo, Zumbrota)

Also known as M. E. Larson. Born in Wanamingo, Minnesota, 1871. Predecessor: O. E. Pearson.

Laurens, A.
1890s–1914, North Dakota (Fargo), Missouri (Livingstone, Billings)

Lee, Christian T.
North Dakota (Fargo, Harvey, Grand Forks)

Born in Norway, 1871. Emigrated 1888. Worked for Hans T. Hansen in Fargo. May have worked as "Lee & Co." in the 1920s in Grand Forks.

Lee, Frank Julius
Tacoma, Washington

Born in Wisconsin, 1864.

Lee, Martha (Lee Brothers Studio)
1940s, Minneapolis, Minnesota

Also known as Mrs. Thorwald Lee. Took over Lee Brothers business from her husband, Thorwald Lee, in the 1940s.

Lee, Peder (Lee Studios)
1880s–1940s, Minnesota (St. Paul, Minneapolis)

Born in Kristiansund, Norway, 1862. Died 1945. Established St. Paul studio in 1903. In partnership with his brother, Thorwald, until 1919. Moved to Austin, Minnesota, in 1927.

Lee, Thorwald (Thorvald) (Lee Brothers Studio)
1880s–1940s, Minnesota (Minneapolis, St. Paul)

Born in Kristiansund, Norway, 1864. In partnership with his brother, Peder Lee, until 1919, when Peder concentrated on business in St. Paul and Thorwald continued in Minneapolis.

Leet, Sigmund (Leet & Bogdan)
1920s, 1930s, Minnesota (Minneapolis, St. Paul)

Lien, Andreas P.
1900–circa 1909, Minnesota (Hanska, Minneapolis)

Born in Lesjaskogen, Norway. Brother of Mathias Lien. His successor in Hanska was Mina Westbye.

Lien, C. K.
1870s–1880s, North Dakota (Cooperstown), Minnesota (Mayville)

Lien, Mathias
Minnesota

Born in Lesjaskogen, Norway. Emigrated 1897. Died 1899. Brother of Andreas P. Lien.

Lind, Thyra
Born in Gildeskaal, Norway, 1865. Emigrated 1903.

Lofthus, P. H.
1890s, Houston, Minnesota

Born in Norway, 1866. Listed as "photographist" in the U.S. census of 1895.

Lonset, Elias
1910s, Stewart, Minnesota

Magnusen, Norwall
1880s, St. Paul, Minnesota

Marthinson, ?? (Marthinson & Borgen)
circa 1890, Reynolds, North Dakota

Mathieson, Henrietta
1880s, 1910s, Duluth, Minnesota

Born in Hamarøy, Norway. Trained as a photographer in Norway before emigrating. Worked as an assistant and retoucher for Boyer Brothers in the early 1890s. His sister, Marie, also listed "photographer" as occupation.

Mehl, George O.
Minneapolis, Minnesota

Melby, G. M.
1920s, Minneapolis, Minnesota

Moe, O. J.
1880s–1890s, Minnesota (Northfield, Appleton)

Moe, Ole
1870s–1880s, Minneapolis, Minnesota

Moen, Carl Robert (Moen's Art Studio)
1900s–1910s, Minnesota (Peterson, Harmony, Mabel, Preston), Wisconsin (LaCrosse)

Born in Arendahl Township, Minnesota, 1878.

Morrison, Martin
1884–1916, Norway (Jæren), Iowa (Ames), Alabama (Birmingham, Fruithurst)

Born in Time, Jæren, Norway, 1844. Died 1916.

Moss, T. F.
1890s, Houston, Minnesota

Mossefin, Mons O. (Piper& Mossefin)
1890s–1920s, Minnesota (Duluth, Crookston, Bagley)

Born in Voss, Norway, 1860. Died 1926. Retoucher at the Robinson Studio in Duluth. Successor: H. M. Rudd.

Myhre, Martinius O.
Watson, Minnesota

Born in Larvik, Norway. Genealogy of the Myhre family indicates that Martinius T. Myhre emigrated from Larvik to Minnesota in 1860.

Myhre, Ole S. (Myhre Studio)
1890s–1920s, Minnesota (Luverne, Sacred Heart)

Also known as O. S. Myhre. Successor: Ole C. Sparstad.

Myhre, S. H. (Myhre Studio)
1922, 1926–27, 1930, Luverne, Minnesota

Also known as Sandy Myhre.

Myklebust, Christ Pedersen
Eagle Grove, Iowa

Born in Uskedal, Norway, 1869. Emigrated 1905. Also worked as a photographer on commission in Norway for American customers.

Nasvik, Harland P.
1930s–1990s, New Hampshire (Durham), Minnesota (Minneapolis)

Born in St. Paul, Minnesota, 1908. Died 1993. Head of photography department at General Mills.

Newman (Nymoen), Amund
1880s, Fergus Falls, Minnesota

Born in Målselv, Norway, 1843. Emigrated 1868. After his time as a photographer in Fergus Falls, moved to Lane County, Oregon, where he worked as a tailor.

Nygaard, Harlan Kenneth (Photoplating Company)
1930s, Minneapolis, Minnesota

Born 1899. Died 1965.

Nygaard, J. J.
1900s, Buffalo, Minnesota

Nygaard, Magnus (Nygaard & Smith)
1910s, Minneapolis, Minnesota

Odegard, Elsa
1940s, Mankato, Minnesota

Ofstie, B. G.
1910s, Minnesota (Minneapolis, St. Paul)

Oftedahl, J. J.
1910s, Royalton, Minnesota

Oftedahl, O. G.
1920s–1930s, Mankato, Minnesota

Oftedahl, Ole J.
1900s–1910s, Minnesota (Pemberton, Little Falls)

Ohlsen, Mrs. E. C.
1910s, Minneapolis, Minnesota

Oleson, Anna G. (Oleson Gallery)
1870s–1890s, Minneapolis, Minnesota

Also known as Mrs. John H. Oleson or Anna Oleson Heighstedt. After John H. Oleson died in 1881, Anna took over the business, selling ambrotypes and tintypes. She married Andrew Heighstedt in 1889, at which point he began running the business.

Oleson, E. S.
1880s, Stillwater, Minnesota

Oleson, John H. (Oleson Gallery)
1870s–1880s, Minneapolis, Minnesota

Born in Norway, 1850. Died 1881. Photographer with W. H. Jacoby's gallery before starting his own business. His wife, Anna G. Oleson, continued operating the gallery after his death.

Oleson, Louis
Fertile, Minnesota

Oleson, Paul
1890s, Lamberton, Minnesota

Olsen, Beatrice
1910s, St. Paul, Minnesota

Olsen, C. E.
1920s, Minneapolis, Minnesota

Olsen, D. C.
1890s–1920s, Minnesota (St. Paul, Kenyon, Hibbing)

Also known as D. C. Olson.

Olsen, Don
1890s, Hibbing, Minnesota

Born 1862. Died 1946.

Olsen, L. W.
1910s, St. Cloud, Minnesota

Olsen, O. S.
Sauk Centre, Minnesota

Olsen, Olaf J.
1910s–1930s, LeRoy, Minnesota

Also known as O. J. Olsen or Olof Olson.

Olsen, P. B.
1920s, Minneapolis, Minnesota

Olsen, S.
Probably 1880s–1890s, Brooklyn, New York

Olsen, Wayne C.
Duluth, Minnesota

Olson, Andrew C. (Olson Studio)
1899–1910s, Montana, North Dakota (Fargo), Washington (Vernon)

Born in Sigdal, Norway. Emigrated 1892.

Olson, H. L.
1890s–1920s, Minnesota (Granite Falls, Montevideo, Litchfield)

Born in Norway, 1849.

Olson, Olaf (Olson's Photo & Art Shop)
1900s–1920s, Minnesota (Moose Lake, Duluth, Cloquet)

Born in Norway, 1883. Died 1949. Possibly same person as Oliver Olson.

Onstad, Roy
1914, Wykoff, Minnesota

Opsahl, A. M.
1910s, Deerwood, Minnesota

Opsahl, Anton H. (Opsahl Studio)
1890s–1900s, Minneapolis, Minnesota

Offered portraits in crayon, pastel, and watercolor.

Opsahl, Anton M.
1890s–1910s, Brainerd, Minnesota
Successor: Lars Swelland.

Opsahl, Helga
1900s, Minneapolis, Minnesota

Oren, E. O. (E. O. Oren, Photographer) (Oren & Kufner)
1880s–1890s, Wells, Minnesota

Also known as Eric O. Oren or Erick O. Oren. Born in Norway, 1868. Studied with predecessor James W. Bangs. Began career as an itinerant photographer.

Orninggaard, N. S.
1890s, Minnesota (Grove City, New London, Willmar)

Also known as N. S. Oringgard. Early itinerant photographer. Established branch studios in Grove City and New London, Minnesota.

Osmunson, O. A.
1900s, Crookston, Minnesota

Ostboe, P.
1890s, Prairie River, North Dakota

Ostrom, Christian Johan (Ostrom Studio)
1880s–1940s, Minnesota (Minneapolis, Winthrop, Gibbon), North Dakota (Hillsboro)

Born in Nordfjord, Norway, 1865. Died 1947. Learned photography in Minneapolis. Daughter, Elsie F. Ostrom, continued the business after his death.

Ostrom, Elsie F. (Ostrom Studio)
1940s, Winthrop, Minnesota

Continued the business of her father, Christian Johan Ostrom.

Overland, A. P. (Overland Gallery)
1890s–1910s, Minnesota (Fergus Falls, Two Harbors, Duluth)

Bought Charles E. Bergren's gallery and later sold it back to him.

Overland, Carl
1890s, Minneapolis, Minnesota

Ovestrud, Edmund
1910s–1920s, Spring Grove, Minnesota

Born 1884. Died 1947. Schoolteacher and amateur photographer.

Oyloe, Gilbert G. (Olson & Oyloe)
1880s–1930s, Ossian, Iowa

Successor to the Angell Photo Gallery. In partnership with son, Harold A. Olson, 1920–32.

Oyloe, O. G.
1887–1900, Brookings, South Dakota

Ran furniture store with Carl A. Johnson, 1889.

Petersen, August (Emil)
1890s, Iowa (Gladbrook), Minnesota (Lester Prairie)

Peterson, B. O.
1890s–1900s, Minnesota (Clinton, Owatonna, Graceville, Benson)

Born in Norway, 1874.

Peterson, Christian N. (Peavey & Peterson)
1870s–1930s, Faribault, Minnesota

Born in Norway, 1860. Employed by A. F. Burnham. In partnership with Louis Peavey until 1894.

Peterson, Hildur E. A.
1910s–1920s, Minneapolis, Minnesota

Also known as Mrs. Frank A. Allen or Hildur Frey Allen Peterson. Born in Minnesota, 1888. Died 1927. Photographer and water colorist. Worked at several Minneapolis studios, including E. A. Brush Studio and Bank Brothers Studio.

Quam, M. J. (Quam & Drysdale)
1900s, Walker, Minnesota

Originally dealt in clothing and lumbermen supplies in Brainerd and set up clothing store in Walker. Entered photography business with James S. Drysdale.

Renaas, Albert
1890s–1900s, Decorah, Iowa

Probably born in Toten, Norway.

Reppen, N. O.
1880s, Browns Valley, Minnesota

Born in Sogndal, Norway, 1856.

Risem, Olaf
1900s–1910s, Minnesota (Ely, Virginia)

Also known as Olaf Risen. Successor: John L. Hakkerup.

Rosaas, Edna S.
1930s, Duluth, Minnesota

Rosaas, O. T.
1910s–1920s, Duluth, Minnesota

Rosendahl, Peter Julius
1910s–1940s, Spring Grove, Minnesota

Born in Spring Grove, Minnesota, 1878. Died 1942. Farmer and amateur photographer. Son of Norwegian immigrants. Creator of Norwegian-American comic strip *Han Ola og han Per*, 1918–42.

Roseth, William
1890s, Tracy, Minnesota

Rudd, Harry
Fargo, North Dakota

Born in Norway, 1875. Emigrated 1882. Brother of Peter Axel Rudd. Could be photographer listed as H. M. Rudd but not listed as one in 1900.

Rudd, Peter Axel
circa 1900, Fargo, North Dakota

Born in Norway, 1873. Emigrated 1882. Brother of Harry Rudd.

Rumsey
Whitewater, Wisconsin

Possibly Ole Martin Ramsø, who called himself Ramsey in the United States.

Sagen, Hans O.
1880s–1890s, St. Paul, Minnesota

Salveson, Sigurd (Salveson's Studio)
1910s, Thief River Falls, Minnesota

Sandven, A. A.
1900s, Minneapolis, Minnesota

Sather, Evan A.
1880s–1900s, Minnesota (Bemidji, Minneapolis)

Sather, J. P.
1890s, Benson, Minnesota

Sather, Oscar A.
1890s, Minneapolis, Minnesota

Sather, Theodore A.
1880s–1900s, Minnesota (Minneapolis, Duluth, Hutchinson)

Born in Norway, 1863. Apprenticed with A. Larson in Minneapolis. Purchased Hutchinson studio from John H. Gravenslund in 1896. Successor: Andrew E. Halmrast.

Schawang, Peter
1900s–1950s, Minnesota (Duluth, St. Paul), New York (Buffalo)

Born in Nebraska. Worked in partnership with his son, Peter Schawang Jr.

Schawang, Peter, Jr.
1950s, St. Paul, Minnesota

Worked in partnership with his father, Peter Schawang.

Selset, Alfred J.
1900s–1910s, Minneapolis, Minnesota

Siverts, Peter
1880s–1890s, Minnesota (Dawson, Crosby) Successor: A. C. Rosetter.

Sivertsen, Ferdinand S.
Born in Bergen, Norway, 1878. Emigrated 1894.

Sivertsen, Sverre J.
Born in Lillehammer, Norway, 1876. Emigrated 1903. Photographer and portrait painter.

Sjordal, Theodore
1880s, Underwood, Minnesota
Born in Trondhjem, Norway, 1860.

Skaga, C.
Two Harbors, Minnesota

Skage, Christian L. (Blakemore & Skage)
1890s–1910s, Minnesota (Duluth, Minneapolis)

May be the same person as C. Skaga.

Skage, Isaac A. (Skage Brothers)
1910s, Minneapolis, Minnesota

Skarstad, Julius
1920s, Rushford, Minnesota

Skomsvold, Mathias J. (Fredricks & Skomsvold)
1900s–1910s, Duluth, Minnesota

Skontorp, Finn (Finns Studio)
1950s, Brooklyn, New York

Skrivseth, Jacob L. (Flaten & Skrivseth)
1870s–1880s, 1900s, North Dakota (Mayville, Hillsboro, Fargo), Minnesota (Faribault, Moorhead, Crookston)

Also known as J. L. Skrevseth. Born in Nordmøre, Norway, 1853. Emigrated 1869. Trained as a photographer in both Norway and Albert Lea, Minnesota. Worked in partnership with O. E. Flaten in Moorhead, Minnesota. The two men apparently built a traveling wagon with a built-in darkroom. Flaten stayed in Moorhead and Skrivseth traveled throughout the Red River Valley shooting small-town and farm scenes. They were the official photographers for the St. Paul, Minneapolis, and Manitoba Railroad (later the Great Northern). His partnership with Flaten dissolved in 1881, and he moved to Buxton, North Dakota. He then moved to Hillsboro, North Dakota, in 1882, where he opened a studio. In Hillsboro he rose to prominence and served as the community's mayor.

Sogn, Chester E.
1920s–1940s, Minnesota (Pipestone), Washington (Spokane)

Solberg, O.
1890s, 1900s, Iowa (Decorah, Cresco)

Solem, S. L.
1890s–1900s, Minnesota (Minneapolis, Little Falls)

Sparstad, Ole C.
1890s–1910s, Sacred Heart, Minnesota

Born in Goodhue County, Minnesota, 1869. Trained by Ole S. Myhre in Sacred Heart, Minnesota.

Steihaug, Ole (Steihaug Studio)
1890s–1900s, Minnesota (Kenyon, Minneapolis)
Also known as Ole Stelhaug.

Stene, Charles F.
1890s–1900s, North Dakota (Fargo, Hatton, Aneta)

Born in Wisconsin, 1862. Took over his brother Robert Stene's studio in 1899. Also involved in running a clothing store. Established branches in Hatton and Aneta circa 1900.

Stene, Robert (Hanson & Stene)
1890s–1920s, North Dakota (Fargo, Oakes, Lidgerwood), Texas (Stepenville)

Born in Minnesota, 1872. Brother of Charles F. Stene. For a short period in partnership with Hans T. Hanson in Fargo. Had branches in Oakes and Lidgerwood, North Dakota. By 1899 no longer listed as living in Fargo. Working as a photographer in Stephenville, Texas, in the 1900 U.S. census.

Swelland, Lars
1910s–1920s, Brainerd, Minnesota

Learned photography from Anton M. Opsahl; later bought his studio. Successor: Jessie D. Canniff.

Syftestad, J. T. (Anderson & Syftestad)
1890s, Appleton, Minnesota

Synnes, Albert
Gonvick Area, Minnesota

Thu, Rasmus P.
1890s–1920s, Norway and United States

Born in Tu, Klepp municipality, Jæren, Norway. Crossed the Atlantic regularly, offering images of Norway to immigrants and images from the United States to their relatives in Norway.

Thune, Halvor W. (Thune & Folkendahl)
1880s–1920s, Ada, Minnesota

Pioneer photographer of Ada.

Tollefson, G. L.
1900s, Minneapolis, Minnesota

Ulfseth, C.
1890s–1900s, Brenner, Minnesota

Vang, Knut
1930s–1950s, Brooklyn, New York

Born in Christiania, Norway. Emigrated 1924. Trained as a photographer in Norway.

Viknes, John
1880s–1930s, Minnesota (Clay County), North Dakota (Fargo), Washington (Tacoma, Stanwood)

Also known as John Wagness (Wigness and Forseide). Born in Ulvik, Norway, 1858. The 1880 U.S. census listed him as a photography artist. Probably the same person as John Thorvakd Wagness from Hardanger, Norway. Settled first in Clay County, Minnesota, but later moved to Fargo and Tacoma, working as a photographer in both places. Wagness traveled to the Yukon and worked as a photographer.

Vikre, Geneva (Vikre Studio)
1910s–1940s, Ortonville, Minnesota

Successors: Harold and Marie Vikre.

Vikre, Harold (Vikre Studio)
1940s–1970s, Ortonville, Minnesota

Predecessors: Peter and Geneva Vikre. Successors: Dave and Candy Bjerk.

Vikre, Marie (Vikre Studio)
1940s–1960s, Ortonville, Minnesota

Predecessors: Peter and Geneva Vikre. Successors: Dave and Candy Bjerk.

Vikre, Peter B. (Vikre Studio)
1910s–1940s, Ortonville, Minnesota

Predecessors: Theodore and Elizabeth Farrington. Successors: Harold and Marie Vikre.

Voss, C. L. (Voss & Cappelen)
1910s–1920s, Minnesota (Glenwood, Morris, Benson)

Voss, Harry C.
St. Paul, Minnesota

Voss, Pearl (possibly Voss Sisters)
1920s, Glenwood, Minnesota

Waale, Thomas (Waale Studio)
1920s–1940s, Thief River Falls, Minnesota

Wange, Sylvester Peter (Wange Studio)
1880s–1950s, Minnesota (Ada, Hawley, Audubon)

Also known as S. P. Wenge. Born in Gudbrandsdalen, Norway, 1866. Died 1956. Combined business of photography studio and barbershop.

Wangsness, G. K.
1910s–1940s, Minnesota (Dawson, Appleton)

Predecessor: M. J. Viken.

Westbye, Mina
1907–11, Minnesota (Hanska), Norway (Trysil)

Born in Trysil, Norway, 1879. Emigrated 1900. Took over the gallery of A. P. Lien in 1907.

Wilse, Anders Beer
1880s–1940s, Norway (Christiania), Washington (Seattle)

Born in Flekkefjord, Norway, 1865. Emigrated 1884. Died in Oslo 1949. Traveled extensively throughout Norway. Established a studio in Christiania in 1901 after spending seventeen years in the United States.

Wold, ?? (Carlson & Wold)
1880s–1890s, Willmar, Minnesota

Notes

Introduction

1. Østrem, *Norsk utvandringshistorie*, 33.
2. Semmingsen, *Veien mot Vest*, 233.
3. Gerber, *Authors of Their Lives*, 42.
4. Bate, *Photography*, 244.
5. Ibid., 245.
6. Roberts, *Photography and Its Violations*, 53–54.
7. Ibid., 36.
8. Semmingsen, *Veien mot Vest*, 215.
9. Gerber, *Authors of Their Lives*, 28.
10. Trachtenberg, *Reading American Photographs*, xiii.
11. See, for example, Frizot, ed., *New History of Photography*, 26.
12. Nelson, ed., *Diary of Elisabeth Koren*, 357–58.
13. Koren, *Fra Pioneertiden*, 163. I have cited the original letter, which is now in the National Archives of Norway in Oslo.
14. Øverland and Kjærheim, eds., *Fra Amerika til Norge II*, 37–38.
15. The citation comes from copies of Gro Svendsen's letters in the National Archives of Norway. The letters are published in English in Farseth and Blegen, trans. and eds., *Frontier Mother*, 45.
16. Øverland and Kjærheim, eds., *Fra Amerika til Norge*, vols. 1-7.
17. Bjorli, "Et fotografisk gjennombrudd," 69–112.
18. Bonge, *Eldre norske fotografer*, 11.
19. Larsen and Lien, *Norsk fotohistorie*, 41.
20. Bonge, *Eldre norske fotografer*, 11.
21. Ibid., 434.
22. See, for example, Perez, *Displaced Visions*; or Yochelson and Czitrom, *Rediscovering Jacob Riis*.
23. Williams, *Framing the West*.
24. Pegler-Gordon, *In Sight of America*, 7.
25. Lee, *A Shoemaker's Story*.
26. Mirzoeff, "Multiple Viewpoint," 3.
27. Gabaccia and Moch, "Preface," ix.
28. Mirzoeff, "Multiple Viewpoint," 1.
29. For a discussion about Blegen and his Scandinavian-American peers' contributions to epistolary research, see Gerber, *Authors of Their Lives*, 33-50; and Wtulich, *Writing Home*, 47.
30. Blegen, *Grass Roots History*, vii.
31. Blegen, *Land of Their Choice*, 14.
32. Blegen, *Grass Roots History*, 19-27.
33. Blegen, *Land of Their Choice*, 14.
34. Blegen, *Norwegian Migration to America*, 213.
35. Blegen, *Grass Roots History*, 144-45.
36. Gerber, *Authors of Their Lives*, 34.
37. Ibid., 5.
38. The letter research did not end with Blegen. In the 1930s, the work of collecting letters continued with the contributions of the Norwegian historians Arne Odd Johnsen and Ingrid Semmingsen (1910-1995), the pioneer of Norwegian emigration history research. For Semmingsen, as for Blegen, this documentation represented an important part of the research and the basis for her comprehensive scholarly publishing. The America-letters that have been collected are now in the Department of Historical Documents (Kjeldeskriftavdelingen) in the National Archives of Norway. The work of systematically publishing these letters began at the end of the 1980s and resulted in the comprehensive seven-volume work, *Fra Amerika til Norge: Norske utvandrerbrev*, edited by Orm Øverland and Steinar Kjærheim and published from 1992 to 2010. In the United States, corresponding work was done by historian Solveig Zempel in the single-volume *In Their Own Words: Letters from Norwegian Immigrants* (1991).
39. Øverland, "Learning to Read Immigrant Letters."
40. Øverland and Kjærheim, eds., *Fra Amerika til Norge III*, letter 79, 214.
41. Ibid., letter 156, 346.
42. Øverland, ed., *Fra Amerika til Norge VI*, 96-97.
43. Ibid., 364.
44. Stanley, "The Epistolarium," 208.

45. Gerber, *Authors of Their Lives*, 42.
46. Blegen, *Norwegian Migration to America, 1825–1860* and *Norwegian Migration to America: The American Transition*.
47. Blegen, *Norwegian Migration to America, 1825–1860*, 317–18.
48. Ibid., 342.
49. Blegen, *Grass Roots History*, 86, 96.
50. Ibid., 97.
51. Ibid., 21.
52. Svalestuen, "Professor Ingrid Semmingsen," 12.
53. Semmingsen, *Veien mot Vest*, 307.
54. Roberts, "Photography after the Photograph," 285.
55. Ibid.
56. Ibid.
57. Roberts, *Photography and Its Violations*, 1–5.
58. Mirzoeff, ed., *Diaspora and Visual Culture*, 12.

1. The Glass Plates in the Tobacco Barn

1. Aars, "Andreas Dahl," 38.
2. Mandel, *Settlers of Dane County*, 8.
3. Ibid., 10.
4. Teigen, "Legacy of Jacob Ottesen."
5. Identification was undertaken by the picture archivists at the Wisconsin Historical Society in Madison.
6. Øverland and Kjærheim, eds., *Fra Amerika til Norge III*, letter T-18, 480–81.
7. Ibid., letter 79, 214.
8. Ibid., letter 133, 306.
9. Fapso, *Norwegians in Wisconsin*, 15.
10. Øverland and Kjærheim, *Fra Amerika til Norge III*, letter 155, 342–43.
11. Ibid., letter T-18, 481.
12. Mandel, *Settlers of Dane County*, 9–10.
13. Ibid., 50.
14. Taft, *Photography and the American Scene*, 167–85.
15. Holmes, "Stereoscope and the Stereograph," 78–79.
16. Taft, *Photography and the American Scene*, 185.
17. Mandel, *Settlers of Dane County*, 82.
18. Orvell, *American Photography*, 27.
19. Larsen and Lien, *Norsk fotohistorie*, 6.
20. Ibid., 104.
21. Ibid., 43.
22. Bennett and Juhl, *Iowa Stereographs*, 220.
23. Bonge, *Eldre norske fotografer*, 44.
24. Risa, "Rasmus Pederson Thu," 15–16.
25. "Amerika-bilete," 7.
26. Orm Øverland has brought this correspondence to my attention. The name of the photographer is spelled two different ways in these letters.
27. Gjerde, *Minds of the West*.
28. Ibid., 2.
29. Ibid., 5.
30. Gjerde, "Echoes of Freedom," 51.
31. Gulliksen, "Ole E. Rølvaag," 159.
32. Bakken, *Snikkaren Aslak Olsen Lie*, 13.
33. Ibid., 79.
34. Ibid., 86.
35. An example of Aslak Lie's magnificent carpentry work, a richly decorated cupboard, is exhibited in the Minneapolis Institute of Art.
36. Lovoll, *Promise of America*, 75.
37. Gjerde, *Minds of the West*, 116–17.
38. Lovoll, *Promise of America*, 151.
39. Teigen, "Legacy of Jacob Ottesen," 2.
40. Ibid., 4.
41. Lovoll, *Promise of America*, 151.
42. Leiren, *Marcus Thrane*, 24.
43. This information comes from Professor Terje Leiren, University of Washington, Seattle.
44. Leiren, *Marcus Thrane*, 93.
45. Mandel, *Settlers of Dane County*, 24.
46. Dahl, *Hospitalsmissionen i Tvillingbyerne*.

2. Views from Main Street

1. Lovoll, *Norwegians on the Prairie*, xiii.
2. Ibid., 3–36.
3. St. Mane and Ward, *Lanesboro, Minnesota*, 64–65.
4. Wist, *Rise of Jonas Olsen*.
5. Øverland, "Translator's Introduction," xi–xx.
6. Wist, *Rise of Jonas Olsen*, 287.
7. Clarke, "Public Faces, Private Lives."
8. For a discussion of Walker Evans's photographic work, see Larsen, *Album*, 156–67; and Olin, "It Is Not Going to Be Easy."
9. Gjerde and Qualey, *Norwegians in Minnesota*, 13–23.
10. Wist, *Rise of Jonas Olsen*, 123.
11. This and other biographical information comes from the Northwest Minnesota Historical Center at Minnesota State University Moorhead.

12. Gjerde and Qualey, *Norwegians in Minnesota*, 23.
13. Lovoll, *Norwegians on the Prairie*, 77.
14. Larsen and Lien, *Norsk fotohistorie*, 188–93.
15. Lovoll, *Norwegians on the Prairie*, 94.
16. Øverland, "Translator's Introduction," xxviii.
17. Wist, *Rise of Jonas Olsen*, 167.
18. Lovoll, *Norwegians on the Prairie*, 91.
19. Danielsen, "Den Faglige og Politiske Organisering," 9–11.
20. Peihl, "Wange's Photographs," 8–9.

3. Last Seen Alone on the Prairie

1. Flå, "Økt kvinneutvandring," 171–72.
2. Johannesson, "Photo Exile," 17.
3. Bonge, *Eldre norske fotografer*, 23.
4. For information on Magdalene Norman, see Matland, "Magdalene Norman og fotografi," 68; and Gulden, "Magdalene Norman."
5. Transcribed from Magdalene Norman's travel journal for 1906, identified by Ann Torday Gulden.
6. Bonge, *Eldre norske fotografer*, 150.
7. *Hanska: A Century of Tradition*, 117.
8. The information comes from the photography archive at the Institute for Regional Studies, North Dakota State University.
9. Letter from Anna M. Johnson, Park River, Walsh County, North Dakota, August 26, 1898, to Morten Pedersen and Mette Pedersdatter Nordhus, Rennesøy, Rogaland, in *Fra Amerika til Norge VI*, ed. Øverland, letter 114, 254.
10. "Directory of Minnesota Photographers."
11. A short overview of Mina Westbye's biography can be found in Lahlum, "There Are No Trees Here," 156–58.
12. *Davison's Minneapolis City Directory*.
13. "One Hundredth Anniversary."
14. Øverland, *Western Home*, 157.
15. *Bulletin of the Torrey Botanical Club*, 484–87.
16. Letter from Alfred Gundersen to Mina Westbye, Observatory Hall, Middletown, March 1905.
17. Letter from Mina Westbye to Alfred Gundersen, January 27, 1905.
18. Ibid.
19. Ibid.
20. Letter from Mina Westbye to Alfred Gundersen, Trysil, North Dakota, Sunday, April 29, 1905.
21. Ibid.
22. Letter from Mina Westbye to Alfred Gundersen, Minneapolis, February 10, 1905.
23. Letter from Mina Westby to Alfred Gundersen, February 2, 1906.
24. Ibid.
25. *Hanska: A Century of Tradition*, 116–17.
26. Letter from Mina Westbye to Alfred Gundersen, Christiania, Norway, December 8, 1908.
27. Ibid.
28. Letter from Mina Westbye to Alfred Gundersen, Trysil, Norway, 1910.
29. Ibid.
30. Hellesund, "Den norske peppermø."

4. Place and the Rhythm of Life

1. Buckley, "Humor of *Han Ola og han Per*," 11.
2. Ibid., 17.
3. The first study was Wogsland, "Han Ola og Han Per." Then came Bengtson, *Han Ola og Han Per*. In 1984, Buckley and Haugen edited *Peter J. Rosendahl, Han Ola og han Per*; they presented not only English translations of the headings and the dialogue, and Norwegian translations of the many English words in the comic strip, but also well-written and informative essays on the humor and language in the Rosendahl series. Finally, as late as 2007, Tormod Kinnes wrote a master's thesis in the English department at the Norwegian University of Science and Technology in Trondheim about Rosendahl's humor.
4. Haugen, "Language of Han Ola og han Per," 27.
5. Buckley, "Humor of *Han Ola og han Per*," 15.
6. Bengtson, *Han Ola og Han Per*, 2.
7. Ibid., 11; Wogsland, "Han Ola og Han Per," 2.
8. Published in *Decorah-posten*, January 8, 1926, 5. Translated by Haugen, in Buckley and Haugen, eds., *Peter J. Rosendahl, Han Ola og han Per*, 5.
9. Johnson, "Settler History," 9, 32.
10. Buckley, "Humor of *Han Ola og han Per*," 21.
11. Haugen, "Language of Han Ola og han Per," 33.
12. Transcription of Peter J. Rosendahl's diary is in Georgia Rosendahl's possession.
13. Cited in Muller, *Spring Grove*, 19.
14. See Hansen, "Fotografiets dagligtale."
15. Hansen, "Fotografiets dagligtale," 112–23.

16. For a discussion of the meaning of place, see Greve, "Her."
17. See Bachelard, *Poetics of Space.*
18. Greve, "Her," 45.
19. Gjerde, *Minds of the West.*
20. Ibid., 177.
21. Ibid., 322.

5. Out of Cupboards and Drawers

1. For discussions about the tactile and material side of photography, see Di Bello, *Women's Albums*, 139; Edwards, "Photographs as Objects"; and Batchen, *Each Wild Idea*, 6–80.
2. Kracauer, "Fotografiet."
3. See Kracauer, *Theory of Film*, and his posthumously published *History: Last Things before the Last.*
4. Jansen and Ryningen, *Kultursoge*, 383.
5. Ryningen et al., eds., *Utvandringi til Amerika*, 11.
6. Ibid.
7. Barthes, *Det lyse kammer*, 117.
8. Letter to Gunnar T. Strømme from Tarald G. Bø, July 29, 1892. Private collection.
9. Inscription on the back of a photograph sent from Olav K. Moen, Canby, Minnesota.
10. Letter from Aanond O. Rysstad, July 12, 1888, King p.o. Polk Co, Minnesota, in *Utvandringi til Amerika*, ed. Ryningen et al., 87.
11. Letter from Gunnar Austegard, September 2, 1928, New York, 507 W 184, in *Utvandring til Amerika*, ed. Ryningen et al., 96.
12. Øverland, "Intruders on Native Ground," 31.
13. The information comes from a conversation with the photograph's owner, Ingebjørg Vegestog Homme, May 2004.
14. Øverland, "Intruders on Native Ground," 26.
15. Written down by Anders H. Helle, now living in Austad in Bygland municipality, Setesdal.
16. Risa, *Bilete frå Hå*, 207.
17. Skretting, *In My Father's Footsteps*, 5.
18. Risa, *Bilete frå Hå.*
19. Ibid., 147.

6. Saved from Oblivion

1. Batchen, *Each Wild Idea*, 57.
2. Di Bello, *Women's Albums*, 8.
3. For a discussion of how archive form, the material aspects of the archives, is part of shaping history, see Ernst, *Sorlet från arkiven.*
4. "Worringer, Ingeborg Grinde."
5. For a discussion of Andreas Larsen Dahl's photographic work, see chapter 1.
6. Edwards, *Raw Histories*, 109.
7. Lundwall, ed., *Memories of Grandma's Place*, 12.
8. Ibid., 18.
9. Ibid., 23–24.
10. Ibid., 19.
11. Lovoll, *Century of Urban Life.*
12. Ibid., 279.
13. Ibid., 298.
14. For an in-depth discussion of the use of mixed media in women's album production, see Di Bello, *Women's Albums*, 150–51.
15. Letter from Josefa Kallestad to her son, Leif, December 24, 1980.
16. Letter from Josefa Kallestad to her son, Leif, February 16, 1982.
17. Ringdal, *Lapskaus Boulevard*, 8.
18. Worley, "The Past Is Never Lost," 7–9.
19. Ibid.
20. Cited in Worley, "The Past Is Never Lost," 148.
21. I am grateful to Victoria Hofmo of the Scandinavian East Coast Museum for helping me to acquire some of this information in the museum's archives.

Conclusion

1. Roberts, *Photography and Its Violations*, 4.
2. Ibid.
3. Ibid., 36.
4. Olson, *Vikings across the Atlantic*, 31.
5. See Bergland and Lahlum, eds., *Norwegian American Women.*
6. See Hansen, *Encounter on the Great Plains.*
7. Lien and Nielssen, *Museumsforteljingar*, 78.
8. Ahmed, *Cultural Politics of Emotion*, 2.

Bibliography

Aars, Ivar. "Andreas Dahl." In *Årbok for Valdres 1999*. Valdres: Valdres Historielag, 1999.

Ahmed, Sarah. *Cultural Politics of Emotion*. London: Routledge, 2004.

"Amerika-bilete: Sjeldne bilete frå Bømlo." *Årshefte 2006*. Bømlo: Bømlo Tur- og Sogelag, 2006.

Bachelard, Gaston. *The Poetics of Space*. 1958. Reprint, Boston: Beacon Press, 1994.

Bakken, Reidsar. *Snikkaren Aslak Olsen Lie: Bygdekunstnar i Valdres og Wisconsin 1798-1886*. Oslo: Novus, 2000.

Barnouw, Dagmar. *Critical Realism: History, Photography, and the Work of Siegfried Kracauer*. Baltimore, Md.: Johns Hopkins University Press, 1994.

Barthes, Roland. *Det lyse kammer: Bemærkninger om fotografiet*. Copenhagen: Rævens Sorte Bibliotek, 1986.

Batchen, Geoffrey. *Each Wild Idea: Writing, Photography, History*. Cambridge, Mass.: MIT Press, 2001.

Bate, David. *Photography: The Key Concepts*. London: Bloomsbury, 2016.

Baxandall, Michael. *Patterns of Intention: On the Historical Explanation of Pictures*. New Haven, Conn.: Yale University Press, 1985.

Bengtson, Julius D. *Han Ola og Han Per: Language and Literature in the Comic Strips of Peter Julius Rosendahl*. N.p., 1977.

Bennett, Mary, and Paul C. Juhl. *Iowa Stereographs: Three-Dimensional Visions of the Past*. Iowa City: University of Iowa Press, 1997.

Bergland, Betty A., and Lori A. Lahlum, eds. *Norwegian American Women: Migration, Communities and Identities*. St. Paul: Minnesota Historical Society Press, 2011.

Bjorli, Trond Erik. "Et fotografisk gjennombrudd: Fotografisk og nasjonal modernisering i fotografen Anders Beer Wilses bildeproduksjon ca. 1900–1910." PhD diss., University of Bergen, 2014.

Blegen, Theodore C. *Grass Roots History*. Minneapolis: University of Minnesota Press, 1947.

——. *Land of Their Choice: The Immigrants Write Home*. Minneapolis: University of Minnesota Press, 1955.

——. *Norwegian Migration to America: The American Transition*. Northfield, Minn.: Norwegian-American Historical Association, 1940.

——. *Norwegian Migration to America, 1825–1860*. Northfield, Minn.: Norwegian-American Historical Association, 1931.

Bonge, Susanne. *Eldre norske fotografer: Fotografer og amatørfotografer i Norge frem til 1920*. Bergen: Universitetsbiblioteket, 1980.

Buckley, Joan N. "The Humor of Han Ola og han Per." In *Peter J. Rosendahl, Han Ola og han Per: A Norwegian-American Comic Strip*, edited by Joan N. Buckley and Einar Haugen. Oslo: Universitetsforlaget, 1984.

Buckley, Joan N., and Einar Haugen, eds. *Peter J. Rosendahl, Han Ola og han Per: A Norwegian-American Comic Strip*. Oslo: Universitetsforlaget, 1984.

Bulletin of the Torrey Botanical Club 85, no. 6 (1958).

Clarke, Graham, ed. *The Portrait in Photography*. London: Reaktion Books, 1992.

——. "Public Faces, Private Lives: August Sander and the Social Typology of the Portrait Photograph." In *The Portrait in Photography*, edited by Graham Clarke, 71–93. London: Reaktion Books, 1992.

Dahl, Andreas L. *Hospitalsmissionen i Tvillingbyerne: Oplevelser og erfaringer*. Minneapolis, Minn.: Augsburg Publishing House, 1917.

Danielsen, Jens Bjerre. "Den faglige og politiske organisering blant danske og skandinaviske immigranter i USA fra 1880'erne til 1920'erne. En oversikt." *Arbejderhistorie* 24 (1985).

Davison's Minneapolis City Directory. Vol. 33. Minneapolis, Minn.: Minneapolis Directory Company, 1905.

Di Bello, Patrizia. *Women's Albums and Photography in Victorian England*. Aldershot, UK: Ashgate, 2007.

"Directory of Minnesota Photographers." Minnesota Historical Society. http://www.mnhs.org/people/photographers/V.php.

Earle, Rebecca, ed. *Epistolary Selves: Letters and Letter-Writers, 1600-1945.* Sydney: Ashgate, 1999.

Edwards, Elizabeth. "Photographs as Objects of Memory." In *Material Memories: Design and Evocation,* edited by Marius Kwint, Christopher Breward, and Jeremy Aynsley, 221-36. Oxford: Berg, 1999.

——. *Raw Histories: Photographs, Anthropology and Museums.* Oxford: Berg, 2001.

Edwards, Elizabeth, and Janice Hart. *Photographs, Objects, Histories: On the Materiality of Images.* London: Routledge, 2004.

Engen, Arnfinn, ed. *Utvandringa—Det store oppbrotet.* Oslo: Det Norske Samlaget, 1978.

Ernst, Wolfgang. *Sorlet från arkiven: Ordning ur oordning.* Glänta, Sweden: Glänta produktion, 2008.

Fapso, Richard J. *Norwegians in Wisconsin.* Madison: Wisconsin Historical Society Press, 2001.

Farseth, Pauline, and Theodore C. Blegen, trans. and eds. *Frontier Mother: The Letters of Gro Svendsen.* Northfield, Minn.: Norwegian-American Historical Association, 1950.

Flå, Vibeke. "Økt kvinneutvandring fra nord-norske byer på slutten av 1800-tallet og fram til 1915." In *Norwegian American Essays,* edited by Øyvind T. Gulliksen, David C. Mauk, and Dina Tolfsby. Oslo: Norwegian-American Historical Association and Norwegian Emigrant Museum, 1996.

Frizot, Michel, ed. *A New History of Photography.* Cologne, Germany: Könemann, 1998.

Gabaccia, Donna R., and Leslie Page Moch. "Preface." In *Citizenship and Those Who Leave: The Politics of Emigration and Expatriation,* edited by Nancy L. Green and François Weil. Urbana: University of Illinois Press, 2007.

Gerber, David A. *Authors of Their Lives: The Personal Correspondence of British Immigrants to North America in the Nineteenth Century.* New York: New York University Press, 2006.

——. "The Immigrant Letter between Positivism and Populism: American Historians' Uses of Personal Correspondence." In *Epistolary Selves: Letters and Letter-Writers, 1600-1945,* edited by Rebecca Earle. Sydney: Ashgate, 1999.

Gjerde, Jon. "Echoes of Freedom: The Norwegian Encounter with America." In *Fiksjon, Fakta og Forskning: Seminar om den tidlige utvandringa til Amerika,* edited

by Nils Olav Østrem. Stavanger: Rapporter fra Universitetet i Stavanger, 2007.

——. *The Minds of the West: Ethnocultural Evolution in the Rural Middle West, 1830-1917.* Chapel Hill: University of North Carolina Press, 1997.

Gjerde, Jon, and Carleton C. Qualey. *Norwegians in Minnesota.* St. Paul: Minnesota Historical Society Press, 2002.

Green, Nancy L., and François Weil, eds. *Citizenship and Those Who Leave: The Politics of Emigration and Expatriation.* Urbana: University of Illinois Press, 2007.

Greve, Anniken. "Her: Et bidrag til stedets filosofi." PhD diss., University of Tromsø, 1998.

Gulden, Ann T. "Magdalene Norman: Fotograf, Dampskipsekspeditør og Bon Viveur," 2006.

Gulliksen, Øyvind T. "Ole E. Rølvaag og immigrantenes religiøse identitet." *Årbok for Helgeland,* 2006.

Gulliksen, Øyvind T., David C. Mauk, and Dina Tolfsby, eds. *Norwegian American Essays.* Oslo: Norwegian-American Historical Association and Norwegian Emigrant Museum, 1996.

Hansen, Christine. "Fotografiets dagligtale: Studier i familefotografiets ulike funksjonsmåter og erkjennelsespotensial." Master's thesis, University of Bergen, 2005.

Hansen, Karen V. *Encounter on the Great Plains: Scandinavian Settlers and the Dispossession of Dakota Indians, 1890-1930.* Oxford: Oxford University Press, 2013.

Hanska: A Century of Tradition, 1901-2001. Hanska, Minn.: Hanska Centennial Committee, 2001.

Haugen, Einar. "The Language of Han Ola og han Per." In *Peter J. Rosendahl, Han Ola og han Per: A Norwegian-American Comic Strip,* edited by Joan N. Buckley and Einar Haugen. Oslo: Universitetsforlaget, 1984.

Hebel, Udo J., ed. *Transnational American Memories.* Berlin: De Gruyter, 2009.

Hellesund, Tone. "Den norske peppermø: Om kulturell konstituering av kjønn og organisering av enslighet 1870-1940." PhD diss., University of Bergen, 2001.

Holmes, Oliver W. "The Stereoscope and the Stereograph." In *Classic Essays on Photography,* edited by Alan Trachtenberg. New Haven, Conn.: Leete's Island Books, 1980.

Jansen, Leonard, and Alfred Ryningen. *Kultursoge. Vol. 7 of Valle kommune.* Valle: Valle kommune, 1994.

Johannesson, Lena. "Photo Exile: On the European Experience and Women Photographers in Germany and Sweden." In *Women Photographers—European Experience*, edited by Gunilla Knape and Lena Johannesson. Gothenburg: Acta Universitatis Gothoburgensis, 2004.

Johannesson, Lena, and Gunilla Knape, eds. *Women Photographers—European Experience*. Gothenburg: Acta Universitatis Gothoburgensis, 2004.

Johnson, O. S. "Settler History from Spring Grove and Surroundings, Minnesota." N.p., 1920. www.springgrovemnheritagecenter.org.

Kinnes, Tormod. "The Humor of *Han Ola og Han Per* Taken Seriously." Master's thesis, Norwegian University of Science and Technology, 2007.

Koren, Elisabeth. *Fra Pioneertiden: Uddrag fra Elisbeth Korens Dagbog og Breve fra Femtiaarene. Udgivet af hendes Børn.* Decorah, Iowa: Udgivernes Forlag, 1914.

Kracauer, Siegfried. "Fotografiet." *Kultur og Klasse* 44 (1982): 7–19. Danish translation by Peter Larsen, 1927; English translation by Thomas Y. Levin, in *Critical Inquiry* 19, no. 3 (1993): 421–36.

——. *History: Last Things before the Last.* 1969. Reprint, Princeton, N.J.: Markus Wiener, 1995.

——. *Theory of Film: The Redemption of Physical Reality.* Oxford: Oxford University Press, 1960.

Kwint, Marius, et al., ed. *Material Memories*, Oxford: Berg, 1999.

Lahlum, Lori A. "'There Are No Trees Here': Norwegian Women Encounter the Northern Prairies and Plains." PhD diss., University of Idaho, 2003.

Langholm, Sivert, and Francis Sejersted, eds. *Vandringer: Festskrift til Ingrid Semmingsen på 70-årsdagen 29. mars 1980.* Oslo: Aschehoug, 1980.

Larsen, Peter. *Album: Fotografiske motiver.* Oslo: Spartacus Forlag, 2004.

Larsen, Peter, and Sigrid Lien. *Norsk fotohistorie: Frå daguerreotypi til digitalisering.* Oslo: Det Norske Samlaget, 2007.

Lee, Anthony W. *A Shoemaker's Story: Being Chiefly about French Canadian Immigrants, Enterprising Photographers, Rascal Yankees and Chinese Cobblers in a Nineteenth-Century Factory Town.* Princeton, N.J.: Princeton University Press, 2008.

Leiren, Terje I. *Marcus Thrane: A Norwegian Radical in America.* Northfield, Minn.: Norwegian-American Historical Association, 1987.

Lien, Sigrid, and Hilde W. Nielssen. *Museumsforteljingar: Vi og dei andre i kulturhistoriske museum.* Oslo: Det Norske Samlaget, 2016.

Linkman, Audrey. *The Victorians: Photographic Portraits.* London: Tauris Parke Books, 1993.

Lovoll, Odd S. *A Century of Urban Life: The Norwegians in Chicago before 1930.* Chicago: University of Illinois Press, 1988.

——. *Norwegians on the Prairie: Ethnicity and the Development of the Country Town.* St. Paul: Minnesota Historical Society Press, 2006.

——. *The Promise of America: A History of the Norwegian-American People.* Minneapolis: University of Minnesota Press, 1999.

Lundwall, Helen O., ed. *Memories of Grandma's Place, Homesteading & Our Families.* Printed for private circulation, 2002.

Mandel, David. *Settlers of Dane County: The Photographs of Andreas Dahl.* Madison, Wis.: Dane County Cultural Affairs Commission, 1985.

Matland, Susan. "Magdalene Norman og fotografi." *Årbok for Tysfjord* 11 (1993).

Mirzoeff, Nicholas, ed. *Diaspora and Visual Culture: Representing Africans and Jews.* London: Routledge, 2000.

——. "The Multiple Viewpoint: Diasporic Visual Cultures." In *Diaspora and Visual Culture: Representing Africans and Jews,* edited by Nicholas Mirzoeff. London: Routledge, 2000.

Muller, Chad. *Spring Grove—Minnesota's First Norwegian Settlement.* Chicago: Arcadia Publishing, 2002.

Nelson, David T., ed. *The Diary of Elisabeth Koren, 1853–55.* Northfield, Minn.: Norwegian-American Historical Association, 1955.

Oldervoll, Jan. "Kva hadde befolkningsveksten å seie for utvandringa?" In *Utvandringa—Det store oppbrotet,* edited by Arnfinn Engen. Oslo: Det Norske Samlaget, 1978.

Olin, Margaret. "'It is not going to be easy to look into their eyes'": Privilege of Perception in *Let Us Now Praise Famous Men.*" *Art History* 14, no. 1 (1991): 92–115.

Olson, Daron W. *Vikings across the Atlantic: Emigration and the Building of a Greater Norway, 1860–1945.* Minneapolis: University of Minnesota Press, 2013.

"One Hundredth Anniversary of the Nora Free Christian Church, Unitarian Universalist, Hanska, Minnesota, 1881–1981: Amandus Halvdan Norman." Nora Free

Church file. New Ulm, Minn.: Brown County Historical Society.

Orvell, Miles. *American Photography*. Oxford: Oxford University Press, 2003.

Østrem, Nils Olav, ed. *Fiksjon, Fakta og Forskning: Seminar om den tidlige utvandringa til Amerika*. Stavanger: Rapporter fra Universitetet i Stavanger, 2007.

——. *Norsk utvandringshistorie*. Oslo: Det Norske Samlaget, 2014.

Øverland, Orm. *"Det smærter mig meget at nedskrive disse Linjer til Eder": En utvandrerhistorie i brev Heddal-Telemark-Wisconsin*. Notodden: Notodden Historielag / Telemark Historielag, 1995.

——, ed. *Fra Amerika til Norge IV: Norske utvandrerbrev 1875 1884*. Oslo: Solum Forlag, 2002.

——, ed. *Fra Amerika til Norge VI: Norske utvandrerbrev 1895-1904*. Oslo: Solum Forlag, 2010.

——. "Innledning: De tidlige Amerikabrevene." In *Fra Amerika til Norge I: Norske utvandrerbrev 1838-1857*, edited by Orm Øverland and Steinar Kjærheim. Oslo: Solum Forlag, 1992.

——. "Intruders on Native Ground: Memories of Land-Taking in Norwegian Immigrant Letters." In *Transnational American Memories*, edited by Udo J. Hebel. Berlin: De Gruyter, 2009.

——. "Learning to Read Immigrant Letters: Reflections towards a Textual Theory." In *Norwegian American Essays*, edited by Øyvind T. Gulliksen, David C. Mauk, and Dina Tolfsby. Oslo: Norwegian-American Historical Association and Norwegian Emigrant Museum, 1996.

——. "Translator's Introduction." In Johannes B. Wist, *The Rise of Jonas Olsen: A Norwegian Immigrant Saga*. Minneapolis: University of Minnesota Press, 2006.

——. *The Western Home: A Literary History of Norwegian America*. Chicago: University of Illinois Press, 1996.

Øverland, Orm, and Steinar Kjærheim, eds. *Fra Amerika til Norge: Norske utvandrerbrev*. 7 vols. Oslo: Solum, 1992-2010.

——, eds. *Fra Amerika til Norge I: Norske utvandrerbrev 1838-1857*. Oslo: Solum Forlag, 1992.

——, eds. *Fra Amerika til Norge II: Norske utvandrerbrev 1858-1868*. Oslo: Solum Forlag, 1992.

——, eds. *Fra Amerika til Norge III: Norske utvandrerbrev 1869-1874*. Oslo: Solum Forlag, 1993.

Pegler-Gordon, Anna. *In Sight of America: Photography and the Development of U.S. Immigration Policy*. Berkeley: University of California Press, 2009.

Peihl, Mark. "Wange's Photographs Document over 50 Years of Community Life." *Clay County Historical Society Newsletter* 20, no. 5 (1997).

Perez, Nissan N. *Displaced Visions: Emigré Photographers of the 20th Century*. Jerusalem: Israel Museum, 2013.

Reiakvam, Oddlaug. *Bilderøyndom-Røyndomsbilde: Fotografi som kulturelle tidsuttrykk*. Oslo: Det Norske Samlaget, 1997.

Ringdal, Siv. *Lapskaus Boulevard: Et gjensyn med det norske Brooklyn*. Oslo: Golden Slippers, 2007.

Risa, Lisabet. *Bilete frå Hå: Folk og miljø 1860-1950*. Hå: Kulturetaten, 1990.

——. *Fotografihistoria sett frå Rogaland*. Stavanger: Wigestrand Forlag, 2011.

——. "Rasmus Pederson Thu—reisefotografen, friluftsfotografen og atelierfotografen." In *Svarthvitt kulturhistorisk fotografi*. Oslo: NMU-Fotosekretariatet / Norsk Fotohistorisk Forening, 2001.

Roberts, John. "Photography after the Photograph: Event, Archive and the Non-Symbolic." *Oxford Art Journal* 32, no. 2 (2009): 281-98.

——. *Photography and Its Violations*. New York: Columbia University Press, 2014.

Ryningen, Alfred, et al., eds. *Utvandringi til Amerika. Vol. 10 of Valle kommune*. Valle: Valle kommune, 2001.

Semmingsen, Ingrid. *Norway to America: A History of the Migration*. Minneapolis: University of Minnesota Press, 1978.

——. *Veien mot Vest: Utvandringen fra Norge til Amerika, 1825-1865*. Oslo: Aschehoug, 1941.

Skretting, Harald. *In My Father's Footsteps—75 years later*. Hå: Hå kommune, 2000.

Stanley, Liz. "The Epistolarium: On Theorizing Letters and Correspondences." *Auto/Biography* 12 (2004): 201-35.

St. Mane, Ted, and Don Ward. *Lanesboro, Minnesota: Historic Destination*. Mount Pleasant, S.C.: Arcadia Publishing, 2002.

Svalestuen, Andres A. "Professor Ingrid Semmingsen—emigrasjonshistorikeren." In *Vandringer: Festskrift til Ingrid Semmingsen*, edited by Sivert Langholm and Francis Sejersted. Oslo: Aschehoug, 1980.

Taft, Robert. *Photography and the American Scene: A Social History, 1839-1889*. New York: Dover, 1964.

Teigen, Erling T. "The Legacy of Jacob Ottesen and the Enduring Legacy of Preus, Koren and Ottesen." Paper presented at the 36th Annual Reformation Lectures, Bethany Lutheran College, Mankato, Minn., October 30-31, 2003. http://www.wlsessays.net/bitstream /handle/123456789/1598/TeigenOttesen.pdf

Trachtenberg, Alan, ed. *Classic Essays on Photography.* New Haven, Conn.: Leete's Island Books, 1980.

——. *Reading American Photographs: Images as History.* New York: Noonday, 1990.

Tveite, Stein. "Overbefolkning, befolkningspress og vandring." In *Vandringer: Festskrift til Ingrid Semmingsen på 70-årsdagen 29.mars 1980*, edited by Sivert Langholm and Francis Sejersted. Oslo: Aschehoug, 1980.

Williams, Carol J. *Framing the West: Race, Gender and the Photographic Frontier in the Pacific Northwest.* Oxford: Oxford University Press, 2003.

Wist, Johannes B. *The Rise of Jonas Olsen: A Norwegian Immigrant Saga.* 1920. Reprint, Minneapolis: University of Minnesota Press, 2006.

Wogsland, John D. "Han Ola og Han Per." Independent Study. Decorah: Luther College, 1965-66.

Wolthers, Louise. "Blik og begivenhed: En diskussion af fotografiets historiske potentialer med nedslag i krig, koloni og kommercialisme 1860-1920." PhD diss., University of Copenhagen, 2008.

Worley, Vivian Aalborg. "The Past Is Never Lost." Master's thesis, University of Bergen, 2007.

"Worringer, Ingeborg Grinde: Family History and Photographs, 1870-1935, 1971." Wisconsin Historical Society, Madison.

Wtulich, Josephine. *Writing Home: Immigrants in Brazil and the United States 1890-1891.* New York: Columbia University Press, 1986.

Yochelson, Bonnie, and Daniel Czitrom. *Rediscovering Jacob Riis: Exposure Journalism and Photography in Turn-of-the-Century New York.* New York: New Press, 2007.

Zempel, Solveig. *In Their Own Words: Letters from Norwegian Immigrants.* Minneapolis: University of Minnesota Press, 1991.

Illustration Credits

Photographs and illustrations in this book are printed courtesy of the institutions and individuals listed here. Identification numbers for specific collections, where applicable, are included in parentheses. Dates and the photographer's name, if known, are in the captions.

Cultural History Collection, University of Bergen Museum, Bergen, Norway: Figure 1.14.

Picture Collection, University of Bergen Library, Bergen, Norway: Figures I.4, 1.11, 1.12.

Historical and Cultural Society of Clay County, Moorhead, Minnesota: Figures 2.43–2.55, 3.4, C.1 (Flaten/Wange Glass Plate Negative Collection).

Institute for Regional Studies, North Dakota State University, Fargo, North Dakota: Figure C.2 (Myrtle Porterville Photograph Collection, Mss 296.147.62).

Minnesota Historical Society, St. Paul, Minnesota: Figures I.11, 1.16, 2.1–2.10, 2.33–2.42 (Ole Aarseth Photograph Collection, I.97), 3.3.

National Library of Norway, Oslo, Norway: Figure 1.13 (Olsen, Ole Tobias, NB.01.01.1860).

Northwest Minnesota Historical Center, Minnesota State University Moorhead, Moorhead, Minnesota: Figures 2.11–2.32 (Haakon Bjornaas Photograph Collection, S4852).

Norwegian-American Historical Association, Northfield, Minnesota: Figures 6.21–6.37 (John Kallestad Family Papers, P1413).

Norwegian Museum of Cultural History, Oslo, Norway: Figures I.5 (NF.00607), I.6–I.10 (NF.08382).

Private collections: Figure I.1 (author's collection); Figures 1.15 and 1.17–1.21 (courtesy Richard Morrison); Figures 3.1 and 3.5–3.16 (courtesy Glenn N. Durban); Figures 5.40–5.42 (courtesy Egil and Anne Karin Jåsund); Figures 5.43–5.49 (courtesy Lisabet Risa); Figures 5.50–5.56 (courtesy Geir Palle Haarr); Figures 6.14–6.20 (courtesy Helen Olson Lundwall); Figures 6.38–6.51 (courtesy Peter Syrdahl).

Regional State Archives, Stavanger, Norway: Figure 5.39.

Setesdal Museum, Rysstad, Norway: Figures I.2, I.3, 5.1–5.38.

Trondenes Historical Center, Harstad, Norway: Figure 3.2.

Vesterheim Norwegian-American Museum, Decorah, Iowa: Figures 4.1–4.38 (Peter J. Rosendahl Collection), 6.1–6.7 (Iver Rockvog Collection, 1896).

Wisconsin Historical Society, Madison, Wisconsin: Figures I.12 (WHi-29970), Andreas Larsen Dahl Photograph Collection; 1.1 (WHi-26684), 1.2 (WHi-27635), 1.3 (WHi-34652), 1.4 (WHi-27505), 1.5 (WHi-1955), 1.6 (WHi-27201), 1.8 (WHi-52245), 1.9 (WHi-27097), 1.10 (WHi-25549); Ingeborg Grinde Worringer Family History and Photograph Collection: Figures 6.8 (WHi-63551), 6.9 (WHi-63548), 6.10 (WHi-63547), 6.11 (WHi-63549), 6.12 (WHi-63546), 6.13 (WHi-64459).

Index

posing strategies: of Dahl, 40, 58, 244; of Knudsen, 44; of Norwegian photographers, 44–45; of Wange, 88

postcard photography: of Aarseth, 79–86; of Bjornaas, 68–74, 246; of Bjornaas, conflict between golden dream of America and its everyday reality depicted in, 69–70, 77–79; of Bjornaas, travels to collect raw material for, 70–74, 77–79; discontinuation of postal system monopoly on producing postcards and, 71; industrially produced pictures, 162–63, 164

prejudice, 226

"Puzzle of the Ages, The" (Rosendahl), 147

Quaker movement, 19

Quam, M. J. (Quam & Drysdale), 261

"Race at Fargo State Fair, 1910" (Bjornaas), 75

railroad, settlements in rural areas enabled by, 34, 61

railway station, photograph of Norwegian-Americans at, 67, 68

real estate: homesteading, 23, 107–8, 111, 112, 113–16, 206, 211–13, 247; speculation in, 107–8

Red River Valley, Minnesota, 68; Anglo-American settlers' domination of politics and culture in, 84; urbanization of, 71; Wange, photographer-barber of Hawley in, 86–97; Yellow Medicine County, Aarseth's photographs in, 79–80, 86

Ree, Arnt, 181, 183, 185

Ree, Arnt Jensson, 181, 182, 183, 184

Ree, Bernice and Violet, 184, 185

Ree, Jens, 181, 183

Ree, Johanna, 181, 182

Ree, Lars, 181, 183

Ree, Lisa Taletta, 181, 182

Ree, Nils, 181, 183, 184

Ree, Valetta, America-photographs left by, 181–85

Ree, Vilhelm, 181, 183, 184; departure photograph, 181–82; family reunions, 182–84

Rekve, Sjur, portrait of family of, 40, 45

Reme, Eva, ix

remigration, 238; of Westbye, 110–11, 116–17, 119. *See also* Norway

Renaas, Albert, 261

Reppen, N. O., 261

research, fields of, 3

Restauration (sloop), 19

Riis, Jacob, 13

Ringdal, Siv, 237–38

Risa, Lisabet, 51, 177

Risem, Olaf, 261

Rise of Jonas Olsen: A Norwegian Immigrant Saga, The (Wist), 64–66, 69

Riverside Studio, 77

Roberts, John, 3, 21, 244

Rockefeller family, bragging pictures of emigrant working for, 165

Rockvog, Iver, photo album of, 193–95; pictures of heroes in, 193–94, 195, 196, 197

Rødvik, Sigvart, 144

Rohde, Anton, 187, 188

Rølvaag, O. E., 53

Roosevelt, Theodore, 81

Rosaas, Edna S., 103, 261

Rosaas, O. T., 103, 261

Rosendahl, Carl Otto, 122, 127

Rosendahl, Georgia, 123, 126

Rosendahl, Gladys, 122, 123, 136, 138

Rosendahl, Gunnhild, 122

Rosendahl, Othelia, 127, 134, 135

Rosendahl, Paul, 122, 134

Rosendahl, Peter Julius, 23, 121–47, 247, 261; background and education of, 122, 124, 126; camera used by, 125–26; comic-strip series by, 23, 122, 123–32, 146, 267n3; comic-strip series by, parallels to personal life and work of, 126–27; daily activities and family snapshots of, 134–40; diary in snapshots, 133–40; fascination with modernity, 127–29; interest in nature and animal life, 129, 130–31, 138, 139–43; as mechanical farmer, 126–27; path through the woods as central motif of, 142–43; photographs as political statements, 144–47, 247; place in words and images for, 140–43; poems of, 140–42, 144, 147; self-portrait of, 126, 127; as village photographer in Spring Grove, 125

Roseth, William, 262

Royce Studio, 190

Rudd, Harry, 262

Rudd, Peter Axel, 262

Rudd (Rud), Harold, 102

Rumsey, 262

rural communities in Norway, America-photography in. *See* Norwegian rural communities, America-photography in

Rysstad, Aanond O., 268n10

Rysstad, Ånund O., 168

Rysstad, Gunnbjørg, 168, 169

Rysstad, Hallvard S., 171

Rysstad, Knut Å, bragging picture of, 168

Rysstad, Knut Pålsson, bragging pictures of, 165–66

Sagen, Hans O., 262

St. Olaf College (Northfield, Minnesota) students, 232, 234

Salveson, Sigurd (Salveson's Studio), 262

framing of Norwegian ethnicity connected to American lifestyle and symbols as recurrent theme in, 232; Hine as role model photographer for, 230–32; Norwegian Constitution Day (17th of May) parades in, 228–37, 238, 239; pan-Scandinavian nature of, 230; self-portrait in front of his home, 229

Tagg, John, 3
technology, immigrants' encounter with, 168, 169
telephone, bragging pictures showing, 168, 169
Thompson, Marit Skogen, 29
Thompson, Martha Skogen, 29
Thrane, Marcus, 12; national self-awareness of, 58; as newspaper editor, 57; Norwegian-American movement, 57; as portrait photographer in America, 56–57; as socialist leader in Norway, 56; supporters of, Dahl's family portrait of, 31–32, 56–58, 244, 246
Thrane Art Company, 52
Thu, Rasmus P., 51, 263
Thune, Halvor W. (Thune & Folkendahl), 263
Thussel, Nels J., 91, 93
Tidemand, Adolph, 19
Tollefsen, Thea, album left by, 177–81
Tollefsen, Tollef, 179
Tollefson, G. L., 263
"Tordenskjold Lutheran Church," Otter Tail County, Minnesota (Bjornaas), 73
Trachtenberg, Alan, 5
tractor, Rosendahl's self-built, 127, 128
transnational perspective, shift to, 13–14, 15
traveling "America-agents," 152
traveling photographers, 16–17;

Bjornaas' caricature drawing of, 70; itinerant "cheats," 34. *See also* Dahl, Andreas (Andrew) Larsen
Trysil, North Dakota, Westbye's photographs from, 108–9
Trysil, Norway, Westbye's childhood home in, 106–7, 110–11
Turner, Frederick Jackson, 14
Tveiten, Sigrid, 175

Ulfseth, C., 263
Underhill, Irving, 163
Underwood, Minnesota, photographs of, 68–69
Underwood & Underwood Publishers, 52
Undset, Sigrid, 118
Unitarian Church, 110
University of Washington Libraries, 251
Uppstad, Torbjørg Taraldsen, 162, 163

Valle, Setesdal, letters and photographs sent to, 6, 7, 158–59, 163, 164
Vang, Knut, 263
Veien mot Vest: Utvanderingen fra Norge til Amerika, (1825–1865) [The way west: Emigration from Norway to America, 1825–1865] (Semmingsen), 20
Vesterheim Museum (Decorah, Iowa), 251; Rockvog photo album in, 193–95; Rosendahl picture archives at, 122–23, 126
Vietnam War, service in, 229
View from the Island Tysnes (Knudsen), 42–43
"Views from Norway: [The Farm] *Litreæt* and the people there" (Myklebust), 52
Vigenstand, Paul Torstenson, 16, 33
Viking View Company, 52
Viknes, John (John Wagness), 264
Vikre, Geneva (Vikre Studio), 104, 264

Vikre, Harold (Vikre Studio), 104, 264
Vikre, Marie (Vikre Studio), 264
Vikre, Peter B. (Vikre Studio), 264
violation, concept of, 3
"visiting card" format, portraits in, 153–55, 186–87
Voss, C. L. (Voss & Cappelen), 264
Voss, Harry C., 264
Voss, Pearl (possibly Voss Sisters), 104, 264
Voss Sisters (Glenwood, Minnesota), 104

Waale, Thomas (Waale Studio), 264
Wagness, John (John Viknes, John Thorvakd Wagness), 264
Walle, North Dakota, settlement of, 172–73
Wange, Sylvester Peter (Sylfest Vange: S. P. Wenge) [Wange Studio], 86–97, 264; art photography of, 89; background and life in Hawley, 87–88; informal modes of posing, 88; as local master of ceremony, 246–47; major events of people's lives photographed by, 91–97, 247; photographic documentation of local businesses, 91, 92–93, 246–47; self-portrait of, 87
Wangsness, G. K., 264
Washington, emigrants in, 159–62
Weary Men (Trætte Mænd) (Garborg), 114
wedding ceremony, photograph of, 91, 94
Westbye, Mina, 23, 99–100, 104–18, 119, 264, 267n11; childhood in Trysil, Norway, 106–7; homesteading in North Dakota, 107–8, 111, 112, 113–16, 247; letters of, 113–18, 267n17, 267nn20–24, 267nn26–29; photographic fragments of visual biography of, 105–12; return to America to marry Gundersen, 111, 117–18;

Sigrid Lien is professor of art history at the University of Bergen and a leading authority on Norwegian photography. Her books include *Norsk fotohistorie: Frå daguerreotypi til digitalisering, Kunsten å lese bilder, Talende bilder: Tekster om kunst og visuell kultur,* and the edited collection *Uncertain Images: Museums and the Work of Photographs.*

Barbara Sjoholm is a translator of Norwegian and Danish and the author of many works of fiction and nonfiction. She lives near Seattle, Washington.